Hong Kong Arts Festival at 50

2 0 2 2

藝術節簡介

香港藝術節於 1973 年正式揭幕，是國際藝壇中重要的文化盛事。每年二、三月期間呈獻優秀本地及國際藝術家的演出，以及舉辦多元化的「加料」和教育活動，致力豐富香港的文化生活。

香港藝術節是一所非牟利機構，除了政府的恆常資助及票房外，主要收入來自熱心人士的贊助和捐獻。

使命

- 舉辦一個高水平的藝術節，得以：
 - 豐富香港文化生活；
 - 產生催化作用，引起大眾對藝術的興趣；及
 - 促進文化交流。

節目

- 呈獻一個兼容並蓄的藝術節，得以：
 - 凸顯最新的藝術趨勢；
 - 為本地藝術界帶來創意及具啓發性的影響；及
 - 展示本港難得一見的製作。

- 安排上演世界各地（包括中國內地）的節目，
 以維持藝術節作為國際上重要藝術節的地位。

- 推介本地傑出人才，特別著重：
 - 新作品；
 - 特別為藝術節製作的演出；及
 - 凸顯香港文化特色的節目。

Introduction of HKAF

Hong Kong Arts Festival (HKAF), launched in 1973, is a major international arts festival committed to enriching the cultural life of the city by presenting leading local and international artists in all genres of the performing arts as well as a diverse range of "PLUS" and educational events in February and March each year.

HKAF is a non-profit organisation. Apart from recurrent funding from the government and box office revenues, its principal income sources are from generous sponsorship and donations.

Mission

- To present an arts festival of the highest artistic standard that will:
 - enrich the cultural life of Hong Kong;
 - act as a catalyst and arouse wider interest in the arts; and
 - encourage cross-cultural fertilization.

Programme

- To present a balanced Festival programme that will:
 - highlight the latest artistic trends;
 - be innovative and inspirational in its influence on the local arts scene; and
 - present works not frequently seen in Hong Kong.

- To stage programmes from around the world, including Mainland China, which sustain the Festival's reputation as a major international arts festival.

- To showcase the best of local talent with a preference for:
 - new works;
 - productions specifically mounted for the Festival; and
 - programmes highlighting the cultural setting of Hong Kong.

前言

行政長官的話

欣逢香港藝術節金禧之慶，謹此衷心致賀。過去半個世紀，本港這項盛事每年均呈獻繽紛多元的世界級藝術節目，包括音樂、歌劇、戲劇、舞蹈、電影、多媒體等，為大家帶來源源不絕的娛樂、新知和啟發。藝術節不但令市民的文化生活增添姿彩，還提升香港在國際藝壇的聲譽。

我樂見藝術節致力培育本地藝術人才，而且成績令人鼓舞。五十年來，藝術節委約和製作的本地作品有逾二百五十項，涵蓋所有創作類別。藝術節亦於過去三十年廣泛推行藝術教育計劃，讓八十多萬名學生欣賞表演、參觀彩排，以及參加工作坊及大師班，為他們提供大量機會以不同方式探索和體驗藝術。

近年，藝術節著力把藝術與科技融合，並推出一系列藝術科技節目及相關教育活動。此外，藝術節不忘照顧不同能力的人士，為他們舉辦表演及外展活動，共享藝術、文化及表演的樂趣。

衷心感謝藝術節團隊每年悉心籌辦香港藝術節，呈獻中西交融的藝術文化盛宴，展現香港中西薈萃、璀璨多姿的特色，並且堅持不懈為藝術奉獻心力。我深信，在未來半個世紀，藝術節定會繼續為香港以至全球帶來歡樂和啟迪，並繼續發光發亮，協助香港發展成為國家「十四五」規劃所支持的中外文化藝術交流中心。

香港特別行政區行政長官
李家超

Preface

Message from The Chief Executive

I am delighted to congratulate the Hong Kong Arts Festival on its 50th anniversary. Over the past half century, the Festival, being Hong Kong's signature arts event, has entertained, informed and inspired us with a rousing variety of world-class arts programmes in music, opera, theatre, dance, film, multimedia and more. And while the Festival cultivates our cultural life, it also boosts Hong Kong's international reputation in the arts.

The Festival's influence on developing local artists is particularly gratifying. It has commissioned and produced more than 250 local productions across all creative categories over the past 50 years. Through its extensive arts education programmes of the last 30 years, the Festival has also provided some 800,000 students with wide-ranging opportunities to enjoy the arts. More than attending performances and rehearsals, students are invited to take part in workshops and masterclasses, to explore and embrace the arts in a multitude of ways.

In recent years, the Festival has put increasing emphasis on integrating arts and technology, featuring a series of arts-tech programmes and related educational offerings. It also organises performance and outreach activities for people of varying abilities to share with them the joy of arts, culture and performance.

The Hong Kong Arts Festival, in its annual blend of Eastern and Western arts and culture programming, is a resplendent reflection of Hong Kong. For that, and for its enduring commitment to the arts, I am grateful to the Festival team. I am confident that the Festival will continue to delight and enlighten Hong Kong, and the world, over the next half century, while supporting our development into an East-meets-West Centre for International Cultural Exchange as laid down in the National 14th Five-Year Plan.

John KC Lee
Chief Executive
Hong Kong Special Administrative Region

主席的話

香港藝術節在 2022 年昂然邁進五十週年，是一個重要的歷史里程碑。

半世紀以來，藝術節每年雲集世界及本地藝術翹楚，中西薈萃，結合傳統與創新，帶來舞蹈、音樂、歌劇及戲劇等精采表演，不但是亞洲區首屈一指的年度藝術盛會，在國際藝壇亦已奠定重要的地位。

藝術節與時代息息相關，為這個城市傾注無限創意，同時向世界展現香港兼容並蓄、活力澎湃的文化面貌。我深信豐盛多元的文化藝術生活，是香港這個國際大都會不可或缺的重要元素。

除了邀請國際頂尖藝術家來港獻藝，藝術節也非常重視推動本地藝術發展，努力為創意洋溢的藝術工作者搭建平台，讓他們盡展才華，與世界各地演藝精英同台演出，綻放異彩，為香港與世界藝壇擔當橋樑角色。

藝術節的節目包羅萬有，一方面透過呈獻新穎破格的演出，帶領潮流，讓觀眾得以欣賞走在世界最前端的藝術；另一方面，以較傳統的藝術形式滿足不同觀眾的口味，老幼咸宜。藝術節每年吸引數以十萬計的本地及海外藝術愛好者，熱烈捧場。觀眾無論以香港為家，還是慕名而來，都能感受箇中都會魅力。而觀眾的支持與參與，是驅動藝術節向前邁進的力量。我想藉此機會，向每一位藝術家及支持藝術節的觀眾，表達我們真摯的感謝。

香港藝術節能夠擁有今日的成就，實在有賴各界人士的支持與努力。在此，我由衷感謝香港特別行政區政府經由康樂及文化事務署的年度撥款，香港賽馬會慈善信託基金半世紀以來的信任與支持，眾多企業及基金會的慷慨贊助，以及各機構與個人的熱心捐助。

藝術節一直積極推進藝術教育和普及工作。「青少年之友」成立三十年來，已為逾八十萬位本地中學生及大專生提供藝術體驗活動。在此，我向每一位參與香港藝術節外展教育項目的校長、老師和學生，以及各項活動的合作夥伴等，致以由衷的謝意。

最後，我借此機會感謝藝術節大家庭的每一位成員，包括五十年來參與各個委員會的成員，以及每一位藝術節同事。因爲你們不懈的努力和堅持，藝術節才得以不斷發展。

在未來的日子，我們會力求突破，秉持豐富香港文化生活的信念，繼續為大家呈獻世界各地精采且多元的節目，提供各種外展與教育項目。期望香港藝術節在下一個五十年，為香港帶來更豐碩、更令人振奮的文化成果。

查懋成
香港藝術節主席

Message from The Chairman

In 2022, the Hong Kong Arts Festival celebrates its 50th anniversary, marking a historic milestone.

For half a century, the HKAF is an annual showcase of leading international and local performing artists, renowned for its unique blend of East and West with equal importance attached to great traditions and contemporary creations. Presenting a wide array of dance, music, theatre and opera performances, the HKAF is the region's premier arts event and has firmly established itself as a major international arts festival.

The HKAF has always kept pace with the times and served as a springboard to creativity and diversity for the city while presenting to the world Hong Kong's eclectic and vibrant offering in arts and culture. The resulting rich and diverse cultural milieu has undoubtedly been instrumental in Hong Kong's becoming a global metropolis.

In addition to inviting internationally renowned artists for performances, the Festival is deeply committed to local arts development. It has established creative platforms for arts practitioners to foster artistic creations and nurture talents. Local artists are encouraged to maximise their potential and shine on stage alongside top performers from around the world. In this regard, the Festival plays a significant role in connecting Hong Kong to the international arts scene.

The HKAF programme line-up is well known for its richness and quality. The Festival stays at the forefront of the arts by introducing cutting-edge and innovative international programmes. At the same time, it appeals to a wider audience of all ages with programmes in traditional art forms. Every year, the HKAF draws arts lovers from near and far in the hundreds of thousands, adding to Hong Kong's attractiveness both as a home and a tourist destination. The audiences' support and participation has provided the impetus for the Festival to move forward and strive for improvement. I would like to take the opportunity to give thanks to all participating artists and audiences who have supported the Festival over the decades.

The HKAF's growth and accomplishments are possible only with the dedicated support and efforts of many organisations and individuals. I extend my sincere gratitude to the HKSAR Government, acting through the Leisure and Cultural Services Department, for its annual subvention. We are immensely grateful to The Hong Kong Jockey Club Charities Trust for its support and trust over the last half-century, to numerous corporations and foundations for their generous sponsorship, and to organisations and donors for their charitable donations.

As a champion of arts education for young people, the HKAF's "Young Friends" scheme has reached over 800,000 local secondary and tertiary school students with arts activities in the 30 years since its inception. I would like to thank every principal, teacher and student who has taken part in the Festival's outreach and educational events as well as the partners in these activities.

Finally, yet importantly, I wish to express my appreciation to every single member of the HKAF family, including members of committees over the past 50 years and the Festival staff team. The Festival would not have grown and excelled without your unwavering efforts and dedication.

In the years ahead, we are committed to reaching greater heights while upholding the vision of enriching the cultural life of the city. The Hong Kong Arts Festival is poised to present more exciting and diverse programmes as well as a wide array of outreach and educational events. The Festival will continue its journey into the next 50 years with more contributions and exciting accomplishments for the arts in Hong Kong.

Victor Cha
Chairman, Hong Kong Arts Festival

行政總監的話

當我們準備為香港藝術節在2022年慶祝五十週年，其中一個構想是怎樣向歷來曾經參與藝術節的朋友致謝。當初促成香港藝術節的創立，實在有賴高瞻遠矚的先行者，而藝術節能夠茁壯成長，與香港一起經歷種種挑戰，是眾多支持者共同努力的成果。於是，我們決定籌備出版一本專集，以表謝意，同時，回顧香港藝術節五十載的經驗，探索其方向、定位及挑戰。

本書劃分不同主題，收錄歷史片段及與海內外藝術家的訪談節錄，藝術節過去的工作，以及藝術工作者參與其中的回憶感受。更聚焦探討藝術節如何立基於香港，放眼世界，在世代轉變、百花齊放環境下的使命、發展和未來展望。

編輯委員會最初一致構思，邀請香港最具權威的藝評人周凡夫先生，撰寫一篇特稿，檢視藝術節對香港文化生態的影響，以及與社會之間的連繫互動。周先生見證著香港藝術節的誕生及成長，由他來宏觀分析實在最合適不過。雖然這篇特稿成了周先生的遺作，我們也痛失一位藝術界的活字典，但透過他的眼中，可以認識藝術節於香港及亞洲區內之獨特角色，以及整體對香港文化生活的貢獻。

由首屆藝術節僅有七十多場演出，發展到現在已倍增的規模，此外還有「加料」和教育活動等，香港藝術節團隊一如既往竭盡心力，以豐富香港的文化生活為初心，延續五十年的優良傳統，精心發掘本地及國際的星級藝術家，點亮香港大小舞台。

舉辦藝術節所需的不僅是一支團隊，更是一個廣大的社群。香港藝術節的創立及持續發展，有賴社會各界如藝術家、觀眾、贊助者、捐款人的支持，我們向多年來貢獻藝術節的人士致敬之餘，亦希望激勵同業繼續共同努力，拓展更新的領域。

感謝藝術使我們相遇，在未來的日子裡，我們必會堅守崗位，冀望為大家帶來更多出色的節目與活動，讓藝術燃點生活，為香港更添姿采！

最後，衷心感謝參與此書製作，以及對香港藝術節有貢獻的所有人士。

何嘉坤
香港藝術節行政總監

Message from The Executive Director

When we started planning the 50th Anniversary of the Hong Kong Arts Festival in 2022, one of the first things we wanted to do was to acknowledge and thank the people who have been a part of the Festival community over the decades. Founded by visionary leaders, and supported by a community of arts lovers through myriad challenges, the Festival was able to grow and thrive. Festival as we know it today is the result of contributions by many. We therefore decided to produce a record of this fifty-year history, told in many voices, from many perspectives; and to examine its legacy, its position and its challenges.

This book traces the Festival's history through stories and images from the past, organized by themes. It includes recollections of local and international artists who share their memories of being in the Festival, and their views about the Festival's work. The book also highlights how the Festival became rooted in Hong Kong while upholding a global vision, its evolution in response to a changing and increasingly diverse environment, its mission and its future prospects.

A unanimous decision by the Editorial Committee was to commission leading arts critic Chow Fan Fu to write a review. We were delighted that he readily accepted and produced an insightful essay on the HKAF's impact on Hong Kong's cultural development and its interaction with the city at many levels, based on his own observations having personally witnessed the inception and development of the Festival. This essay became Chow's last piece of writing, and we are saddened by the loss of this respected and knowledgeable arts personality, who was not only encyclopedic about the arts in Hong Kong but was also well connected in many part of Asia.

From an initial offering of about 70 performances when it was first launched, the HKAF has since more than doubled the number of performances presented each year, and has also developed in depth as well as scale. This is in addition to a diverse range of "PLUS" and educational events organized every year. The Festival team remains dedicated to the event's original cause of enriching the cultural life of the city and serving as a platform for cultural exchange. Faithful to its mission, the Festival continues to present leading local and international artists in all genres of the performing arts, lighting up Hong Kong stages large and small.

Presenting the Festival takes more than a team, it takes an entire community. This community, without which the Festival could not have been established and developed, consists of artists, audiences, sponsors, donors and many others. We gratefully acknowledge and thank them for their contributions over the years, and look forward to collaborating with many partners and stakeholders to reach further and soar higher in the future.

The arts provide a unique connection between people and cultures, across time and space. The Festival team remains committed serving this city which is our home, and to brightening lives with the power of the arts.

Last but not least, we extend our sincere gratitude to everyone who participated in the production of this book, and to all who contribute to the HKAF, past and present.

Tisa Ho
Executive Director, Hong Kong Arts Festival

目錄 Contents

前言
Preface

I. 扎根香港的國際藝壇盛事
Part 1: A Major International Arts Festival –
In, Of and For Hong Kong

第一章　藝術節的序幕
Chapter 1: Arts Festival - The Prologue　　17

第二章　本地化進程
Chapter 2: The Progress in Localisation　　41

第三章　領域與視野
Chapter 3: Diversity and Vision　　65

第四章　群策群力 得道多助
Chapter 4: Community Support, Sponsors and Donors　　149

第五章　撒種躬耕藝術教育
Chapter 5: Planting the Seeds through Arts Education　　173

第六章　與社會脈搏並肩
Chapter 6: In Sync with the Pulse of Society　　197

II. 半世紀的足印 挑戰與展望
Part 2: The Past and the Future

第七章　放眼世界！更要立足本土！[周凡夫特稿]
Chapter 7: Global Outlook with Firm Foothold in Hong Kong –
Feature by Mr Chow Fan Fu　　219

第八章　挑戰與展望
Chapter 8: Challenges and Looking Ahead　　239

附錄
Appendix

1982-2021香港藝術節委約及新製作
1982-2021 HKAF Commissions and Productions　　250

香港藝術節過往節目
HKAF Past Programmes　　251

PART I

扎根香港的國際藝壇盛事
A Major International Arts Festival –
In, Of and For Hong Kong

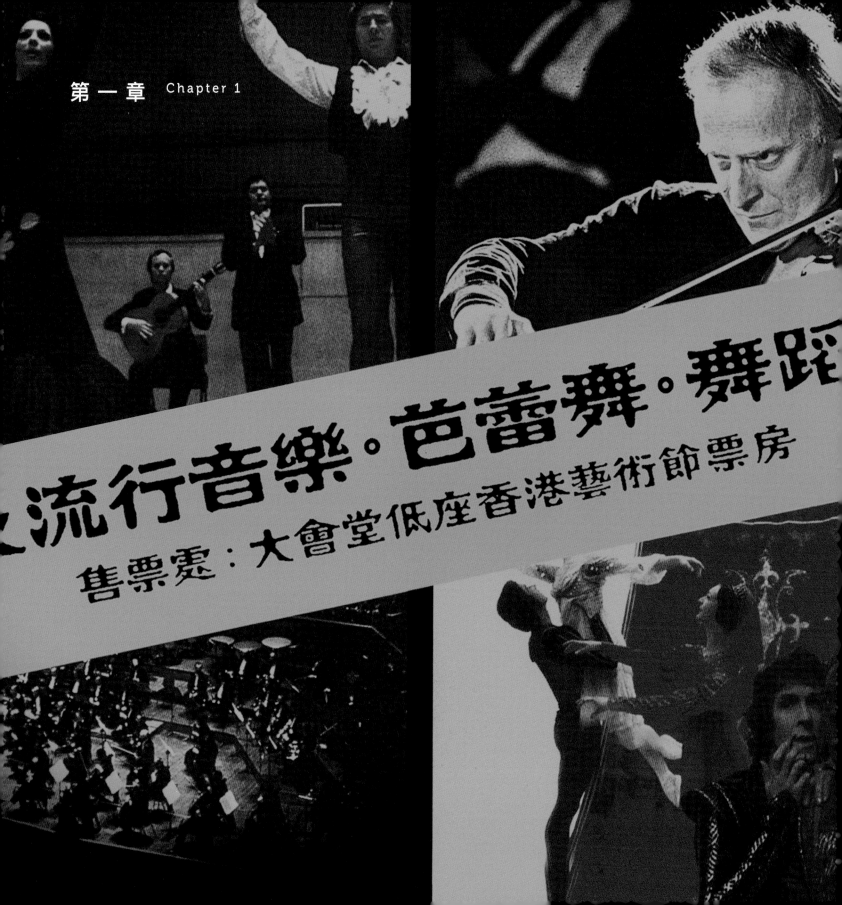

流行音樂。芭蕾舞。舞蹈

售票處：大會堂低座香港藝術節票房

藝術節的序幕
Arts Festival - The Prologue

一個藝術節的誕生，與城市的歷史文化發展息息相關。五十年前的香港，本土藝術文化還在泥土裡靜待灌溉。香港藝術節的出現成了一個契機，隨著世界級藝術團體和知名藝術家的到訪，讓香港觀眾以至訪港旅客大開眼界。每年一度的藝術節，透過音樂、舞蹈、歌劇、戲劇等藝術形式，把人世間的悲歡離合帶進劇院，也一點一滴滋潤了我們的文化土壤，推動香港的藝術文化發展。半個世紀前把世界帶到香港，今天也把香港帶到全世界，藝術成了這道重要的橋樑。

回到最初，是這樣開始的。

The creation of an arts festival is always concomitant with the social and cultural development of its birthplace. Half a century ago, Hong Kong's potential in arts and culture had yet to be unleashed. The emergence of the Hong Kong Arts Festival (HKAF) thus was an opportunity for world-class arts groups and renowned artists to visit Hong Kong, inspiring both local audiences and visitors. The annual showcase of performances in music, dance, opera, theatre and other art forms brings to the stage all of life's emotions. Year after year, the Festival nourishes the city's cultural milieu while propelling Hong Kong's arts development. Fifty years ago, the HKAF was instrumental in bringing the world to Hong Kong. Today, it remains an important platform for Hong Kong to assert its presence in the international arena through the arts.

初心只為推動旅遊業

1970年初，在英國海外航空(即英國航空前身)擔任銷售推廣經理的查理斯·哈代，構想到在香港舉辦一個國際藝術節以推動香港旅遊，讓香港在遊客心中除了是「購物天堂」，也是一個可提供高質藝文活動的城市。

於是哈代第一時間跟香港旅遊協會(現稱香港旅遊發展局)商討可行性，當時的行政總監亨利·史丹利對這個計劃非常有興趣，哈代更專程從英國飛到香港視察環境，並與旅遊酒店業界洽談，業界反應理想。天時、地理、人和，漸次具備。

當然，要舉辦一個成功的國際藝術節不只要有機票和酒店，最重要還是節目。當時身為倫敦市藝術節藝術總監，也是英航的顧問伊安·韓德加入了這個創始團隊，著手撰寫計劃書。韓德從事過或創辦過許多藝術節，如愛丁堡、巴斯、布萊頓等等，在藝壇被譽為「藝術節先生」。

半年後，哈代帶著這個計劃到香港，跟當時的港督戴麟趾、市政局議員、酒店及商界人士會面，尋求各方支持。英航香港經理大偉·克里迪很快便籌得港幣四十五萬元以啟動計劃，目標定在1972年1或2月期間舉行首屆藝術節。

Festival Created to Encourage Tourism

At the turn of the 1970s, Charles Hardy, a sales promotion manager with British Overseas Airways Corporation (BOAC, the predecessor of British Airways) conceived the idea of establishing an international arts festival in Hong Kong to encourage tourism. Hong Kong was already well known to tourists for being a shopper's paradise and Hardy saw in it the potential to offer high-quality arts and cultural activities.

Hardy immediately explored the possibility with the Hong Kong Tourist Association (HKTA, now known as Hong Kong Tourism Board). Major Harry Stanley, Chief Executive of HKTA at the time, was receptive to the proposal. Hardy even travelled to Hong Kong from the UK to check on venues and facilities and the level of support from the tourism and hospitality industry, both of which were enthusiastic about the idea. With the timing, location and people ready, the stars were aligned for the HKAF to take place.

Of course, it would take more than just airline tickets and hotel accommodation to put together an international arts festival and the programmes were of paramount importance. Ian Hunter was the City of London Festival's Artistic Director and a consultant for BOAC. He lent his professional services by joining the founding team and preparing the proposal. Widely lauded as "Mr Festival", Hunter worked in and founded many arts festivals in cities across the UK, including Edinburgh, Bath and Brighton.

當時香港已有一個舉辦了數年的國際音樂節，哈代等人曾研究是否可以交由他們去處理藝術節的行政事宜。不過當時音樂節的人手及規模不足以應付一個國際藝術節，認為需要尋找更多的資源。幸運地，哈代認識了影視鉅子邵逸夫。那次戰戰競競走到清水灣的邵氏影城，他的目標是尋求二十五萬英磅的經費。早在會面前邵逸夫已看過了計劃書，會面期間打了一個電話，哈代相信電話另一邊廂是政商翹楚馮秉芬，兩人談了良久，掛斷電話後，邵逸夫跟哈代說：「Mr Hardy, you have your Festival」。

於是香港藝術節協會在1972年2月29日正式註冊成立。馮秉芬出任首位主席，邵逸夫為副主席。藝術節成員迅速埋班就位，韓德出任藝術總監，連同經理歐白淑靈，還有票務主任馬斌，主力工作人員不足五位。

宣傳推廣的任務落在香港旅遊協會，主要針對日本、澳洲、美國及歐洲市場。英航提供機票資助，香港酒店業協會聯繫旅館，為訪港藝術家提供優惠住宿。當時還成立了一個專門負責接待訪港藝術家的婦女委員會，成員包括倫美蘭、梁王培芳、趙世彭夫人等等。

萬事俱備，不過原本定在1972年開幕的目標似乎太趕急，於是第一屆藝術節定在1973年2月26日正式開幕。

從意念誕生到藝術節揭幕，前後只有三年時間，合眾人之力推動的香港藝術節總算有一個美好的開始。翻查歷史，原來早於1955年已有一個民辦的「香港藝術節」，也是每年一屆，為期約三星期。活動內容包括攝影、藝術及視覺藝術展，英/粵語戲劇等等，在中環的天星碼頭、干諾道中的新填地、香港大學馮平山圖書館及陸佑堂等地方舉行。而這個「香港藝術節」只辦了六屆，止於1960年。由此看來，香港不同階層很早已有意識要辦一個藝術節，只是要等待一個合適的時機，也必須要結合多方人才和資源才成功讓藝術節扎根香港。

社會環境造就

從另一個角度要追溯香港藝術節的誕生，就不得不環顧五十年前香港的社會面貌。六十年代末至七十年代初的香港仍處於經濟未起飛的狀態，社會不穩定，民生也有很大的改善空間。

Six months later, Hardy came to Hong Kong with the proposal and sought support for the project by meeting with then Hong Kong Governor David Trench, officials from the Urban Council, representatives of the hotel industry and leading business figures. David Creedy, the local BOAC Manager, eventually raised HK$450,000 to help underwrite the new venture. The target date for the first edition of the Arts Festival was January or February of 1972.

There was already an international music festival in Hong Kong for several years by then, and Hardy's team did consider entrusting the Arts Festival's administration to the organisers of the existing event. However, they soon realised the manpower and scale of the music festival would be insufficient to handle an arts festival on an international level, and more resources would be required. Luckily, Hardy made the acquaintance of film and television magnate Run Run Shaw. He remembered being nervous when he made a trip to Shaw Studios in Clearwater Bay in the hope of securing £250,000 in funding. Having read the proposal prior to the meeting, Run Run Shaw made a lengthy phone call with someone who Hardy believed was the prominent businessman and politician Kenneth Fung Ping-fan. After he hung up, Shaw said to Hardy: "Mr Hardy, you have your Festival."

The Hong Kong Arts Festival Society was formally established and registered on 29 February 1972, with Kenneth Fung Ping-fan as its inaugural Chairman and Run Run Shaw as Vice Chairman. The team for the Arts Festival immediately took shape. Ian Hunter was appointed Artistic Director. Sonia Archer was Festival Manager and Henry Ma Box Office Manager, meaning there were fewer than five key staff.

The Hong Kong Tourist Association was tasked with publicity and promotion, which was geared towards the Japanese, Australian, American and European markets. BOAC provided fare subsidies while the Hong Kong Hotels Association contacted hotels to provide accommodation for visiting artists at a discount. A Ladies Committee headed by Mrs David Landale, Mrs Henry Leung and Mrs Betty Chao was formed to assist and entertain the artists during their stay in Hong Kong.

Although everything started to fall into place, it soon transpired that the Festival's original target date of 1972 would not be met, so the first festival was put back a year. The inaugural edition of the Arts Festival would not take place until 26 February 1973.

「在當時的社會背景下，由不同社會領袖所發起的民間組織，其實是發揮了凝聚社區的作用，而香港藝術節也是其中之一。」陳祖澤於第一屆藝術節同年，開始擔任港督麥理浩（當時藝術節贊助人）的私人秘書。他亦曾以香港賽馬會董事身份，擔任過香港藝術節執行委員會委員 (1996-2002年；2002年擔任副主席)。除了見證著藝術節的誕生與發展，他亦深深體會到藝術節這類民間組織，對香港社會整體發展的重要性。

「記得當年馮秉芬和邵逸夫兩位，經常到總督府跟麥督開會，討論有關香港藝術節的大小事宜。香港經歷六七暴動後，社會氣氛其實不太穩定，政府和各界人士都渴望能為香港做點事，於是發起了各類民間組織，例如香港公益金(成立於1968年)、香港節(辦了三屆)、香港藝術節等。政府亦按當時社會需要，改組市政局，成立廉政公署，開發新市鎮，實施免費教育，以及推行十年建屋計劃等，務求凝聚和建設社會。」

談到對藝術的興趣，陳祖澤特別提到參與英語粵劇的演出。「華仁戲劇社於1947年由黃展華老師成立。最初因為華仁的神父把粵劇填了英語的歌詞，讓外籍觀眾能欣賞粵劇文化，發覺反應很好，於是黃展華便翻譯了三十多齣粵劇，例如《鴉雀如何作鳳凰》。我和志趣相投的同僚和朋友都有演出，曾在香港和加拿大等地表演，亦為公益金、保良局、東華三院等團體籌款，可謂寓興趣於公益。」

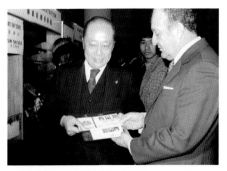

(左) 馮秉芬主席從郵政司魏達賢購買首張藝術節紀念郵票
(left) Chairman Kenneth Fung purchased the first HKAF commemorative stamps from the Postmaster Malki Addi (1974)

It took only three years from Hardy's original idea for the Arts Festival to become reality. The herculean efforts of everyone involved made the first HKAF a success. Groundbreaking as it was, the Festival was not the first of its kind in the city. Records show that a "Hong Kong Arts Festival" had been mounted in the city by its Chinese population as early as 1955. It was also an annual event, lasting about three weeks. Festival activities included photography, arts and visual arts exhibitions, theatre in English and Cantonese, at venues such as the Star Ferry Pier in Central, the reclamation area at Connaught Road Central, the University of Hong Kong's Fung Ping Shan Library and Loke Yew Hall. This earlier "Hong Kong Arts Festival" lasted for only six editions and ended in 1960. Its existence shows there was a demand among Hong Kong people for such a festival where audiences could sample some of the best performing arts the world had to offer. That would arrive a decade or so later. When all the conditions, including a myriad of experts and vast resources, came together, a world-class arts festival finally took root in Hong Kong.

Social Environment as Impetus

A good place to start tracing the birth of the HKAF would be Hong Kong's social landscape of 50 years ago. In the late 1960s and early 1970s, Hong Kong's economy had yet to take flight. There was much upheaval in society and the economic situation of the average Hongkonger left a lot to be desired.

"With the social background at the time, the non-governmental organisations initiated by society leaders were able to promote community cohesion, with HKAF being a case in point," John Chan Cho-chak says. In the year the Festival was first held, Chan became Private Secretary to Governor Murray MacLehose

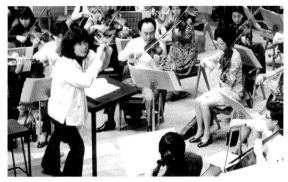

新日本愛樂交響樂團為1973年藝術節在大會堂綵排，指揮是小澤征爾
Rehearsal of New Japan Philharmonic Orchestra at the City Hall for the 1973 HKAF, Ozawa Seiji being the conductor

(the HKAF's patron at the time). As a steward of The Hong Kong Jockey Club, Chan was a member of the HKAF's Executive Committee from 1996 to 2002, serving as Vice Chairman in his final year. In addition to witnessing the growth and development of the Festival, Chan attested to the importance of how non-governmental organisations like the Festival were part of a drive to develop Hong Kong society as a whole. "I remember when Kenneth Fung Ping-fan and Run Run Shaw used to have meetings with Governor MacLehose at the Governor's House to discuss matters large and small about the Hong Kong Arts Festival," Chan says. "As Hong Kong society was not quite stable after the 1967 riots, both the government and many others were eager to make more contributions. This led to the launch of different non-governmental organisations such as the Community Chest of Hong Kong (established in 1968), the Festival of Hong Kong (held for three editions) and the HKAF. Responding to the needs of society, the government also re-organised the Urban Council, established the Independent Commission Against Corruption, developed new towns, started to provide free education and launched the ten-year housing programme. All the initiatives were geared towards community cohesion and societal development."

Chan himself had a keen interest in the arts, even performing Cantonese opera in English. "Wah Yan Dramatic Society was established by Wong Chin-wah in 1947," he recalls. "It started with the attempt by a Jesuit priest from Wah Yan to set English lyrics to Cantonese operas so the art form could be appreciated by foreign audiences. The response was overwhelmingly positive, and Wong translated more than 30 Cantonese operas such as *A Lizard Is No Dragon*. I performed alongside colleagues and friends, both in Hong Kong and Canada. The performances were also part of fundraising efforts for organisations such as the Community Chest, Po Leung Kok and the Tung Wah Group of Hospitals. It was fulfilling to advocate for social causes through my leisure pursuit."

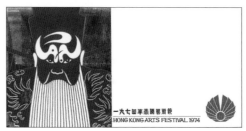

「香港藝術節」首日封
'Hong Kong Arts Festival's First Day Cover (1974)

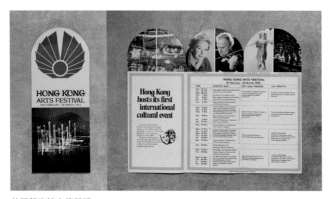

首屆藝術節宣傳單張
Promotional pamphlet of the first HKAF (1973)

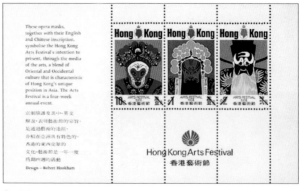

「香港藝術節」郵票小全張 (© 香港郵政)
Hong Kong Arts Festival's Souvenir Sheet (© Hong Kong Post)

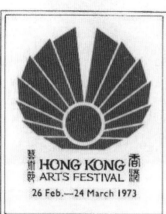

HONG KONG ARTS FESTIVAL

26 Feb.—24 March 1973

Festival News

From the 26th February to the 24th March 1973, Hong Kong sets the stage for one of the most exciting artistic events ever seen in South East Asia.

The Hong Kong Arts Festival is being organised along similar lines to the world renowned Edinburgh Festival and will be the first cultural gathering of its kind in Asia. Each month from now until it commences, this page of the Hong Kong Travel Bulletin will bring you all the Festival news — details of programmes, artistes, dates, timings, tickets, bookings . . . it will all appear in this monthly Festival news column.

The planning for this spectacular Festival is already well under way and a firm programme has been outlined. Internationally recognised artistes will gather from all corners of the world to combine with traditional performing groups from selected Oriental countries, as well as local performers, to take part in the most imaginative and colourful cultural Festival ever staged in Asia.

For classical music followers, the London Philharmonic Orchestra, on an exclusive visit to Hong Kong, will give several concerts under conductors, Bernard Haitink and John Pritchard; soloists include Ida Haendel (violin) and John Lill and Michael Roll (piano).

Elizabeth Schwarzkopf, a firm favourite of international audiences will give recitals during two days of the Festival and the world famous Seiji Ozawa will conduct the Japan Philharmonic, universally recognised as Japan's leading orchestra. Yehudi and Hephzibah Menuhin add their own talents to the growing list of musical celebrities; Yehudi will conduct the Menuhin Festival Orchestra and appear as a soloist.

Throughout the Festival, international pop stars and popular groups will provide entertainment for those with a taste for soul, folksy and more modern music. The Hong Kong Arts Festival truly promises to have something for everyone, all nationalities and all age groups.

No aspect of the arts will be forgotten. For drama enthusiasts, the highly respected English repertory theatre company from the Bristol Old Vic Theatre will perform each evening alternating a classic Shakespearian play with a popular modern production and Sir Michael Redgrave will display his own unique brand of stage acting skill in a dramatic theatre piece.

Side by side with the traditional occidental theatre performers will be the classical oriental dance companies. With exotic music, spectacular dance routines and vivid, highly coloured costumes, these troupes will provide an exciting contrast and vibrant entertainment.

Dame Margot Fonteyn and the London Gala Ballet will provide the main attraction for followers of the pas de deux. Fonteyn, the most famous of all prima ballerians, has been engaged to perform both clasical and contemporary ballets; appearing with her will be Andre Prokovsky and Galina Samtsova. In case this treat is not sufficient to satisfy the ballet buffs, The Royal Swedish Ballet Group will also be lending their talents to this illustrious gathering.

Apart from the symphony orchestras, theatre companies, pop stars, ballerinas and dancers already booked, the Arts Festival will feature visual arts exhibitions, including works by internationally known painters and sculptors and notable local artists. For four weeks, the Colony will be in the midst of a deluge of culture, entertainment and virtuosity.

Next month we will be bringing you details of advanced booking procedures. All details will be covered, but if you need any further specific information, please contact the nearest office of the Hong Kong Tourist Association; offices are listed in the box below.

Information on Hong Kong tourist facilities and activities can be obtained from any of the following Hong Kong Tourist Association offices around the world:

Imperial Hotel, 2174 East Building, 1-1-1 Uchisaiwai — Cho, Tokyo, Japan; Chichester House, 278-282 High Holborn, London W.C. 1, U.K.; 1 Rue Pedro Meylan 1208 Geneva; Bligh House, 4-6 Bligh Street, Sydney, Australia; 291 Geary Street, San Francisco Calif., 94102; 548 Fifth Avenue, New York N.Y. 10036; 159 Bay Street, Toronto Ont., Canada; 675 Davis St., Vancouver B.C., Canada; 1600 Stanley Street, Montreal Quebec, Canada; 38 Av. George V, 75 Paris VIII, France; Neue Kraeme 29, 6 Frankfurt-am-Main, West Germany.

HONG KONG TRAVEL BULLETIN

Published by the Hong Kong Tourist Association on the 10th Day of Each Month.

Editor: David J. Bell.

G.P.O. Box 2597 Hong Kong Telephone: H-244191

Airmail postage rate (for 12 issues): Asia, HK$6; Europe, Africa, Australia, New Zealand & Oceania, HK$12; North America, HK$24; South America, HK$30, Local postage, HK$1.20 per year.

Printed by Dai Nippon Printing Co., (Int'l) Ltd., Hong Kong.

香港旅遊協會向遊客宣傳第一屆藝術節
Hong Kong Tourists Association's Travel Bulletin for promoting the first HKAF

藝術節的營運模式

藝術節的誕生是一個來自民間的倡議，資金的募集也是來自民間。

要籌備第一屆的藝術節，動用的資源可不少。韓德有豐富的經驗，他建議參考愛丁堡藝術界的營運模式，結合政府資助、商界贊助及票房收入的三角關係。

然而，政府最初的取態是，不給予直接的資助，希望觀察藝術節能否持續舉辦，最少成功舉辦三、四屆，才認真考慮長遠的資助。不過港督麥理浩是藝術愛好者，每屆他都會安排數個酒會及午餐會，接待參與的藝術家。此外，政府新聞處早年亦協助藝術節的工作，如提供辦公設備、統籌本地與外地的媒體關係及廣告，以及刊物製作。

旅遊協會在第一屆有直接的資助，並負責海外的推廣和銷售，而英航、酒店業除了提供特別優惠，也協助向遊客推廣。市政局除了以成本價提供大會堂的設施，大力配合，也提供直接的資助。

委員會一直積極爭取商界的支持及資源協助。有趣的是當年有一個「擔保人」的做法，是希望找到好些大企業、富商及相關協會，為藝術節做銀行擔保，以作融資；還有，倘若那年藝術節有虧蝕，擔保人就會出手捐資。這樣的貢獻可說是藝術界企業社會責任的先河。

由第一屆開始，提供優惠學生票一直是藝術節持守的方針，幸而社會上很支持這個理念，早年學生票優惠的資金主要來自何東爵士慈善基金及香港賽馬會慈善信託基金，學生得以低於半價的折扣欣賞高質演出，所以每年藝術節公開售票都會有學生通宵排隊的新聞。

The Arts Festival's Operating Model

The Arts Festival was a recommendation conceived by the community, as would also be the case in the initiation of fundraising efforts.

The inaugural edition of the Arts Festival called for considerable resources. Ian Hunter drew on his past experience and suggested the three-pronged approach of government funding, commercial sponsorships and ticket sales, which was the operation model used in Edinburgh.

However, the government's initial stance was to observe and assess the sustainability of the Arts Festival before providing direct funding. Long-term funding would only be considered if the Festival was a success for three or four editions. Nevertheless, Governor Murray MacLehose was passionate about the arts. During every edition of the Festival, he would arrange several cocktail receptions and luncheons to receive participating artists. In addition, the government's Information Services Department would assist the Festival during its early years by providing office equipment, coordinating press releases and advertisements for local and overseas media, and helping with publications.

For the inaugural edition of the Festival, the HKTA provided direct funding and was responsible for overseas promotion and sales. Both BOAC and the hotel industry provided special offers and helped with promotions to tourists. In addition to providing the venue of City Hall at cost, the Urban Council also contributed with direct funding.

要辦籌款晚會才能續辦

馮秉芬出任了兩屆的主席，到1974年6月邵逸夫便接任。

好景不常，第一屆的藝術節剛完結，香港正值大規模的股災，從1973年3月到1974年12月，恆生指數由高位暴瀉達九成。當時藝術節面對嚴重的財政困難。觀眾消費意欲下降，所以在第二屆的節目選取上，也要作出相應調整。不過，這屆仍有享譽國際的澳洲雪梨交響樂團，以及倫敦交響樂團和傅聰的載譽演出。香港管弦樂團亦首度在藝術節登場。

邵逸夫上任不久，便邀請趙世彭夫人出任婦女委員會主席，且於翌年在希爾頓酒店辦了一個慈善舞會，每桌籌一萬元，結果籌得超過一百萬元，才能填補赤字。

那次籌款晚會發生了一些趣事，在拍賣環節時，除了由委員會捐出一件白玉古董擺設外，主席邵逸夫更捐出自己的一匹愛駒作拍賣籌款，成為一時佳話！

1980年藝術節首天票房開售，大會堂外大排長龍
A long queue on the first day of 1980 HKAF Counter Booking outside City Hall

The Committee was proactive in seeking support and resources from the business community. An interesting approach at the time was to seek "guarantors" for the event. Ideally, a large enterprise, affluent businessmen or an associated organisation could serve as guarantor, which would help with financing. Should there be losses incurred by the event, they would be underwritten by the guarantor, making this one of the first corporate social responsibility initiatives in the arts sector.

One vision upheld by the Arts Festival since its inception was to provide student tickets at a discount, an initiative the public was very receptive towards. During the Festival's early years, funding for discounted student tickets came primarily from the Sir Robert Ho Tung Charitable Fund and The Hong Kong Jockey Club Charities Trust, allowing students to attend high-quality performances for less than half the price of regular tickets. As a result, the sight of students queuing overnight for Arts Festival tickets when they went on sale would make news coverage every year.

Fundraising Dinner to Keep the Festival Afloat

After serving as Chairman for two editions of the Festival, Kenneth Fung Ping-fan stepped down and was succeeded by Run Run Shaw in June, 1974.

There were challenging times ahead, however, just after the first edition of the Arts Festival closed. Hong Kong's stock market suffered a disastrous crash from March 1973 to December 1974, with the Hang Seng Index plummeting by 90 per cent. The Arts Festival faced serious financial difficulties as audiences were reluctant to spend money. As a result, programme selections in the second edition had to be adjusted accordingly. However, the Festival that year still featured the internationally renowned

Hallé's Herculean labours in Hongkong

Hongkong was all paper lanterns, coloured lights and brightly illuminated signs proclaiming "Kung Hei Fat Choy", which is Cantonese for Happy New Year, when I emerged from Kaitak airport on the first of this month to attend the fourth Hong Kong Arts Festival. China's lunar year, this time the propitious Year of the Dragon, had just begun, in Hong Kong a four-day public holiday.

Bang in the middle of it the festival was due to start—bang is not quite the mot juste since the traditional fireworks are prohibited these days, alas ! The opening event of the festival aptly demonstrated that this British colony is one place where, pace Kipling, East and West emphatically do meet. Britain had exported the bands of the Grenadier Guards (fife-and-drum as well as military) who marched up and down, across and round the square between City Hall and Queen's Pier, playing music as diverse as "Roll out the Barrel", "Land of Hope and Glory" and "Va, pensiero" from Verdi's Nabucco. Hongkong supplied two groups of graceful Chinese girls who danced with fans and baskets, and choirs of boys and girls who sang Mandarin songs, to a piano accompaniment that sounded rather unauthentic.

Then came the most striking confrontation. Into the square at top speed writhed the year's own dragon, its immensely long, brilliant-hued body and monstrous, lovable head supported by some two-dozen fleet-footed boys (memories of Hoffnung's Fafner !). It halted at the steps in front of City Hall, and Sir Murray McLehose, the Governor of Hongkong, symbolically brought the beast to life by touching its eyes and tongue with a magic wand, whereupon it perked up and skedaddled away, while the rest of us, those who had tickets, went to hear the Hallé Orchestra give the first concert of the festival.

European residents used to regard the colony as a cultural desert unless they made common cause with the age-old and thriving Chinese artistic activity. As the aeroplane increasingly shrank the world, musicians and other representatives of Western arts likewise stopped in Hongkong more frequently. The City Hall was built, with two auditoria, one for symphony concerts, the other for theatre or chamber music. Next year the new Arts Centre will be open, with further halls for artistic events.

In the middle of this crescendo Hongkong decided to mount an arts festival and turned to Ian Hunter, Britain's festivalmaker-in-chief, Hunter brought to Hongkong an annual orgy of the world's outstanding artists in music, theatre, dance. Now he has handed over the artistic direction to Anthony Chardet of Chichester Festival Theatre, and Hongkong Festival's policy is discreetly moving away from the international supermarket concept towards one where, like Hongkong itself, east meets west and in which

the major artistic events will be culled as much from the east as from Europe and America.

For the European residents of Hongkong, the attraction of this festival is still the visit of the Hallé Orchestra, the Chichester Theatre, John Field's assembly of ballet stars, together with Emlyn Williams as Charles Dickens, Cleo Laine and John Dankworth, and from elsewhere in Europe the Swiss Mummenschanz mime company and Paco Peña's flamenco troupe. Already this Hongkong Festival has proved commercially the most successful to date. Practically everything is sold out, and on the first night the Governor announced that from now on the Government will substantially subsidize the festival, it is said to the extent of 25 per cent of the budget.

The Hallé Orchestra has shouldered a Herculean labour by giving 11 concerts in two weeks, its own conductor James Loughran being assisted by Meredith Davies and Owain Arwel Hughes. Programmes are, by British festival standards, conventional, Rachmaninov the most prominent composer. Several British works were included, properly, though Walton was the only living composer represented.

The first concert amply demonstrated the dramatic improvement in fire and precision and varied stylistic accomplishment that Loughran has imposed on the Hallé since he took over after Barbirolli's death. With his readings of Dvořák's New World, Rachmaninov's second, and Brahms's first symphonies, played with freshness and splendour, he established his authority as an interpreter of stature. I admired his honest accompaniment to Stoika Milanova's gracious account of Beethoven's violin concerto, even more his sterling support of the powerful and enthusiastic interpretation by Moura Lympany of Rachmaninov's third piano concerto. The other soloist in these concerts was Peter Katin whose imperious exposition of the great Brahms B flat piano concerto duly impressed Hongkong.

This year's musical programmes prompt two questions. Does the Hongkong Festival intend to be international only in the selection of performers, or also in the audiences it attracts ? An international audience will want, surely, a more recherché repertory. And then, granted that older people in Hongkong pine for live performances of standard symphonic favourites, should not this festival be attracting young audiences by bringing the most tasteful and inventive rock groups and specialists in contemporary classical music ?

Mr Chardet is as keen to broaden the festival's repertory as its scope, but his first duty has been to make it commercially viable. It may be three or four years before he works his way to the sort of Hongkong Festival that he ideally envisages.

William Mann

By courtesy of the Courtauld Trustees

Robins: gardens of delight

...ws in the middle distance ...ph Allen's Wharf, with the ...lway track curving away ...wards his great Palladian ...ansion, Prior Park, and ...yond to the free stone quarries that were the source ...of his fortune and of the city's ...alas, too friable, beauty. Allen died in 1765 and Robins's last view of Bath is of Bishop Warburton's Gothic monument to the man who had been a friend as well as patron for so long.

Robins's views of the great houses and gardens of the south-west begin with Charlton Park, Cheltenham, where the formal layout is still basically in the Tudor tradition, with a parterre in the manner of Le Notre, Louis XIV's brilliant garden designer. Benjamin Hyett's house and gardens at Painswick near by are recorded in a magnificent drawing of the same year, which shows as the focal point of the garden a fantastic Gothic exedra, in contrast to the uncompromising Palladianism of the house. This drawing has a decorative border of shells and flowers rendered in exquisite detail, while a later (1759) view of Pan's Lodge on

the same estate is enclosed in a wildly extravagant Rococo Gothic framework of Chippendale-style trellis festooned with giant convolvulus, with, in the foreground, a group of young musicians serenading the god himself.

At Hyett's house in Gloucester there was an amazing arbour in a hybrid style combining Gothic, Chinese and classical elements, and Robins's drawing of it, although a perfectly straightforward record, is remarkably evocative, with its neatly arranged flower pots, comb-back Windsor chairs and, in the foreground, a riotously Baroque statue apparently inscribed "Nassos" and therefore presumably representing either Hercules battling with the centaur Nessus, or the latter carrying off Dejanira : in fact the creature seems to have wings and, could well be Pegasus.

In many of the drawings there are gardeners and milkmaids actually at work, as well as fashionably dressed landowners and their families disporting themselves : a view of the pink-walled orangery at

Woodside, Richard Bateman's house at Old Windsor, is peopled by an aproned gardener carefully carrying a precious plant in a pot as well as a very grand lady in a hooped skirt and a flat straw hat clutching two supercilious lap-dogs.

Not all the drawings are of specific places, and the extraordinary Gateway containing a gate made up of rakes and pitchforks and surmounted by an owl perched on the keystone of the arch in an open niche flanked by consoles would make a perfect backcloth for La Fille mal gardée. Since the exhibition opened in December, several new drawings have come to light, including three in the British Museum formerly attributed to Thomas Loggan, and a fan in a private collection bearing a representation of Ralph Allen's stone quarry at Prior Park, a nice illustration of the Age of Reason's concern never to lose sight of the essentials, even on something so fragile and ephemeral as a fan.

Jeffery Daniels

Anatol
Open Space
Irving Wardle

With so much of Schnitzler's work gathering dust, it seems rather unadventurous for the Open Space to revert to the early Anatol plays. A programme note hopefully links the author with the Vienna of Freud and Hitler. But nothing in the production besmirches the whipped cream and waltz-time image, notwithstanding (courtesy of the Goethe Institute) a knowing new translation by Frank Marcus and a 24-foot revolve that goes clanking round between one bitter-sweet episode and the next.

There are six of these, chosen to show off the "frivolous melancholic" play-boy in a series of contrasted disenchantments before leading to the slaughter with a ...breakfast. The main ...

Who Killed Penelope ?
Thames
Alan Coren

We do not muck about in the ...rolous Crime Squad. Within ...of the close of last ...had up in ...

managed to convey an overall impression that what I had been watching had taken place on a train passing mine in the opposite direction ?

Nor could I feel that the cameramen were entirely blameless: true, many of them could in some fairness claim they did not know what was going on, they were only carrying out orders, but surely when ...time to lie flat on the ...were required for the ...ir lenses up ...agonists

邵逸夫邀請趙世彭夫人出任婦女委員會主席
Run Run Shaw invited Mrs Betty Chao to chair the Ladies Committee

從第三屆開始，除了企業擔保及捐助外，藝術節開始爭取個別節目的贊助。

直至1976年，整體銷售數字由60%升至90%，成績斐然。就在這一年，港督麥理浩正式確定每年給予藝術節資助，得到政府的肯定，那年起，企業擔保便不再需要特別捐資補貼虧蝕。再加上各界的贊助及票房收入，奠定了藝術節的營運模式，一直發展至五十年後的今天。

承先啟後

前人種樹，半個世紀以來從無間斷，讓我們可欣賞來自世界各地，形形式式的表演藝術，豐富香港人的文化生活。沒有這些先行者，香港便沒有了一個國際藝術節。

從先行者手上得到啟發，接力延續，令香港藝術節茁壯成長。

愛丁堡廣場舉行的開幕巡遊匯演
Opening parade at the Edinburgh Place (1977)

Sydney Symphony Orchestra from Australia, the London Symphony Orchestra and performances by the pianist Fou Ts'ong. The Hong Kong Philharmonic Orchestra also made its debut at the Festival that year.

Shortly after Run Run Shaw became Chairman, Betty Chao was invited to chair the Ladies Committee. She helped organise a charity ball at the Hilton Hotel the following year, raising HK$10,000 from each table. Over a million dollars was raised to make up the Festival's deficit.

The fundraising dinner was also memorable for its auction. In addition to the Committee donating an antique white jade ornament, Chairman Shaw made headlines when he donated one of his stable's horses to be sold to the highest bidder.

From the third edition on, the Festival started to seek sponsorship for individual programmes in addition to corporate guarantee and donations.

Ticket sales figures were outstanding in 1976, climbing from 60 to 90 per cent. It was this year that Governor Murray MacLehose confirmed annual recurrent funding for the Arts Festival. With the government's affirmation, there was no longer a need for a corporate guarantee to underwrite possible losses. This, coupled with sponsorships and ticket sales, became the operating model which continues to underpin the development of the Arts Festival almost 50 years on.

Honouring and Carrying Forward the Legacy

After half a century of pioneering efforts from our predecessors, we are now able to enjoy a rich variety of performing arts programmes from around the world, which has also enriched the arts and culture of Hong Kong. Without these visionaries, Hong Kong would not have an arts festival of international calibre.

The HKAF continues to be inspired by these forerunners, and remains committed to carrying forward the legacy by reaching greater heights in the future.

明珠繞風帆

香港藝術節的節徽，一直沿用了半個世紀，是當年經過設計比賽得來的。評審委員會由六人組成，其中包括香港及日本的知名設計家，分別是石漢瑞及田中一光。結果，後來也成為香港名家的青年韓秉華，在五十一位參賽者中脫穎而出。他的構圖意念是以代表香港的帆船及散發光芒的東方明珠組成。韓秉華其時就讀中文大學校外課程修讀設計文憑，老師是王無邪。

Pearl Perched on a Junk Boat

The HKAF logo, which has continued to represent the Festival for half a century, was the result of a design contest. The six-person jury panel included renowned designers from Hong Kong and Japan, including Henry Steiner and Ikko Tanaka. The winner out of 51 entries was Hon Bing-wah, then a young designer who would go on to great fame. His winning submission featured a luminous pearl perched on a junk boat, both of which were representative of Hong Kong. At the time, Hon was studying design at School of Continuing and Professional Studies of Chinese University of Hong Kong and was taught by Wucius Wong.

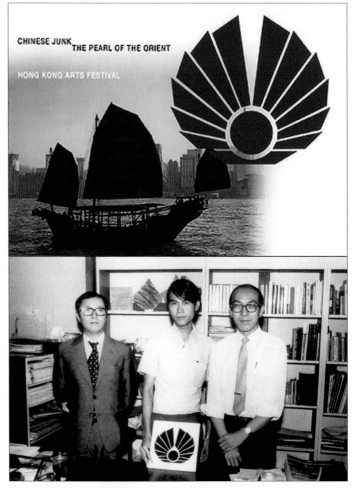

（左起）藝術節徽號設計比賽評選委員會主席田中一光，
得獎者韓秉華及其老師王無邪
(from left) HKAF Symbol Competition's Judges Panel Chair,
Ikko Tanaka, awardee Hon Bing–Wah and his teacher Wucius Wong

香港國際音樂節

馮秉芬的兒媳馮慶鏘伉儷在外地生活多年，1967年回港，有感香港這城市雖小，卻是中西文化匯聚的地方。當時香港被稱是個文化沙漠，但兩人作為藝術愛好者，看到日本能夠吸引很多外國樂團到訪，為何這些藝術家不可以在日本演出前後，途經香港呢？加上香港已有一個很好的演出場地大會堂，只是還沒有被充份利用。

馮慶鏘夫人憶述：「直至某次聚會，船王董浩雲來探訪家翁，他是一位音樂愛好者，我們跟他談到在香港辦音樂節的可能性。董先生認識一位中國指揮家好友董麟，他在美國懷俄明州舉辦音樂節。不久，我們認識了董麟，他對這個提議很有興趣，認為可以先從邀請一個樂團加幾位獨奏家開始，於是他幫忙籌辦音樂節。就在1968年成立了一個非牟利組織：香港國際音樂節協會。董麟擔任藝術總監。

「到了1970年中，英國海外航空和香港旅遊協會在推動香港藝術節這計劃，請來愛丁堡藝術節的韓德來港與不同界別人士會面，商討在香港舉辦藝術節的可能。我和慶鏘便說，香港國際音樂節已在香港成功舉辦了三年，且有少許盈餘，我們樂見規模更大的機構把它發揚光大。」這樣，香港國際音樂節協會便最終解散，隨之而來香港藝術節協會便於1972年成立。

「香港藝術節的首任主席是馮秉芬，而當年孕育舉辦國際音樂節的最早討論，就是在他的家裡發生，兩個計劃的結合好像是一個因果循環。」

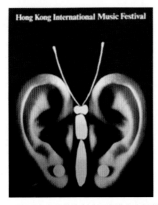

香港國際音樂節海報（馮慶鏘夫人提供）
Poster of Hong Kong International Music Festival (courtesy of Mrs Nelly Fung)

Hong Kong International Music Festival

Kenneth Hing-cheung and Nelly Fung, son and daughter-in-law of Kenneth Fung Ping-fan, returned to Hong Kong in 1967 after years of living overseas. To the Fungs, Hong Kong might have been small in size but it enjoyed a unique blend of eastern and western culture. It was frequently derided as a "cultural desert", however. Passionate about the arts, the Fungs observed Japan's success in attracting overseas arts groups to perform. Would it not be possible, they reasoned, for these artists to make a detour to Hong Kong either on the way to or from Japan? Moreover, Hong Kong had at its disposal City Hall, an outstanding performance venue which was very much underused.

"It was not until a social gathering when shipping magnate Tung Chao-yung, a music lover, visited my father-in-law that the idea was further explored," Nelly Fung recalls. "We discussed with Tung the possibility of organising a music festival in Hong Kong. Tung was a good friend of Ling Tung, a Chinese conductor who had previously organised the Grand Teton Music Festival in Wyoming in the US. We later befriended Ling Tung, who was very interested in the suggestion. He believed the music festival could begin with inviting one group and several soloists, and he quickly sprang into action to plan the event. By 1968, the Hong Kong International Music Festival Society was registered as a non-profit-making organisation, with Ling Tung taking on the role of Artistic Director.

"In the early 1970s, BOAC and the Hong Kong Tourist Association started working on a Hong Kong Arts Festival project. Ian Hunter from the Edinburgh International Festival was invited to Hong Kong to meet people from different sectors to explore the possibility of organising the Arts Festival. My husband and I commented that the Hong Kong International Music Festival had already been held in Hong Kong for three years with success and a small surplus. We would be happy to see a larger institution bring it to greater heights." So the Hong Kong International Music Festival Society was eventually dissolved and the Hong Kong Arts Festival Society subsequently established in 1972.

"The first chairman of the HKAF was Kenneth Fung Ping-fan, while the earliest discussions on organising an international music festival had been initiated at his home. The combination of the two projects felt like a natural evolution destined to happen."

執行委員會的組合

藝術節執行委員會的創會成員都是德高望重的商界領袖。參與藝術節的工作，每人都各擅其職，協力但求把藝術節誕生出來，並能茁壯成長。

馮秉芬成為首屆香港藝術節的主席，邵逸夫為副主席，港督麥理浩成為贊助人。其他包括香港旅遊協會的潘恩、怡和大班布朗、英航香港代表達根，還有厄特利義務司庫等。

委員會陸續增添不同界別的代表成員，如市政局（沙利士）、匯豐銀行（沈弼）、酒店業協會（胡民勝）、政府新聞處（霍德）；以及邀請相關的人士出席會議，務求集思廣益，盡用人脈，推展計劃及解決一浪接一浪的難關。

資源所限，早年藝術節沒有固定的辦公室，每次委員會開會都像打游擊般在不同會員的辦公室內舉行。

此外，藝術節組成了一眾超過八十人的義務諮詢，來自不同的藝術、文化、教育、商業界別，為這新生命出謀獻策。

Putting it Together: The Committee

The founding members of the Festival Committee were all highly respected business leaders. When working on the Festival, the members put forth their best efforts of fulfilling one singular vision, which was to launch the Arts Festival and to see it grow in the years to come.

Kenneth Fung Ping-fan became the inaugural Chairman with Run Run Shaw as Vice Chairman and Governor Murray MacLehose as Patron. Other members included John Pain from the HKTA, managing director of Jardine Matheson Jeremy Brown, E.M. Duggan from BOAC in Hong Kong, and M.J. Uttley as Honorary Treasurer.

Committee members represented different sectors of society, including the Urban Council (Arnaldo de Oliveira Sales), HSBC (Michael Sandberg), the Hong Kong Hotels Association (Manual Woo) and the government's Information Services Department (David Ford). Other people with relevant expertise and interests were invited to attend meetings.

Having only limited resources, the Arts Festival lacked a fixed office in its early years, meaning every Committee meeting was convened at the offices of various members.

In addition, the Arts Festival established a group of Honorary Advisers with more than 80 members from various arts, cultural, educational and commercial sectors to provide counsel for the exciting new enterprise.

（左起）邵逸夫主席、香港旅遊協會的潘恩於1976年開幕晚宴
(from left) HKAF Chair Run Run Shaw and Hong Kong Tourist Association's John Pain at 1976 opening dinner

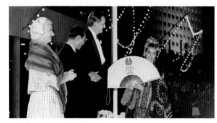

港督麥理浩及夫人於1978年開幕禮
Governor Maclehose and Mrs Maclehose at 1978 opening ceremony

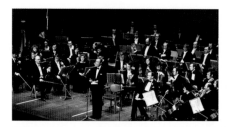

（中）邵逸夫於1978年藝術節開幕音樂會（伯恩茅斯交響樂團）
(middle) Run Run Shaw at the opening concert in 1978 HKAF (Bournemouth Symphony Orchestra)

（左起）哈代、馮秉芬、香港酒店業協會的胡民勝於1996年開幕晚宴
(from left) Charles Hardy, Kenneth Fung and Hong Kong Hotels Association's Manuel Woo at the 1996 Festival Opening

伊安・韓德
Ian Hunter

韓德
借鏡愛丁堡藝術節

韓德這位「藝術節先生」擔任首三屆的藝術總監，這是兼任職位，他大部份時間都是在英國，可謂遙控先驅。

韓德有份參與創辦愛丁堡藝術節，有豐富藝術行政經驗及獨到商業眼光。香港藝術節初年自不然在很多地方借鏡愛丁堡藝術節，例如在節目的選取編排、營運模式等，均以這個享譽世界的文化盛事為藍本。

任內韓德就當時香港三大文娛康樂活動，包括香港學校音樂及朗誦節、香港節及香港藝術節，進行分析及研究。

他形容當時主辦藝術節這構思「風險極高，可幸算是化險為夷。如果一個藝術節能自負盈虧，門票定價不太高昂，而酒店也願意繼續支持的話，為期四星期也不算太長。他認為藝術節倘能得到政府承諾支持，把活動打造成世界級盛事，例如在歐洲主流報章刊登相關報導，向觀眾灌輸前衛音樂及其他藝術形式等，這些做法會較為可取。」

Ian Hunter
Drawing Experiences from the Edinburgh International Festival

Widely lauded as "Mr Festival" in the art world, Ian Hunter served as Artistic Director for the first three editions of the HKAF. It was a part-time post for Hunter, who spent most of his time in the UK, making him perhaps one of the earliest proponents of global remote work.

A seasoned and experienced arts administrator with business acumen, Hunter had been involved in establishing the Edinburgh International Festival as a major event on the international arts calendar. So it was only natural that the HKAF would in its early years follow many of the examples that had made Edinburgh such a success. The Scottish festival would become a blueprint for the HKAF in multiple areas, including programme selection and arrangement, as well as operations.

During Hunter's tenure, he conducted research and analysed Hong Kong's three major cultural events including the Hong Kong Schools Music and Speech Festival, the Festival of Hong Kong and the HKAF.

He described the Hong Kong Arts Festival as "an enormous gamble which, by and large, had paid off. If a festival can be made self-financing, four weeks is not too long if seats are not highly priced and hotels and so on are prepared to continue their support". He thought it might be wise to get a commitment from the government to enable the organisers to make the Festival a world event, such as coverage in all the big European newspapers, and audiences could be educated towards more avant-garde music and the like.

選擇檔期有玄機

香港藝術節一直以來都是在二、三月農曆新年後舉行，為期約四個星期。為何選擇此檔期？原來跟入境旅遊有關。農曆新年從來是入境旅遊的淡季，所以航空公司和酒店業都希望促銷，對藝術節來說，亦可降低成本，可謂雙贏。只是在此檔期舉辦大型藝術節，一定要有吸引大眾的節目。

藝術節的初心是為吸引多些海外遊客，然而即使在做了不少功夫宣傳，頭數屆的海外遊客佔觀眾僅兩成以下，不過，藝術節對推廣旅遊業的重要性是肯定的。

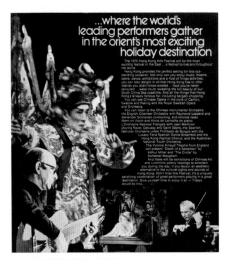

1975 年香港藝術節宣傳單張
Promotional pamphlet of 1975 HKAF

Reason Behind Setting the Festival Period

The HKAF is held every year for around four weeks across February and March, after Chinese Lunar New Year. This decision was not arbitrary and there was plenty of wisdom behind the particular Festival period, which came down to tourism. As the Lunar New Year had always been the slowest period for inbound tourism, both the airline and hotel industry wished to drive sales through promotions and events. It was a win-win situation for the Arts Festival, too, with lower airline fares and hotel room prices. Organising a major arts festival during the period however required programmes with wide appeal.

The Arts Festival was created initially to attract more overseas tourists. Even after a considerable effort promoting the festival, overseas tourists made up less than 20 per cent of audiences during the first few editions. But the overall importance of the Arts Festival in promoting tourism cannot be understated.

婦女委員會

婦女委員會的成立,相信在藝術界是創立了先河。

藝術節第一屆便成立這個義工團隊,為數超過二十人,目的是專門負責接待訪港的藝術家,團隊由藝術節委員會成員的夫人和友好組成,來自世界各地、帶來不同的語言和文化。當時外國藝術家對香港不太熟悉,所以不太熱衷來香港,她們便擔起像藝術節大使的任務。由落機的一刻至離開香港,婦女委員會的義工會盡地主之誼,帶藝術家遊覽香港,體驗香港獨特的地方,當然也會品嚐地道美食,讓他們在藝術節完結時帶著愉快的心情回家。別少覷這方面,香港藝術節能夠在海外迅速打響名堂,不少是因為來訪過的藝術家,因著已留下良好印像,口耳相傳,透過他們把香港美好的一面帶到全世界。

其中一位婦女委員會成員馮慶鏘夫人提到:「婦女委員會做了一個成功的公關及融合工作,讓海外的藝術家認識到香港是一個極佳的旅遊地方,也有出色的表演場地及愛好藝術的觀眾。」

委員會的成員也協助推廣藝術節給各自的圈子,並曾安排一些酒會,讓海外的藝術家跟本地的同道得以交流聯繫。

趙世彭夫人除了是婦女委員會的中堅份子,她在1978年加入藝術節委員會,成為首位女士會員。趙夫人曾接待不少國際知名藝術家,還記得有一趟,著名芭蕾舞家瑪歌·芳婷在演出完畢離開香港前,說希望參觀當時新落成的匯豐銀行,於是義工團隊她們便設法完成她的心願,由匯豐大班充作導賞員,瑪歌·芳婷開心地盡興而歸。

Ladies Committee

The establishment of the Ladies Committee may be among the first of its kind in the art world.

The volunteer team was formed during the first edition of the Arts Festival, with more than 20 members. Its purpose was to welcome visiting artists when they arrived in Hong Kong. The team consisted of wives and friends of Festival Committee members and they came from all over the world, with diverse linguistic and cultural backgrounds. Overseas artists at the time were initially hesitant about visiting Hong Kong as they were not familiar with the city. So the Ladies Committee took on the role of being ambassadors for the Arts Festival. They played host during artists' entire stays by showing them around Hong Kong, visiting unique places in the city and helping them try the local food. The volunteers ensured these guests enjoyed their trip before returning home and their contributions cannot be underestimated. The HKAF quickly established a strong reputation in no small part because visiting artists got such a favourable impression of the city and helped spread the message of Hong Kong's appeal across the world.

Nelly Fung, a member of the Ladies Committee, commented that "the committee proved to be a successful and fruitful public relations and bonding exercise. Gradually, the word spread that Hong Kong was an excellent place to visit, with attractive venues and appreciative audiences".

Members of the committee also helped promote the Arts Festival within their social circles. They arranged cocktail parties to facilitate exchanges between overseas artists and their local counterparts.

As a core member of the Ladies Committee, Betty Chao joined the Festival Committee in 1978 and became its first female member. Mrs Chao greeted many famous international artists and recalled the occasion when the iconic ballet dancer Margot Fonteyn performed at the Festival. Fonteyn expressed a wish to visit the newly completed HSBC Building before she left Hong Kong. The volunteer team sprang into action. With HSBC's Chief Executive as her guide, Margot Fonteyn was able to visit the building to round off her enjoyable trip.

藝術節主席為訪港的藝術家在家或酒店設宴歡迎答謝，已成為一個傳統
It has been a tradition for HKAF Chairmen to either host welcome luncheons at the residence or thank-you dinners at a hotel for incoming artists

英國茨塞斯特節日戲團的劇團及舞台經理霍文東，回想 1976 年來港上演《奧賽羅》，
演出之餘，獲藝術節主席及婦女歡迎委員會成員邀請，參與多個招待會及活動，
印象猶新，例如到邵氏影城午宴及觀賞電影，駕駛趙世彭夫人借出的遊艇。

Max Howard, Company and Stage Manager of The Chichester Festival Theatre Company, vividly recalls their *Othello* performance in 1976 HKAF and their invitations to various receptions and activities hosted by the Chairman and members of the Ladies Hospitality Committee. Pictures were taken showing the view from the driveway of the Shaw Studio City where they had luncheon and movie screening as well as his driving Mrs Betty Chao's speedboat.

陳達文
藝術節在大會堂的日子

如果沒有香港大會堂，五十年前的香港藝術節怎樣落地生根？

「韓德說過，辦藝術節首要條件是要有場地。」1961年入職大會堂任副經理的陳達文，見證了香港藝術節的誕生。

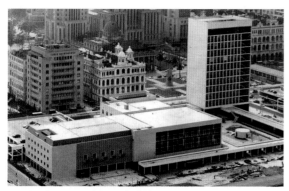

香港大會堂於 1962 年在中環海濱落成
Hong Kong City Hall opened on the Central harbourfront in 1962

1973 年，第一屆香港藝術節舉行之時，大會堂已開幕十年，不過要應付這個嶄新的國際藝術節還不是件容易的事。「大會堂當時做的節目很簡單，我們辦的星期日音樂會，門券只售一元。」陳達文說為了吸引多些年青觀眾，所以有星期日一元音樂會，票價是晚上節目的十分一。「事實上，票價應反映節目的質素。（註：首屆藝術節的最高票價為$60。）當時大會堂主要是本地節目，間中也會有外國藝團演出，主要是電影業鉅子歐德禮帶來香港，租用大會堂的場地而不是由我們主辦。」

「1973年的香港大會堂已經累積了一班觀眾，他們大多喜歡莫札特、莎士比亞、芭蕾舞及經典戲劇。那個時候要看世界一流的演出，必然會到大會堂，所以藝術節開始時非常成功。大會堂開幕時舉辦的第一個音樂會是倫敦愛樂樂團，當時指揮馬爾科姆·薩金特說過是他到訪過眾多音樂會中音響最好之一，大概是經口耳相傳，所以大會堂在歐洲也有點名聲。其實，大會堂初期的設計是仿傚倫敦的皇家節日音樂廳，因為那個音樂廳的音響出色。首屆藝術節另一個令我形象深刻的是柏高·班拿佛蘭明高表演，有節奏有感情，香港觀眾也很喜歡。」

Darwin Chen
The Arts Festival's Days in City Hall

Without Hong Kong City Hall, it is unlikely the HKAF would have been able to establish a foothold half a century ago.

"Ian Hunter once said: before having an arts festival, you need to have the venue first," Darwin Chen says. Chen, who started working at Hong Kong City Hall as Assistant Manager in 1961, can attest to this insight, having been there for the birth of the HKAF.

City Hall had already been open ten years by the time the HKAF was first held in 1973. However, handling a new arts festival on an international level was far from easy. "The programmes that took place at City Hall were very simple in nature at the time," Chen says. "We presented Sunday concerts with tickets sold for one dollar." Those Sunday concerts with one-dollar tickets, one-tenth of the price for evening programmes, were put on to attract younger audiences.

"The ticket price is actually indicative of the programme quality. (At the first HKAF, the highest ticket price was $60.) Most performances at City Hall in those days were by local groups with a few by overseas touring companies. Those were programmes staged in Hong Kong by entertainment giant Harry Odell, who just rented the venue. We had nothing to do with the organising.

"By 1973, Hong Kong City Hall had already built an audience, who mostly enjoyed works by Mozart and Shakespeare, ballet performances and drama classics. At that time, if you wanted to see a world-class performance, it meant visiting City Hall, so the Arts Festival started with great success. Malcolm Sargent conducted the London Philharmonic Orchestra at the City Hall's opening concert, and said the concert hall had some of the finest acoustics in the whole world. Perhaps because of the positive word of mouth, the City Hall got somewhat of a reputation in Europe. During its early days, the City Hall's design in fact resembled London's Royal Festival Hall because of the outstanding acoustics. During the first edition of the Arts Festival, I was also deeply impressed by Paco Pena's *Flamenco Puro*. The dance performance was filled with rhythm and emotion, and was well received by the Hong Kong audience."

（左起）陳達文伉儷與馮慶鏘夫人於1976年開幕酒會
(from left) Mrs and Mr Darwin Chen with Mrs Nelly Fung at 1976 opening reception

既是場地管理者也是觀眾

藝術節開幕之時，陳達文已成為大會堂經理，所以差不多每晚也在場，直言藝術節讓他大開眼界，除了有機會欣賞到很多平時沒機會看的世界級藝團演出，更成了很好的學習機會。

「雖然已有十年的場地管理經驗，但一下子有那麼多國際藝團來演出，而且每人的要求也不同，過程一點也不容易。不過最重要還是溝通，不論是跟藝術家、燈光師、服裝師，整個流程要很清晰，如何跟外國的製作團隊合作是一個學習過程。」

「另一個挑戰是觀眾秩序、場地管理的細節問題。大會堂開幕時已確立了不准吸煙、不可以在演出期間站立隨處走動的規則。大會堂的常客已習慣，問題不大，不過藝術節吸引了新的觀眾，他們從來沒有踏足過大會堂，所以每次節目演出前會重提場館規則，頭幾屆在場館內也有觀眾拍照、站立走動這些事情發生。我們提醒帶位員跟觀眾溝通一定要有禮貌，所以觀眾也很明白。」

「其實當時的公民質素也很好，好像門票開賣第一天，大會堂會大排長龍，甚至排到門外走廊，反應很熱烈。當時的冬天比現在冷得多，但很多人還是一大清早甚至通宵排隊購票，秩序也很好。」陳達文提到當時公開售票時會有兩條人龍，一是買正價票，另外一條就是學生票。「藝術節的票價相對地比較貴，為吸引多些年青人，多些本地觀眾入場，所以找了贊助推出優惠學生票。」

Both a Venue Manager and an Audience

When the Arts Festival first opened, Chen was already the venue's manager and had to be present almost every night. He was candid about how the Arts Festival broadened his horizons. In addition to being able to enjoy many world-class arts performances that were rarely available in the city, it also became an excellent learning opportunity.

"Even with a decade of experience managing the venue, the process was far from easy when faced with a sudden influx of international arts groups, each having their own specific requirements," he says. "However, what matters most is communication. Whether it was with the artists, the lighting crew or costume team, the entire process had to be very clear. Working with overseas production teams is a learning process in itself.

"Another challenge was venue management, including audience conduct. The rules of no smoking and remaining seated during performances were established when City Hall opened. Existing audiences at City Hall already observed these rules and that did not present a problem. However, the Arts Festival attracted new audiences, who had never set foot there before. So the house rules were read out before every performance. During the first several editions of the Festival, there were instances where audience members took photos or did not remain in their seats. We would remind ushers to remain courteous and polite when communicating with audience members, who would be understanding as well.

"People actually behaved very civilly. Take the first day of public ticket sales for example. People were very enthusiastic, with long queues forming outside the corridor. Winter was much colder then but many people arrived in the early morning or queued up overnight in a very orderly fashion for tickets." There were two queues during public ticket sales, one for standard price tickets and the other for student tickets. "Ticket prices for the Arts Festival were relatively high. To draw a larger local audience, including young people, sponsors were sought to provide student tickets at a discount."

為了買票，廢寢忘餐！
Skipping food and sleep for the tickets!

給社會大眾的世界級藝術

1975 年香港藝術節，英格蘭室樂團和西班牙舞蹈團最高票價是 $75，最低是 $10。當時大會堂的節目票價大概是 $10。「藝術節的門票的確不是特別普及，因為節目要有水準，所以要花費多一點去邀請頂級的藝術家來港演出。票價的釐定當然跟支出與收入有關，藝術節開始時並沒有獲得任何政府資助，大部份資源都是來自商界。」

「一開始藝術節邀請了曾任愛丁堡藝術節藝術總監的韓德加入，他在四十年代二戰後協助創辦愛丁堡藝術節，當時英國百業蕭條，愛丁堡市政府不太支持舉辦藝術節，認為是浪費金錢。然而韓德卻懂得找政府支持，又想到找商業贊助，所以他也將這個營運模式帶來香港，跟政府打交道，再找英資機構贊助，然後是票房收入。韓德這個理念當時沒有人會想到。我從他身上學了很多東西，特別是節目策略，要求節目要有高水平的藝術價值，同時不會偏離大眾口味，不能太前衛，也不是『為藝術而藝術』。所以節目要有票房，要得到社會支持，是帶領大眾而不是強行改變大眾品味。」

World-Class Art for the Public

During the HKAF in 1975, the highest and lowest ticket prices for the English Chamber Orchestra and the Lucero Tena Spanish Dance Ensemble were $75 and $10 respectively. In comparison, ticket prices for City Hall programmes were around $10. "Arts Festival tickets were indeed higher than the norm at the time. As a high-quality international programme will likely cost more money, ticket prices are set accordingly. The Arts Festival did not receive any government funding initially and most resources came from the business community.

"In the beginning, Ian Hunter was invited to join the Arts Festival. He used to be the Artistic Director of the Edinburgh International Festival, which he helped to found in the 1940s after the Second World War. The economy in the UK was sluggish at the time and Edinburgh Council was reluctant to organise the arts festival, which was considered a luxury they couldn't afford. Hunter, however, knew how to seek support from the government and commercial sponsors. He subsequently applied the same approach in Hong Kong. Hunter liaised with the government and looked for sponsorship from British firms. There was also income from ticket sales. Hunter's ideas were original at the time. I learned a lot from him, especially in programme strategy. The programme should be of high artistic calibre, while not deviating from the mainstream. It cannot be too avant-garde or 'art for art's sake'. The programme should therefore perform at the box office with support from the public. It is intended to lead the public's taste rather than changing it by force."

Chen said that he was greatly inspired by Hunter. "His inclination in the arts was integration in the community. I believe in the direction of bringing art out into society. Performing arts should be a part of daily lives, just like young people on a date during the 1980s would attend a concert at City Hall."

Promotion of Local Arts Development

In addition to bringing world-class performing arts performances to Hong Kong, the HKAF also influenced Hong Kong's arts development. "The Urban Council, responsible for arts and cultural development, became financially independent in 1973. It was headed by Arnaldo de Oliveira Sales, who loved music and was supportive of the arts. Budgets for City Hall gradually increased at the time the Urban Council started to organise programmes.

陳達文說韓德對他有很大的啟發,「他在藝術方面的取向是融入社區,我相信藝術一定要走入社會這個方向,表演藝術要成為日常生活,就好像八十年代的年青人拍拖也會去大會堂聽音樂會。」

促進本地藝術文化發展

藝術節除了把世界級的表演藝術帶來香港,也影響了香港的藝術文化發展。「負責文化事務的市政局自1973年財政獨立,而當時的主席沙利士熱愛音樂,很支持文化藝術,逐漸增加了大會堂的預算,此時市政局才開始主辦節目。」

「藝術節的成功首先要有場地,另外要拓展觀眾就要有好節目。當時我想到藝術節是一年一度,全年的其他日子沒有節目,所以便構思了兩個項目,一是夏天的嘉年華,另一是年底的亞洲藝術節。因為當時藝術節主要是歐洲節目,讓我們學習英國人是如何籌辦大型的藝術節,如何找商業贊助。亦因為藝術節的出現,才啟發了後來我們草擬香港文化政策時,其中一個重點便是發展場地,培養專業的表演藝術人才和觀眾拓展。」

「1977年開始,本地藝團像香港中樂團、香港話劇團、香港芭蕾舞團、香港舞蹈團等陸續成立;八十年代初,沙田大會堂、荃灣大會堂、屯門大會堂相繼落成,香港的藝術文化發展進入了新的階段。」陳達文還記得當初1962年大會堂的出現也有人覺得是大白象,因為當年很多香港人不懂文化。二十年後,因為大會堂、因為香港藝術節,播下的種子已種出了大樹。

中西文化橋樑

因以推動旅遊為目標,最初的香港藝術節以外國節目為主,沒有太多本地節目。陳達文提到早期只有香港管弦樂團、香港兒童合唱團的參與,當時香港管弦樂團也是1974年剛轉成職業樂團。

「直至1977年香港中樂團成立後才多些本地節目,而且藝術節還有一個要求,就是多些本地創作,委約藝團演出新作品。藝術節不只有世界級的表演,也是發表新作品的平台。我認為其中一個轉振點是八十年代鄧小平改革開放後,中國內地非常渴望認識西方文化,外國藝團也希望到中國內地演出,香港藝術節便成了

"You first need a venue for an arts festival to succeed. In addition to that, you need good programmes to increase your audience. The Arts Festival is an annual event and programmes were lacking for the rest of the year. So I started two events, one of which was the Summer Fun Festival and the other the Asian Arts Festival, held at the end of the year. As the HKAF featured mostly European programmes, it helped us to learn how British people organised large-scale arts festivals and found commercial sponsors. The new Arts Festival also inspired our drafting of Hong Kong's cultural policy, with the focus being venue development, nurturing professional performance artists and audience development.

"From 1977, a succession of local arts groups were established, including Hong Kong Chinese Orchestra, Hong Kong Repertory Theatre, Hong Kong Ballet and the Hong Kong Dance Company. A range of new venues, among them Sha Tin Town Hall, Tsuen Wan Town Hall and Tuen Mun Town Hall, also opened in the early 1980s. Hong Kong's arts development entered into a new phase." Chen recalls that when City Hall first opened in 1962, it was considered a white elephant by some because many Hong Kong people did not understand the value of culture. Twenty years later, enormous growth had been made possible by the seeds planted by City Hall and the HKAF."

Bridging Chinese and Western Culture

With its objective of promoting tourism, the HKAF initially featured mainly overseas programmes. Chen says that, among local arts groups, only the Hong Kong Philharmonic Orchestra and the Hong Kong Children's Choir took part in the Festival in its early days and the Philharmonic only became fully professional in 1974.

"It was not until 1977, when the Hong Kong Chinese Orchestra was established, that more local programmes were presented. The Festival also had a mandate of featuring more local works and commissioning arts groups to perform new ones. The Arts Festival was not only a showcase for world-class performances but also a platform to debut new works. I believe that one of the turning points was Deng Xiaoping's reform and opening-up policy in the 1980s. Mainland China was eager to learn about Western culture while overseas arts groups wished to perform in Mainland China. The Festival thus became a bridge that facilitated cultural exchange between East and West. There was also a high level of trust in the HKAF as a brand on the Mainland. One of the most memorable programmes after 1997 was *Raise the Red Lantern,* the Ballet by the National Ballet of China (2002). The highly innovative

一個窗口，真的做到東西文化交流，而且中國內地對香港藝術節這個品牌也有信心。1997後印象最深刻的其中一個節目，是中國國家芭蕾舞團的《大紅燈籠高高掛》(2002)，整個製作很具創意，創作團隊有旅德的華裔編舞王新鵬、旅居法國的華人作曲家陳其鋼，加上張藝謀的電影語言，穿著中國旗袍跳芭蕾舞，把西方的芭蕾舞以創新的手法呈現，透過香港藝術節這個平台，把中國新的創作帶到全世界。」

從大會堂經理，直至2002年當上香港藝術發展局主席，陳達文一直有列席或出任香港藝術節的執行委員會(至2004年)，看著香港藝術節成長。「當初想做的計劃現在也做到，例如教育項目、加料節目等。藝術節為香港帶來多方面的經驗，其中之一是如何尋找商業贊助，當時香港的藝團不懂得籌款，藝術節引入了商業贊助的概念。韓德一開始便認為要有企業支持，要找社會各階層、知名度高的社會賢達，而不只是藝術家。後來本地藝團公司化，也是參考藝術節的管治模式，在上設立一個執行委員會，訂定大方向及管治，並由專職的行政人員推動落實。昔日大會堂不少同事也參與本地藝團公司化運作，當中亦有成為藝團的行政總監，因為他們早年在大會堂工作接觸了藝術節的運作，知道如何跟藝術家打交道，要顧及票房，明白市場推廣，找商業贊助，社區人脈的影響力。原本只是公務員，卻因為藝術節而對藝術文化發展有所認識。所以藝術節對香港有很多方面影響未必容易看得到，卻是切實地存在。香港要做國際城市，吸引人才，除了薪酬外，藝術也很重要，倫敦便是一個很好的例子。」✿

production was created by Chinese choreographer Wang Xinpeng, who was based in Germany and Chinese composer Chen Qigang, who was based in France. Together with the film language of Zhang Yimou and ballet dancers in *cheongsams*, ballet as a western art form was presented with creativity. It was through the HKAF that this new work from Mainland China made its debut on the world stage."

From his days as Manager of City Hall to when he became Chairman of the Hong Kong Arts Development Council in 2002, Chen was a constant on the HKAF's Committee (on which he served until 2004) and witnessed the Festival's growth at close hand. "We were able to accomplish the projects planned initially including educational programmes and Festival PLUS. Through the Arts Festival, Hong Kong gained experience in many areas, one of which was seeking commercial sponsorship; this was an area that Hong Kong arts groups at the time were not familiar with. Ian Hunter identified the need for corporate support right from the start, which also entailed reaching out to people from different walks of life, including prominent socialites, and not just artists. When local arts groups became corporatised later, they also referred to the Arts Festival's model of governance, including a General/Executive Committee established to formulate overall direction and governance with the group managed by professional administrators. Quite a few colleagues during my days at City Hall became involved in the operations of local arts groups when they were corporatised, with some taking on the post of Executive Director. It was during the early years working at City Hall that they learned about the operations of the Arts Festival and gained experience as they liaised with the artists, considered the box office, learned about marketing, sought commercial sponsorship, and made use of their professional networks. Originally civil servants, they learned about arts development because of the Arts Festival. So the Arts Festival influenced Hong Kong in many ways that are not readily apparent but the impact was certainly concrete and substantial. Hong Kong, being an international city, requires more than just money to attract the top talents. London is a very good example of how art is also another important factor for consideration." ✿

第 二 章 Chapter 2

本地化進程
The Progress in Localisation

歷史往往是回顧過去,才連繫到種種偶然的脈絡。當初正是英國航空公司的市場經理哈代為推動旅遊業,才遇上娛樂大亨邵逸夫,推波助瀾,找來韓德把愛丁堡藝術節的概念帶到香港。就這樣,創辦於上世紀七十年代的香港藝術節,在有限的資源下為香港帶來世界級的表演藝術。

創始初期財政不穩,舉步維艱,從韓德到奇切斯特藝術節的助理總監安東尼·沙達及曉拔·威利士,藝術節有賴這幾位英國的專家擔任藝術指導,在英國遙距把優質節目帶到香港。除了借助他們的眼光,藝術節的執行委員都絞盡腦汁,傾囊相助,集結社會資源,為藝術節打下良好的基礎,成功建立品牌。

經過頭兩年的摸索,藝術節也逐漸需要聘任本地華人,如負責公關宣傳的關美楓、粵劇聯絡的程佩英、舞台聯絡的麥秋。後來馬斌於 1976 年從票務轉為首位華人藝術節的行政主任。

走到八十年代,當藝術節漸次成長,從牙牙學語開始,到自信地找自己的路,不能再依靠海外專家。從首位本地聘任的總經理史迪敦開始,不論是人事聘任,節目取向,還是目標觀眾,再不是以推動旅遊為主要目標。把世界級藝術帶給香港觀眾,與本地藝團的合作,更符合以立足香港、連結國際為宗旨的藝術節。

在短短十年間,藝術節的節目編排從英國遙距控制,慢慢演變成以香港作為指揮基地。史迪敦於 1981 年加入香港藝術節,出任總經理 (1983 年改稱總監),他在劍橋大學修讀音樂,除了是作曲家,也曾在唱片業任職及擔任皇家北部交響樂團總經理。史迪敦的職責,不僅是領導藝術節的行政工作,更要逐步取代海外的藝術總監,所以從 1983 年起便結束威利士的合約,正式由本地統籌節目的選取及編排。在香港確立藝術總監的職責是一個里程碑,這決定直接影響日後節目方向和與本地口味的融合。

(左起)曉拔·威利士、蘇孝良(香港管弦樂團總經理)、安東尼·沙達、吳樹熾(香港演藝學院董事局首任主席)(約攝於 1975/76)
(from left) Hubert Willis, So Hau-Leung (General Manager of Hong Kong Philharmonic), Anthony Chardet, Alex Wu Shu-Chih (founding Council Chair of Hong Kong Academy for Performing Arts) (circa 1975/76)

票務主任馬斌(中)與同事在大會堂開設臨時售票處
Box Office Manager Henry Ma (middle) and colleagues setting up the temporary ticketing booth in City Hall (1974)

In retrospect, history is often a chain of events linked by happenstance. As sales promotion manager at BOAC (as British Airways was then known), Charles Hardy's chief aim was to promote tourism, a goal that eventually led to his meeting media mogul Run Run Shaw. As the idea blossomed, Ian Hunter was recruited to bring the concept from Edinburgh International Festival to Hong Kong. This became the impetus for the HKAF to be established in the early 1970s, and world-class performing arts programmes were brought to Hong Kong despite limited resources.

Working with financial instability and numerous challenges in its early days, the artistic direction was shaped with the help of a number of British experts, including Ian Hunter, followed by Anthony Chardet who had previously been assistant director of the Festival of Chichester, and Hubert Willis. They introduced high-quality programmes to Hong Kong while working remotely from the UK. Aided by their insight and acumen, the Arts Festival's Committee worked tirelessly and amassed the social resources vital to building a solid foundation and strong reputation for the HKAF.

After the first two years of exploration, the Arts Festival gradually hired local Chinese as part of the working team; the first on board were Maple Quon as Public Relations and Press Manager, Teresa Ching as Cantonese Opera Liaison, and James Mark for Liaison Officer. Henry Ma, initially responsible for ticketing, became the Arts Festival's first Chinese Administrative Officer in 1976.

In the 1980s, the Festival started to form its own identity, rather than relying on overseas experts. Starting with the appointment of Keith Statham in 1981 who was the first General Manager recruited in Hong Kong, the Festival's personnel appointment, programme direction and target audience were no longer geared towards promoting tourism. Bringing world-class arts performances to Hong Kong audiences and strengthening collaborations with local arts groups became goals more fitting for an international arts festival now firmly established in Hong Kong.

Statham, whose title was changed to Director in 1983, was a composer who studied music at Cambridge University and who had worked in the recording industry before becoming General Manager of the Royal Northern Sinfonia. He oversaw the Festival's administrative work and also, over time, took on the role of Artistic Director, which was still being fulfilled by Willis from the UK. This meant a fully local team became officially responsible for the selection and arrangement of programmes. Establishing the responsibilities of an Artistic Director in Hong Kong was a milestone as it had a direct impact on the direction of future programmes and how they would cater to local needs and tastes.

However, some assistance from outside Hong Kong was still required for the international programmes. So Statham recruited Joseph Seelig, who was working in arts management in London, to be the "eyes and ears" for the HKAF in Europe, especially regarding overseas theatre and dance programmes. Seelig provided the latest information, made recommendations, and liaised with overseas arts groups and artists.

史迪敦（前右二）與藝術節團隊，包括馬斌（後右三）、
金學忠（後左二）、陳蘊煇（前左一）
Keith Statham (front, second right) with HKAF staff,
including Henry Ma (back, third right), Elvis King (back, second left) and
Susanna Chan (front, first left) (1985)

然而國際的節目某程度仍需借助外力，所以史迪敦聘請了在倫敦從事藝術管理的約瑟·施力加入，擔任歐洲代辦，作為藝術節在歐洲的「耳目」，特別是戲劇、舞蹈等海外節目，施力提供最新的訊息及建議，以至聯絡海外藝團和藝術家。

史迪敦領導藝術節從 1981 年到 1987 年走過六個年頭，是一位有視野遠見的舵手。任內更為藝術節帶來新創意，嘗試與香港電台合作，與當時的古典音樂台台長高德禮一同監製多齣歌劇作品，包括《士兵的故事》(1980)、《中國人》(1982)、《秘婚》(1983)、《女人心》（亦譯為《試情記》）(1984)。（高德禮後來於 2003 至 2006 年出任藝術節的行政總監。）

因史迪敦曾任職數間國際級唱片公司，對音樂市場有豐富經驗，經常親自撰寫宣傳文稿，筆鋒簡而精，是出色文膽。他的國際視野把藝術節目包裝得更切合贊助商的要求，從而擴大收入來源。他離開藝術節後，在香港自組藝術代理公司，成功把藝術結合名貴商品推銷。

踏入八十年代中葉，與創辦初年相比，香港的藝術文化也步進茁壯成長的階段，本地專業藝團（如香港管弦樂團、香港話劇團、香港芭蕾舞團），即將步進第一個十年。繼香港藝術中心完工，荃灣、沙田、屯門大會堂紛紛落成，以至1984年香港演藝學院成立，1989年香港文化中心開幕，演藝文化節目及場地大大增加。在這個背景之下，鄭新文在 1988 年加入香港藝術節，成為首位華人總經理（其後改稱行政總監），意味著香港藝術節步進另一新的里程碑。

During his tenure as head of the Arts Festival from 1981 to 1987, Statham was a visionary leader. He came up with innovative ideas including collaborations with RTHK, in producing a series of operas with Douglas Gautier, head of RTHK Radio 4, including *The Soldier's Tale* (1980), *Le Cinesi* (1982), *The Secret Marriage* (1983) and *Cosi fan tutte* (1984). Gautier would, himself, later be the Festival's Executive Director, from 2003 to 2006.

Having worked for several international record labels, Statham was experienced in the music market. An excellent writer, he often penned the publicity material himself. With his international outlook, the Festival's programmes were packaged to be more aligned with the requirements of sponsors, which helped expand sources of income. After Statham left the Arts Festival, he established a communications company that promoted luxury goods in connection with the arts.

In the mid-1980s, arts and culture in Hong Kong entered into a phase of growth different to the Festival's inception. This period saw the establishment of local professional arts groups such as the Hong Kong Philharmonic Orchestra, Hong Kong Repertory Theatre and Hong Kong Ballet. Both the number of performing arts programmes and venues increased dramatically after the completion of the Hong Kong Arts Centre, Tsuen Wan Town Hall, Sha Tin Town Hall and Tuen Mun Town Hall, the establishment of the Hong Kong Academy for Performing Arts in 1984 and the opening of the Hong Kong Cultural Centre in 1989. It was against this backdrop that Tseng Sun-man joined the HKAF in 1988, becoming the first-ever Chinese General Manager (title later changed to Executive Director) as the HKAF journeyed on towards another milestone.

香港電台在香港理工學院舉辦民歌音樂會推廣藝術節
RTHK's folk concert promoting the HKAF at the Hong Kong Polytechnic (1980)

鄭新文
首位土生土長舵手

新上任的鄭新文如何帶領已有十五年歷史的香港藝術節(1973-1988)？他認為當時交到他手上的藝術節根基其實很好。「首先是得到很強的社會支持，管治團隊出色，委員會的組合由知名商界人士組成，馮秉芬、邵逸夫、匯豐大班、怡和大班，不同界別的社會領袖等等，有本地也有外國人。還有領事夫人、大企業行政總裁夫人組成的婦女歡迎委員會。每個委員會都各擅勝場，參與的委員樂於投入，善用社會資源，並配合有效及精簡的工作團隊。所以那時藝術節已建立了良好的品牌，得到觀眾的信任。」

行之有效的管治團隊，除了為藝術節打下穩固根基，也建立了一些特定文化。「邵逸夫主席從來都是自己淘腰包買票，除了開幕節目我們會邀請所有董事、資助及贊助機構代表、合作夥伴、媒體等參加開幕演出。因此長久以來沒有人會要求免費門票，即使是委員會成員，甚至是當時的港督也需要真金白銀買票，這是邵逸夫主席留傳下來非常重要的文化。也因為他的關係，那年代的開幕儀式會在無綫電視現場直播半小時，另外無綫還安排一些免費的藝術節節目預告。」

鄭新文上任前，總經理的位置懸空了一年。「1987年史迪敦離職後，由當時的副主席潘恩暫時幫忙處理藝術節的事務，而當時香港藝術中心也有提供行政上的支援，同時，委員會進行政策方向檢討，包括對未來總經理的要求。」

Tseng Sun-man
The First Chinese Hong Kong Native in Charge

Tseng Sun-man believed the Arts Festival, by now 15 years old, was already blessed with a strong foundation when he took charge. "Firstly, there was already strong support from society," he said. "The governing team was outstanding, while the General Committee was made up of prominent businessmen including Kenneth Fung Ping-fan, Run Run Shaw, directors of HSBC and Jardine Matheson, and pillars of society from different sectors. Both locals and foreigners were part of the Committee. There was also the Ladies Hospitality Committee formed by the spouses of both consuls general and directors of major corporations. The Committees were all outstanding while members were devoted, making good use of social resources. All were complemented by an efficient and compact working team. As a result, the Arts Festival had already established a brand of repute and earned the trust of audiences."

The competent governing team laid a solid foundation for the Festival and also initiated some traditions of their own. "Chairman Run Run Shaw always paid for his tickets out of his own pocket, with the exception of the Opening Programme, when all directors, representatives of donors and sponsors, partnering units and the media would be invited to attend the opening performance. So, no one, including General Committee members, would ask for free tickets. Even the Governor of Hong Kong had to buy his own. This became a highly important culture built on Chairman Shaw's example. It was also thanks to him that the Opening Ceremony was broadcast live on TVB for half an hour, with some previews of Arts Festival programmes also aired on the channel."

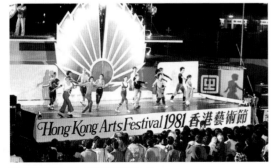

藝術節開幕儀式在無綫電視現場直播
Opening ceremonies of the HKAF were broadcast live at TVB (1981)

（左起）鄭新文與經理級同事：陳海昌、梁掌瑋、鄧潔儀
(From left) Tseng Sun-man with his managerial colleagues: Chan Hoi-cheung, Grace Lang and Jeanny Tang (1989)

當日為歡迎鄭新文加入藝術節，特別開了記者招待會。新人事新作風，雖然藝術節的核心理念沒有改變，但為了配合香港社會的轉變，藝術節也要思考是否需要新的發展方向。「回想當時提出過的一些想法，第一是要做觀眾拓展，吸引新觀眾之餘也要擴闊既有觀眾的視野，第二就是要帶來創意創新的節目。」

挑戰就在眼前，要撲火也要播種。

在播種之前，先要處理迫在眉捷的問題。鄭新文憶述：「剛加入時才發現原來有那麼多工作要處理，例如於半年後即 1989 年的藝術節還有些節目未定好，而且不少行政崗位懸空，包括所有經理級的職員，因此首半年我和新的管理團隊往往通宵達旦工作。」

「第二是財政挑戰。因為先前兩年政府特意減低藝術節的撥款，使協會儲備金額大幅減少。加上 1989 年的重頭節目維也納管弦樂團，因為外幣浮動關係，超出近百萬元預算，加劇了我們的財政負擔。我發覺假如政府資助不回復先前的水平，協會當年會進入負債的狀態。慶幸當時的政府官員簡何巧雲理解，問題源於雙方溝通，於是安排我們到立法會要求追加撥款。我要到立法會解釋為何需要額外資助。還記得當時有議員問藝術節是否行政費太高，是否管理不善等？當然感覺上不太好受。」

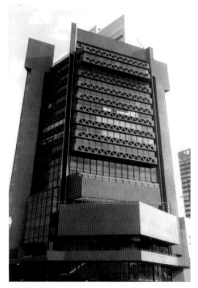

香港藝術中心外貌
Outlook of Hong Kong Arts Centre (1980s)

Before Tseng took up the post, it had been vacant for a year. "After Statham resigned in 1987, Vice Chairman John Pain helped out temporarily with the Festival's affairs and the Hong Kong Arts Centre also provided administrative support. At the same time, the Committee reviewed the Festival's policies and direction including its requirement for the future General Manager."

To welcome Tseng joining the Arts Festival, a press conference was held. While new changes were expected with new leadership, the Festival's core philosophy remained the same. In the face of transformations in Hong Kong society, however, the Arts Festival also needed to consider new directions in development. "There were some ideas put forward at the time. The first was audience development, which included drawing new audiences while expanding the horizons of existing ones. The second was to introduce creative and innovative programmes."

Plenty of challenges await Tseng with fires to put out and development plans to put into motion.

Before planting the seeds for audience development, there were urgent matters to handle. Tseng remembered: "I only realised how much work there was on hand when I started at the job. Some of the Arts Festival programmes scheduled for six months later in 1989 were still unconfirmed while some administrative posts including managerial positions remained vacant. As a result, the new management team and I often worked all night during my first six months on the job."

"Secondly, there was the financial challenge. Financial reserves for the Festival had dropped drastically because the government had reduced funding for it in the preceding two years. In addition to this, the major programme in 1989 was the Vienna Philharmonic Orchestra. Due to currency fluctuations, we went nearly a million dollars over budget which further increased our financial burden. I knew we'd be mired in debt if government subventions did not return to what they were. Rachel Cartland, the government official at the time, was fortunately understanding of the situation. We subsequently arranged to seek additional funding from the Legislative Council—I stated the case in front of the Council myself. I remembered the Council members asking if the Festival's administrative expenses were too high and whether the Festival was poorly managed. It certainly wasn't a very pleasant experience."

「第三個挑戰是當時收到建議，藝術節與演藝學院及藝術中心三家合併。我個人的觀察可能是藝術中心一直做很多演出節目，但資源不足，因為收入主要來自租金；後來收入不穩定，做少了節目，卻仍有一班出色的節目團隊。而當時的演藝學院想開設一個節目部門，還登廣告招聘，但最後也辦不成，大概是找不到資源。」鄭新文猜想這是合併建議背後的原因，結果如何我們都知道。「如果三者合併，將發展成為灣仔區的一個文化匯聚點，因此我要馬上準備文件與委員會討論。我和藝術節的委員都看不到合併對藝術節有何價值，三者的目標不相容，結果委員會否決了那個建議。所以合併的建議提醒我們必須檢討藝術節，我們的定位在哪裡，獨特性在哪裡，這也是我上任後的另一挑戰。」

所謂有危便有機，經此一役後，令藝術節及資助機構更清楚要有完善機制，鼓勵藝術節積累一定比例的財政儲備。而資助機構也更願意在每年資助比例上達到共識，使藝術節的收入更趨穩定。

"The third challenge was receiving a recommendation for the HKAF to be merged with the Hong Kong Academy for Performing Arts (HKAPA) and the Hong Kong Arts Centre (HKAC). Based on my personal observation, the recommendation was made perhaps because the HKAC presented many performing arts programmes but lacked resources because their income primarily came from rentals. Later, they would present fewer programmes because of unstable income but still retained an outstanding programme team. At the same time, the HKAPA wanted to establish a programme department, using even open recruitment. It ultimately did not materialise, perhaps for lack of resources." Tseng speculated on the reasons behind the recommendation for the merger. "If the three were merged, it would become a focal point for culture in Wan Chai District. I quickly prepared the documents and had discussions with the General Committee. Neither the Arts Festival committee members nor I saw any benefit for the Arts Festival in a possible merger as the objectives of the three parties were incompatible with each other. The General Committee eventually declined the recommendation. This episode reminded us of the necessity of reviewing the Arts Festival in terms of our positioning and uniqueness. This was another challenge after I started the job."

Turning a crisis into an opportunity, there was now greater awareness among the HKAF and its subsidising organisations on having effective measures and to accumulate a certain percentage of financial reserves. The subsidising organisations were also more willing to reach a common consensus on the portion of funding each year, thus increasing the stability of the Festival's income.

（左起）港督衛奕信、邵逸夫、鄭新文於 1989年藝術節開幕禮
(from left) Governor David Wilson, Run Run Shaw, Tseng Sun–man at the 1989 HKAF Opening Ceremony

節目策劃

作為藝術節的總經理，除了處理行政工作外，鄭新文也參與構思節目的工作，與同年加入藝術節的助理總經理（後來的節目總監）梁掌瑋（Grace Lang），還有駐英國的國際節目總監施力（Joseph Seelig）一起策劃節目。「其實我是可以不用理會節目，可以全部交由Joseph負責的，由他替我們炒幾碟好餸，也能完成一個藝術節。可是我跟Grace很投入，喜歡一起構思和策劃節目。」施力從八十年代開始替藝術節搜羅國際節目，自從鄭新文和梁掌瑋開始主動去找節目，他的角色也漸漸改變，變成配合藝術節的要求。

「我們認為研究數據是很重要的規劃基礎。當時通過觀眾調查我們知道藝術節約有20%的觀眾想看新節目，他們相信藝術節這個品牌，所以我們可以作新嘗試。另外我的前任史迪敦開始了特別為藝術節而製作歌劇演出的傳統。1990年我們推出《茶花女》，當中有講述巴黎上流社會的派對。如果由香港的合唱團來做，本地人扮外國人置身巴黎，感覺會很勉強。於是我們想到不如把服裝換成長衫，場景變成上海，這樣便比較合情理，也唯有是自己製作才可以做這些創新。」

《茶花女》節目宣傳
Promotion of *La Traviata* (1990)

Programme Planning

As the Festival's General Manager, Tseng handled the administrative work and also took part in programme planning. Along with Grace Lang, who joined the Arts Festival the same year as Assistant General Manager (subsequently Programme Director) and International Programme Director Joseph Seelig, who was based in the UK, they were responsible for planning the programmes. "Actually, I wasn't obliged to take part in programme planning and could have left the task entirely to Joseph. The Arts Festival could have gone ahead just with him 'cooking up some delicious dishes', so to speak. Grace and I, however, were very involved and loved conceiving and planning the programmes together." Seelig had looked for international programmes on behalf of the Festival since the early 1980s. Since Tseng and Lang started to proactively plan the programmes, Seelig's role gradually changed to meet the Festival's changing needs.

"We believed that research data was crucial to planning. From audience surveys, we found that around 20 per cent of the Festival's audience wanted to watch new programmes. We could try new things because they trusted in the Arts Festival as a brand. In addition, Keith Statham, who was my predecessor, started the tradition of staging opera at the Festival. In 1990, we produced *La Traviata*, which included lavish party scenes of bourgeois Paris society. It might have seemed out of place for the Hong Kong chorus to be dressed up as Parisians. So we suggested changing the costumes to cheongsams and moving the location to Shanghai, which would make more sense. These innovations were possible only because it was our own production."

"Grace and I were quite willing to present creative programmes. An example would be when the City of Birmingham Symphony Orchestra, led by music director Simon Rattle, performed in 1992. Rattle suggested performing the Turangalîla Symphony by French composer Olivier Messiaen. This is a very special work that had never been performed before in Hong Kong and would probably have been considered obscure by local audiences. After lengthy discussions, we felt it was our responsibility to promote new works, even with the risk involved, and arranged for it to be performed on the group's third performance. Hopefully, the orchestra's wonderful performances on the first two nights would motivate the audience to catch the third one. It ended up being a moderate box office success and broadened the audience's horizons."

「我跟Grace願意帶來創新的節目，例如1992年伯明翰市交響樂團在音樂總監西蒙‧歷圖領導下演出。歷圖建議演出法國作曲家梅湘的圖倫加利拉交響曲，這是一首非常特別的作品，但從來沒有在香港演出過，相信很少本地觀眾認識。我們討論了很久，雖然有風險但最後也認為有責任去推廣，於是安排作品在最後第三場演出，希望聽了第一、二晚樂團精彩演出的觀眾會加聽第三場。結果票房也不錯，擴闊了觀眾的眼界。」

除了來自世界各地的節目外，藝術節一直也有本地節目，不過早期為數不多，八十年代主要也是依靠大團提供節目。「香港管弦樂團歷史長一點（1974年成為職業樂團），至於當時的香港話劇團、香港舞蹈團等都只是成立了十年左右。期時藝術節的本地節目確實是不足夠，原因之一是我們沒有提供資源給本地藝團創作節目，所以做甚麼節目我們沒有控制權，而當時也只有大團可提供節目。大概是在1991或92年間，鄺為立在《信報》撰文，批評我們「太殖民」，於是我跟Grace找他來傾談，聽聽他的意見，結果，最後還邀請他加入我們的團隊。」

「其實鄺為立的批評也是有道理的，1987年演藝學院培育了首屆畢業生，到了九十年代是他們發展的黃金時代，但卻缺乏演出機會。所以外間批評藝術節沒有給與他們演出機會，我們也很理解。後來我1992年做策略檢討，就回應了本地藝術家的訴求，開始提供資源給本地製作。第一個委約的本地節目是音樂劇《風中細路》，那年還辦了一個『香港演藝日』，也是慶祝藝術節二十周年的節目。」

對鄭新文來說，1991年的藝術節比較能夠反映他的理念。「我自己對節目的理念是希望做多些主題式的節目，好像1991年莫札特逝世二百周年，便做了一系列不同組合的音樂會。另外安排了拉丁美洲舞蹈系列。這些主題式的節目安排不是票房考慮，你可以說使不同節目更有意義地連結，也可以說是教育，使觀眾對作品或創作人有更深的瞭解。」

從八十步進九十年代，香港的演藝文化漸次成長，區域市政局在1986年成立，管理位於新界的沙田、屯門、荃灣大會堂。市政局的香港文化中心在1989年落成。演藝場地增多，直接影響演藝文化發展，鄭新文說當時確實出現了「搶節目」的情況。「很多陳達文的下屬（曾在大會堂工作的市政局職員），被派到區域

There had been programmes featuring local groups in addition to those from around the world. They were however few in number during the early years. In the 1980s, they were mainly programmes from the major arts groups. "The Hong Kong Philharmonic Orchestra was a little older, having become a professional orchestra in 1974. Hong Kong Repertory Theatre and Hong Kong Dance Company had been established only around ten years. Local programmes were indeed lacking, partly because we did not provide resources for local arts groups to create these programmes. So we had no control over the programmes, and only the major arts groups were able to provide programmes at the time. In around 1991 or 1992, Kwong Wai-lap wrote an article in the *Hong Kong Economic Journal* which criticised the Festival for being 'too colonial'. So Grace and I talked to him to hear him out. We ended up asking him to join our team."

"Kwong Wai-lap's criticism was, in fact, justified. In 1987, the first batch of students from the HKAPA had just graduated. The 1990s would be the perfect time for them to develop professionally. But there weren't enough opportunities for performances. So we could understand the criticism of the Festival for not providing them with opportunities. We conducted a review of our strategy later in 1992. Responding to requests from local artists, we started to provide resources for local productions. The first commissioned local programme was the musical *The Kids, The Wind & The City*. We also organised the 'Hong Kong Performing Arts Day', which was a programme to celebrate the Arts Festival's 20th anniversary."

The Festival in 1991 was a better reflection of Tseng's philosophy. "My philosophy was to have more thematic programmes such as celebrating the 200th anniversary of Mozart's death in 1991 with a variety of concerts. There was also a series of Latin American dance

毛俊輝正綵排《風中細路》
Fredric Mao rehearsing *The Kids, The Wind & The City* (1994) (©謝明莊)

市政局，他們都很進取，積極爭取海外藝團到這些新場地演出，其實這是很健康的現象。他們會安排在新界幾個場地巡演，由於當時市政局資助的藝團，像香港話劇團便不會到沙田演出。所以藝術節的節目在九十年代開始也擴展至新界的場地。不過區域市政局如果主辦這些節目，需要完全承擔財政支出，我們不會用市政局的資助補貼。」

「對藝術節來說，最大競爭大概是文化中心成立。我們邀請海外藝團必定是在二、三月間來港演出，但市政局卻沒有時間限制。這亦令我們再思考藝術節其實要做甚麼。最擔心的一年也就是在1990、1991年間，文化中心剛開幕之時，搞了半年的藝術節，請來不少世界知名藝術家，像傑西·諾曼殿堂的級數，我們不斷思考那年要做甚麼節目才可吸引觀眾！結果Grace和我決定1990藝術節重點放在舞蹈節目上，因為文化中心開幕藝術節的音樂節目最強，我們安排了史圖加芭蕾舞蹈團、保羅·泰勒舞蹈團、格魯吉亞舞蹈團，還安排了一些在香港少見、有特色的節目，例如十二世紀早期音樂劇《但以理和獅子》、台灣皮影戲、兩個小丑節目等，結果票房很好。當然新文化中心也吸引新觀眾。1991年因為是莫扎特逝世二百周年紀念，我們在年初推出紀念系列先聲奪人。」

莫扎特專輯宣傳
Promotion of "Mozart Series" (1991)

programmes. These thematic programmes were not based on box office considerations. It can be described as forging meaningful connections between the programmes or education for the audience to have a deeper understanding of the works or their creators."

In the 1990s, Hong Kong's culture in the performing arts gradually grew. Established in 1986, the Regional Council oversaw the Sha Tin, Tuen Mun and Tsuen Wan Town Halls in the New Territories. The Hong Kong Cultural Centre under the Urban Council officially opened in 1989. The increase in the number of performing arts venues directly influenced the development of performing arts culture. Tseng recalled there was indeed a "competition for programmes". "Many people who worked under Darwin Chen [Urban Council employees who worked at Hong Kong City Hall] were assigned to the Regional Council. They were proactive in inviting overseas arts groups to perform at these new venues. This was a very healthy phenomenon. They would arrange performances across the venues in the New Territories. As arts groups funded by the Urban Council such as Hong Kong Repertory Theatre did not perform in Sha Tin, the Arts Festival programmes during the 1990s also started to be staged in New Territories venues. However, the Regional Council had to be fully responsible for financial expenditures when organising these programmes as we would not use funding from the Urban Council."

"For the Arts Festival, its biggest competition was likely the opening of the Cultural Centre. Our invitations sent to overseas arts groups were always for performances in Hong Kong between February and March. The Urban Council, on the other hand, had no such seasonal constraints. So it led us to reflect again on what the Arts Festival strives to achieve. The most worrying year was from 1990 to 1991 when the Cultural Centre first opened and organised a six-month festival that featured many world-renowned artists, including the likes of Jessye Norman. We kept thinking about what programmes to present that year to draw audiences. Grace and I ended up putting the focus on dance programmes for the Arts Festival in 1990 because the music programmes in the Cultural Centre's opening were the strongest offering. We ended up inviting the Stuttgart Ballet, Paul Taylor Dance Company and Georgian State Dance Company. We also arranged some unique programmes rarely performed in Hong Kong including the 12th-century liturgical drama *Daniel and the Lions*, shadow puppet theatre from Taiwan and two clown programmes. We ended up having good ticket sales. The new Cultural Centre drew in new audiences as well. As 1991 was the 200th anniversary of Mozart's death, our commemorative programmes also made the first impression right at the start of the year."

青少年之友

站穩了陣腳，是時候播種。1992 年創辦的「青少年之友」計劃便是鄭新文撒下的種子。

「我是讀音樂出身，做藝術管理其實也是想做觀眾拓展，希望多些人喜歡音樂：加入藝術節前在音樂事務統籌處、香港管弦樂團也是做推廣工作，經常到學校辦音樂會、講座等。活動雖然很受歡迎，但完結後學生往往很快便忘掉。回想當日構思這個計劃，其實是很具體的，想到中學時參加過童軍的愛丁堡獎勵計劃，而訓練也有不同的獎章，讓我有一個很清晰的概念，就是做觀眾拓展是必須持續地進行而不是一次性的活動。所以『青少年之友』那本 passbook 是最核心的一環。參加這個計劃除了可免費欣賞兩個藝術節節目外，還鼓勵他們參加其他節目和活動，然後儲印花換獎賞，每年最高分的一位更會獲得特別獎品，還記得有一年是大提琴家王健的簽名海報。」

「另外一個特色是直接聯絡學生，就是直接營銷，因為他們離開學校後，還可跟他們保持聯絡。理想中是希望設三級制，第一年是基本級，看些主流的節目，第二年可以選擇一些具特色的，如果可以持續三年時間，這個學生有潛質成為恆常觀眾，像音樂試考級那樣。不過在我任內做不到，在藝術節的時間不夠。其實當年也想像不到青少年之友這個計劃在藝術節完結後還有那麼多節目，有夏天活動，又有實習機會，變了培養藝術愛好者的一個小社群。」鄭新文提到當年尤德爵士紀念基金的支持很重要，最初是青少年之友唯一的贊助。眨眼 2022 年已是青少年之友三十周年，樹苗成長，但卻永遠保持年青。

Young Friends

After addressing the urgent issues and having settled into his job, it was time for Tseng to start planting the seeds for audience development. Young Friends was established in 1992 to this very end.

"As a music major, I wanted to be engaged in audience development besides arts management in general, hoping for more people to enjoy music. I worked at the Music Office prior to joining the Festival and was engaged in promotional activities while working at the Hong Kong Philharmonic Orchestra, presenting concerts and talks in schools. Although the activities were popular, they were often quickly forgotten by the students. The Young Friends project had concrete details when it was first conceived. In secondary school, I participated in a Duke of Edinburgh Award in which award levels could be achieved through Boy Scout training. This led me to the clear concept of audience development being a continuous process instead of a one-off event. So the Young Friends passbook became a core component. Besides enjoying two Arts Festival programmes free of charge, participants were encouraged to attend other programmes and events in return for stamp rewards. A special prize would be given to the member with the highest points every year. I remember one of the special prizes was a poster signed by cellist Jian Wang."

"Another feature of Young Friends was maintaining direct contact with the students. This was essentially direct marketing, as we could keep in touch with them after they left school. Ideally, it would be a three-level system. The first year was foundational, with some mainstream programmes. The second year's programmes could be more particular. The member had the potential to become a regular audience member after three years, with the process similar to graded music examinations. However, the plan was not accomplished during my term at the Arts Festival. Still, Young Friends completely exceeded our expectations in having so many programmes after the completion of the Festival including summer events and internship opportunities, transforming itself into a community that cultivates arts lovers". Tseng emphasised the importance of initial support from the Sir Edward Youde Memorial Fund, as it was the sole sponsor of Young Friends when it was first conceived. Young Friends will celebrate its 30th anniversary in 2022, with its programme as fresh and vibrant as ever.

鄭新文完成他的各項大計後，向主席鮑磊透露1994年藝術節後離任的打算。鮑磊挽留不果後，請他重新設計行政與藝術分工的員工架構。鄭新文建議他的崗位（最高負責人）更名為行政總監，新設立節目總監職位，專注節目策劃及執行，向行政總監負責，並由當時的助理總經理梁掌瑋擔任此新職。建議得到鮑磊和委員會一致支持，這個架構也一直沿用至今。

鄭新文離開藝術節後，曾經負責香港電台第四台和香港藝術發展局。作為資深藝術行政人員，過去二十年在香港及內地教授不同的藝術管理課程。「2000年後在內地新建了很多演出場地，而香港藝術節在內地是一個名牌，每年都有很多內地的藝術管理人員來港參加香港藝術節而取經。例如上海文化廣場每年保送幾個職員來看藝術節。他們特別對藝術節的高效營運方式感興趣。」

要說到舉辦一個成功的藝術節的秘訣，鄭新文很爽快的說：「節目當然是重中之重！」

鮑磊 香港藝術節主席（1990-2001）

說到他與藝術節的淵源，始於他的日籍太太 Noriko。

Noriko 在1983年曾加入藝術節的婦女歡迎委員會，義務接待來訪的外國藝術家，鮑磊因此也與藝術節結緣。這段緣份一直至鮑磊卸任主席後也延續下來，與藝術節依舊緊密聯繫，2019年藝術節的開幕禮，便找到他的身影。身在英國的鮑磊，原期待可以來港參加藝術節五十周年的開幕禮。

曾任怡和董事、立法局議員、香港旅遊協會主席的鮑磊，在政商界經驗豐富，廣結善緣，1990年接替邵逸夫擔任藝術節主席至2001年，帶領藝術節創下不少佳績。

「記得鮑磊曾告訴我，世上沒有免費午餐，資助多了，介入也會多了。」鄭新文在藝術節擔任總經理的日子，與當時的主席鮑磊合作無間。這句說話，反映了鮑磊對藝術節營運的一些想法。

作為主席，藝術節的財政來源從來都是需要長遠部署的挑戰。藝術節一直以政府資助、商業贊助及票房收益作為主要收入來源。在政府資助以外，鮑磊積極開拓另一收入來源：贊助和

Having accomplished his objectives, Tseng revealed to Chairman Martin Barrow his intention to step down after the 1994 Arts Festival. Barrow attempted, unsuccessfully, to persuade Tseng to stay and then asked him to redesign the staff structure, to divide up the work between administrative and arts-related endeavours. Tseng recommended renaming his position Executive Director and to create the post of Programme Director, which would be focused on programme planning and execution. The Programme Director would report to the Executive Director, with the ideal candidate being Assistant General Manager Grace Lang. Tseng's recommendations were unanimously approved by Barrow and the General Committee, and the structure remains in use today.

After Tseng left the Arts Festival, he served as head of RTHK Radio 4 and secretary-general of the Hong Kong Arts Development Council. As a veteran arts administrator, he has taught many courses on arts management over the past 20 years in Hong Kong and Mainland China. "Many performance venues were built in Mainland China after 2000. As the HKAF is a brand of repute in Mainland China, many arts administrators from there visited Hong Kong every year to observe the Festival. For example, Shanghai Culture Square sends several staff every year, as they are particularly interested in the Festival's highly efficient operating model."

When asked about the secret of organising a successful arts festival, Tseng quickly replies: "What matters is the programme!"

Martin Barrow
Chairman of Hong Kong Arts Festival (1990-2001)

Barrow's relationship with the Arts Festival started with his Japanese wife Noriko.

Noriko was inducted into the Festival's Ladies Hospitality Committee in 1983 and volunteered to greet overseas artists. This marked the beginning of his involvement with the Arts Festival, which extended well after he stepped down from the role of Chairman. He maintains close contact with the Festival and was present at its Opening Ceremony in 2019. Barrow is currently living in the UK and is looking forward to attending the Opening Ceremony of the 50th HKAF originally..

Barrow was previously a company director of Jardine Matheson, a member of the Legislative Council of Hong Kong, and Chairman of the HKTA. As a prominent political and business figure with

捐款。他認為要更有系統地進行籌款工作，開設了專責籌募發展的行政職位，並於 1991 年成立了籌款委員會，藝術節籌款從此正式進入有系統階段。關於這個委員會，鄭新文想到一段有趣的小插曲。「當年香港 IBM 贊助藝術節的開幕節目，慣常的做法是送一定數目的贈票給贊助商，但因為開幕演出要招待包括港督等數百位貴賓 VIP，所以送給贊助商的座位在 VIP 後面，IBM 的總裁拍枱大罵。當然我們也承認是做得不夠好，結果我跟鮑磊商量，把較前的位置劃分一半給他們。節目完結後總裁跟我說很滿意，並有興趣加入委員會。鮑磊立即邀請他擔任籌款委員會的主席，他也答應了，並做得很有成績！」

在任期間，鮑磊致力減低藝術節對政府資助的依賴（從 45% 減低至 40%），但提升從贊助及捐獻而來的收入達至總收入的 20%（原 16%）。

鮑磊對藝術節的運作有一定理解後，就提出要進行策略規劃，根據當時最新的社會和藝文環境，為藝術節確定方向、定位，釐定發展策略等。鄭新文憶述，1992 年這次的策略規劃對他個人非常有啟發性，也相信這次的規劃對藝術節其後的發展有深遠的影響。

鮑磊的領導作風也極富冒險精神。1996 年加拿大歌劇團兩個由羅伯特·利柏殊執導的歌劇，絕非主流，利柏殊的劇場風格向來十分前衛。鮑磊卻大力支持，是次演出也令藝評家與觀眾留下深刻印象，是藝術節的一大突破。

（左起）DFS 免稅店 Richard Airth 與 IBM 總裁 Robert Savage
在學生票計劃的支票捐贈儀式
(from left) Richard Airth of DFS and Robert Savage, Managing Director
of IBM at the Student Ticket Scheme cheque presentation (1996)

（左起）渣打銀行華禮信伉儷及鮑磊於 1997 年藝術節開幕酒會
(from left) Mr and Mrs Ian Wilson of Standard Chartered Bank, Martin
Barrow at 1997 Festival Opening Reception

a wealth of experience and strong connections, he succeeded Run Run Shaw as Chairman of the HKAF, a post he held until 2001. Under his leadership, the Festival achieved many great successes.

Tseng recalls his days as General Manager of the Festival: "I remember Barrow once told me there is no such thing as a free lunch—when subvention increases, so will the level of intervention." It was a comment that aptly reflected Barrow's thoughts on the Festival's operations.

Planning for the Festival's financial resources had always been a challenge requiring long-term strategy. The Festival's operating model had been based on three main sources of income: government subventions, commercial sponsorship and ticket sales. Barrow was active in exploring other sponsors and donations, as well as maintaining government subventions. Recognising the need for fundraising on a systematic basis, an administrative post for development was created and the Development Committee established in 1991. Tseng recalled an interesting anecdote about the Committee: "At the time, IBM Hong Kong was the sponsor of the Arts Festival's Opening Programme. The common practice is to provide the sponsor with a certain number of complimentary tickets. However, there would be several hundred VIPs, including the Hong Kong Governor, attending the Opening Programme. The seats given to the sponsors ended up being behind the VIP seats, and this infuriated the Managing Director of IBM Hong Kong.

在卸任前的一篇訪問提到，原來鮑磊是1965年在怡和當見習行政人員時開始學習普通話，後來他當上香港旅遊協會主席時經常到中國各地考察，一口流利的普通話便大派用場。當他擔任藝術節主席時，其中一個目標便是積極開拓藝術節與中國內地、日本以至亞洲各國藝術家的合作機會，並把他們帶到國際舞台。其中一個例子便是1997年的開幕節目《馬可·波羅》。《馬可·波羅》是香港藝術節跟慕尼黑雙年展、巴伐利亞國立歌劇院及荷蘭藝術節共同製作，愛丁堡藝術節委約譚盾創作音樂的創新之作。

《悟空》宣傳明信片
A promotional postcard of *Goku* (2001)

另外，2001年《悟空》以四種語言重新演繹這個跨越時代和年齡層的經典故事，由日本影法師劇團、香港中英劇團、北京市兒童藝術劇團、韓國愉快的夥伴聯合演出及協助製作。而在日本國際交流基金會支持下，除了分別到四個合作城市上演，更到澳門、廣州及新加坡作巡演。

「我很榮幸能接替邵逸夫爵士擔任香港藝術節主席，他既是香港藝術節的創辦人，也是一位非常出色的主席，我在任時也致力傳承他所建立的卓越成果。我擔任香港藝術節主席的十二年間，工作充滿趣味，而且也很難忘。回想當時在香港的生活非常忙碌，我所擔任的不同崗位正好互相補足，發揮正面積極的作用。」

「開幕禮一向是精采盛事，當年十分期待，最喜愛是大家在藝術節以外比較隨意的一些聚會。每年藝術節期間在我石澳家中聚首一堂，很高興能認識來自世界各地的藝術家，對我來說相當難忘。藝術節團隊一向表現出色，我奉行『漫遊式管理』，所以經常造訪藝術節辦事處，不但和經理們交談，也會和所有同工交流。」

We had to admit that the arrangement could have been better. Eventually, I discussed with Barrow and half of the better seats were allocated to the sponsor. The Managing Director of IBM voiced his satisfaction after the end of the programme and was interested in joining the Committee. Barrow immediately invited him to be the Chairman of the Development Committee. He also agreed and ended up doing a great job!"

During his tenure, Barrow worked hard to lower the Festival's reliance on government subventions, which fell from 45 per cent to 40 per cent, and also helped raise income from sponsors and donations to 20 per cent of total income from 16 per cent.

Once Barrow had attained a certain level of understanding of the Festival's operations, he proposed the need for strategic planning, determining the Festival's direction, positioning and development strategy based on the social and arts environment of the day. Tseng recalls that he was greatly inspired by the strategic plan in 1992, which had a profound impact on the development of the Festival for years to come.

Barrow was also adventurous. In 1996, the two operas by the Canadian Opera Company and director Robert Lepage were hardly mainstream fare, with Lepage's theatrical style famous for being avant-garde. They were strongly supported by Barrow. The performances were a hit with critics and audiences alike, and constituted a major breakthrough for the Arts Festival.

In an interview before he stepped down as Chairman, Barrow revealed he had learned Mandarin in the 1960s while a management trainee at Jardine Matheson. It was something that would be valuable when he became Chairman of HKTA and travelled extensively in China. During his time as Festival Chairman, one of his prime objectives was to develop closer collaborations with artists in China, Japan and the rest of Asia, and to present them on the international stage. One example would be *Marco Polo*, the Opening Programme of the HKAF in 1997. Co-produced by the HKAF, Munich Biennale, the Bayerische Staatsoper and the Holland Festival, *Marco Polo* was an innovative work by Tan Dun commissioned by the Edinburgh Festival.

In 2001, *Goku (Monkey King – a New Journey to the West)* reinterpreted the timeless classic that transcended eras in four different languages. It was a joint production and performance by Japan's Kageboushi Theatre Company, Hong Kong's Chung Ying Theatre Company, Beijing Art Troupe for Children and Korea's

「我對藝術節的關注，除了是要保持其趣味，還有節目要多元平衡，這極具挑戰。我們從世界各地搜羅頂級演出，邀請了包括中國內地、俄羅斯和日本的藝團來港。尤其記得俄羅斯指揮家瓦萊里·格杰夫，他所帶領的演出令我留下深刻印象，我的日籍妻子也協助開啟了日本方面的聯繫。」

「香港是人們來訪、工作及投資的地方，每天都有各式各樣的活動進行。藝術節正是展示香港活力的最佳例子，鞏固香港作為國際都市的定位。」

「我們希望遊客來港不只是為了購物，這裡還有很多地方、活動可供遊歷。香港是一個多姿多采的大都會，具備豐富的文化元素。這正是我們向遊客宣傳的訊息，希望他們會在港停留多一倍的時間。」

「香港藝術節是香港的國際平台。」

鮑磊與夫人在藝術節期間，於住所邀請藝術家共進午餐
During the Arts Festival, Martin Barrow hosted Artist Lunches with his wife at his residence

鮑磊與美國爵士色士風音樂家喬·亨德森共進午餐
Martin Barrow and Joe Henderson, American jazz saxophonist, at the Artists Lunch (1997)

Joyful Theatre. With the support of the Japan Foundation, it was performed in the cities of the four collaborating companies and also toured to Macau, Guangzhou and Singapore.

"It was my honour to succeed Sir Run Run, the founder and a great Chairman of the HKAF. I did my best to follow his success," says Barrow. "The 12 years' service with the Arts Festival was interesting and memorable. Back in those days, I always had a busy life in Hong Kong. And I considered my various roles to be complementary and positive."

"The opening ceremony was a great event I always looked forward to. And what I loved most was those informal get-togethers outside the Festival. Every year the gathering in my home in Shek O during the Festival was an unforgettable moment for me. I was delighted to catch up with many artists from all over the world. Of course the Arts Festival's team is always wonderful. 'Management by wandering about' is my philosophy, that's why it's always on my list to go to the Arts Festival office, not only to talk to the managers but all the staff."

"My concern was keeping the Arts Festival not only very interesting but also to have a range of balanced programmes. This was a challenge. We have top-class performances from all over the world including wonderful groups from places like Mainland China, Russia and Japan. I remember the Russian maestro conductor Valery Gergiev. His concert was very memorable to me. As for Japan, I thank my wife for the special connection."

"Hong Kong is a place to visit, to work, and to invest. There are so many happenings in Hong Kong. The Arts Festival shows a good example of what is going on in Hong Kong and enhances the branding of Hong Kong as an international city."

"We hope tourists don't see Hong Kong as only for shopping. There's so much to do and see. And Hong Kong is such a cosmopolitan city with rich cultural offerings. That's the message to tourists. We hope they would want to double up their time here."

"The Arts Festival is an international platform for Hong Kong."

約瑟·施力
歐洲的耳目

生於互聯網年代的人，大概想像不到在八十年代是如何與世界聯繫，要辦一個國際藝術節，必然需要最新的外國資訊。從最初韓德把英國的藝術家帶到香港，藝術節逐漸意識到需要更強更直接的雷達網，主動搜尋更多元化的藝術節目。在外遊不像今天這樣方便的年代，一個代表藝術節的節目策劃是最理想的人選。在八十年代開始加入香港藝術節的約瑟·施力，機緣巧合下認識了當時剛出任總經理的史迪敦，成了藝術節在歐洲的耳目。

施力是倫敦國際默劇藝術節的創辦人，同時亦從事藝術管理工作，代表當地劇場、舞蹈、音樂不同範疇的表演藝術團體接洽海內外演出，故與世界各地的藝術機構也有緊密聯繫。

1982年，澳洲的伯斯藝術節總監邀請他擔任其歐洲代表並專程到柏斯一趟。想到從英國到澳洲的漫長飛行時間，施力決定中途停留香港遊覽，當時藝術中心的經理安得烈·威爾許（Andrew Welch）是他的好友，Andrew把他介紹給史迪敦，於是開始了與藝術節的合作。當鄭新文執掌藝術節後，施力正式擔任國際節目總監一職，與梁掌瑋合作，為藝術節挑選節目，與海外藝術家洽談。後來梁掌瑋當上節目總監，開始到歐洲以至世界各地搜羅節目，施力的角色轉為國際藝術顧問，同時也負責撰寫節目場刊的英文版本。

當初施力是怎樣和史迪敦開展合作？施力回想：「史迪敦是一位音樂家、作曲家，也曾擔任樂團經理。他希望我能提供有關戲劇和舞蹈等最新情報，我也向他推薦了很多表演節目，特別是比較另類和不那麼傳統的戲劇及舞蹈演出，還有形體和視覺劇場、木偶戲等。他採納了我不少建議，而那些建議其後也被節目委員會通過。當然，有時委員會成員就某些節目亦會提出異議，但他們看來都很信任我，印象中，我建議的節目也沒有失敗之作。」

無論如何，與文化和表演藝術重鎮遙遙相距，不能前赴當地觀看演出，當然有欠理想。「鑑賞音樂尚可不用親赴現場，例如大家都知道柏林愛樂樂團是非常優秀，這一點你在收聽演奏錄音已能評定。不過，戲劇和舞蹈演出始終還是要親身在現場觀看，不能

Joseph Seelig
The Eyes and Ears in Europe

Those born in the internet age may find it hard to imagine how people stay globally connected in the 1980s. Having the latest information from around the world is critical to organising an international arts festival. Ever since Ian Hunter first introduced artists from the UK to Hong Kong stages, the Arts Festival had gradually realised the need for a stronger and more direct network to look for more diversified arts programmes. At a time when travelling abroad was not so convenient, a programme planner overseas representing the Arts Festival was essential. The ideal candidate turned out to be Joseph Seelig who joined the HKAF in the 1980s. Seelig happened to meet Keith Statham, then General Manager of the Festival, by chance and ended up becoming the eyes and ears of the HKAF in Europe.

As co-founder of the London International Mime Festival, Seelig was also involved in arts management, representing performing arts groups for local and overseas performances and had close ties with arts institutions around the world.

In 1982, the Director of Australia's Festival of Perth invited Seelig to be their representative in Europe and to make a trip to Perth. Seelig stopped over in Hong Kong to see the city. His friend Andrew Welch, General Manager of the Hong Kong Arts Centre at the time, introduced him to Statham, which led to Seelig's collaboration with the Arts Festival. When Tseng took over the Festival, Seelig was formally appointed International Programme Director. Seelig worked with Lang in selecting programmes for the HKAF and liaising with overseas artists. Lang later became Programme Director and started to visit Europe and elsewhere to look for suitable programmes. Seelig became International Programme Consultant and was also responsible for writing the English version of the house programmes.

Seelig recalls how he worked with Keith Statham in the beginning: "Keith was a musician, composer and former orchestra manager. What he wanted was intelligence about theatre and dance etc. and I recommended a lot of programmes, especially different and less conventional theatre and dance, physical and visual theatre, puppetry etc. Many of my suggestions were taken up by Keith and, in turn, approved by the Programme Committee—not always without some argument, but they seemed to trust me and I can't remember any terrible failures!"

單靠口碑和評論。因此，史達敦當時便問我能否充當香港藝術節在歐洲的耳目。當年國際業務往來大多倚靠空郵及電話溝通，我們和倫敦、巴黎或紐約通電話，也須顧及時差，因為我當時身處歐洲，這便容易得多。我們當時的聯絡方式是透過電報，很難想像現在所有事情都已簡單得多。」

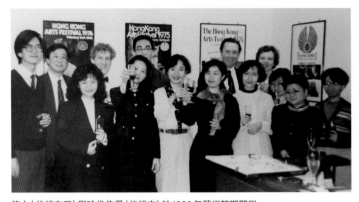

施力（後排左三）與哈代伉儷（後排右）於1989年藝術節期間與
藝術節工作團隊合照。
Seelig (3rd left, back) with HKAF staff, and Mr and Mrs Charles Hardy (right back)
during the 1989 HKAF

為藝術節引入節目時，施力最主要的考量是什麼？

「在非華語節目方面，藝術節盡力吸引頂尖及享負盛名的藝術家參與，這是我們的目標。當有了足夠的知名藝術家，便可加入一兩個演出，讓未知名而具潛質的藝團或藝術家參與。」

「說來有趣，經費當時對我們來說並不是大問題。贊助商都樂意支持知名藝術家的演出，這些演出的門票價格頗高，通常都會售罄。但藝團往往希望在來港前後於亞洲區內巡迴演出，這樣殊不簡單，日本喜歡邀請知名的樂團，但早年很多藝團其實沒什麼其他城市可去。安排海外藝團及藝術家進出香港相對容易，但當演出牽涉其他城市時，事情便會變得複雜，而且支出也會更龐大。」

「我們遊說正在冒起（以及那些陷入低潮！）的年輕藝術家來港並不太難，但要邀請星級藝術家或享負盛名的藝團就困難得多。雖然如此，我依然相信他們總會為某些原因而選擇到其他地方

There are disadvantages of being far away from major centres of culture and performing arts if, for whatever reason, you don't travel to see work. "It's not so hard with music—we all know the Berlin Philharmonic is a good orchestra—you can hear that from a recording, but theatre and dance for example, need discovering in person—you can't just rely on reputation and reviews. Hence, Keith asked if I would be interested in being the HKAF's eyes and ears in Europe. You have to remember that in those days international business was mostly still conducted by airmail letter and telephone, and of course the time difference made the latter a bit tricky for speaking to London or Paris or New York. Much easier for us. And we also had access to telex for international communication—hard to imagine how much simpler everything is now."

What would be Seelig's major considerations for bringing programmes to the HKAF?

"In terms of non-Chinese programmes, the Festival wanted the biggest and most famous names it could attract. So that's what one looked for. And if we had sufficient big names, well, we could slip in one or two shows by exciting companies or artists who hadn't yet become famous or simply weren't known in Hong Kong."

"Interestingly, money wasn't necessarily the big problem. Sponsorship could usually be found for big names. Ticket prices for those were quite high and everything was always pretty much sold out. But companies often wanted to tour the region, and that wasn't so simple. Japan took major orchestras, but in the early days there really wasn't anywhere else to go. And while it was relatively simple to fly people to and from Hong Kong, the moment you involved other destinations it all got rather complicated and much more expensive."

"Younger artists, those on the way up (and those on the way down!) aren't hard to persuade. As for the stars or established companies, that was much harder, but I always think they will go somewhere to perform if there's a special reason. And visiting exotic Hong Kong was a reason in itself for many...and by the end of the 1980s we had a range of well-equipped venues that could accommodate the most complex productions."

"In 1987, following the visit of Glyndebourne Touring Opera to open the new Academy for Performing Arts, we decided to produce our own opera, Wagner's *Flying Dutchman*, and we continued with

演出。對很多藝術家來說，香港充滿異國風情，已可成為來訪理由。1980年代末期，我們已有不少設備完善的場地，即使是最複雜的製作也能應付。」

「1987年，格連德本巡迴歌劇團來港為新落成的香港演藝學院作開幕演出後，我們決定自行製作歌劇演出，劇目為華格納的《漂泊的荷蘭人》。隨後數年我們也繼續自行製作歌劇演出，歌劇製作絕不簡單，但我們也做到了。難得從世界各地邀請到出色的指揮、導演、設計師，以及知名歌唱家，來港作數星期的排練。」

「你可說我們在節目編排上最大的考量，就是要把最好的戲劇、音樂及舞蹈演出帶來香港，這說法聽起來似是陳腔濫調，但的確是我們的宗旨——就是讓市民盡興及得到啟發，同時讓較創新破格的製作和風格較大膽的節目，為市民帶來驚喜，希望觀眾能擁抱這些全新的觀賞體驗。要達到這目標並不容易，不過根據我的經驗，觀眾往往比自己想像中更好奇和樂於接受新事物。」

至於對哪些節目最難忘，施力憶述：「由我開始在藝術節工作至今，可以肯定世界頂級藝術家和藝團大多已在香港藝術節演出過。我特別喜歡早年的藝術節，那時我們開始邀請新世代的創作者參與，舉個例說，1994年，我們便請來當代馬戲團創意一族，反傳統的音樂大師菲力普·格拉斯，比利時當代舞蹈巨星羅薩絲舞蹈團，以及美國另類劇場劇團伍斯特劇團，在同一屆藝術節聚首一堂。另一邊廂，尤里·特米爾卡洛夫、聖彼得堡管弦樂團及莫斯科藝術劇院，粒粒巨星，那一屆的節目，正好糅合了創新與傳統。」

「1989年的維也納管弦樂團也令我留下深刻印象，不單是我和勤務總監哈代花了超過兩年時間商討樂團來港演出安排、對話比和我們對妻子的還要多，整個過程複雜得令人洩氣。同樣情況也出現在巴黎歌劇院芭蕾舞團來港演出，這規模龐大的藝團有他們自己的一套做法。或許我應該寫書，回顧那些幾乎令我們陷入絕望的商談過程。」

驅使繼續在香港藝術節工作的原因是什麼？「正如我先前所說，我對香港一見鍾情，這一點始終沒變。我很享受和藝術節的一眾

our own productions for several years. No small matter, producing an opera, and we did it all. Amazing really, we engaged a conductor, director, designer, and flew over really good and famous singers from all over the world to spend weeks rehearsing in Hong Kong."

"You could say that the major programming considerations were to bring the best in theatre, music and dance to Hong Kong—it sounds a cliché but it's true—to entertain and inspire, and at the same time to surprise people with less conservative productions, more adventurous repertoire, and try to persuade audiences into new experiences. It wasn't always easy but in my experience audiences are always more curious and adventurous than they themselves think they are."

When asked which programmes are most memorable, Seelig says: "From the time I first became involved to the present day, I'm sure that most of the world's leading artists and companies have performed at the HKAF. I suppose I look back fondly to earlier years when we started to bring a new wave of creators—for example, in 1994 we presented the contemporary circus Archaos, music iconoclast Phillip Glass, Belgium's contemporary dance sensation Rosas and the American alternative theatre company, The Wooster Group, all in one programme. Yuri Temirkanov and the St Petersburg Philharmonic and the Moscow Arts Theatre ensured our star name credentials, but this was a fabulous mix of new and tradition."

"The Vienna Philharmonic in 1989 was memorable, not least because Charles Hardy (the HKAF's Logistic Director) and I spent more time talking to each other about travel arrangements over two years than either of us spent talking to our wives. It was just so complicated and frustrating. It was the same with the Paris Opera Ballet—another huge organisation that seemed to have its own rules. I should have written a book about those negotiations that drove us almost to the brink of despair."

Seelig never lacked motivation to continue working with the HKAF, "As I said before, I fell in love with Hong Kong at first sight, and that hasn't really changed at all. I've enjoyed working with so many colleagues in the Festival office, some for a very long time—Grace, Katy, Kwok-wan and many others, talented people who have helped take the Festival to new levels and made it admired and envied all over the world."

同事合作，有些同事已在藝術節工作了一段長時間，包括梁掌瑋、鄭尚榮、蘇國雲和其他同事。我也享受和有才華的人合作，在他們協助下，藝術節得以進步提升，在世界各地備受推崇。」

「我非常樂意傳授我的知識及技巧，說來奇怪，我當時在地球的另一端，但感覺上和在香港的同事出奇地親近。我覺得我們建立了優秀的團隊，因此每當有人辭職轉工時，總會覺得傷感。」

「我必須坦白說，透過和香港藝術節的合作，藝術節的名聲也讓我獲益良多。藝術節的工作讓我學到不少待人接物及管理的技巧，也讓我往後得到不同形式的工作機會，但這些機會總是因某些原因而被我推掉，除了紐西蘭國際藝術節藝術總監一職。我從1996年至2000年擔任這個職位，然後成為該藝術節的副總監及歌劇監製，直至2004年為止。我一直以來都頻繁穿梭各地，同時應付香港藝術節及其他工作，我也很高興至今仍和香港藝術節保持合作。」

一個成功的藝術節，應包含什麼元素？「說得實際和簡潔點，我曾在不同城市出席藝術節，藝術節最重要的就是節目，以及娛樂性和觀眾投入度，這是別出心裁的節目編排，才能引發話題，令觀眾看得開心。」

「要舉辦一個精采和值得推介的藝術節並不容易，團隊必須對其藝術視野有信心，而和許多商業機構一樣，行之有效的領導也很重要。某些年度的整體表現可能比其他年度好，但你要引領團隊每年進步，嘗試新事物及新構思，在保留傳統的前提下重新演繹經典作品。優秀的藝術並不廉價，廉價的藝術也不會優秀。一個成功的藝術節必須仰賴切實資助、尊重，也需要一點運氣。藝術家們長途跋涉來到香港，需要得到悉心照顧。我很喜歡藝術節早期在婦女歡迎委員會協助下照顧藝術家的方式，安排大家在邵逸夫主席的大宅共進晚餐。藝術家就是香港藝術節的最佳代言人，他們回國後會告訴其他同道難忘的經歷，讓大家也紛紛希望來港演出。」

「我認為最成功的藝術節往往都能令全城矚目，大家都知道藝術節在進行中，香港藝術節就做得到。」

"I enjoyed passing on my knowledge and skills. It was odd—I was on the other side of the world but felt incredibly close to colleagues in Hong Kong. It felt like a good team and I was always sad when someone with whom I'd had a close working relationship moved on to another job."

"And to be absolutely honest—my association with the HKAF and its glamorous reputation has served me well too. It taught me a great deal about people and management, it generated various interesting festival job offers which for one reason or another I didn't accept, with the exception of the post of artistic director of the New Zealand International Festival of the Arts, which I held from 1996 to 2000, subsequently working as its Associate Director and opera producer until 2004. I've always travelled widely and managed to combine my work for the HKAF with other commitments, and I'm so delighted to still be involved with the HKAF."

What are the key elements for organising a successful Festival? "I'll be practical and brief—and I've had experience of festivals in different cities," Seelig says. "The most important things are the programme, and the degree of excitement and enthusiasm, the buzz and feel-good factor that a cleverly programmed festival can generate."

"And putting a great and worthwhile programme together isn't easy. The team has to trust the artistic vision, and as with any business there has to be effective leadership. Some years will be better than others but you have to aim for improvement year on year—new adventures, new ideas, new interpretations of great classics as well as maintaining tradition. Great art isn't cheap and cheap art isn't great. A successful festival needs proper funding, respect, and, well, a bit of luck. And artists need looking after—they've come a long way to Hong Kong. I loved the way the Festival looked after them, in the early years with the help of the Ladies' Hospitality Committee, with dinners for everyone at Chairman Run Run Shaw's house. Artists were the HKAF's best advertisement; they would go home and tell other artists how wonderful it was. Sooner or later, everyone wanted to perform in Hong Kong."

"The most successful festivals I know are felt and are visible all over the town. Impossible not to know there's a festival happening. I've seen it happen in Hong Kong."

金學忠
海陸空「三軍司令」

在香港藝術節工作超過四十年的物流及接待經理金學忠（Elvis）是藝術節的長期服務員工。「我大概在1978、1979年加入藝術節，之前在香港藝術中心做前台和票房的工作。還記得當時藝術節辦公室是在中環消防局大樓（現恒生銀行總行位置），後來搬到灣仔分域街。那時辦公室只有五個職員，另外還有兩個在英國，一位是藝術總監的曉拔・威利士，另一位是哈代。哈代在1977年從英航退休，之後便加入藝術節擔任勤務總監一職，他們都是在英國處理藝術節的工作，到藝術節舉行前一個月才會來香港。」

「最初我是負責票務事宜，當時每年大概只有十多個節目，還沒有城市電腦售票網，全是人手處理票務。在公開售票的日子，我們會聘請約十個臨時職工，到大會堂低座即現在衣帽間的位置，開設臨時售票處。售票期間工作非常繁忙，我們要準備不同場地的座位表，每賣出一張便記下那座位，確定該位置已售出，不容有失。票房開賣第一週最多人蜂擁而至，當時的學生票極為優惠，所以吸引不少年青人通宵排隊，甚至早兩日已現人龍。很記得頭幾年排第一位的是同一個人，他應該是大學生。」

Elvis King
The 'Commander-in-Chief' across Sea, Land and Air

Logistics Manager Elvis King is one of the HKAF's longest-serving staff members, having worked for the Festival for over 40 years. "I worked at the Hong Kong Arts Centre's front desk and box office counter prior to joining the Arts Festival in around 1978 or 1979. The Arts Festival office was located at Central Fire Station (where the Hang Seng Bank Headquarters Building is located now) then and later moved to Fenwick Street in Wan Chai. There were only five employees at the office then. Two other staff members, Artistic Director Hubert Willis and Charles Hardy, were in Britain. When Hardy retired from British Airways in 1977, he joined the Arts Festival as Logistic Director. They worked for the Arts Festival while in the UK and only came to Hong Kong a month before the start of the Festival."

"I was initially responsible for ticketing and there were fewer than 20 programmes every year. There was no URBTIX back then and all tickets were sold in person. We would hire around ten temporary staff whenever there were public ticket sales and set up a temporary ticket counter in City Hall Low Block where the Cloakroom is located. It was very busy during the ticketing period and we had to prepare the seating plans for various venues. Each seat had to be marked accurately once the ticket was sold. Most tickets were sold during the first week of sales. As student tickets were sold at big discount of regular ticket prices, many young people queued up overnight for the tickets, sometimes as early as two days in advance. I remember it was the same person who was first in the queue for the first few years. He was probably a university student."

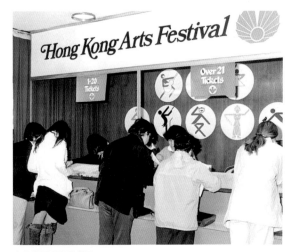

大會堂票房開售首日
First Counter Booking Day at the City Hall (1979)

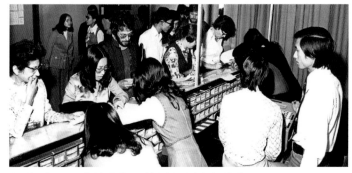

人手售票的日子。藝術節的售票櫃檯後來留給大會堂長期使用
The days of selling tickets by hand. The Festival's Ticket Counter soon became a permanent asset for the City Hall

接待藝術家要周到

1985年城市電腦售票網正式啟用，人手售票的年代結束，Elvis的主要工作由票務轉向物流方面。藝術節的物流工作講求許多部署聯絡，包括為訪港藝團預訂機票及抵埗後的交通接送，還有運送演出的佈景道具。「所以我說笑自己是『海陸空三軍總司令』，因為三種運輸方式也有涉及。」

「總司令」發動的第一個行動便是安排航班。「確認節目後，便會跟藝團緊密聯繫，取一些基本資料，如有多少人到港，行程大概怎樣。到正式簽了合約後才訂機票，我們會直接跟航空公司合作。不過，很多藝術家會在演出前或後，順道到其他地方旅遊或公幹，我們一般訂的團體票就不能作特別安排，他們要另行處理。這都是一般藝術節的慣例，由主辦單位安排機票，這樣比較容易控制情況。」看似簡單，但當要處理數之不盡的要求時，總司令便要懂得應變。

Elvis說哈代是他的師傅，當年常跟他到機場接機。「哈代負責聯絡及接待海外藝團，如果是著名的藝術家或大團，他會親自到機場接機。當時藝術節的規模沒那麼大，即使是芭蕾舞團、管弦樂團最多也只是三數十人。我跟他合作了多年，直至他退休，就由我接手，但哈代也會在背後繼續支援。他教曉了我一事，藝術家來港演出，我們必須讓他們處於最佳狀態，才對得起買票入場的觀眾。所以對於歐洲的藝團，我們會安排他們在工作前兩天抵港，讓他們有充足的時間休息，這樣才有好的演出，對觀眾公平。另外就是盡可能安排直航，因為轉機容易耽誤時間及出錯，加上安排早兩日到港，萬一航班有甚麼延誤也能趕得及。還有，酒店最好鄰近演出場地，方便之餘又可減省交通費。」

Attentive Care in Receiving Artists

When the URBTIX ticketing system commenced operations in 1985, the era of selling tickets in person ended and King's job duties shifted from ticketing to logistics. The logistical needs for the Festival required a lot of planning and liaison including booking flight tickets for visiting artists prior to arrival and arranging their transport once they arrived in Hong Kong. Sets and props for the performances also needed to be shipped. "So, I call myself the "Commander-in-Chief across Sea, Land and Air", because all three freight methods are involved."

As 'Commander-in-Chief', the first task to execute is flight arrangements. "After confirming the programmes, we maintain close contact with the arts groups to obtain some key information such as the number of people coming to Hong Kong and the approximate itinerary. We will deal with airlines directly to book the flights and they will be booked only after the contract is signed. However, many artists like to detour to other locations for leisure or business before or after their performances. We cannot make special arrangements as tickets are booked as a group, and the artists need to handle flight changes on their own. Having the organiser arrange flights is common practice among arts festivals as it is easier to handle and control." Although the task might appear simple, King needs to be flexible and responsive when handling numerous requests.

King calls Hardy his mentor and often accompanied him when receiving overseas artists. "Hardy was responsible for greeting and liaising with the overseas arts groups. For famous artists or major arts groups, he would go to the airport to greet the visitors. The Arts Festival was not so large then. Even a visiting ballet company or philharmonic orchestra would involve fewer than 40 people coming to Hong Kong. I worked with Hardy for many years. I took over his duties when he retired but he continued to give me support. One thing he taught me was to help artists maintain their top form during their stay in Hong Kong as this would only be fair to the ticket-buying audiences. Therefore, we arranged for arts groups from Europe to arrive in Hong Kong two days before their performances to ensure sufficient rest for good performances, as expected by the audience. In addition, we tried our best to arrange direct flights because transfers are more susceptible to delays and mistakes. If it is arranged that the visiting artists arrive in Hong Kong two days in advance, they can still arrive in time if there are flight delays. It is also preferable that the hotel is close to the performance venue for the sake of convenience and to cut down on transport expenses."

安排貨運要靈活

安排了人，然後是貨。Elvis說貨運可以很複雜又可以很容易。「佈景道具的運送，一般是採取空運或船運，中國內地可能會選取陸路。至於佈景在香港製造還是運送過來，要視乎哪種比較划算。如果在香港造的話，藝團的負責人會安排同事過來跟進。至於運送佈景，時間上要寬鬆一點，例如從英國運佈景到香港，大概需要六個星期，才算充足時間。師傅說過，人可以改變但貨不可以，所以如果貨來不到，責任就是由人去承擔。」

數十年來Elvis在藝術節遇過的驚險事情也有不少。「記得2007年英國的威爾斯國立歌劇院，當時貨船到了杜拜，但我根據經驗知道若繼續船程一定會遲到，於是決定當船抵達新加坡後，即取貨、再轉空運來港，這才不至耽誤演出。有了這次經驗，日後經船運，一定安排比原定時間早兩星期前來港，即使要付倉存費也不想冒險。」

「另一次是2018年蘇黎世芭蕾舞團。合約原定是他們安排船運，但發覺船公司行程資料出錯，憑過去經驗估算，這樣的行程應該來不及。然而貨已上了船，於是去到中東某地方先取回貨運，藝團也特別派人飛抵當地安排轉運。那次如果我們不介入就一定趕不及，所以貨運也盡可能是由我們負責，除非有贊助，那就作別論。」

「還有，最深刻應是2020年香港藝術節因新冠疫情首次全部取消。2、3月舉行的節目，貨運在前一年12月中已開始從歐洲陸續出發，十幾個貨櫃已在海中，到最後整個藝術節要取消，結果貨運到香港後又要訂船原櫃送返。」

機票旅館確認、貨運到港，然後就是最後一步，藝術家抵港。「我們會預先提供資料，教他們抵港後，怎樣出機場，到哪裡集合。但很多時候他們未必會跟足我們的指示，特別是規模較大的藝團人數多，有些出了機場或會自行搭的士，記得我們曾經要租過『大聲公』擴音器作聯絡。至於VIP，我們會安排怡中航空服務的接機服務，他們可以到禁區位置接待，然後帶藝術家取行李過海關，再交給我們團隊。早期還有婦女委員會，她們很熱心，義務接待海外藝術家，而且更會在空檔時帶他們遊覽香港。後來藝術家漸多，接送的工作就交由聘請的藝術家聯絡員負責。」

從最初每年十多個節目到今天超過百多場的演出，Elvis直言也曾犯錯，「當然我也試過出錯，例如機票的名字錯了，那便由我負責罰款。每年差不多超過一千人來港，真的會很容易看錯日期人名等細節，出錯有時也在所難免。所以真是一步一驚心，責任很大。」🌸

梁掌瑋到機場歡送維也納管弦樂團
Grace Lang bidding farewell to Vienna Philharmonic Orchestra at airport (1989)

Flexibility in Freight Arrangements

Freight is next on the list after making arrangements for the visitors. King says this could be very complicated or straightforward. "Air or sea freight is usually used for shipping sets and props. Land freight might be used for Mainland China. Costs will be considered when deciding between having a set made in Hong Kong or shipped to Hong Kong. If it is to be made in Hong Kong, someone from the arts group will come to Hong Kong to follow up on the matter. There should be enough leeway for shipping time. For example, the estimated time required for shipping a set from the UK to Hong Kong should be at least six weeks, just to be safe. My mentor taught me that the people involved can change but the set cannot. If they fail to arrive in time, the people bear the responsibility."

Over the past few decades, King had some close calls while working for the Festival. "I remember an occasion in 2007 when the freight ship for Welsh National Opera arrived behind schedule in Dubai. I figured the freight definitely would not arrive on time. So I decided to pick up the goods once the ship arrived in Singapore and freighted them the rest of the way by air so they'd arrive in Hong Kong in time for the show. After this incident, a leeway period of 14 days was added to all sea freight to Hong Kong. Although this means additional storage fees, it mitigates the risk of late arrival."

"The most memorable experience of all was when the Arts Festival programmes in 2020 had to be cancelled because of the COVID-19 situation. For programmes to be held in February and March, the freight was already on its way from mid-December on, more than ten containers at sea. When the Arts Festival was cancelled, the entire freight had to be sent back to their port of departure."

After flights and hotels are booked and freight to Hong Kong arranged, the last step is the artists' arrivals to Hong Kong. "We provide information in advance, including transport from the airport and the designated meeting point. However, they might not follow our instructions, especially large arts groups with many people. Some might leave the airport or take a taxi on their own. I remember we once needed to rent a loudspeaker for liaison. For VIPs, we arrange meet-and-greet services from Jardine Aviation Services; the VIPs are met in the restricted area, and they are helped with their baggage through customs before being handed over to our team. In the early days, there was also the Ladies Committee, the members of which were dedicated and volunteered to greet overseas artists. They also showed the artists around the city during free time. It was not until when the number of artists increased that artist coordinators were hired to take over the task of greeting."

The Festival has gone from initially presenting fewer than twenty programmes a year to more than a hundred performances now. The growth hasn't been without its pains and King admits to having made mistakes: "I definitely made mistakes, including misspelling passenger names on flight tickets. When that happens, I am personally responsible for the additional fees incurred. With nearly one thousand people arriving in Hong Kong each year for the Festival, it is really easy to misread details such as dates and names and mistakes are inevitable. So the work comes with great responsibility and requires constant vigilance." ❁

領域與視野
Diversity and Vision

香港藝術節 1973 年正式揭幕，迎來了一股新氣象。開始時雖然節目不多，卻能呈現國際化的面貌，如新日本愛樂交響樂團、倫敦愛樂交響樂團、曼奴軒節日管弦樂團、布利斯托爾老域劇團，加上著名音樂家小澤征爾和傅聰等，為藝術節打響頭炮。

當藝術節成立時，便以舉辦高水平的藝術節為定位。早年以外國節目為主，亦會演出本地民間、以至區內亞洲的表演項目，例如粵劇、潮劇，甚至印度舞等。1976 年市政局創辦亞洲藝術節後，便減少了亞洲地區的傳統藝術節目。到了八十年代，藝術節規模逐漸擴大，隨著節目委員會的成立，加入專家意見，除節目維持高水平外，更趨向多元化，同時平衡不同類型的演出。藝術方向亦與時並進，以搜羅貼近最新藝術潮流、具創意及本港難得一見的製作為目標，提高大眾對藝術的興趣，豐富香港文化生活並促進文化交流。

以香港為本位的藝術節，每年除了帶來世界各地的節目外，積極發展本地藝術。八十年代藝術節開始與海外藝術家及藝團聯合製作，同時亦開始為本地藝術家提供創作平台，委約及製作各類型的新創作，包括室內歌劇、當代舞蹈、戲劇、戲曲等等，並配合藝術節的各項贊助計劃及市場推廣，務求更有效地推動本地藝術文化發展。

廣闊的領域，高瞻的視野。五十年來，香港藝術節為觀眾帶來過千個藝團及藝術家的演出，篇幅所限，此處只能透過當中部份藝術家，分享與藝術節共同奮鬥過的旅程。

每一位參與過藝術節的名字，無論台前幕後，共同成就了香港這個國際多元的藝術盛宴。

The HKAF ushered in a new era for the city's arts scene with its first edition in 1973. Though the initial line-up did not include many programmes, it had artists of international calibre, with the New Japan Philharmonic Orchestra, the London Philharmonic Orchestra, the Menuhin Festival Orchestra and the Bristol Old Vic. Renowned musicians including Seiji Ozawa and Fou Ts'ong also took part, getting the Festival off to a phenomenal start.

Since its inception, the HKAF has firmly positioned itself as a presenter of high-quality programmes. In the early years, the Festival line-up primarily comprised programmes by overseas companies, with some programmes from Hong Kong and neighbouring Asian countries. These included Cantonese opera, Chiu Chow opera and also Indian dance. After the Urban Council established the Festival of Asian Arts in 1976, there were fewer traditional Asian programmes in the Festival's line-up. By the 1980s, the HKAF had grown in scale and stature. The newly established Programme Committee brought in experts to advise on maintaining high-level content while achieving greater diversity and striking a balance among programmes in different genres. The Festival's artistic direction has kept pace with the times, actively pursuing innovative programmes rarely seen in Hong Kong. The objective has been to fuel audience interest in the arts and to enhance Hong Kong's cultural milieu while facilitating cultural exchange.

While featuring programmes from around the world, the Festival had its roots firmly in Hong Kong, meaning that its international outlook was balanced by a regard for Hong Kong's own arts development. The Festival began co-productions with overseas artists and arts groups in the 1980s. These newly available creative platforms for local artists, together with commissions and productions, led to new works including chamber opera, contemporary dance, dramas and Chinese operas. Such works are also aligned with the Festival's various sponsorships and marketing efforts to drive local arts development.

The HKAF has presented over 1,000 captivating programmes by arts groups and artists over the past 50 years. This book includes accounts from some artists who shared their creative journeys with the Festival.

We should also acknowledge the equally important contribution of everyone who has participated in the Festival, in whatever capacity, helping to make it an international grand feast of the arts in Hong Kong.

節目委員會的角色

1980年成立的節目委員會，擔當了重要的角色，成員由不同藝術範疇的專家組成，就節目方向給與意見，豐富了節目內容。隨後藝術節陸續帶來不同類型的藝術表演，除了每年重點節目的管弦樂團和歌劇，還有戲劇、舞蹈、戲曲、民族節目、合家歡節目等。

盧景文
節目委員會主席

盧景文以往從事大學行政，曾任香港演藝學院校長，並擔任多項文化、教育、藝術的公職。而且多年來藝術創作不斷，製作了不少的歌劇、舞台劇及音樂劇。

在香港藝術節成立之時，盧教授已參與其中的籌備工作，在諮詢會中提出建議。早年藝術節音樂場刊的介紹文字，都是出自盧景文的手筆。「因為對歌劇比較有專注的興趣，我記得第三屆的節目有瑞典皇家歌劇院，兩個作品都是莫扎特的，我有幫忙場刊的中文翻譯。那次比較印象深刻，因為演出者、導演、設計，都是非常有份量，而且主演的女高音是當時世界著名的伊麗莎白‧蘇德史杜林。以後就成為藝術節的一個傳統，每年都有一個歌劇重頭戲。到1993年我做了演藝學院校長，也貢獻一分力，就是提供一個非常優美的環境給藝術節演出，而且，演藝學院培養出來的台前幕後人才，亦有參與藝術節。」

盧景文曾加入藝術節執行委員會，並在1997年加入節目委員會，2018年起，擔任節目委員會主席。「委員會有不同的專才，他們每年也會到外地看演出，像對戲曲有研究的譚榮邦，對歐洲表演藝術有很深認識的喬治‧比安科羅索，還有本身是藝術家的紀大衛等等，他們對藝術節都很有貢獻。委員會很信任藝術節的同事，而同事們每年在策劃及揀選節目時，也會跟委員會商討，聽取意見。在節目策劃上，藝術節一直努力尋找世界頂尖、多元的藝術節目來港。」

「有別於七十年代初期的藝術節，主要由代理人負責籌劃節目，後來的香港藝術節已逐漸確立了自己的特色、形象及方針。藝術節在香港藝術界發揮積極作用，如今更成了國際藝壇借鏡的典範，為本地藝團帶來正面的影響，鼓勵他們全力以赴，做到最好。」

Role of the Programme Committee

The Programme Committee began to play a significant role when it was formed in 1980. The committee, constituted of experts from different arts disciplines, provided counsel on the programme directions and enhanced the programme's offering. The Festival continued to flourish and extend its range. In addition to the flagship programmes of orchestras and western opera, there was also drama, dance, Chinese opera, folk or traditional forms, and family programmes, among others.

Lo King-man
Chairman of Programme Committee

Lo King-man enjoyed a distinguished career in academic administration. He was Director of the HKAPA and held a wide range of public offices related to culture, education and the arts. A prolific artist himself, Lo produced countless western operas, plays and musicals during his career.

Lo was already involved at the outset of the HKAF when he made recommendations at consultation meetings. During the Festival's early years, Lo contributed to house programmes for concerts. "My interest was more focused on western opera, and so I helped out with the Chinese translations of the house programmes. They were for two Mozart operas by the Royal Swedish Opera during the third edition of the Festival. The occasion was memorable, as the performers, director and design were all of considerable stature. The programmes even featured Elizabeth Söderström, the world-famous soprano. The Festival later started the tradition of presenting a major opera each year. After becoming the Director of the HKAPA in 1993, my modest contribution was to provide an ideal venue for performances of HKAF's programmes. Onstage and offstage talents nurtured by the HKAPA also took part in the Festival."

Lo served on the Festival's Executive Committee, and joined the Programme Committee in 1997. In 2018, he became Chairman of the Programme Committee. Lo says: "The Committee members provide a variety of expertise and they would attend performances abroad every year. Committee members included the likes of Tam Wing-pong, who is an expert in Chinese opera, Giorgio Biancorosso, who has a wealth of knowledge on performing arts in Europe, and David Gwilt, who is an artist and musician himself. They have made tremendous contributions to the HKAF. The Committee has great confidence in the Festival team. Every

「每年除了以交響樂團、歌劇和戲劇為重點，我認為也可增加現代馬戲或形體戲劇的節目，這些節目既適合一家大小，又可以帶來歡樂的氣氛，增加藝術節的節慶色彩。在香港，藝術節是唯一推動世界性節目的文化機構，未來應繼續保持國際色彩，令香港人透過藝術節擴闊視野。」

盧景文出席 2017 年藝術節的閉幕演出
Lo King-man at the 2017 HKAF Finale

紀大衛
節目委員會中堅份子

紀大衛是本地音樂界的重要名字，多年來投身大學的音樂教育，同時亦是作曲家，更於報章撰寫樂評，在電台主持音樂節目，曾經擔任不少文化藝術機構的委員會委員，以及藝術節節目委員會主席。今天依然是節目委員會委員，繼續協助藝術節帶來優質的節目。

最初，節目委員會的功能是要與藝術總監，討論挑選演藝者及節目編排的事宜。「那時愈來愈多意見認為，藝術節在聘用海外的藝術總監的同時，本地人士也應參與其中。還記得有人批評藝術節執行委員會成員都是外行人，他們在旅遊及商界長袖善舞，相對在藝術和節目方面的人脈稍遜。要令批評者滿意，倒不如讓他們參與其中！」

談到節目委員會的角色，紀大衛稱：「我們的職責是物色最傑出和精采的節目後，著力推介。換句話說，我們須確保所選的節目具備上乘質素，達到國際水平。據我理解，節目委員會不須考慮經費問題。我相信委員會每位成員都致力讓每一屆藝術節做得比以往更好。如果藝術節受到重重限制，又怎能達到盡善盡美？」

year when the team starts to plan ahead and select programmes, they would seek the Committee's opinions through discussions. In terms of programme planning, the HKAF has always been tireless in bringing a wide range of world-class programmes to Hong Kong."

"Unlike the early days in the 70s and 80s when artistic direction was in the hands of agents, the HKAF has now developed its own nuance, its own brand and its own approach. The function of the HKAF in relation to the Hong Kong arts scene is really in showing examples of some of the best performances and trends now happening in the world. That serves as a catalyst and an encouragement to local arts groups to do their best."

"While the main focus every year falls on classical music, opera and theatre, there could be more contemporary circus or physical theatre programmes. These programmes are family-oriented and are great fun, and they bring a festive spirit to the event. The Festival is the only arts organisation in Hong Kong dedicated to programmes from around the world. This international outlook should continue in the future for Hong Kong people to broaden their vision through the Festival."

David Gwilt
Stalwart of the Programme Committee

David Gwilt is a preeminent figure in Hong Kong's music world. In addition to contributing to music education at university over several decades, Gwilt is also a composer. His other roles include writing music reviews and hosting music programmes on radio. Gwilt is often invited to serve on music and arts organisations. He is former Chairman of the HKAF's Programme Committee and remains a Committee Member, continuing his contributions to bringing high-quality programmes to the Festival.

Initially, the Programme Committee functioned as a channel of communication with the UK based Artistic Director on the selection of performers and programme arrangements: "There had been growing noise that there should be local input apart from an overseas artistic director. I recall there was once criticism that the Festival Committee had no expertise in the arts. The Committee members were all well-connected with the tourism trade and money, but not the arts! One way to keep critics quiet was to get them to join the gang!"

「我很享受擔任主席的工作，感覺有點像當幼稚園老師般訓導小朋友！成員們都各擅勝場，他們之間有時的確會因意見分歧而辯論，間中也會和藝術節團隊議論，我們並非最終決策者，但會盡力協助落實最佳方案。」

為香港藝術節引入節目時，要面對什麼挑戰？「其中一項挑戰，就是要遊說來港的藝團（尤其是樂團）演出特定的作品。我們可以請到國際頂級樂團來港，但正因為他們是頂級樂團，往往認為可以隨意演出。若連續三天也是演奏同一曲目，實在有欠理想。我們期望那些大名鼎鼎的樂團突破常規，表演超乎想像的精采節目。然而和頂級樂團的商議過程實在不容易，節目委員會必然全力支持節目總監，步調一致。」

紀大衛除了擔任節目委員會，本身也是藝評人及觀眾。對於這些不同角色，紀大衛說：「我樂於擔任節目委員會主席一職，也相信我的多重身份不會構成利益衝突。藝評人的角色就是輔助及推廣藝術。而作為觀眾，我有時也會感到失望。但總括而言，我很喜愛這些不同角色。」

數十年參與香港藝術節，紀大衛的難忘回憶應該不少。「某次和赫赫有名的鋼琴家雅莉絲亞·拉洛嘉合照，被 *Tatler* 雜誌刊登，也令我留下深刻印象！」

紀大衛（左）與夏佳理主席出席第 41 屆藝術節開幕禮
David Gwilt (left) and Chairman Ronald Arculli at the 41st HKAF Opening Ceremony (2013)

On the role of the Programme Committee, Gwilt says: "Our job is to try to promote the very best programmes we can possibly find. In other words, we are here to 'ensure the best possible of international standards'. My understanding was that the Programme Committee should not be concerned with money. I think everybody on the Committee works with a motivation to forge a better and better festival each time. How can you produce the best possible festival for Hong Kong under certain constraints?"

"I had a wonderful time as Chairman. It's like disciplining a lot of kindergarten children! Members have their own expertise. They argue and debate, sometimes amongst themselves, sometimes with the Arts Festival team. We are not the body to make the final decision, but we try to help to bring the best decisions!"

On the topic of challenges in bringing programmes to Hong Kong, Gwilt comments: "One challenge of presenting an art festival is to persuade visiting groups, especially orchestras, to play specific works. You can get the agreement to have first-class international orchestras to come. But because they are first class, sometimes they feel they can play what they want! We can't accept the same programmes for three days. We think it's not good enough. We don't accept normal repertoire with powerful groups. We expect something spectacular, out of the ordinary. The negotiation is quite tough. One thing for sure is the Programme Committee backs up the Programme Director. We are on the same page with the Programme Director."

Apart from being a Programme Committee member, Gwilt is also a musician, an art critic and an audience member. Looking at his different roles, Gwilt comments: "I loved being the Chairman of the Programme Committee and I don't think there is a conflict of interest among different roles. The role of an art critic is to assist the art and to promote the art. As an audience member, sometimes it might be disappointing. But I love all these roles!"

Over decades of involvement in the HKAF, there have been many unforgettable moments for Gwilt: "One memorable moment was my picture with the legendary pianist Alicia de Larrocha being featured in *Tatler* magazine!"

節目編排的推手

梁掌瑋
節目總監

梁掌瑋(Grace)在1988年加入香港藝術節，與當時新任總經理鄭新文，兩位「本地薑」一起把藝術節變成一個既面向世界，亦更貼近香港的年度文化藝術盛事。Grace自小接觸藝術，包括第一屆香港藝術節；她在美國唸大學時在校內的藝術中心做兼職，希望日後可從事藝術行政工作。「那時聽了很多音樂會及演出，很想日後能在幕後工作，促成這些節目。」回港後達成心願，在藝術節工作數十載，為香港觀眾帶來無數精采藝術節目。

「早期的確是比較多英國節目，以古典音樂會為主，也有一些名家的展覽，如齊白石、亨利·摩爾等。」從外國到本地，從邀約到合作，Grace對藝術節的轉變可說是瞭如指掌。「最明顯的一個轉變，是藝術節在九十年代自家製作歌劇，當時已經有一段時間沒有本地的歌劇節目，我們第一個製作的是1990年的《茶花女》，邀請了湯沐海當指揮，把故事的場景變成上海，演員還穿上旗袍，當時是頗為創新，這個節目反應很好，是藝術節的一個突破。隨後連續幾年我們也有製作歌劇，好像馬修·伯恩也曾經替《費加羅的婚禮》(1991)做燈光及服飾設計。不過製作歌劇所費不菲，到了1994年的《魔笛》，因為沒有資源，租用了西班牙歌劇院的佈景，而且還要籌款才能演出。」此後，歌劇依然是藝術節的重頭節目，除了邀請外國歌劇院來港演出，另外一個方向是與國際藝團聯合製作。

香港藝術節一直與世界各地的藝術機構有著緊密聯繫，從最初邀請藝團來港演出，合作模式慢慢開始變化，再也不只是買賣關係。Grace提到九十年代外國很多劇院、歌劇院面對經營困難，要尋求出路，所以要跟其他藝術機構共同製作。「可以說是由自我為中心變成合作模式，我們也在這時開始與其他藝團聯合製作節目，大中型演出也有，用這種模式製作了不少室樂歌劇。其中一例是1997年的開幕節目《馬可·波羅》，這是譚盾最早在香港

Mastermind in Programme Arrangement

Grace Lang
Programme Director

Grace Lang joined the HKAF in 1988. Along with the newly appointed General Manager Tseng Sun-man, also a Hongkonger, she helped the HKAF evolve into a major arts and cultural event with both a global outlook and deep connections to Hong Kong. Lang had been exposed to the arts since childhood and even attended the first edition of the Festival. She later worked part-time at the on-campus art centre during her university studies in the United States. It was her goal to be engaged in arts administration: "At the time, I attended many concerts and performances. I aspired to make these programmes happen by working behind the scenes." She fulfilled her dream upon her return to Hong Kong and worked at the Festival, serving Hong Kong audiences by orchestrating the planning for countless outstanding HKAF's programmes.

"There were indeed more programmes from the UK at first, with a focus on classical concerts. There were also exhibitions of renowned artists, including Qi Baishi and Henry Moore." Lang is highly knowledgeable about the evolution of the HKAF from overseas to local programmes, and from commissioned works to collaborations: "The most prominent change was the HKAF having its own opera productions, beginning in the 1990s. At the time, no local opera programmes had been featured for quite some time. Our first production was *La Traviata* in 1990, with Muhai Tang invited as conductor. The setting was changed to Shanghai, with the performers dressed in cheongsams. It was quite an innovation at the time and the programme received very positive feedback. It became a breakthrough for the Festival and was followed by more opera productions in the years that followed, including *The Marriage of Figaro* (1991) in which Matthew Bourne worked on lighting and costume design. However, opera productions are very costly. By the time *Die Zauberflöte* was performed in 1994, we had to rent the set from the Gran Teatre del Liceu in Barcelona due to lack of resources, and we had to raise funds for the performances." Subsequently, operas have been a flagship programme in the HKAF. While foreign opera houses are invited to perform in Hong Kong, the Festival has also pioneered a new direction of having co-productions with international arts groups.

上演的作品。當時是愛丁堡藝術節委約譚盾創作音樂,原本是由香港藝術節、荷蘭劇院及愛丁堡藝術節共同製作,然後在三地巡演,後來愛丁堡藝術節沒有資源,最後是香港藝術節跟慕尼黑雙年展、巴伐利亞國立歌劇院及荷蘭藝術節共同製作。」

為了搜羅世界各地最精采的演藝節目,Grace與國際節目總監約瑟·施力分工合作,從主要由施力建議,到1994年開始Grace正式擔任節目總監,開始親自飛到外國看演出,選節目,洽談合作。經常周遊列國自然有很多有趣的經驗,Grace說某年到荷蘭烏得勒支參加舞蹈節,因為那處只有一間旅館,剛巧有會議而客滿,於是要住進農場裡,每日也會經過羊群。因為這並不是觀光旅遊,資源有限,每次到海外都是行程緊密。「最厲害的一次是七天橫跨歐美幾個城市,先從香港飛往洛杉磯看歌劇,大衛·霍克尼負責舞台設計的歌劇《崔斯坦與伊索德》,然後飛到休斯頓看Houston Grand Opera的《莎樂美》,計劃1998年來香港演出。緊接飛到歐洲,到德國的烏帕塔然後回港。」最後一站,正是要看翩娜·包殊(Pina)烏珀塔爾舞蹈劇場與藝術節共同製作的新作《抹窗人》。

翩娜·包殊(前左)透過梁掌瑋(後左)的安排下,在香港期間與不同的演藝文化人交流,包括舞蹈家梅卓燕(後右)

With Grace Lang's (left back) arrangement, Pina Bausch (left front) met with a lot of artists and cultural personnels, amongst which was choreographer Mui Cheuk-yin (right back)

The HKAF continues to maintain close liaison with arts organisations around the world. From initially inviting arts groups to Hong Kong for performances, the partnership slowly evolved. Lang says many overseas theatres and opera houses struggled during the 1990s and co-productions with other arts organisations became a solution: "They changed from being self-oriented to collaborative. It was around this time that we began to co-produce programmes, making both mid- and large-scale productions. With this approach, some chamber operas were produced. An example would be *Marco Polo*, the opening programme in 1997. This was Tan Dun's first work to be performed in Hong Kong. At the time, the Edinburgh International Festival commissioned Tan Dun to compose the work. It was supposed to be co-produced by the HKAF, the Dutch National Opera and the Edinburgh International Festival, with performances at all three. However, the Edinburgh International Festival lacked the necessary resources and it was eventually co-produced by the HKAF, the Munich Biennale, the Bayerische Staatsoper and the Holland Festival."

Both Lang and International Programme Director Joseph Seelig set off to look for the finest programmes from around the world. Seelig was initially responsible for making recommendations. When Lang became Programme Director in 1994, she took the initiative to attend overseas performances, make selections and discuss collaborations in person. There were many interesting experiences on her frequent travels. Lang remembers visiting the Netherlands for a dance festival in Utrecht, and there was only one hotel, which was fully booked due to a conference. She eventually had to stay at a farm and passed flocks of sheep every day. As these were not leisure trips and the budget limited, the schedule for every trip was jampacked: "My most hectic trip involved visiting several European and American cities in the space of seven days. I first flew from Hong Kong to Los Angeles to attend the opera *Tristan and Isolde*, with set design by David Hockney. Then I flew to Houston to watch *Salome* presented by the Houston Grand Opera as the programme was planned for the Festival in 1998. Afterwards, I immediately flew to Europe to visit Wuppertal in Germany before returning to Hong Kong." On her last stop, Lang attended *The Window Washer*, a new work co-produced by Pina Bausch Tanztheater Wuppertal and the HKAF.

The idea of working with Pina Bausch came about over a cup of coffee: "I befriended Pina at a consular reception when she came to Hong Kong for a performance. Her dance group would visit Paris in June every year for performances, and we watched a show together at Théâtre de la Ville. When we were having coffee after the show, I asked if she would be interested in coming to Hong Kong to create

說起那次合作，Grace 說是從一杯咖啡醞釀出來。「Pina 某次來港演出，隨後在領事的宴會中認識了她。她的舞團每年 6 月也會到巴黎演出，有次我們一起在巴黎城市劇院看演出，好像是 *Zingaro*，完場後一起去喝咖啡，我問她有沒有興趣來香港創作新演出，我跟她說 1997 年回歸對香港很重要，她說很有興趣。以往應康文署的邀請來港演出，每次都是困在劇院綵排，從來不知香港是怎樣。於是我們安排她在 1996 年秋天先來港到處看看，認識香港，和本地的藝術文化界交流。這個作品在藝術節公演前，1 月先在烏帕塔首演，我當然要飛去看看。」

《抹窗人》是 Pina 在香港看到在高樓大廈那些抹窗工人而命名，作品後來在世界各地巡演，大概是藝術節巡演最多的作品。「值得一提是當年由恒生銀行贊助，中場還看到很多銀行家在談論作品，實在是有趣的經驗。」

Grace 提到跟藝術家的認識，以至後來促成的合作，往往都是漫不經意。「某年到德國看漢堡芭蕾舞團的演出，當時塔利亞劇院正在上演羅伯特·威爾遜的《黑騎士》，不過因為滿座沒機會看到，卻在劇院門口認識了劇團總監，我跟他說希望也能把這個節目帶到香港，就在我離開漢堡、上飛機前談妥了。」歐洲以外，鮑磊擔任藝術節主席期間，因為日籍太太的關係，藝術節又開拓了日本的節目。「從早期的蜷川幸雄，到鈴木忠志、笈田ヨシ等等，都是未曾在香港演出過的日本藝團。另外一個有趣的合作是和日本影法師劇團製作的《悟空》，並由香港中英劇團、北京市兒童藝術劇團、韓國愉快的夥伴聯合演出及協助製作。」

Grace 強調因為觀眾對藝術節已建立信心，所以有把握將創新的節目帶來香港，即使是傳統的藝術或知名藝團，也與他們一起發掘新意。「雖然大部份知名交響樂團的巡迴音樂會，一般都是既定的曲目，不過我們有時也會跟藝團一起構思，務求演出是特別為藝術節而設，帶動觀眾的欣賞水平和眼界。好像辛辛那提交響樂團的指揮路易·朗格黑跟我們一起構思演出曲目。英國鋼琴家喬安娜·麥克瑞格在大會堂演奏作曲家梅湘的作品，雖然是現代音樂作品，入座率也不錯。今天世界各地的樂團經常到內地巡演，他們大都是演奏知名古典作曲家耳熟能詳的作品，誤以為觀眾只喜歡聽那些，其實這是很不健康的現象。」

a new work. Having told her about the importance of Hong Kong's reunification with China in 1997, she expressed great interest in the idea. On previous visits, she had usually been stuck in the theatre for rehearsals and did not have any idea about Hong Kong. So we arranged for her to visit Hong Kong in the autumn of 1996. This allowed her to get to know Hong Kong better by looking around and meeting people from Hong Kong's arts sector. The resulting work premiered in Wuppertal in January prior to its performance at the Festival. So I needed to see the performance in advance."

The Window Washer was named after the window washers on Hong Kong skyscrapers. The work subsequently toured around the world and was likely to be the HKAF production that toured the most: "It was worth mentioning that the production was sponsored by Hang Seng Bank then. It was really interesting to hear many bankers discussing the work during the intermission."

Lang's acquaintance and subsequent working relationship with artists sometimes happened completely by coincidence: "I once went to Germany for a performance by Hamburg Ballet, and *The Black Rider* by Robert Wilson was playing at the Thalia Theatre. Although the show was sold out, I got to know the theatre group's director outside the theatre. I told them I'd love to bring the show to Hong Kong, and the arrangements were already made by the time I left Hamburg." Besides programmes from Europe, the HKAF also started to have programmes from Japan, thanks to the connections of Chairman Martin Barrow, whose wife is Japanese: "Japanese theatre luminaries, from Yukio Ninagawa during the Festival's earlier years to Tadashi Suzuki and Yoshi Oida, all made their Hong Kong debuts at the HKAF. Another interesting co-production was *Goku (Monkey King)* with Japan's Kageboushi Theatre Company in association with Hong Kong Chung Ying Theatre Company, Beijing Art Troupe for Children and Korea's Joyful Theatre."

The Festival has built a following among audiences, according to Lang, which allowed innovative programmes to be introduced to Hong Kong. Even with traditional art or renowned arts groups, the Festival always worked with them to make the programme refreshing: "Although most of the famous symphony orchestras have an established touring repertoire, we often work with them to ensure performances are tailored for the HKAF, to give the audience something more. For example, we worked with Louis Langree, music director of the Cincinnati Symphony Orchestra, to devise its programme at the Festival. British pianist Joanna MacGregor performed a composition by Messiaen in her recital at City Hall, and the attendance for this piece of

傳統藝術以外，藝術節亦非常注重不同類型的節目。「記得有一次，我們請來了捷克的布拉格螢光劇團，一個全黑的合家歡節目，香港生活節奏很快，大家不習慣看這種演出，所以觀眾都很安靜，因為都睡著了！這是文化差異，其實也沒關係，我們不會因此而放棄這類型的節目，而是更用心的思考怎樣跟觀眾建立關係，如何更有效地介紹這種作品。即使大家不熟悉某些藝團，但由於信任我們的選擇，對我們有信心，所以更樂意接受新創作。」畢竟藝術節不是要推介單純的娛樂節目，目的不是要討好觀眾，而高入座率也不是唯一的目標。「記得一次來自荷蘭的鋼琴家在演藝學院演出，演奏的都是現代音樂作品，沒有莫札特也沒有很熟悉的名字，觀眾不多，卻看到一位媽媽帶著七、八歲的女孩來聽音樂會，好奇之下跟她傾談，原來她當年曾經參加我們的『青少年之友』計劃，她明白音樂不只是幾位出色的作曲家。這次的觀眾不多卻不代表失敗，單是這位觀眾已令我很滿足。」

不論是世界頂尖，還是潛質新星；是傳統經典，還是另類前衛，對 Grace 來說這些都不是先決條件，五十年不變的，就是「不斷發掘不同的節目」。藝術節，就是發掘藝術之旅。

contemporary music was fairly good. Orchestras from around the world nowadays, when presenting in Mainland China, often play familiar works by famous classical composers. This is based on the assumption that those are the only works that audiences want. It's not a very healthy trend."

Other than programmes in traditional art forms, the Festival offered a variety of programmes: "We once invited the Black Light Theatre from the Czech Republic and the family programme was performed in front of a completely black backdrop. The audiences were perhaps more used to Hong Kong's fast pace of life than these performances. In fact, they went quiet because they all fell asleep! This was a case of cultural differences, which we were fine with. Instead of shying away from these types of programmes, we double our efforts to figure out how to build a stronger relationship with the audience and to be more effective in presenting the work. Even when the public might not be too familiar with a certain arts group, they are more willing to explore new works as they trust us and our selection of programmes." After all, the Festival does not exist just to present popular entertainment or to please audiences. High attendance is not the one and only sole objective. Lang remarks: "There was a recital by a Dutch pianist at the HKAPA that featured contemporary compositions instead of works by popular composers like Mozart. Among the sparse audience was a mother with a girl who was around seven or eight. I chatted with her out of curiosity, and it turned out that she used to participate in our 'Young Friends' project. She understood that music was not just about a few composers. A small audience does not necessarily mean failure. This audience alone gave me a strong sense of satisfaction."

Lang does not prioritise when choosing among world-class artists and emerging talents or deciding between traditional classics and the avant-garde. The firm stance over the past 50 years is a "quest for diversity in programmes". The HKAF is itself a journey of discovery in the arts.

（一）海外的演藝者

翩娜‧包殊烏珀塔爾舞蹈劇場
香港為創作靈感之源

翩娜‧包殊烏珀塔爾舞蹈劇場五度參與香港藝術節，而1997年的《抹窗人》，更是與香港藝術節聯合製作，以香港為創作靈感出發的作品。翩娜‧包殊（Pina）在2011年離世，留下無數經典作品。曾任 Pina 的藝術助理及綵排總監、舞團藝術總監，現為藝術管理總監的羅伯特‧斯特姆（Robert），連同曾演出多個 Pina 作品的舞者海倫娜‧派康（Helena），一起訴說 Pina 與香港的故事。

1997年在香港上演的新作《抹窗人》，當時還未定下這個名字，節目場刊詳細記下了 Pina 在 1996 年 10 月下旬至 11 月中，在香港的日程誌，當中踏過的足跡，遇上的人和事，是如何轉化成《抹窗人》。Robert 說 Pina 的作品就像一個拼貼，「Pina 總是由一張白紙開始，去尋找最細微的東西，慢慢發展下來卻會變得像珊瑚礁一樣斑斕。當然她是知道自己的要求，卻沒有預計最後的結果，所以每次跟她合作總是獨特的體驗。」

翩娜‧包殊攝於香港
Pina Bausch in Hong Kong (1996)

(1) Overseas Artists

Tanztheater Wuppertal Pina Bausch
Hong Kong as Creative Muse

Tanztheater Wuppertal Pina Bausch performed at the HKAF in five different editions, including the programme *The Window Washer* in 1997, which was a co-production with the Festival and was creatively inspired by Hong Kong itself. Pina Bausch left a lasting legacy of countless dance classics when she died in 2011. The story of Bausch and Hong Kong is recounted by Robert Strum, the great choreographer's former artistic assistant and rehearsal director. Strum was also formerly the artistic director of Tanztheater Wuppertal and is now its director of artistic management. Helena Pikon, veteran dancer of Bausch's works, also shares the story of Pina and Hong Kong.

Scheduled to appear in Hong Kong in 1997, *The Window Washer* was a new work initially untitled and conceived by Bausch during her visit to Hong Kong from late October to mid-November in 1997. This trip was chronicled in detail in the house programme, including Bausch's schedule in Hong Kong, the people and things she encountered, and how these became the inspiration for *The Window Washer*. Strum described Bausch's work as a collage: "She starts from a blank page. She looks for little things. Her pieces develop like coral reefs. She knows what she is looking for, but she has no idea what it will look like. It's very special working with Pina."

Pikon recalls her days rehearsing in Hong Kong. "I was actually sick for some time and stayed in the hotel room for about a week. And the thing that I was seeing and hearing the most was this very friendly woman who took care of the rooms and always said 'Good morning' and 'Thank you' to me. This conversation inspired the opening scene of *The Window Washer*. When I recovered and went out, I felt I was a little mouse. This incredible city is full of life and colour. I remembered my joy was going to eat. From having congee only when I was not feeling well, I started to enjoy local dishes including dim sum, fish balls, pineapple buns, egg waffles, and Peking duck, both grilled and in soup. I loved going to the restaurant near the theatre, because there was a big table so we could enjoy eating together. We rehearsed in a studio by day and

《抹窗人》 *The Window Washer* (1997) (©Robert Stefanski)

Helena 回想起當日在香港排練的日子,原來是由「早晨」和「謝謝」開始。「因為我剛到埗病了一陣子,整整一個星期留在酒店,所以接觸最多的是替我打掃房間的清潔人員,跟我說『早晨』和『謝謝』,這也成了演出開首的兩句說話。病癒後,感覺自己像隻小老鼠,在這個充滿色彩與生命力的城市奔走。最高興是可以不停地吃,由生病時初嚐吃粥,到後來嚐盡地道美食:點心、魚蛋、菠蘿包、雞蛋仔、北京填鴨等等。最喜歡到劇院附近的酒樓,一大伙人圍著大圓枱一起吃。我們日間排練,晚上出外吃飯遊覽。排練時,Pina 總是會提問,問我們的經歷,她總是先做資料搜集,去找一些感興趣的東西。我們已習慣跟她這樣合作,收集我們的見聞,當然還有她自己所見,回到德國後開始創作。跟 Pina 合作有很多有趣的時刻,當你以為她已找到某些很美麗很有趣的東西,怎知她卻沒有因此停下來,而是不斷向前尋找,直至找到滿意的一刻。就如你可以選擇不同的裙和鞋,所以當中有很多可能性。」

《抹窗人》可說是為 1997 年的香港而創作。Helena 認為作品是超越了文化和地域的界限。「我們找到痛苦與快樂,人類的共同情感,不同人自有不同的想法,Pina 當然是不會加以解釋。例如舞台上會出現火,令我想起龍。我的腦海浮現這樣的一個景象:整晚坐在維港海邊看風景,看著那些建築、船隻,我想像龍看到這些風景也很開心,但景色卻突然被建築物遮擋,所以感到很

went out to see the sights and to eat in the evenings. When we were in the studio, I remembered Pina asking us questions about what we were seeing. It's her way of doing research to collect what she thinks is interesting and what we give her. That's pretty much how we usually work with Pina. First, she collects everything that we can give her, as well as a lot of things which she has seen herself. Then when she goes back to Germany, she starts choreographing the piece. There have been some moments which were very beautiful with Pina, where she always tried again and again. Even when you saw something beautiful and you thought she would keep it, she always tried to go further to find new things again and again until she found exactly what she wanted. It's like you have a choice between different kinds of dresses, and just with the different dresses and shoes, there can be a lot of possibilities."

While *The Window Washer* was created for Hong Kong in 1997, Pikon considers the piece and the message behind it to be universal: "There is pain and joy, and all these are universal feelings. Every person should have their own interpretation of it. Pina did not explain what it was. For example, there was a fire on stage which reminded me of a dragon. I recalled my experience of sitting looking at the Harbour all night. I was looking at the buildings, the water and the boats, and I could imagine a dragon feeling so happy looking at the view, but suddenly it was covered by buildings, so it feels angry. If you can recall, there's a little boy in *The Window Washer*. The little boy found a hole, and it's as if the dragon can see the incredible view once again. On top of the fire, there were also a lot of flowers,

《康乃馨》 Nelken (Carnations) (2011)

憤怒。在作品中還有一個小男孩，他找到了一個洞，感覺就像龍再次看到美麗的景色。舞台上還有很多鮮花，大概有一千八百朵，我個人覺得像個火山。」Robert認為作品不只是與香港的聯繫，也是關於生命，「就好像作品不只是用香港、內地或其他的音樂，甚至是無音樂。Pina喜歡到處看找靈感，不是找出大家有甚麼分別，而是有甚麼把我們連在一起。我們很容易看到彼此相異之處，但作品卻是關於共同性，原來不同地方的人，分別不是那麼大。我想Pina決定做這個作品，是因為對這個地方和這裡的人有某種信任。相信香港在她心中有獨特的位置，而我們舞團也經常來港演出，是其中一個到訪最多的城市。」

香港觀眾愛Pina，舞團也對香港留下良好的印象，Robert說：「香港觀眾很開明，願意接受新事物。」隨後為藝術節觀眾帶來了《月滿》、《康乃馨》、《死而復生的伊菲格尼》、《穆勒咖啡館》及《春之祭》。雖然Pina離開了，但舞團依然努力傳承她的精神。「很多新加入的舞者未曾與Pina合作，我想到如何把Pina的作品傳承。如果有機會重演《抹窗人》，我會告訴年輕舞者關於我的香港記憶。」

about 1,800 of them. I personally thought it looked like a volcano." Strum thinks the work had elements that really connected to Hong Kong but was also relevant to life in general: "The work used not only Hong Kong or Chinese music but also other music, and even sometimes no music at all. Pina enjoyed going to different places, not to see what makes us different from one another, but to see what connects us. Things that make us different can be spotted very quickly but she did not put a lot of it in her work. Her work was about human beings living everywhere. There are not so many differences. I think when Pina decided to do a co-production with the place, she only did it when she already had built a kind of trust in the place and people. And the company returned regularly for many years. There aren't many places that the company goes to regularly and Hong Kong is for sure somewhere we performed many times."

Hong Kong audiences were very positive about Bausch's work and her company also had a good impression of Hong Kong: "The Hong Kong audiences are very open and willing to try new things." After this production, the HKAF presented *Vollomond*, *Nelken*, *Iphigenia in Tauris*, *Café Müller* and *Le Sacre du Printemps*. Although Bausch has passed away, the dance company continues to pass on her philosophy: "We have a lot of new dancers who never worked with Pina and we think of ways to build on her legacy and move forward. If we were to perform *The Window Washer* again, I would tell the young dancers about my memories of Hong Kong."

約翰・紐邁亞
漢堡芭蕾舞團藝術總監和首席編舞

能夠帶領一個世界知名芭蕾舞團五十年，除了魄力、創意、耐力還有對藝術的熱愛。約翰・紐邁亞(Neumeier)自1973年出任漢堡芭蕾舞團總監和首席編舞，在他的帶領下，舞團在德國舞蹈界鋒芒畢露，更是備受國際認可的頂級芭蕾舞團之一。他擅長糅合現代舞蹈和古典芭蕾舞於作品之中，並創立了獨特的個人舞蹈語言。漢堡芭蕾舞團四度參與藝術節，從經典的《茶花女》、《胡桃夾子》，《仲夏夜之夢》到原創的《尼金斯基》、《貝多芬計劃》、《馬太受難曲》和總結個人創作的《約翰・紐邁亞的世界》，演出作品豐富多元。

Neumeier 每次也為香港帶來獨特的節目，似乎對香港的觀眾特別用心。「我們不是來重複在漢堡的演出，而是為香港再創造，因為是面對完全不同的觀眾群。記得 2003年，第二次來港，Grace 提議我們演出《馬太受難曲》，一個很特別的作品。香港觀眾是很願意接受新事物，所以每次也會悉心揀選節目。雖然從某角度來說，觀眾都是一樣，因為我們不是透過語言，舞蹈是人與人之間的共通連繫。但因為觀眾的反應，香港給我很好的回憶。我的作品是關於表達人的各種感覺情緒，如何與其他人連結，所以到不同的地方演出，也需要改良一下作品，讓觀眾有更清晰的畫面，更容易投入。」

令 Neumeier 特別難忘的，是 2019年的演出。「那年在香港演出《胡桃夾子》，這是為小孩而製作的節目，藝術節策劃了不少特別活動，而且處理得非常好，那些細節的安排令我很難忘。演出時我置身小朋友當中，感覺很美好。我知道藝術節不是有很多資源做額外的活動，但也把資源投放在小孩身上，啟發他們，實在難得，我們舞團也要學習。」藝術節為《胡桃夾子》的演出策劃了不少「加料節目」，當中包括演前講座、展覽、後台參觀、兒童工作坊等等。

Neumeier 說每次參與香港藝術節，都是給自己的一項挑戰。「我不純然為西方世界而創作，也希望作品可以感動不同文化的人。正因如此，每次也很小心揀選作品，不一定是最受歡迎的劇目，

John Neumeier
Artistic Director and Chief Choreographer, Hamburg Ballet

To lead a world-renowned ballet company for 50 years requires not only bold resolution, endurance and creativity, but also an unwavering passion for the arts. John Neumeier has been Artistic Director and Chief Choreographer of the Hamburg Ballet since 1973. During his tenure, the company has shone and soared on Germany's dance scene and become one of the top ballet companies in the world. Neumeier is a master at combining classical ballet tradition with contemporary forms while developing a unique personal choreographic language. The Hamburg Ballet has been invited to four editions of the Festival, presenting classics like *Lady of the Camelias*, *The Nutcracker*, *A Midsummer Night's Dream* and original works including *Nijinsky*, *Beethoven Project I*, *St Matthew Passion* and *The World of John Neumeier*, which paid tribute to Neumeier's large and diverse body of work.

Every programme Neumeier presented in Hong Kong was unique and chosen with attention to the specific Hong Kong audiences. Neumeier says: "I didn't want merely to repeat the performance that we did in Hamburg, but to give new life to the ballets for the stages in Hong Kong and a different kind of audience. I remember, for our second visit to Hong Kong in 2003, Grace Lang requested the *St Matthew Passion*. I admired and was impressed by her courage to present something which was so unusual for the people of Hong Kong. Hong Kong audiences have a great curiosity to discover new things and we select our programmes with care. At the same time, as we must not rely on language, communication can be more direct. The human being is the instrument and subject of dance. The common instrument of our humanity unites performers and audiences worldwide. My work gives living shape to basic human emotions, to project and to communicate with an audience."

但必須具有藝術價值、有趣以及具前瞻性。」2019 年的演出中最後有他的一段獨白:「約翰‧紐邁亞的世界,我的世界就是舞蹈⋯⋯創作是舞蹈中令人最興奮的一部份,幾乎從一開始我就不只是想跳舞,我想要創造舞蹈,用動作來講述那些精采絕倫而難以言表的故事。」他的舞蹈世界,從巴赫到伯恩斯坦、尼金斯基到文學。「這演出原本是為意大利一個藝術節而創作,我們在教堂門口演出,面對差不多有二萬名觀眾。後來每次演出也有少許改動,因為作品是關於我的創作旅程。」

帶領舞團半世紀,Neumeier 還是永不言休。「當然我還有新創作,否則我也不是個編舞者,其中一個新作是《貝多芬計劃 I》,希望可以帶到香港演出。我對這個城市有很多難忘的回憶,也希望再次來港。」五十年,剛好與藝術節同年,談到未來舞團的發展,「對芭蕾舞團來說,創意和創造是最關鍵,舞團不只是建基於過去的成就,而是希望一直演下去。」

《貝多芬計劃 I》 *Beethoven Project I* (2019) (© Kiran West)

《仲夏夜之夢》 *A Midsummer Night's Dream* (1999) (© Holger Badekow)

Neumeier found his Hong Kong performance in 2019 especially memorable: "We danced *The Nutcracker* for a performance exclusively for children. The Festival had a number of special programmes for children and they were organized and carried through extremely well. In 2019, the Festival arranged a number of "PLUS" programmes for *The Nutcracker*, including a pre-performance talk, an exhibition, a backstage tour and a children's workshop. I was impressed by the detailed arrangements. I remember well sitting in the audience among the children and feeling their excitement. We all know that festivals are always lacking funds, but the gift of a free performance exclusively for children was truly generous and a great investment for the future. At home in Hamburg, we copied this idea during the present season with great success."

Every time he has taken part in the HKAF has been a personal challenge for Neumeier: "What I am showing should be relevant not only to the Western world, but it should also resonate with people from different cultures. So, the pieces were always chosen very carefully. Not necessarily the most popular, but pieces which were artistically diverse, interesting and also progressive." His 2019 performance ended with *The World of John Neumeier* in which he himself narrated aspects of his life: "My world is dance ... Creation is the most exciting aspect of dance. Almost from the beginning, I wanted not only to dance myself, but to create dances – to tell wonderful, wordless stories in movement." *The World of John Neumeier* explores choreography on music from Bach to Bernstein, and from a portrait of Nijinsky to dances of literary inspiration: "The piece was actually made for an arts festival in Italy and was performed in front of a cathedral for an enormous audience of around 20,000 people. We have done slightly different versions in subsequent performances, because there is always something new – I'm constantly creating."

After leading the dance company for half a century, Neumeier is still tireless in creating: "Absolutely, otherwise I couldn't be an artistic director. It was important to present my newest work *Beethoven Project I* in Hong Kong. I have wonderful memories of the city and I hope to come back to Hong Kong again." The Hamburg Ballet, just like the HKAF, is also 50 years old. On the future of the ballet company, he says: "'Creation' is essential for a ballet company. A director should not rely only on the classics of the past but invent steps into the future."

阿蘭‧普拉特
芭蕾B之C藝術總監

「芭蕾 B 之 C」這個有趣的舞團名字，是否事先張揚其與別不同的風格？唸教育治療出身的阿蘭‧普拉特（Platel），1986 年與友人創立這個比利時當代芭蕾舞團「芭蕾 B 之 C」，作品貼近比利時超現實主義，混淆「高雅」與「低俗」藝術的分野。他們的作品不講故事，也不精心設計舞蹈結構，而是片段式的，打破固有規限，以及關注日常生活的動作。從一個小眾品牌開始，1993 年以《早安夫人》震驚國際。在 2000 年，Platel 帶著《巴赫浮世繪》首次與香港藝術節觀眾見面，想不到這個作品，靈感是來自香港。

「我從某相片集看到，九龍某地方的一系列生活照片，人們在屋頂和家人、鄰居相聚，我覺得非常有趣。所以跟佈景設計師說不如以這系列照片作參考，沒想到我們最後會獲邀到來演出這個作品。香港對我來說是很特別的地方，我來自歐洲一個古老而細小的城市，跟香港是完全不同的環境。」

《巴赫浮世繪》由巴赫的音樂引發，透過其音樂道盡人間百態。「我從沒有接受正統的舞蹈或劇場訓練，走進表演藝術是一個意外。或者是這個原因，我沒有把自己當作編舞看待，我的創作過程都是依賴演出者在排練時的分享。我們利用很長時間排練，開始時我不是主導，只是參與者，過程沒有甚麼計劃，也不知往哪個方向走。我們花了很多時間認識對方，最重要的是我很相信舞者的意見，他們也要敢於分享。」《巴赫浮世繪》正是這樣的一個作品，把不同的人集合在一起，成年人小孩、專業非專業、音樂人、演員舞者，從而達至某種美學，沒有修飾。「我甚至會形容是『邋遢』的演出，有點粗糙，有點混亂，既不是古典也不是現代。」合作的演員都會稱他為「爸爸」，大概他的演出團隊就像個小家庭。

《巴赫浮世繪》
lets op Bach (2000) (©les ballets C de la B)

Platel 說觀眾能夠接受這個作品也讓他有點意外。「或許觀眾是看到某種自然的氣氛感覺而引起共鳴。演出中舞者不是去炫耀技巧，而是透過動作、感覺、聲音去溝通，那個年代的確是頗創新，當然今天越來越多創作是利用這些元素。」演出中有專業舞者，有少年有小女孩，在舞台上建立一個多元化的世界。

Platel 記得當時香港觀眾很喜歡這個演出，留下的都是美好回憶。「我從別的地方聽說香港的觀眾都是比較被動和安靜的，但那次的經驗卻是完全相反，反應很熱烈，完全出乎意料。作品引發的討論，甚麼是舞蹈，在台上看到甚麼，又看不見什麼。雖然已是二十年前，但仍然記得那次獨特的經驗，這也不是恭維的說話。」Platel 的作品就是這樣連結了不同文化的觀眾。

Alain Platel
Artistic Director, les ballets C de la B

The unusual name of les ballets C de la B is a hint to its inimitable style. A remedial educationalist by training, Alain Platel established the Belgian contemporary ballet company with friends. The company's work is in the tradition of "Belgian surrealism", which has blurred the lines between "high" and "low" art. Its works do not represent stories or follow carefully conceived structures of dance; they are fragmented, breaking through rigid disciplines with attention focused on the everyday nature of movement. Having had a cult following for years, the company broke onto the international scene with *Bonjour Madame*. In 2000, Platel took part in the HKAF for the first time with *Iets op Bach*. It may come as a surprise that the work was inspired by Hong Kong.

Platel explains: "I was inspired by a series of photos that I saw, about life in Kowloon. I was fascinated by the fact that people would use their roofs of their apartments to gather and have family reunions, gatherings with their neighbours, etc. So I asked the man who made the set to draw inspiration from those pictures. In the end, being invited to perform in Hong Kong was very special for this reason. Hong Kong is a very special place for me. The place I come from is a very old small city. So, when you come to Hong Kong, it's a huge experience."

Taking the work of Bach as a starting point, *Iets op Bach* is a kaleidoscope of humanity through music: "I have no formal dance or theatre training. It was really by accident that I ended up making theatre and dance performances. Perhaps because of this, I never see myself as a choreographer. I depend very much on what performers are willing to share in the studio during rehearsals. We have long period of rehearsals. At the start of a project, I'm not the boss but more of a participant. I don't have a specific plan, and I don't know where we're going to end up. We take a lot of time getting to know each other. Another thing I find extremely important is to trust their feedback. I depend very much on what people are willing to share." *Iets op Bach* is such a case, mixing adults and children, professionals and non-professionals, musicians, actors, dancers and so on. The work achieves a kind of unpolished aesthetic: "It was, in a formal sense, quite a 'dirty' performance. It had nothing to do with classical dance or contemporary dance." The performers started to call him Papa as his team of performers was like a little family.

Platel was quite surprised by the reception to this work: "Perhaps it referred to a certain kind of natural habitat or atmosphere that people could recognise. You didn't see fancy dancers showing their skills. We showed dancers trying to communicate through movements, feelings, thoughts and even their voices. In those days, it was quite new, but today, there are more and more theatre directors and choreographers doing that sort of stuff." The performance was a microcosm of diversity, with professional dancers, young people and even a young girl together on stage.

Platel recalled the audience's warm reaction: "I was told the Hong Kong audiences tend to be a little bit reserved and quiet, but it turned out to be the opposite. The work aroused more discussion about topics such as what dance is, what we see, and what we don't see. Even though it was 20 years ago, the unique experience remains etched in my memory and that is no hollow compliment."

舞團另一齣在藝術節上演的節目《信逝》
Another performace staged at the HKAF, *Foi* (2004) (©les ballets C de la B)

經典與創新歌劇共冶一爐

「香港藝術節對西方歌劇的推廣很有貢獻，世界最頂尖的歌劇院，像馬林斯基劇院、莫斯科大劇院都曾在藝術節演出。曾經有人質疑是否值得花那麼多資源邀請這些歌劇院來港，但其實大部份歌劇節目的票房也不錯，因為觀眾知道藝術節的歌劇是有一定的水準。當然因為資源問題，不能每年都帶來大型的歌劇作品。其實，藝術節也帶來不少創新的歌劇，早於九十年代其中最大的一個突破是由羅伯特·利伯殊導演、加拿大歌劇團的《藍鬍子城堡》，這是貝拉·巴托的歌劇作品，當時是比較罕見。雖然票房不理想，但是讓香港觀眾有機會認識創新的歌劇。」

— 節目委員會委員譚榮邦

節目委員會委員譚榮邦(右)與行政總監何嘉坤
Programme Committee member Tam Wing-pong (right) and
Executive Director Tisa Ho (2006)

杜達美
光芒四射的指揮家

生於委內瑞拉一個音樂世家的杜達美，十八歲已擔任西蒙·玻利瓦爾交響樂團指揮，二十八歲成為洛杉磯愛樂樂團指揮，是該團有史以來最年輕的常任指揮。蜚聲國際後杜達美仍繼續擔任西蒙·玻利瓦爾交響樂團的音樂總監，帶領樂團走向國際。

2015年杜達美與洛杉磯愛樂樂團開啟其亞洲之旅，首度來港演出，在藝術節獻上兩場音樂會。杜達美回想當天帶著興奮開放的心情來港演出，「香港是一個非凡的城市，充滿動感、活力與衝勁。當日在香港文化中心的演出，是非常難忘的經驗，我們演奏馬勒、德伏扎克，還有好友亞當斯的作品《黑色城市》。腦中浮起的都是美麗的畫面，香港觀眾的熱情與投入，推動我們把音樂做得

Classic and Modern Operas Both in the Spotlight

"The HKAF has made immense contributions to the promotion of Western opera. Productions from top opera houses like the Mariinsky Theatre and the Bolshoi Theatre have been featured over the years. There have been questions about whether inviting these companies to Hong Kong is worth the resources devoted to these projects. However, box office revenues for most of these productions have been positive because audiences recognise the high quality of the HKAF's opera programmes. Because of the lack of resources, large-scale operas have not been available at the Festival every year. But the Festival also featured many ground-breaking operas. One major breakthrough in the 1990s was the Canadian Opera Company's production of *Bluebeard's Castle*, directed by Robert Lepage. This opera by Béla Bartók was relatively unknown at the time. Although the box office was not ideal, it was a treasured opportunity for Hong Kong audiences to explore these innovative operas."

- Tam Wing-pong, member of Programme Committee

Gustavo Dudamel
Superstar Conductor

Born into a musical family in Venezuela, at the age of 18, Dudamel was already conducting the country's Simón Bolívar Symphony Orchestra. He went on to become conductor of the Los Angeles Philharmonic (LA Phil) as their youngest-ever chief conductor. After his rise to international fame, Dudamel continued to be Music Director for the Simón Bolívar Symphony Orchestra, ushering the group into the international arena.

Dudamel and the Los Angeles Philharmonic embarked on an Asian tour in 2015. For their Hong Kong debut, they performed two concerts at the HKAF. Dudamel recalls coming to Hong Kong with an open mind and open heart, and a feeling of excitement: "Hong Kong is like no other city in the world, it has such an incredible sense of movement and hyperactivity. It was an unforgettable experience to perform with the LA Phil at the stunning Hong Kong Cultural Centre, playing Mahler, Dvorak and *City Noir* by my dear friend John Adams. I fondly recall how warm the people of Hong Kong were, and how the high-octane energy pushed us all to new heights of music-making. It was memorable to see how connected everyone was to the music, and of course I must mention

更好，以音樂連繫彼此，是難忘的共同經歷。當然我也不會忘記香港的美食。」杜達美說：「香港藝術節是世界上最重要的藝術活動之一，豐富了香港，以至來自世界各地不同人的城市生活。」

杜達美一直相信音樂能改變世界，多年來推動音樂教育。2012年成立的杜達美基金，把音樂藝術帶給基層兒童。「我們相信音樂能夠帶來改變，從而令我們成為更好的世界公民。音樂帶給我們創意、專注與開放包容，令我們培養專注力、重視紀律，這些都是成為未來領袖的先決條件，從而建立更美好的社會。基金會在世界各地把無數的年輕音樂家聚集起來，推動這件美好的事情。」

杜達美在2021年剛成為巴黎歌劇院的音樂總監，希望下次有機會再次來港，為香港觀眾帶來歌劇作品。

how delicious the food was!" Dudamel considers the HKAF to be one of the world's greatest arts festivals: "It enriches the culture of the city so much, and the people of Hong Kong, as well as the world."

With a steadfast belief that music can change the world, Dudamel has always been passionate about music education. In 2012, he established the Dudamel Foundation to expand access to music for underprivileged children. "We are driven by the belief that music can help us transcend our differences, and can make us better citizens of the world. The creativity, collaboration and openness that music instils in us can also encourage focus, discipline, and respect. It is all of these qualities combined that make the leaders of tomorrow and build a better society. We have created programmes around the world that have brought thousands of young musicians together in harmony to move this wonderful initiative forward."

In 2021, Dudamel assumed a new role as Music Director of the Paris Opera, and Hong Kong audiences will certainly look forward to their next appearance at the Festival .

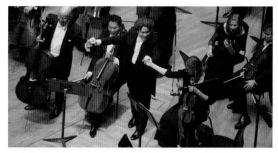

杜達美與洛杉磯愛樂樂團首度來港演出
Gustavo Dudamel and Los Angeles Philharmonic had debut performance in Hong Kong (2015)

杜達美利用虛擬現實技術將交響樂體驗帶到農村社區
Dudamel employs VR technology to bring the symphonic experience to rural communities (© laCaixa Foundation)

尼古勞斯・巴赫勒
巴伐利亞國立歌劇院

巴伐利亞國立歌劇院是世界著名歌劇院之一，早於 1653 年以慕尼黑為家，到今天，每年有超過六十萬觀眾入場欣賞超過三百場演出。2012年，藝術節把歌劇院經典歌劇《女人心》帶來香港，這是莫扎特和劇作家達龐特合作的三部作品的最後一部，被譽為是喜劇與精采旋律的完美結合，佈局勻稱，製作精良。2008年起擔任歌劇院總經理的尼古勞斯・巴赫勒(Bachler)，那次隨團來港，除了美麗的海港，還記得觀眾的笑聲。「觀眾反應很熱烈，充滿歡樂氣氛，此劇的確有很

Nikolaus Bachler
Bayerische Staatsoper

The Bayerische Staatsoper is one of the world's leading opera houses. Founded in Munich in 1653, it attracts around 600,000 people to more than 300 performances every year. In 2012, the HKAF presented the Bayerische Staatsoper's production of Mozart's classic opera *Così fan tutte*. The last of the three works Mozart wrote in collaboration with librettist Lorenzo da Ponte, *Così* is believed to be the *ne plus ultra* of the *opera buffa* form. The opera is esteemed for its mix of comedy and gorgeous melody, and has been acclaimed as a theatrical work of fine, symmetrical construction. General Manager of the Bayerische Staatsoper since 2008, Nikolaus Bachler

《女人心》*Così fan tutte* (2012)

多有趣的元素，很高興觀眾明白到整齣歌劇的佈局。不過令我最難忘的是，中場休息期間，一位觀眾主動前來跟我傾談，討論關於莫札特的事，發覺他對莫札特的認識比我更深，知識非常豐富。而在我看來大部份觀眾也很開放，演出期間都是非常美好的時光，很希望再有機會重臨。」

原本歌劇院於2020年二度來港，演出李察・史特勞斯《拿索斯島的亞莉安妮》，無奈疫情關係被迫取消。「這些日子全世界都是艱難，我們沒有停下來，依然繼續工作，做了很多網上節目，透過新的渠道接觸了很多新觀眾，我們還做了一個叫『星期一音樂會』的免費網上節目。線上放映無疑是令我們更容易接觸世界各地更多觀眾，也因為巡演困難，必須尋找另一個形式與海外觀眾見面。當然我們都知道現場演出是無可替代，因為必須要與觀眾溝通，正如當天在香港演《女人心》，讓我們即時感受到觀眾的熱烈反應。」

Bachler 2021年7月離開巴伐利亞國立歌劇院，之後加入薩爾茲堡音樂節擔任藝術總監。離別之際，他說：「期望繼續與藝術節連繫，把有趣的東西帶到香港。我認為任何藝術節必須要有鮮明的個性，要建立獨特的標記，同時要為所在的地方帶來最好的東西，一些一年只看到一次的節目，我想這是關鍵所在。」

came to Hong Kong for the production. He was amazed by the splendour of Victoria Harbour and found the audience's laughter unforgettable: "The audience had so much fun and were so full of joy. This opera had lots of comic elements and I was very surprised the audience understood so well what was behind the whole scene. I also remembered very well that, during the intermission, one audience member came up to me and talked about Mozart. He knew everything about Mozart - probably more than me. I had the feeling that the audiences were very open. We had a really good time, and we were looking forward to come back."

The Staatsoper was supposed to visit Hong Kong again in 2020 with Richard Strauss's *Ariadne auf Naxos*, but the performance was unfortunately cancelled due to the pandemic. Bachler says: "For the whole world, it was very difficult. We never stopped working and presented online programmes, which allowed us to reach a lot of new audiences. We also present a free online programme called the 'Monday Concert'. The online presentations let us reach audiences from around the world. Because of difficulties of touring, this is another way to reach overseas audiences. Of course, we're not giving up live performances. They will always be there because it is a dialogue with the audience. What was so nice in Hong Kong with *Così fan tutte* was the immediate responses we received from the audiences."

In July 2021, Bachler left the Staatsoper and joined the Salzburg Festival as Artistic Director. "I hope to maintain connection with the HKAF, and bring something interesting from Salzburg to Hong Kong," says Bachler. "I believe an arts festival should have a character of its own and a special identity. It is very important to do something special, the very best that you won't see for the rest of the year. I think this is the key."

李察・史特勞斯《拿索斯島的亞莉安妮》
Richard Strauss's *Ariadne auf Naxos* (2020) (© W Hösl)

伊里·克爾曼
捷克布爾諾國家歌劇院藝術總監

2017年藝術節首次邀請捷克布爾諾國家歌劇院來港演出，把捷克最著名的作曲家里奧斯·楊納傑克 (Janácek)介紹給香港觀眾。楊納傑克與布爾諾感情深厚，不僅是因為楊納傑克在那裏渡過大半生，更是因為楊納傑克在布爾諾積極推動當地文化發展。2014年為紀念楊納傑克一百六十周年誕辰，捷克布爾諾國家歌劇院上演了最受歡迎的歌劇《馬克普洛斯檔案》—— 一個不死女人的傳說。

2017年香港藝術節上演《馬克普洛斯檔案》，成為亞洲首演，歌劇院的藝術總監伊里·克爾曼(Heřman)認為那是一個很難忘的經驗。「在布爾諾大部份觀眾都認識這個作品，而且也看過不同的演繹，所以他們會在當中尋找新的元素。香港卻是首次認識，雖然是第一次觀看，但觀眾的反應很投入。這齣歌劇非常特別，故事有點複雜，即使捷克人也要花點時間理解故事，但我很驚訝香港觀眾很努力去看字幕聽音樂，甚麼時候笑、甚麼時候要有反應，掌握得非常準確。捷克觀眾會思考是否在歌劇演出時可以笑，所以很多時留到最後才拍掌。但香港觀眾的反應卻是即時，感受給與演出者的連繫，我想Janácek看到如此反應也會很興奮。事實上他的音樂是很強烈和直接的，不須明白語言也感受到其魔力，音樂正是我們共通的語言。」

那年藝術節還有另一場楊納傑克精選作品音樂會，演奏了《小交響曲》、《永恆的福音》和《格拉高利彌撒曲》，讓香港觀眾對楊納傑克的音樂有更深的認識。「一直學習如何把我們的節目帶到世界另一邊的觀眾，這是很大挑戰，香港藝術節做得很好，花很多功夫去介紹我們的節目，令觀眾更易投入。2017年除了演出，由我們的首席指揮馬可·伊雲奴域舉行了工作坊，能夠在香港聽到年輕的樂手演奏Janácek是一個很難忘的經驗。」

Heřman在2016年首次來港，為2017年的演出作準備，順道也看了藝術節的節目，「印象非常難忘的是柏林廣播電台合唱團的《人的安魂曲》，這是一個很特別的演出，地點在香港大學陸佑堂。開始時我們被帶領進入禮堂，突然發現合唱團和歌手就在我們身旁，整個演出合唱團都在觀眾之間游走，非常獨特的體驗，令我難以忘懷。」

Jiří Heřman
Artistic Director, National Theatre Brno

On its first visit to Hong Kong in 2017, National Theatre Brno from the Czech Republic presented Leoš Janáček, the country's most famous composer, to Hong Kong audiences. The close ties between Janáček and Brno stem not just from the fact that he spent most of his life in the city, but also because he was partly responsible for the basic development of Brno's cultural life. To commemorate the 160th anniversary of Janáček's birth in 2014, National Theatre Brno presented *The Makropulos Case*, the composer's most popular opera.

The performance of *The Makropulos Case* at the HKAF three years later was its Asian premiere and also an unforgettable experience for Jiří Heřman, Artistic Director of National Theatre Brno: "Here in Brno, as people have seen many interpretations and everyone already knows how it should be, people will mostly be looking for what new elements there will be in our productions. But somehow in Hong Kong, even though it was the first time audiences got to see the piece, I remember there were still a lot of great reactions during the performance. This opera is very special because there is a lot of text, which sometimes can mean it is quite complicated to understand the story at first, even for Czech people. And I was so surprised that the Hong Kong audiences were so focused, to follow the surtitles and music simultaneously. They reacted very precisely where they were supposed to laugh or to have certain reactions. People here in the Czech Republic react differently and some people would think that it is not good to laugh during an opera performance. So they wait till the end to laugh or to clap. Hong Kong audiences, however, were so spontaneous. I felt that they were very connected with the artists on stage, the texts and the music. I think Janáček would be happy to see how live reaction could be with his music. Janáček's pieces are very strong and straightforward and the audiences are in it even without understanding the words sometimes. It shows that music is a universal language."

In the same year, the Festival also presented a concert of masterpieces by Janáček, including *Sinfonietta*, *The Eternal Gospel* and *Glagolitic Mass*. The programme deepened Hong Kong audiences' understanding of Janáček's music. Heřman says: "We always have to learn how to cater to audiences on the other side of the world. It is always challenging to prepare our audience, which I think the HKAF does a great job of, as they made very good introductions to the performances. In addition to the 2017

歌劇院與藝術節合作愉快，捷克音樂為藝術節帶來新色彩，2021年再度合作，可惜因疫情關係，改為網上演出。「第二年參與藝術節，原本帶來一個特別的節目，馬爾蒂努的《希臘受難曲》，計劃與香港兒童合唱團合作。節目取消實在有點不開心，因為能夠來到香港介紹捷克的音樂和歌劇對我來說是非常重要的事。幸好也把《耶奴法》、《狡猾的小狐狸》及《失蹤者的日記》改作網上播放，最終也能夠與香港觀眾見面。網上演出其實是另一種體驗，坐在劇院看演出，會感受到舞台上的能量，台上與台下的交流。而網上放映好像在看另一個節目，因為會注意到一些在現場看不到的細節，這也是網上節目可取的地方。」

《耶奴法》 *Jenůfa* (2021) (© Patrik Borecký)

《馬克普洛斯檔案》 *The Makropulos Case* (2017)
(© Hong Kong Leisure and Culture Department)

《狡猾的小狐狸》 *The Cunning Little Vixen* (2021) (©Marek Olbrzymek)

performances, we had a workshop conducted by our music director, Marko Ivanovic. It was a great moment when the young instrumentalists in Hong Kong played Janáček."

Heřman visited Hong Kong for the first time in 2016 for work meetings in preparation for the 2017 performances, and attended HKAF's programmes during his trip: "One production that I found quite memorable was Brahm's *Human Requiem*, presented by Rundfunkchor Berlin. It was held in Loke Yew Hall at the University of Hong Kong. I remembered we were led into the hall, and suddenly we realised the choir and the singers were among us. The show started and they were moving among us. The unique experience was simply unforgettable."

National Theatre Brno has had a great working relationship with the HKAF and the Festival has been enriched by the introduction of Czech music. For the second collaboration in 2021, performances were moved online because of the pandemic. "In our second time at the Festival, we were supposed to come with a very special production of Bohuslav Martinů's *The Greek Passion*, which would also feature the Hong Kong Children's Choir. I felt really sad at first, because to come to Hong Kong and to present Czech music and Czech opera is something really special for me personally. On the other hand, we were still able to present other productions, including *Jenůfa*, *The Cunning Little Vixen* and *The Diary of One Who Disappeared* online to Hong Kong audiences. It is another experience entirely to see online performances, because when you sit in the auditorium, you feel the energy coming from the stage to you. There is somehow an exchange of this energy. However, when we record a performance, it guides the view of the audiences with details they don't see all the time. These are some nice things about online performances."

風格多樣的劇場世界

在藝術節呈獻的劇場及作品，可以看到傳統經典的表演藝術，亦可以找到前衛破格的名字，一直走來，藝術節期望不斷創新、尋索，旨在擴闊觀眾的視野。

布利斯托爾老域劇團
藝術節的老拍檔

歷史悠久的布利斯托爾老域劇團與香港藝術節有深厚的關係，早於 1973 年是首個參與藝術節的海外劇團，讓香港觀眾欣賞到優秀的英國傳統戲劇。輾轉五十年，劇團經歷不同階段的發展，依然與香港藝術節保持緊密聯繫，經常帶來創新劇目。劇團的藝術總監湯·莫里斯(Morris)表示香港藝術節一直是他們的重要夥伴。

Morris 2009年加入布利斯托爾老域劇團擔任藝術總監。「我第一個任務便是翻新歷史悠久的劇院，同時重建劇團的定位和未來動向。當翻查歷史，發覺劇團早於六、七十年代已開始與國際有緊密的聯繫，例如參與首屆香港藝術節。」Morris 表示劇團有段時期與國際間的聯繫似乎是停頓了。「我們是英國持續營運最久的劇團，政府在 1946 年成立藝術局時，劇團是首個在倫敦以外獲資助的。然而有一段日子政府的文化藝術資助削減，此外劇院的建築久遠，不少設備已不合時宜，2007年劇院需要暫時關閉。」劇團重新出發，Morris 強調重建與國際的連繫是重要的一步。「在我加入前，行政總監 Emma Stenning 與藝術節已經緊密的接觸，而藝術節的蘇國雲也曾看過我為國家劇院執導的作品，特別是《戰馬》，更是由他幫忙引進到中國內地。」

A Refreshing Variety of Theatre

A staggering variety of theatre companies have featured at the HKAF over the years, with their works ranging from classics to contemporary plays by leading avant-garde visionaries. The Festival never slackened in innovating and exploring works that expand audiences' horizon.

Bristol Old Vic
An Old Partner of the HKAF

The historical Bristol Old Vic and the HKAF enjoy a long-standing relationship. The Old Vic was the first-ever theatre company from abroad to take part in the Festival in 1973, bringing top-quality productions to Hong Kong audiences. The company has undergone many changes over the past 50 years and continues to maintain close contact with the Festival, presenting a range of innovative programmes. As Tom Morris, the Bristol Old Vic's Artistic Director, says, the HKAF continues to be an important working partner of the theatre.

Morris joined the Bristol Old Vic as Artistic Director in 2009. "When I arrived, my top priority was really to rebuild the historic theatre, and to rebuild its positioning and future development. Looking back at our history, the international reputation of the theatre in the 1960s and 1970s was very strong, part of which was having the great honour of being invited to the first HKAF." According to Morris, the company's international connections appeared dormant earlier: "We are the longest-operating theatre in the UK. When the British government set up the Arts Council in 1946, ours was the first theatre outside London they decided to subsidise. There was a period of reduced funding in British theatre, starting around that time. Also, the theatre building was no longer fit for purpose and actually had to close temporarily in 2007." As the Bristol Old Vic

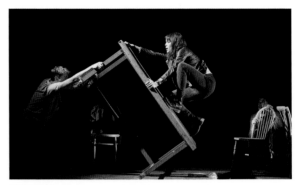

《攀越冰峰》 *Touching the Void* (2019) (© Geraint Lewis)

長久的合作關係是一點一滴慢慢建立，也要遇上適當的時機，2012 年的《神醫》再次連繫了劇團與藝術節。其後，聯同南非木偶劇團的《仲夏夜之夢》(2014)，是布利斯托爾老域劇團的一個大製作，曾到美國多個城市和韓國巡演。兩年後藝術節與英國國家劇院聯合製作的《簡愛》，導演莎莉・庫克森將經典小說搬上舞台。2019 年 Morris 的《攀越冰峰》將真實故事變成劇場作品，緊扣著觀眾。「這些作品都是透過視覺引發想像，以不同藝術形式引領觀眾思考和開拓想像空間。感謝多年來藝術節對我們劇團的興趣，還有香港觀眾的支持，讓我們能把不同類型的節目帶到香港。」

對 Morris 來說，巡演的意義不只是建立劇團的名聲，最重要的是可以接觸不同的觀眾。「因為每個地方的觀眾反應都不同。以《攀越冰峰》為例，作品是帶著某種痛苦和殘酷，原著有一幕是主角在死亡邊緣中掙扎，我和編劇大衛・葛利格設計了他在想像被姊姊折磨欺凌，也認為這個場面是有趣的。英國的觀眾大概也理解趣味所在，卻沒有表達出來。而在香港，觀眾的反應很直接，真的笑了出來。這便是巡演有趣的地方，令我們知道不同觀眾看同一作品也會有不同感受。所以每次演出其實是跟觀眾一起創作，成就一個新作品。現場的氣氛，觀眾的反應，對我們來說非常重要，而香港藝術節往往能製造這種氣氛。」

經常參與世界各地不同藝術節，Morris 直言香港藝術節是與眾不同，「不只是純粹搬演節目，由落機開始已讓人感受到親切的款待，人與人之間的真誠交流。相信這也是為何香港藝術節在國際間有一定的地位，讓不同的藝術工作者樂於成為一份子。」

became ready to re-establish itself, Morris stresses the significant step of rebuilding its international reputation and importance. "Prior to my joining, Executive Director Emma Stenning already had contacts with the HKAF. And it was So Kwok-wan from the HKAF who had seen some of my works at our National Theatre in London, including *War Horse*, and he helped us to take that show to Mainland China."

While a long-term partnership is built slowly over time, it is further strengthened when the right opportunities appear. The Old Vic's production of Brian Friel's *Faith Healer* in 2012 reconnected the group with the HKAF. It was quickly followed by a major production of *A Midsummer Night's Dream* (2014), with the Handspring Puppet Company. The production toured the United States and also played in Korea. Two years later, the HKAF presented *Jane Eyre*, Bristol Old Vic's co-production with the UK's National Theatre, the literary classic being brought to the stage by director Sally Cookson. In 2019, Morris adapted the non-fiction book *Touching the Void* for the stage. "These works have an appeal to the visual imagination of the audience, inviting them to see and imagine things that aren't there. We are grateful for the keen interest from the HKAF and for the support of Hong Kong audiences, which allowed us to bring a variety of programmes to Hong Kong."

For Morris, taking a show on the road is not only about establishing the company's reputation. The most important thing is to reach different audiences. "Everywhere you go, the audiences' response will be different. Take *Touching the Void* for example—there was a certain amount of cruelty and pain in the play. There was a scene where the main character is struggling to survive. The playwright David Greig and I, in our production, came up with a device that he imagines being bullied and tortured by his sister. David

2020年是艱鉅的一年，疫症令所有演出停頓下來，不過 Morris 取態樂觀，「疫情令我們有機會發掘新方向，例如為劇院添置最新的科技及技術，令劇場能夠適應今天的需要。在劇院被迫關閉的日子，這些便變成首要的任務，我們把資源投放在硬件上，讓劇團的節目傳送到世界各地，甚至可作現場直播。」本來2020年在藝術節上演的《大鼻子情聖》雖然取消了，但2022年藝術節卻帶來庫克森另一新作《奇蹟男孩》，見證另一頁創新合作。

《大鼻子情聖》 *Cyrano* (2020) (© Geraint Lewis)

《奇蹟男孩》 *Wonder Boy* (2022) (© Geraint Lewis)

and I thought this was quite funny. For the audiences in the UK, they thought it was a bit funny, but they didn't really laugh. But audiences in Hong Kong thought it was really funny and really laughed! And that's one of the joys of taking work internationally. You discover that what you have created really is forged in the minds of the audiences wherever you go. And you are creating a new work in collaboration with that audience. So the atmosphere within which the work is presented, within which the audiences are invited to come and experience the work is very important. That atmosphere is brilliantly curated at the HKAF."

Having taken part in arts festivals around the world, Morris finds the HKAF unique: "It is not just taking the work to be presented. You feel the quality of the HKAF's invitation, the hospitality and genuine exchange. When you arrive, you are welcomed as a person but not as a commodity. This is likely why the HKAF has a certain international stature with many artists glad to be part of the event."

As elsewhere in the world, 2020 had been a challenging year with many performances suspended due to the pandemic. Morris, however, is optimistic about the situation: "The pandemic has given us the opportunity to explore new directions. For example, we have equipped the theatre with the latest technology that allows us to meet the latest challenges. These initiatives became our top priority during the days when we had no audiences. We invested resources on the most up-to-date technical equipment including the ability to present our programmes to the world by live broadcast." *Cyrano*, originally scheduled for the HKAF in 2020, was cancelled. However, the new production by Cookson, *Wonder Boy*, was staged online in Hong Kong as a new page of innovation and collaboration with the Festival unfolds.

羅伯特・威爾遜
非凡破格的體驗

被《紐約時報》譽為「實驗戲劇界的偉人」的羅伯特・威爾遜 (Wilson)，他的舞台作品結合舞蹈、形體、燈光、雕塑、音樂、文字等多種藝術形式。藝術節四度上演他的作品，雖然我們可以都把這四個作品歸類為歌劇，風格卻是截然不同，《浮士德亮燈記》(1995)、《黑騎士》(1998)、《三毛錢歌劇》(2011)，還有《沙灘上的愛恩斯坦》(2013)，似乎很難找出適當的形容詞去描述這些作品。

「非常榮幸可以帶來不同類型的作品，每次的創作夥伴都不同，湯姆・魏茨跟菲力普・格拉斯的音樂就是兩種風格，貝爾托・布萊希特跟寇特・威爾都是世界級藝術，他們都是來自不同世界的前衛藝術家，在藝術節就是能夠呈現這些不同類型的作品。」Wilson 特別提到與柏林克貝爾劇院合作的《浮士德亮燈記》。「這是我在香港藝術節的第一個節目，當中有來自德國東部的學生，創作的時候，柏林圍牆剛倒下，他們當中有些不懂英語，只懂俄語，為了演出而學習英語。」

Wilson 成長於德薩斯，早年對設計和建築感興趣，後來搬到紐約，被當時一眾前衛編舞喬治・巴蘭欽、瑪莎・葛蘭姆吸引，慢慢走進表演藝術的世界。多年來在世界各地巡演，Wilson 認為藝術節對一個城市是很重要。「我認為很多城市也需要像香港有一個國際藝術節，通過藝術把不同語言文化的人聚集

《浮士德亮燈計》
Doctor Faustus Lights the Lights (1995) (© Gerhard Kassner Fotografie)

Robert Wilson
Mastermind behind Extraordinary Experiences

Robert Wilson has been lauded by the *New York Times* as a "towering figure in the world of experimental theatre". His works for the stage unconventionally integrate a wide variety of artistic media, including dance, movement, lighting, sculpture, music and text. Four of his works have been featured at the Festival: *Doctor Faustus Lights the Lights* (1995), *The Black Rider* (1998), *The Threepenny Opera* (2011) and *Einstein on the Beach* (2013). Although loosely classified as operas, these works differ greatly in style, defying categorisation.

"I've been fortunate to stage works that are very different from each other with different creative partners," Wilson says. "The music of Tom Waits is very different from Philip Glass. I've done *The Threepenny Opera*, by Bertolt Brecht and Kurt Weill. These are world art. They are all avant-garde artists from around the world. We've been fortunate to present works that are quite different from one another at the Festival." Wilson also talked about *Doctor Faustus Lights the Lights*, his collaboration with Berlin's Hebbel Theater: "This was my first production at the HKAF and included young students from the eastern part of Germany. It was shortly after the Berlin Wall came down. Some of the kids didn't speak English and only spoke Russian as a second language. They were only learning English to be in my play."

Born in Texas, Robert Wilson was interested in design and architecture in his early years. After moving to New York, he found himself drawn to the works of pioneering choreographers George Balanchine and Martha Graham, and gradually entered the world of performing arts. With his works having been performed across the world over the years, Wilson believes in the importance of having an arts festival in a city. "Cities need something like the HKAF. An international festival can bring people together, people of different languages, different backgrounds, different cultures. That's what makes the city unique. The HKAF is a window on the Western world. I wish that we would have more of the same in the city where I live, to have a window on what's happening in Mainland China or Hong Kong, to know what kind of theatre the young students are making. In America, we often tend to be very cut off. So, I think that the diversity of HKAF's programmes has been a window on the city and on the world."

《沙灘上的愛恩斯坦》
Einstein on the Beach (2013) (© Lesley Leslie-Spinks)

在一起，這樣才可以令城市變得獨特。香港藝術節是跟西方世界連接的一個窗口，我希望在我居住的地方，可以有類似的東西，能夠看到中國內地和香港的事，知道年輕的劇場人在做甚麼。在美國常常感覺被切斷，所以藝術節的多元化節目是城市與外面世界的一扇窗。」

要數 Wilson 的代表作，《沙灘上的愛恩斯坦》必定榜上有名。這個作品於 1976 年法國阿維農藝術節首演，當時觀眾的反應是不知如何是好，但卻乖乖坐在劇院看了四個半小時。2013 年作品重演，三十多年後，新的觀眾還是不知如何是好。「大家認為這個作品很當代很前衛，但以結構來說其實是很傳統，以四幕三個主題出發，當中以幾何的方程式作出變化，其實是非常數學的計算，就像古代中國、瑪雅和埃及的建築，也是根據幾何方程式。只是觀眾不習慣這種敘事方法，但最後其實都是關於音樂。」《沙灘上的愛恩斯坦》是部非敘事性、人工化的歌劇，其敘述功能從「講故事」徹底轉變為「體驗故事」，探討的是時間本身。「這是一個超越時代的作品，但我從來不會計算我的創作五十年後會是怎樣，這是一生一次的經驗，就像流星一樣，一閃即逝。」

作品可以超越時代，劇場的意義是否隨年月改變。「其實很難說，劇場像河流，有時順勢而行，有時遇上石頭衝擊，有時遇上風暴；也像大樹，有時落葉有時長新葉，但依然是那棵樹，依舊是那條河。我想這是很東方的思維，而我的作品大多靠近禪的哲學，反映了不同面向，因為永遠不只一個答案，而是可以有很多答案。對我來說，天堂與地獄不是兩個世界而是一體。喜歡劇場是因為能容納所有的藝術，繪畫、歌劇、舞蹈、音樂、建築，所有東西都可在劇場發生，或可以說在歌劇裡找到，歌劇的拉丁文，就是作品的意思。」

Einstein on the Beach counts as one of Wilson's masterpieces. When it premiered at the Festival d'Avignon in France in 1976, audiences at the time were unsure of how to react, but were nonetheless enthralled for the show's four-and-a-half-hour running time. When it was presented again in 2013, a new generation of audiences had the same indescribable reactions. "People described it as modern, contemporary and avant-garde. However, it is actually very traditional in terms of the structure. It's a work with four acts, with three themes that recur as themes and variations. It has mathematically a very classical structure, just like Chinese, Mayans and Egyptian architecture and was constructed with classical geometry. It just didn't tell a narrative which most people were thinking that opera should do. But it's like music. It was music." *Einstein on the Beach* is a non-narrative production in which the function of narrative has shifted completely from telling a story to experiencing a story. It is talking about time itself. "*Einstein on the Beach* was a product over time. My work is not about thinking about what it will be in 50 years from now, but it's something that happens once in your lifetime, and so it's like a shooting star that happens once and it will never happen again."

While a work may transcend its times, Wilson's view on theatre changing its significance over time is fluid and organic: "Theatre is like a river. It's always flowing and sometimes it goes over rocks, sometimes it's in a storm. It's also like a tree. Sometimes it loses its leaves, sometimes it has new leaves. But it's always the same tree, it's always the same river. It's a very eastern idea and my work is closer to Zen philosophy in which one can reflect in multiple ways. There's not one answer but many answers. Personally speaking, heaven and hell are not two worlds but one. What I love about the theatre is that you can have all the arts together. You have paintings, lights, opera, dance, music, architecture ... all the arts exist in theatre, and in what we call opera. In the Latin sense of the word, opera means opus or 'work'. So all the arts are there."

羅伯特·利伯殊
劇場魔法師

羅伯特·利伯殊(Lepage)被譽為「現代意象劇的煉金術師」，藝術節四度上演他的作品，不論是1995年的黑色戲劇《測謊機》、1996年的獨幕歌劇《藍鬍子城堡》，2003年的身兼編及導的獨腳戲《捕月》，還有2019年身兼編劇、設計、導演及演出的《887》，不同年代的作品，讓觀眾見證他的各種舞台魔法。他在劇場採用的新技術，徹底顛覆傳統劇場導演的規範。

雖然 Lepage 在2003年才隨演出來港，但香港以至中國傳統文化，早已影響他的創作。「在溫哥華有很多來自香港或廣東的移民，一直被他們的文化吸引著，感到與香港的連繫，所以溫哥華是我最喜愛的加拿大城市，因為能容納亞洲與西方兩種文化。這也是我很喜歡香港的原因，一個融合世界不同文化的地方。」生於魁北克的Lepage，笑言年青時是透過加拿大的華埠認識中國文化。「那時的認識很表面，接觸的方法也很幼稚，就是去華埠，所以《巨龍三部曲》(1985)是從加拿大三個華埠展開。可是我從未踏足中國，後來有機會到香港，然後再到上海和澳門，才開始認識中國文化。為了想認識多一點，於是開始學習看中國書法，後來經常去日本工作，學習日文漢字，所以在香港時也看懂一些中文字，沒有覺得自己像外人，那是非常有趣的體驗，開啟對中國文化認識之門。到了《藍龍》，展示了一個不同的中國，那時我已比較認識中國文化，我會說前作是浪漫，這個是現實。」

想不到Lepage從前的理想是當地理老師，「所以很多作品都是關於旅程，我也喜歡巡演，因為對文化地理地緣政治有興趣。」跨越地理文化，Lepage的創作也是跨越媒體。1994年創辦「機器神製作」(Ex Machina)，他希望名字裏不要有「劇團」一詞，因為「機器神製作」匯聚演員、作家、佈景設計師、技術人員、歌劇演唱家、布偶師、電腦動畫師、影像藝術家、雜技演員和音樂家，是一間跨界別的公司。製作團隊深信，表演藝術如舞蹈、歌劇、音樂，需與錄像藝術如電影、影像藝術、多媒體等結合。

Robert Lepage
Alchemist of Theatre

Hailed as an "alchemist of modern imagistic theatre", Robert Lepage has had four works featured at the HKAF. He made his HKAF's debut with the dark drama *Polygraph* in 1995, which was followed by a production of Béla Bartók's one-act opera *Bluebeard's Castle* in 1996. His next work at the Festival was the one-man show *The Far Side of the Moon* in 2003, which he wrote and directed. In 2019, *887*, which he wrote, designed, directed and performed was presented. His works from different eras attest to his wizardry on stage. Lepage has shaken the dogma of classical stage direction to its foundations, especially through his use of new technologies.

Although it was not until 2003 that Lepage visited Hong Kong with his performance, Hong Kong and Chinese culture have long become a character of his shows. "In Vancouver, there are many immigrants from Hong Kong and Guangdong. I was always very intrigued by the culture, and I know that it was very connected with Hong Kong. Vancouver is my favourite Canadian city because it is very Asian and very welcoming of both the Asian and Western worlds. And that's what I love about Hong Kong, which is like the platform of culture in the world." Born in Quebec, Lepage recalls with humour his exposure to Chinese culture through North America's Chinatowns. "My understanding of Chinese culture was not in-depth and the approach was very naïve, which was by visiting Chinatown. That's why *The Dragons' Trilogy* (1985) was about three different Chinatowns in Canada. But I had never been to China. I ended up knowing more about Chinese culture when I got the chance to go to Hong Kong, and then Shanghai and Macau. I became very intrigued and learned to read Chinese calligraphy. I got to work a lot in Japan and learned how to read Kanji. So I could read so many things in Hong Kong because I could read Kanji. I've never felt foreign, and all this is interesting. It opened my door to understanding Chinese culture. When I did *The Blue Dragon*, it was a very different China because I have already known more about Chinese culture. So the earlier one was more romantic, but this one is more realistic."

It may come as a surprise that Lepage once considered being a geography teacher: "That's why a lot of my work is about travelling. And that's why touring, for me, is the best thing in the world. I've always been very interested in cultures, geography and geopolitics." While crossing borders and cultures, Lepage

「現在劇場的製作方式像倒模，有一個既定制度，編導演等不同崗位，然後開始排練，就像烹飪一樣，每一道菜都是用同一個焗爐，同一溫度和時間製作出來，對我來說是不可能用莎士比亞的方法去製作美國驚嚇戲劇。不論那種烹調方法，時間是一個重要的元素。」

「我們會將排練時間拉長，一開始可能是連續排練五天，然後半年後團隊再聚在一起排練兩星期，再做一個階段性展演。我的創作有時是獨腳戲，有時是歌劇，因此創作過程也不盡相同，就像生命的誕生，人要懷胎十月，貓只需數星期，大象卻需時兩年。我以哥倫布為例，我是船長，有預感前方有陸地，但卻從來沒有去過，也沒有百份百保證一定存在，所以要怎樣令船上的人信任你，跟著你。如果過程中有人問我將要演出甚麼，我是不懂回答。」

不為演出下定義，但強調劇場的意義。「劇場就是一個社群的人看著另一個小社群的人在演出。表演藝術是唯一能提供一種與社群共存，人們想聚集在一起的感覺。二戰後德國被徹底摧毀，他們首要興建的便是劇院，因為人們需要聚在一起。2020 年疫症大流行，大家困在家看了一年 Neflix 精采節目，但還是需要入劇場，一起面對，感受台上台下的交流。我在台上，而你也在這裡，看著只發生在這一刻的演出，這正如佛學活在當下的概念。」

羅伯特．利柏殊《887》
Robert Lepage – *887* (2019)

also roams across different art forms in his work. In 1994, when Lepage asked his collaborators to help find a name for his new company, he had one condition: the word "theatre" could not be part of the name. Ex Machina is thus a multidisciplinary company bringing together actors, writers, set designers, technicians, opera singers, puppeteers, computer graphic designers, video artists, contortionists and musicians. Ex Machina's creative team believes that the performing arts including dance, opera and music should be mixed with recorded arts such as filmmaking, video art and multimedia.

"Theatre today is created in a mould. There's a production structure that is a hierarchy with posts including writer, director. And then you rehearse in a certain way as if every dish is baked in the same oven, with the same temperature and the same time. My idea is that you cannot cook Shakespeare's work and an American psychodrama in the same way. Regardless of the method of cooking, timing remains an important element."

"We spread over the hours of rehearsals. We might have five days of rehearsal and creation, and then goodbye; and people come back six months later, and then we do two weeks, and then we do a little work-in-progress presentation. Sometimes we do one-man shows and sometimes we do an opera. The shows all have different natures like the process of birth. A woman takes nine months to be fully pregnant but a cat takes a few weeks while an elephant takes two years. I compare it to Christopher Columbus. You are the captain of the ship, and have an intuition that there's a continent over there, but you've never been there, and you don't have any guarantee. You only have your intuition. So you have to convince the people on the boat to follow you. So when people ask questions about what my performances will be, I don't know and I never know."

Although the definition of a performance remains elusive, the significance of theatre cannot be over-emphasised: "Theatre is a community watching a small community of actors or artists perform. The performing arts is the only thing that carries the sense of community, the feeling that people want to get together. During World War II, Germany was completely destroyed. One of the first things they reconstructed were the theatres because the people needed to be together. During the pandemic in 2020, people spent a year watching Netflix and high-quality television series. But one needs to be at the theatre in person. I'm there on stage for real, I'm there here and now, and you are the here and now looking at my show, and what was happening is something that can only happen now. So it's very Buddhist, to live in the now."

合家歡節目增節慶氣氛

「Festival」就是節慶的意思，要有歡樂的氣氛，也要讓人大開眼界。藝術節積極打開藝術之門，將一些跨越藝術界別、富娛樂性，適合一家大小的大型節目帶來香港，令藝術節更具節慶的熱鬧氣氛。例如戶外節目《聲光園》、《幻光動感池》、《聲光頌》，還有《星躍馬術奇藝坊》和《藝裳奇幻世界》，吸引了不少新觀眾參與藝術節。

星躍馬術奇藝坊
創辦人巴爾塔巴

2008年，北京奧運會馬術項目在香港舉行，成為當年矚目盛事。藝術節也在這一年特別獻上法國頂尖馬術劇團星躍馬術奇藝坊的亞洲首演《巴圖塔》，一個糅合馬術表演與劇場藝術的節目。《巴圖塔》不只是一場具豐富娛樂性的演出，更是藉著人與馬匹的演出帶出愛與尊重的信念。

「香港的演出非常難忘，特別那個在海旁搭起美麗發亮的帳篷。」在紅磡渡輪碼頭旁的演出，一連三十二場，吸引了超過四萬名觀眾。《巴圖塔》是星躍馬術奇藝坊最大型的一個演出，整個演出團隊有四十五匹馬及五十位工作人員。創辦人巴爾塔巴

星躍馬術奇藝坊 –《巴圖塔》
Zingaro – *Battuta* (2008)

Festivity with Family Programmes

The Latin root of the word "Festival" is about being festive and joyful. The HKAF, while making the arts more approachable, also offers awe-inspiring experiences by bringing many large-scale multi-disciplinary and entertaining family programmes to Hong Kong. Outdoor programmes including *Power Plant*, *Super Pool and Chorus* added to the festivity of the event over the years. There were also *Zingaro* and *World of Wearable Art* which helped to introduce new audiences to the Festival.

Zingaro
Bartabas, Founder

Being co-host of equestrian events of the 2008 Beijing Olympics was definitely one of Hong Kong's highlights that year. To celebrate the occasion, the HKAF presented the Asian premiere of *Battuta* by France's top equestrian theatre group Zingaro. *Battuta* is an entertaining programme that blends equestrian skills and theatre arts, and highlights the communion between humans and horses.

"I have a wonderful memory of *Battuta*'s tour in Hong Kong, especially the vision of the illuminated big top in the bay." Held near the Hung Hom Ferry Pier, 32 performances of *Battuta* were presented to an audience of over 40,000. It was Zingaro's biggest ever show, with about 45 horses and 50 people working on it, and the company's founder, Bartabas is immensely grateful for the Festival's support. "It was a huge honour to come to Hong Kong and take part in the HKAF. Bringing our work to the other side of the world, especially knowing the logistical and financial stakes that Zingaro represents on tour, including transporting 45 horses by plane, tons of equipment by boat and sanitary constraints ... it was such an adventure."

Zingaro means "Gypsy" in Spanish and Italian, and was named after Bartabas's favourite horse. While Zingaro is often described as "equestrian theatre", the programme has already broken free of conventions in theatres. *Battuta* is also a tribute to the Balkan Gypsy culture: "I wanted to work on the notion of speed, freedom, danger, and Balkan gypsy music seemed to be the most appropriate because it is obviously linked to these different notions. I decided to musically surprise our audiences with the crossing and unexpected opposition of two musical groups, the brass of the Shukar band from Moldova, and a string ensemble, the Taraf, from Transylvania." Through the two music styles, Bartabas emphasises the show's exploration on themes of freedom and

(Bartabas) 非常感謝藝術節的支持。「很榮幸可以來港參與藝術節，要把演出帶到地球的另一邊，完全明白到整個製作過程的艱鉅及財政負擔。想想要把四十五匹馬運送到香港，還有配套工具、設施，又要顧及衛生環境，回想過程真是讓人捏一把汗，為了把演出帶給更多的觀眾，當中的壓力和風險有時真的令人很焦慮。不過當想到能夠吸引無數觀眾來欣賞，便成為推動我們的力量，也很有信心可以繼續下去。」

星躍馬術奇藝坊英文原名「Zingaro」，在西班牙語和意大利語意為「吉卜賽人」，以創辦人Bartabas之愛駒命名。奇藝坊常被形容為「馬術劇場」，但它的節目已跳出劇場的框框。而《巴圖塔》更是向吉卜賽文化致敬之作。「我希望透過演出表達速度、自由與危險的概念，以吉卜賽音樂連結似乎是最恰當。所以我以兩隊音樂組合給觀眾驚喜，摩爾多瓦之舒卡銅管樂隊及特蘭西瓦尼亞之塔拉夫弦樂隊，兩種風格截然不同的音樂交換碰撞，拼出刺激的氣氛。」Bartabas 透過這兩組音樂深化《巴圖塔》關於自由和危險的主題。Bartabas 認為有自由，就必定有危險。「真正的自由觀念，是對明天的不確定。而危險也來自速度，正好體現在馬術表演中的馳騁。在大眾心目中，奔馳的馬就是自由的象徵。Bartabas 正是從此出發構思這個演出，而當中最大的挑戰，就是要讓觀眾屏息靜氣，去感受漸強節奏，萬馬奔馳，血脈沸騰的氣氛。」

星躍馬術奇藝坊的演出集合了馬術、舞蹈、世界音樂、詩歌以及各種不同的藝術，無論哪種形式，Bartabas 表示用意都是抒發情緒，引領觀眾開啟一趟旅程。「對我來說，從來也不太確定創作的起點在哪裡。不過為何我會做這一種馬術劇場，首要條件是明白遊牧的生活模式，他的自由與限制，自由可以是一切，卻也必然帶來某種不安。我們開創了一個新方向，卻不知往哪裡去，可是我們不會問未來如何，只會努力活在這一刻。」

奇藝坊成立的宗旨之一，就是要在人馬之間達致崇敬、尊重和平等的關係。「我們是一個半人半馬的部落，與馬匹一起生活一起工作，維持相依相伴的關係。很喜歡部落這個字，它代表了一群獨立的個體，信守不明文的契約，懷著相同夢想，互相扶持，一起闖蕩生命旅程。我喜愛看到我們的成員成長，喜歡看到他們爆發潛力，馬匹也是一樣，不只在工作時，也在日常生活，一起隨著年月成長。」

星躍馬術奇藝坊 –《巴圖塔》 Zingaro – *Battuta* (2008) (© Antoine Poupel)

danger. According to Bartabas, there is no freedom without danger: "True notion of liberty consists of not knowing what tomorrow will bring. This evocation of danger also comes out of an idea of speed, which manifests itself in the equestrian form as a gallop. In the collective imagination, a galloping horse epitomises the notion of freedom. From these observations was born the idea of the show. One of the show's challenges was to hold the audience's attention to experience the escalating rhythm and atmosphere of the spirited horses galloping at full force."

The shows of Zingaro Theatre combine equestrian theatre, dance, world music, poetry, and many other art forms. According to Bartabas, they are all vectors of emotions and invitations to travel: "It is always hard to determine how it started. To invent a form of show like ours, an equestrian theatre, we must first accept the nomadic life that goes with it, its freedoms and its constraints, the freedom that is the essence of all but that also involves some discomfort. We were opening a new path, without necessarily knowing which one. We live in the present when there was neither question of projects nor future."

One of the founding visions of Zingaro is to highlight how reverence, respect and equality define the relationship between human and horse. "Zingaro is a tribe which is half-human, half-horse. We live and work with our horses, it is a relationship based on companionship. I like this word, tribe. It indicates that its members obey unwritten laws, those of very independent people who chose to live the same adventure, to work together in the same dream factory, and to offer what they made there to others. I love seeing people of the company evolve over time; I love seeing them 'bloom', as we say about horses; not only through work but also in their daily lives, through the intensity of their presence and their relationship with time."

《藝裳奇幻世界》 *WOW* (2012)

《藝裳奇幻世界》
創辦人蘇絲‧孟可芙

不只是看得見的藝術，還是穿得上的藝術。《藝裳奇幻世界》(*WOW*)
的創辦人蘇絲‧孟可芙(Moncrieff)1987年在尼爾遜城首次
公演，目的是為了宣傳當地一間藝廊，她把藝術品從牆上拿下
來，再利用現場舞台表演，把它重新展現出來。今天 *WOW* 已成為
新西蘭一年一度，集設計、時裝與舞台表演的盛事，體現「把藝術
品從牆上拿下來，展示在模特兒身上」的概念。在2012年更首次
衝出新西蘭，現身香港藝術節。Moncrieff 認為那次是很成功的
文化交流。「藝術節給與我們無比的支持，來自新西蘭的模特兒
和舞者跟香港的表演者合作得非常順利，台前幕後也相處融洽，
是一次很好的經驗。」

歷時七十分鐘的節目，取材自新西蘭最具代表性、而且最精采的
《藝裳奇幻世界》得獎作品表演，為觀眾展示出超過一百多套
《藝裳奇幻世界》最珍而重之的傑作，當中包括了選自香港知專
設計學院畢業生的優秀作品。「我們揀選了 *WOW* 多年來最精采的
作品，並加入一些代表香港文化的元素。當然從實際的層面出發，
也要容易攜帶，方便演出。不過總的來說，就是希望能吸引更
廣泛的觀眾，例如展示我們傳統的原住民毛利族系列，潮流時尚
多一點的前衛系列，還有沒有特定主題的自由發揮系列，利用
紫外光燈的光影幻象系列等等。」

World of Wearable Art
Suzie Moncrieff, Founder

Art is not merely to be seen but to be worn, too. Suzie Moncrieff,
founder of *World of Wearable Art* (*WOW*), staged the first *WOW*
show in Nelson in 1987 as a promotion for a rural art gallery
when she had the vision to take art off the wall and exhibit it as
a live theatrical show. *WOW* is now an annual iconic event of
New Zealand, a show that celebrates design, fashion and
theatre with designers from around the world creating eclectic
interpretations of "taking art off the wall and onto the human
form". *WOW* was presented outside New Zealand for the first
time in 2012 at the HKAF. Moncrieff considered the occasion a
beautiful cultural exchange: "The HKAF gave us incredible support.
It was a most positive experience and we enjoyed integrating our
New Zealand models and dancers with the local Hong Kong
performers. It was a beautiful cultural exchange right through to
the tech crews working with us. It all ran very smoothly."

The 70-minute performance showcased over 100 top garments from
the World of Wearable Art Awards Show. The show also included
outstanding works by graduates of the Hong Kong Design Institute.
"I chose our top garments from our historic collection spanning
many years of *WOW*. On a practical level, we also chose garments
that could be performed easily and that travelled well. On a whole,
I chose the sections with appeal to a wide audience which included
the Aotearoa section portraying and celebrating our indigenous
Māori culture, Avant Garde which is more fashion inspired,

當日演出也招募了多位香港模特兒、舞蹈員和小孩等參與。Moncrieff 特別記得這班香港的小孩。「他們首次參與這類演出，表演得非常興奮雀躍，去揀選適合角色的服裝，特別記得一位穿上龍服裝的女孩，非常美麗，更成為了香港的宣傳照。」這是 WOW 首個海外大型演出，Moncrieff 說香港演出後反應不錯，「令國際間更多人認識 WOW 這個獨特品牌。隨後更舉辦大型的 WOW 展覽，到美國、澳洲、俄羅斯等地。我們每個成員都在香港得到了一個開心愉快的旅程，不少舞者與香港的演出者成為朋友，小孩也跟我們保持聯絡。我們此後的比賽也吸引了香港人參加，日後希望加強與香港知專設計學院的合作。當然未來若再次舉辦大型國際展覽，也期待再度來港。」

《藝裳奇幻世界》 WOW Show (2012)

Open Section, which has no theme with more creativity and the Illumination section where garments were seen in the dimension of UV light."

Many Hong Kong models, dancers and children were recruited for the performance, and Moncrieff remembered the Hong Kong children quite well: "The Hong Kong children involved had never done anything like the WOW show. They were wonderful to work with and took on the character of their garment with much passion. I remember one child who wore a dragon costume, and she portrayed the character of it so beautifully. It was used in the Hong Kong advertising campaign."

Moncrieff was thrilled with the attendance of the Hong Kong performance, which was WOW's first major overseas performance at the time: "It helped increase the global awareness and credibility of our WOW brand. This spurred us on to create our international travelling WOW exhibition, which went to the United States, Australia and Russia. Our members all enjoyed their trips to Hong Kong. Some of our models and dancers are still in touch and remain friends with the Hong Kong performers today. And some of the children are still in touch with us. We received entries from Hong Kong in our subsequent competitions, and we look forward to stronger collaboration with the Hong Kong Design Institute. If we were to hold large-scale international exhibitions in the future, Hong Kong will be top on our list."

（二）享譽國際舞台的傑出華人

香港藝術節為兩岸三地的藝術家搭建了交流展示的平台。隨著內地改革開放，香港迎接1997年回歸，香港藝術節在由八十年代陸續帶來很多內地的節目，由當年新晉作曲家像郭文景，到特色音樂新疆木卡姆、麗江大研納西古樂會，還有戲劇、舞蹈、地方戲曲等等，透過在藝術節的演出，增強和內地的文化藝術交流，讓亞洲以至世界各地的觀眾認識中國的表演藝術。用優秀的劇目展演，為中國文化的輸出和展示，做出積極的貢獻。

本地藝術方面，藝術節與香港的藝文發展息息相關。七十年代中期至八十年代，本土藝術文化還在萌芽階段，藝術節的本地節目部份，主要由當時幾個較大的藝團提供節目，包括香港管弦樂團、香港中樂團、香港話劇團、中英劇團等。隨著本地藝團發展成熟，演藝學院畢業生陸續加入演藝圈，令台前幕後增加了大量具潛質的新力軍，藝術節持續以委約、自主創作、聯合製作等方式，積極發展原創作品，成了一個推動本地創新的搖籃。

林懷民
雲門舞集創辦人

「香港藝術節跟雲門是同年誕生，是亞洲最早的藝術節之一。」2019年年底正式從雲門舞集退休的林懷民，總結雲門的過去，同時也回望一同成長的香港藝術節。

雲門早於1975年已來港演出，「雲門在兩歲時已來香港，在利舞台的演出引起很多迴響。」八十年代以後，雲門來港超過二十次，當中三度到訪藝術節，分別是2000年的《焚松》、2006年的《行草三部曲》，以及2019年的《雲門舞集45週年林懷民舞作精選》，都是為藝術節精挑細選雲門不同階段的重要作品。「《焚松》是迎接新世紀的一個作品，1999年12月31日在台北首演，演出完結後敲響鑼鼓，迎接二十一世紀。《行草三部曲》，當中有一兩部曾經在文化中心演出，藝術節卻是一次過演出整個系列。2019年那個就是我退休前的作品總結。」

《焚松》以藏人焚松祈福，同時觀視松煙走向，占卜未來，透過舞蹈為世人祈福，千禧年前夕在台北首演，第二站便來到藝術節。

「行草三步曲」 *Cursive: A Trilogy* (2006)

「行草三部曲」分別於2003年首演的《行草》、《行草 貳》及2005年首演的《狂草》，是雲門舞集長年探索東方美學與傳統動作的成果。《雲門舞集45週年林懷民舞作精選》總結了林懷民不同階段的創作歷程。

除了舞團的演出，林懷民也會在來港期間，抽空看看藝術節其他節目，「印象最深刻的是新疆卡姆藝術團的《十二木卡姆》(2000)。地點在大會堂，場地設計有點特別，觀眾像圍著演出者，頓時把這個表演的特色呈現出來，氣氛很熱鬧，觀眾看得很投入。曾經在其他地方看過木卡姆的演出，卻沒有做到這個效果。這正好看到藝術節特別用心，節目部的同事一定是到了新疆去看演出，考慮到原來的文化環境，所以才能把當中的意義和感覺呈現出來。由此可見藝術節揀選節目時不是看錄像，而是經常到世界各地看現場演出，這樣對一個藝術節是非常重要。這些作品好不好是一回事，但如何跟觀眾，跟文化環境連結是很重要。」林懷民認為藝術節總是跟世界的當代節目連接。「而只有香港的藝術節有那麼多中國節目，全世界很少藝術節有這樣的視野。而且香港觀眾很獨特，有不少見多識廣的觀眾。香港像一個混凝島，很城市化，是華人社會一個非常國際的社會，文化土壤是向外型的，跟台灣不一樣。」

「經歷半世紀，我相信雲門跟香港藝術節一樣，都有艱難的時刻。像我們1982年試過停業、2008年排練基地大火，但無論怎樣，我們都能走下去。」

2020年，隨著林懷民退休，由雲門2藝術總監鄭宗龍接任雲門藝術總監。

(2) Outstanding Chinese on the International Stage

The HKAF served as an important platform for facilitating exchanges and showcasing artists from Mainland China, Taiwan and Hong Kong. Following the reform and opening-up of Mainland China, the HKAF introduced a large number of Mainland programmes starting from the 1980s, a process that was accelerated after the reunification of Hong Kong with the Mainland in 1997. Programmes ranged from the then-emerging composer Guo Wenjing, special presentations of music from Mukamu of Xinjiang, and Dayan Naxi Ancient Music Association of Yunnan, as well as drama, dance and regional Chinese operas. HKAF's performances encouraged and strengthened cultural exchange with the Mainland and also allowed audiences in Asia and farther afield to gain a deeper appreciation of China's performing arts. The outstanding repertoire of works contributed to the export and showcase of Chinese culture.

The HKAF has also been closely linked to the city's arts development. In the 1970s and 1980s when the local arts sector was still in its formative stage, the Festival's local programmes were primarily supplied by a handful of larger arts groups, including the Hong Kong Philharmonic Orchestra, Hong Kong Chinese Orchestra, Hong Kong Repertory Theatre and Chung Ying Theatre Company. As the sector matured and grew in stature, and graduates of the Hong Kong Academy for Performing Arts also joined the performing arts scene providing new blood both on stage and behind the scenes, the HKAF provided a helpful platform for local talent. Through its commissions, productions and co-productions, the HKAF continues to develop original works, acting as a crucible for arts innovation in Hong Kong.

Lin Hwai-min
Founder, Cloud Gate Dance Theatre

"The HKAF and Cloud Gate were born the same year. It is one of the oldest arts festivals in Asia," says Lin Hwai-min, who officially retired from Taiwan's Cloud Gate Dance Theatre in 2019. He takes a look down memory lane at Cloud Gate's achievements as well as the HKAF, which grew alongside the company.

Cloud Gate first performed in Hong Kong as early as 1975: "Cloud Gate started to visit Hong Kong two years after it was founded, and its performance at Lee Theatre generated a lot of interest." From the 1980s on, Cloud Gate came to Hong Kong more than 20 times. Three of these visits were performances at the HKAF, namely *Burning the Juniper Branches* in 2000, *Cursive: A Trilogy* in 2006, and Cloud Gate Dance Theatre of Taiwan - The 45th Anniversary Gala Programme Retrospectives of Lin Hwai-min's Works in 2019. These were all milestone works carefully selected by the HKAF and represented Cloud Gate in different phases: "*Burning the Juniper Branches* was a work conceived to embrace the new millennium. It premiered in Taipei on 31 December 1999. When the performance ended, we played gongs and drums to celebrate the arrival of the 21st century. One or two programmes in *Cursive: A Trilogy* had been performed at the Cultural Centre earlier, but the HKAF programme was a presentation of the entire trilogy. The 2019 programme was a summary and retrospective of my work prior to my retirement."

Burning the Juniper Branches comes from the Tibetan custom of burning tree branches to convey prayers to the gods and to pave way for a better life. They also read the rising smoke for portents of the future. The dance was also a prayer for the world. *Cursive: A Trilogy*, consisting of *Cursive*, *Cursive II* – which premiered in 2003 – and *Wild Cursive*, which premiered in 2005, is a landmark series with ground-breaking movement style and original choreographic ideas inspired by Chinese aesthetics. Retrospectives of Lin Hwai-min's Works, on the other hand, chronicled the various stages of Lin's creative journey.

While performing at the HKAF, Lin also took time to attend other Festival programmes: "The most memorable performance I attended was *Mukamu Twelve* by Xinjiang Mukamu Art Ensemble (2000).

《雲門舞集 45 週年林懷民舞作精選》
Cloud Gate Dance Theatre of Taiwan – The 45th Anniversary Gala Programme Retrospectives of Lin Hwai-min's Works (2019)

It was held at City Hall and the set design was rather special, with the performers encircled by the audience. The uniqueness of the performance became evident with the arrangement, and the atmosphere was lively, with the audience strongly engaged. I have attended performances by Mukamu in other places but none of them had the same effect. This is testament to the Festival's careful attention in its programmes. The programme staff must have attended the performance in Xinjiang and taken into consideration its cultural background to extract the work's essence to its fullest. This goes to show how the HKAF selects its programmes by attending live performances instead of relying on recordings. This is highly important for an arts festival. Other than assessing the work's quality, how it connects with the audiences and the cultural background is quite important." According to Lin, the Festival has always been a bridge to contemporary programmes around the world: "Only the HKAF has such a rich offering of Chinese programmes and it has a vision rare among arts festivals everywhere. Hong Kong audiences are unique, with many of them having great insight and knowledge. Hong Kong is like a concrete island and highly urban. It is a Chinese society but very international, with its cultural growth in an outward orientation, which differs from Taiwan."

"After half a century, I am in no doubt that both Cloud Gate and the HKAF have had challenging moments. In our case, we halted operations in 1988 and our rehearsal studio was destroyed by fire in 2008. Nevertheless, we remain firmly rooted and continue on with our journey."

Cheng Tsung-lung, artistic director of Cloud Gate 2, succeeded Lin Hwai-min as Cloud Gate's artistic director in 2020 following Lin's retirement.

湯沐海
沉醉於歌劇的大千世界

自小在上海學習音樂，後來在慕尼黑進修的湯沐海，在八十年代初在國際間嶄露頭角。1982年應大師卡拉揚之邀指揮柏林愛樂樂團，自此開展了他的國際指揮生涯，成為當時歐洲炙手可熱的華人指揮家。香港藝術節在八十年代初已嘗試製作歌劇作品，1990年的《茶花女》便特別邀請了湯沐海擔任音樂總監及指揮，帶領香港管弦樂團演奏這齣經典歌劇。

「我對歌劇是情有獨鍾的，因為爸爸是導演，從小喜歡戲劇，喜歡看莎士比亞，在這樣的環境成長，令我對歌劇有特別的感情。」湯沐海曾於德國的柏林、漢堡國家歌劇院、瑞典斯德哥爾摩皇家歌劇院委任指揮，以及擔任芬蘭國家歌劇院首席指揮。

他指揮的歌劇劇目廣泛，包括《沒有影子的女人》、《杜蘭朵》、《玫瑰騎士》、《黑桃皇后》、《蝴蝶夫人》、《托斯卡》、《燕子》、《沙皇鮑里斯》、《費加羅的婚禮》、《茶花女》、《塞維利亞的理髮師》及《奧塞羅》等經典歌劇。湯沐海說歌劇是一個大千世界。「代表了對追求藝術的理想，不論是古典或是創新，抽象或現實的作品我也喜歡。最重要是跟導演和演員溝通，如何帶出新的意義。當年上演《茶花女》，我們把場景從巴黎換成上海，女演員穿的不是西服，而是中式長衫，就是一個有趣的意念。」威爾第出色的音樂，膾炙人口的茶花女故事，打破了地域和時間的界限，湊合了海外與本地的台前幕後精英，這個演出也特別為香港觀眾而設。

湯沐海（中）與小提琴家姚珏（右）及其女兒於第45屆藝術節閉幕禮
Muhai Tang (centre) with violinist Jue Yao (right) and her daughter at the 45th HKAF Finale (2017)

Muhai Tang
Revelling in the World of Opera

Muhai Tang studied music in Shanghai from a young age and furthered his conducting training in Munich. He arrived on the global music scene in the early 1980s and his international recognition began when Maestro Herbert von Karajan invited him to conduct the Berliner Philharmoniker. This led to engagements and invitations, making Tang one of most sought-after Chinese conductors in Europe. The HKAF started opera productions in the early 1980s, and Tang was invited in 1990 to be music director and conductor of the Hong Kong Philharmonic Orchestra for *La Traviata*.

"I have a special fondness for opera. Because my father was a director, I have always liked dramas and works by Shakespeare. Being raised in this environment led me to be particularly fond of opera." Tang has conducted at Berlin State Opera, Hamburg State Opera, Aalto Theater in Essen and Deutsche Oper am Rhein in Germany, Kungliga Operan in Stockholm, and served as Chief Conductor of the Finnish National Opera.

His repertoire includes *Die Frau ohne Schatten, Turandot, Der Rosenkavalier, Pique Dame, Madame Butterfly, Tosca, La Rondine, Boris Godunov, The Marriage of Figaro, La Traviata, The Barber of Seville* and *Otello*. He describes opera as a grand universe: "It is symbolic of the pursuit of the arts. I like all kinds of operas, whether they are classic or innovative, surreal or realist. What matters the most is the communication between the director and performers and bringing out new meaning from the work. When we staged *La Traviata*, for example, we changed the setting from Paris to Shanghai with the female performers wearing cheongsams instead of dresses. That was an interesting concept." Verdi's outstanding music coupled with the popular story of Camille transcended place and time and became an exceptional production tailored for Hong Kong audiences, featuring the best talents on and off stage from Hong Kong and abroad.

In addition to conducting *La Traviata*, Tang also conducted the Hong Kong Philharmonic Orchestra in concert at the HKAF in 1990. It was not until 2017 that Tang next appeared at the Festival with the grand opera *Dream of the Red Chamber*, a co-production by San Francisco Opera and the HKAF. *Dream of the Red Chamber* was an opera sung in English and an innovative work borne out of cultural exchange between East and West. The production featured a stellar ensemble of international Chinese artists, including the

《紅樓夢》歌劇　*Dream of the Red Chamber* (2017)

除了《茶花女》，湯沐海也為1990年藝術節香港管弦樂團的一場音樂會擔任指揮。直至2017年，三藩市歌劇院與香港藝術節聯合製作大型歌劇《紅樓夢》，湯沐海再次現身藝術節。這齣《紅樓夢》不只是英文歌劇，更是中西文化交流的一個創新之作。由蜚聲國際的華人藝術家攜手創作——著名美籍華人作曲家盛宗亮作曲及編劇，東尼戲劇獎得主黃哲倫聯合編劇，台灣戲劇大師賴聲川執導，奧斯卡金像獎最佳美術指導（《臥虎藏龍》）葉錦添擔任舞台及美術設計，曾參與電影《聶隱娘》的著名編舞家許芳宜負責編舞。「盛宗亮是上海的老朋友，他選取英文作為唱詞，刻意避去傳統的中國音樂色彩，我非常享受這一次的合作。」多年來穿梭於東西方，為不同的文化背景的觀眾演奏樂章，湯沐海說音樂是世界的，「不論是哪個國家，只要是優秀的音樂我也樂於演出。音樂家最想看的是觀眾的笑臉，美妙的音樂，動人的故事，都是真實的，音樂就是我的信仰。」

內地藝團與國際舞台的橋樑

田沁鑫
中國國家話劇院院長

香港藝術節在1986年帶來中國青年藝術劇院的《原野》，以曹禺的作品與香港觀眾見面，打開了藝術節與中國戲劇的連繫，隨後1997年有中央實驗話劇院的《棋人》。這兩個劇團於2001年合併組成中國國家話劇院。2005年，中國國家話劇院帶來《琥珀》；2007年，與香港藝術節及日本東京新國立劇場聯合委約與製作《下周村》，逐漸看到中國戲劇創新之路。

Chinese-American Bright Sheng as composer and co-librettist, along with Tony award-winning playwright David Henry Hwang as co-librettist; Taiwan's Stan Lai as director; Academy Award-winner Tim Yip as production designer and the celebrated dancer Fang-Yi Sheu, who choreographed the award-winning film *The Assassin*. Tang says: "Bright Sheng is an old friend from Shanghai. He chose to have an English libretto to avoid traditional conventions in Chinese music. I enjoyed the collaboration very much." Having travelled back and forth between East and West for many years to perform for audiences from diverse cultural backgrounds, Muhai Tang believes that music is universal in nature: "Regardless of the country, I will be happy to be there as long as there is excellent music to be performed. What music artists want most is satisfied audiences, beautiful music and stories that touch the heart. These are all authentic, and music is where my faith is."

Linking Mainland Arts Groups and the International Stage
Tian Qinxin
Director, National Theatre of China

China Youth Arts Theatre made its debut at the HKAF in 1986 with a production of Cao Yu's *The Wilderness*. This began the Festival's ties with theatre companies from Mainland China. It was followed by *Chess Man* by China National Experimental Theatre in 1997. The two theatre groups later merged as the National Theatre of China in 2001. The National Theatre of China presented *Amber* in 2005 and *Lost Village* in 2007; the latter was co-commissioned and co-produced by the HKAF and New National Theatre Tokyo. Directed by Li Liuyu and Oriza Hirata, the production featured cast and creative talent from both China and Japan.

Tian Qinxin is considered one of the most talented and influential directors in Asia. Her work is known for its novel exploration of classical Chinese themes and world classics, and shrewd portrayal of contemporary subjects. *Green Snake* and *Romeo and Juliet*, both directed by Tian, were commissioned in 2013 and 2014 respectively by the HKAF. Each was a ground-breaking new work received with acclaim in Hong Kong and internationally. For these perennial classics, Tian assembled a Western creative team to interpret an oriental story and a Chinese team to adapt Shakespeare's tragedy, bridging cultures and historical eras.

Green Snake was co-commissioned by the HKAF and the Shanghai International Arts Festival. It came into being when Tian visited

田沁鑫是亞洲當代最具影響力的導演之一，她的作品常以全新角度探索中國古典題材和世界名著，捕捉當代社會話題。藝術節於 2013 年及 2014 年，委約了田沁鑫分別編導《青蛇》和《羅密歐與朱麗葉》兩部突破傳統的新作，在香港以至國際引起相當迴響。一中一西，同是經典的戲碼，田沁鑫以西方的創作團隊去演繹東方的故事，以中國的團隊去改編莎翁名劇，跨越了時代，更跨越了文化。

《青蛇》是藝術節與中國上海國際藝術節聯合委約作品，創作緣起於 2011 年，田沁鑫到英國訪問。「內容選擇方面，我傾向做一部具有中國氣質和文化特色的劇目，用『青蛇』的視角講述中國家喻戶曉的《白蛇傳》故事，這個想法引來蘇格蘭國家劇院（下稱『蘇院』藝術總監維琪·費瑟斯通的興趣，我希望以呈現女性視角和女性表達去講一個『人與蛇妖之戀』的中國故事。在愛丁堡國際藝術節觀摩期間，巧遇香港藝術節的蘇國雲，他提出香港藝術節要以委約的方式進行《青蛇》創作。」

這個創作背後是一個中西合璧的團隊。田沁鑫所屬的中國國家話劇院負責劇本創作與演出，蘇院負責作曲及舞台工作。「在蘇院的藝術支持下，《青蛇》有了一個國際化、造詣很高的創作團隊。服裝造型設計是香港的陳顧方；德國籍海恩塞爾設計了江南特色的瓦舍簷角、窗櫺亭台；蘇格蘭的奇弗斯用多媒體和燈光的配合，以水霧營造夢幻世界。和國外團隊合作，就是想用新的解讀和演繹，為中國故事賦予更多元的文化內涵。」

田沁鑫強調《青蛇》改編自中國經典傳統文化，其實是延續了國家話劇院以中國故事為創作題材的傳統。「長期以來，劇院堅持『中國原創、世界經典、實驗探索』的創作理念，從各個角度深挖具有中國文化特色的故事。《青蛇》在香港藝術節演出六場，場場爆滿，開闢了內地話劇在香港演出的場次紀錄。非常感謝香港藝術節，能夠把香港作家李碧華的《青蛇》帶回香港，讓更多的香港人了解內地話劇。」

《青蛇》的成功，藝術節再接再厲，為「紀念莎士比亞生誕四百五十週年」委約田沁鑫創作《羅密歐與朱麗葉》。「如何讓這部經典的莎劇在中國舞台上大放異彩，這是創作的難點和突破點。中國人演莎士比亞的戲總讓人有種距離感，即使我們的演員穿著本土化

the UK in 2011. "In terms of content, I was partial to producing a programme with Chinese sentiments and cultural characteristics," Tian says. "Vicky Featherstone, artistic director of the National Theatre of Scotland, was intrigued by the idea of telling the Chinese classic tale 'Legend of the White Snake' from the perspective of a 'green snake'. I wanted to tell a Chinese love story between people and spirits from a female perspective, with the theme of womanhood. I met So Kwok-wan from the HKAF at the Edinburgh Festival and he suggested producing *Green Snake* on commission by the HKAF."

The creative team brought together talent from East and West. The National Theatre of China, to which Tian Qinxin belongs, was responsible for the script and the performance; National Theatre of Scotland took care of the music and stage design. "With the support of National Theatre of Scotland, *Green Snake* assembled an international and highly accomplished creative team. Chan Ku-fang from Hong Kong was responsible for the costume design. Merle Hensel of Germany designed the Jiangnan-style glazed roof tiles, window lattices and pavilions. These were complemented by multimedia and lighting by Natasha Chivers from Scotland who created a dreamlike stage with mist. Working with an overseas team helped to enrich a Chinese story through new insights and interpretations."

Tian says adapting a Chinese classic in *Green Snake* was a continuation of the National Theatre of China's tradition of exploring Chinese stories. "The theatre had long upheld the creative vision of Chinese original works. World classics, experimental explorations and stories with Chinese cultural features are observed in depth from different perspectives. *Green Snake* enjoyed a successful run with six sold-out performances at the Festival, and set a record for the number of Mainland Chinese drama performances in Hong Kong. We are thankful the HKAF was able to bring *Green Snake*, a work by Hong Kong writer Lilian Lee, back to the Hong Kong stage so local audiences could learn more about Mainland drama."

The success of *Green Snake* prompted the Festival to commission *Romeo and Juliet* by Tian to commemorate the 450th anniversary of Shakespeare's birth. "The creative challenge is to make a classic Shakespearean play shine on the Chinese stage. It feels distant when Chinese actors play Shakespeare. Even an experimental interpretation of the work with the cast in local costume feels unnatural. After all, it is not something that's in our blood."

（左起）袁泉與秦海璐在綵排《青蛇》
(from left) Yuan Quan and Qin Hailu rehearsing for *Green Snake* (2013)

的服裝，或是我們用實驗的方式來詮釋，總顯得不自然，那畢竟不是我們血液裡流淌著的東西。」田沁鑫認為要讓莎翁落地，不應該限於把文本照搬上舞台，而應該深層次地探尋他的精神、思想。「著手創作時，我採取先『解碼』原著，再『中國化』的兩個步驟。參考了朱生豪譯本和梁實秋譯本，把莎翁的詩化語言與中國當代年輕人的思維充分融合。嚴格遵循文本的大框架，保留莎氏劇作的經典橋段，甚至部份原著的台詞，也都照搬到劇本裡，目的就是為了確保它的血統是純正的。在中國化方面，我把這個故事的發生地放在上世紀八十年代的大院，有大家熟悉的大鐵門、自行車、電線桿等佈景。」

「無論是讓中國故事走向世界舞台，還是把西方故事中國化，放在當下，都是人類共同的情感問題。話劇藝術有著獨特的舞台呈現方式，要充分發揮藝術傳播的優勢，加強與世界的文化交流和互動。」

田沁鑫自2020年起擔任中國國家話劇院院長，提到與香港藝術節的幾次合作中，「感受到香港藝術家前瞻性的藝術理念，香港人的熱情和堅忍不拔。我想，這些都與這座包容、開放，具有國際視野的都市氣質相契合。」

Tian believes in first making Shakespeare approachable. Instead of simply presenting the script on stage, he explored the Bard's spirit and tried to understand his ideas. "I adopted the two-step creative process to first 'decode' the original work and then 'transpose' the play to China. Referring to the two translations by Zhu Shenghao and Liang Shih-chiu, I assimilated the poetic language of Shakespeare with the thinking of young modern Chinese people. The adaptation stuck close to the script's overall framework, retaining the plot and even portions of the original text to maintain its pedigree. When relocating the play to China, I changed the setting to a housing compound in the 1980s with familiar objects such as large wire gates, bicycles and telephone poles."

"Whether presenting a Chinese story on the global stage or relocating a Western play to China, the universal question always centres on human emotions. With its unique presentation on stage, drama should make the most of the power of the arts to strengthen cultural exchange and interaction around the world."

In 2020, Tian was appointed Director of the National Theatre of China. "In my collaborations with the HKAF, I have experienced visionary ideas from Hong Kong artists and Hong Kong people's enthusiasm and determination," she says. "These qualities are in line with the broad-minded open nature and international outlook of the city itself."

《青蛇》 *Green Snake* (2013)（照片提供：中國國家話劇院）(© 解飛)

《大紅燈籠高高掛》 *Raise the Red Lantern* (2002)

趙汝蘅
把中國芭蕾帶到國際舞台

趙汝蘅不獨是中國出色的芭蕾舞者,更是把中國芭蕾舞帶到國際的重要推手。在擔任中國國家芭蕾舞團(中芭)團長期間,致力用西方的芭蕾舞演繹中國的故事和情感,並融入中國舞的文化特點,引起世界芭蕾舞壇的關注。從中國走向國際,趙汝蘅直言香港是一個不可或缺的平台。

「我在 1980 年第一次到香港,待了一個月,學習英國皇家舞蹈學院的課程,當時認識了很多香港舞蹈界朋友,對我來說是一個很大的轉捩點。1984年帶團員到大阪參加比賽,回程時在香港演出,到了1987年又有機會在香港演出《羅密歐與朱麗葉》、《吉賽爾》等作品。我想大概是這些時候藝術節開始關注中國的芭蕾舞團。」趙汝蘅自擔任中芭團長後,積極推動舞團發展,她認為首先要豐富劇目,演繹西方經典作品外,更要有新創作。面對國內的觀眾,她做了中國版的《胡桃夾子》,但要走出國際,明白到不能永遠只演《紅色娘子軍》。「要在西方舞台立足,一定要有自己的東西。」趙汝蘅說香港對她的影響很大,而香港藝術節除了讓她見識世界頂尖的芭蕾舞表演,更啟發她製作芭蕾舞劇《大紅燈籠高高掛》。「我常會去看藝術節,對我來說是很最重要的一件事。我認為藝術節是想盡法把最好的節目帶給觀眾。印象深刻的是2000年伯明翰

Zhao Ruheng
Guiding Chinese Ballet's Leap to the International Stage

Zhao Ruheng was a prominent ballet dancer and also a crucial figure in putting Chinese ballet on the world map during her tenure as artistic director of the National Ballet of China. She did this through ballet works with Chinese stories and sentiments where the cultural elements of Chinese dance were emphasised. For Zhao, Hong Kong was essential for Chinese ballet's leap to the international stage.

"I first visited Hong Kong in 1980 to attend a month-long course given by the Royal Academy of Dance. I became acquainted with many people from Hong Kong's dance world and it was a big turning point for me. In 1984, some of our dancers performed in Hong Kong on the way back from a competition in Osaka. We had the opportunity in 1987 to perform works including *Romeo and Juliet* and *Giselle* in Hong Kong. It was around this time the HKAF started linking up with Chinese ballet companies." After Zhao took over at the National Ballet of China, she put in enormous effort to promote the company. Top of her task list was broadening the repertoire. In addition to performing Western classics, there had to be new works. For Mainland audiences, she presented a Chinese version of *The Nutcracker*. It took more than repeated performances of *Red Detachment of Women*, however, for international success to follow: "To command a presence on the Western stage, we needed something of our own." Zhao acknowledges the impact Hong Kong had on her. The Festival gave her the opportunity to watch world-class ballet performances and also inspired her to produce the ballet *Raise the Red Lantern*. "I often attended the HKAF. What I found most significant was the Festival's dedication to bringing the best programmes to audiences. A memorable experience was watching *Edward II* by the Birmingham Royal Ballet in 2002. It opened my eyes as to how far ballet could go. As well as the classics, there were many modern works. As early as 1999, Lau Chun-keung from the HKAF discussed commissioning new work with us."

As the producer of *Raise the Red Lantern*, Zhao looked internationally to assemble an international creative team. "Zhang Yimou was directing a play at the time and I thought why not a ballet too? So I invited him to join our team. I had also heard Chen Qigang's cello concerto, *Reflet d'un temps disparu*, which I loved. He was also an old friend. I recruited Jerome Kaplan from France for the costume design because I had seen his work for *Romeo and Juliet* by the

《牡丹亭》 *The Peony Pavilion* (2009) (© Hong Kong Leisure and Cultural Services Department)

皇家芭蕾舞團的《愛德華二世》，讓我知道原來芭蕾舞是可以這樣，除了最經典的作品，還有很多現代創作。而早於1999年，藝術節的劉鎮強和我們商討，想委約我們做新創作。」

作為《大紅燈籠高高掛》的製作人及總監製，趙汝蘅四處找來一個國際化的創作團隊。「當時張藝謀在做舞台劇，我想到為什麼他不搞芭蕾舞劇呢？於是邀請他加入創作團隊。至於陳其鋼，我聽過他的《逝去的時光》，喜歡他的音樂。服裝設計是法國的 Jerome Kaplan，因為看過他為蒙地卡羅芭蕾舞團《羅密歐與茱麗葉》的設計，能夠把宮廷服裝變成簡約的設計。燈光設計 Yves Bernard 之前跟我們合作過《吉賽爾》。而誰來編舞是最大問題，因為過去合作的編舞已經退休，我想找一個有國際視野，又認識中國的編舞家，便找了當時在德國的王新鵬，他也跟我們編過《春之祭》。」破天荒的製作班底，趙汝蘅說雖然有很多人支持，但也有人對張藝謀有些意見，加上作品的題材，所以反對聲音也頗大。趙汝蘅頂著壓力，傾全力去作藝術上的探索，《大紅燈籠高高掛》2001年5月在北京首演，2002年在藝術節上演，隨即引起轟動，其大膽嶄新的創作手法，讓世界看見中國芭蕾舞的新景象，隨即獲邀到法國、英國、意大利等地演出。2008年她率團第一次赴英國皇家歌劇院演出《天鵝湖》和《大紅燈籠高高掛》，以及2009年率團赴法國巴黎歌劇院演出《紅色娘子軍》和《希爾薇亞》，演出的成功為劇團贏來了廣泛的國際聲譽。

Monte Carlo Ballet, where he transformed court costumes into sleek and elegant designs. We had previously worked with Yves Bernard on the lighting design for *Giselle*. The choice of choreographer was the biggest challenge because everyone we had worked with before was now retired. A choreographer with international vision and knowledge of China was needed for the production. So I contacted Xin Peng Wang, who was working in Germany at the time. He had choreographed *The Rite of Spring* for us." According to Zhao, the stellar production team was supported by many, but some were sceptical about Zhang Yimou and the theme of the work also led to objections. But Zhao stuck to her guns in the face of pressure. *Raise the Red Lantern* premiered in Beijing in May 2001, and was featured at the HKAF the following year. It was an instant hit, with people scrambling for tickets. Its bold innovative approach led the world to regard Chinese ballet in a whole new light. The company was immediately invited to perform in France, the UK and Italy. In 2008, Zhao led the company to the Royal Opera House for the first time to perform *Swan Lake* and *Raise the Red Lantern*. The following year, the company performed *Red Detachment of Women* and *Sylvia* at the Opéra de Paris in France. The success of these performances won the company an international reputation.

Overseas reviews complimented Zhao on her boldness and courage in taking a gamble that paid off. In 2009, the HKAF presented *The Peony Pavilion*. "It was an invitation from the Edinburgh International Festival. There were many ideas at the time, one of which was to bridge Shakespeare and Tang Xianzu through art. Both died the same year and both wrote about young love. "

The creative team was another international lineup, with Li Liuyi responsible for adaptation and directing, and Guo Wenjing as composer, Fei Bo as choreographer, Emi Wada as costume designer and Michael Simon as stage designer. "I like to work with creative personnel who offer a variety of ideas. For this dance drama, Li Liuyi designed three versions of Du Liniang, including the Flower Goddess Liniang and Kunqu Liniang." Bold in innovation and ready for more challenges, Zhao continued to strive to put the National Ballet of China in the international spotlight.

趙汝薇說當時國外有評論說她是做了一個賭博，結果她贏了。2009年藝術節帶來芭蕾舞團的《牡丹亭》。「這是愛丁堡藝術節的邀請，當時有很多想法，其中一個是把莎士比亞與湯顯祖之間搭一道橋，兩人是同年去世，都是描寫青少年的愛情。」這次創作班底也很國際化，李六乙改編劇本和導演、郭文景作曲、費波編舞，和田惠美任服裝設計、Michael Simon 設計舞台。「我很喜歡找有不同想法的創作人合作。李六乙為這舞劇設計了三個杜麗娘，還有花神杜麗娘和崑曲杜麗娘。」勇於創新，敢於挑戰，趙汝薇成功帶領中國國家芭蕾舞團走出國際。

中國戲曲傳承綻放

藝術節雖然在創辦初期以西方傳統表演藝術為主，但早已意識到本地藝術的重要性，所以初期已有粵劇和潮劇節目，而中國戲曲可說是每屆藝術節不可或缺的一環。

中國的地方戲曲歷史悠久，就像鮮花遍地，各自綻放色彩。藝術節與內地享負盛名的藝團合作，共同策劃節目，帶來京、崑、越、川、梆子等不同種類的戲曲節目。

節目委員會委員譚榮邦提到，藝術節在節目策劃上會先構思特色主題。「我們會跟中國的劇院洽談特別的演出，而不是純粹搬演著名的劇目。以京劇為例，香港觀眾對中國內地的認識還只限於梅蘭芳，我們就辦了《程派藝術一百年》(2004)。另外，有以花臉表演特色為主題的《銅錘架子虎嘯龍吟—京劇花臉流派經典展演》(2011)，及復耀一代宗師的《馬連良紀念系列》(2012)。這些傳統劇目在內地已失傳，因著我們的要求，劇團也要重新學習。我曾在北京住了五年，那段日子不停看戲，有幸看到不少名家晚年的演出，因而知道傳統是怎樣，希望能夠延續這些傳統。」作為國粹，京劇是藝術節非常注重的節目，除了發掘傳統，把經典作品搬到藝術節的平台，嘗試推向國際，更積極尋求突破與創新，延續京劇的傳統，與時代接軌。于魁智和吳興國是藝術節的常客，也是延續傳統與追求創新的最佳例子。

Chinese Opera Continues to Blossom

Although the focus of the HKAF was initially programmes in Western performing arts, there had long been an awareness of the importance of local canon, with Cantonese and Chiu Chow operas among the programme line-ups. Chinese opera also became an integral component of each edition of the HKAF.

Chinese regional operas have a long history and have flourished with their respective distinctive local cultures. The Festival has worked with renowned opera troupes on the Mainland to present a rich variety of Chinese opera programmes, including Peking, *Kun*, *Yue*, Sichuan and *Bangzi* operas.

Programme Committee Member Tam Wing-pong outlines how the HKAF first envisages a special theme when planning programmes: "We discuss with the Chinese opera company about performing something special instead of a well-known canonical programme. Take Peking opera for example: Hong Kong audiences' knowledge might be limited to Mei Lanfang. So we presented *The Art of Cheng Yanqiu: 100th Anniversary* (2004). There was also *Beijing Opera - The Painted Face* (2011), which focused on the artistry of the *hualian* (Painted Face) performances, and *Beijing Opera - A Tribute to Laosheng Master Ma Lianliang* (2012), which paid tribute to the Peking opera master. Some of these traditional programmes had already disappeared from the Mainland repertoire and the opera companies had to learn them again at our request. I lived in Beijing for five years and spent a lot of time there watching Chinese opera. I was fortunate to see a number of veteran performers in their later years. And after learning about them, I felt that these traditions should not be lost, but continue to live and be performed."

As part of Chinese cultural heritage, Peking opera has been treated with great importance by the HKAF. In addition to unearthing past traditions and presenting Peking opera classics, the HKAF strives to bring them to international audiences and to support its traditions through innovation. Both Yu Kuizhi and Wu Hsing-kuo are frequent performers at the Festival and shining examples of maintaining tradition in the midst of continued renewal.

于魁智
發揚京劇傳統精神

于魁智是著名京劇藝術家，曾先後出任中國國家京劇院一團團長、副院長及藝術總監，現為中國戲劇家協會副主席。與藝術節結緣於2000年，代表劇院二團帶來《失空斬》、《奇冤報》、《彈劍記》等多個劇目。

于魁智認為藝術節是一個重要的平台，內地很多京劇院也希望參與其中。「能夠堅持舉辦一個國際性的藝術節達五十年，實在非常不容易。我們在 2000 年開始參與這個年度盛事，可以在香港這個國際大都市、一個重要的對外窗口，展示中國傳統藝術確實是非常重要。京劇是綜合之美，有文有武，經典劇目都是傳揚中華文化美德、忠孝仁愛的精神。」于魁智說到多年來在港上演的劇目都是精挑細選，展現京劇的不同面向。「我們跟藝術節的同事一起溝通商量，特別針對香港的觀眾，感謝香港觀眾對京劇的包容，除了長者外，我們也發現中青代觀眾越來越多。」

京劇是海納百川的藝術，向來有移植、改編的傳統，2018 年中國國家京劇院在藝術節的四晚演出，除了獻上梅派經典《鳳還巢》、花臉代表作《牛皋下書》等劇目外，最矚目的相信是改編經典粵劇《帝女花》。對香港觀眾來說，《帝女花》是家傳戶曉的劇目，1957 年由唐滌生為任劍輝和白雪仙編撰。于魁智除了出演周世顯一角，亦擔任藝術總監，談到改編的過程，還是非常興奮。「《帝女花》深入民心，某年在內地看到報導，得知龍劍笙從加拿大回港演出，我們從來沒看過她的現場表演，於是決心要去香港

Yu Kuizhi
Carrying Forward the Legacy of Peking Opera

Peking opera master Yu Kuizhi was successively leader, vice president and art director of the First Troupe of the China National Peking Opera Company. Currently Vice Chairman of the China Theatre Association, Yu first worked with the HKAF in 2000 when he led the Second Troupe of the China National Peking Opera Company to the Festival with programmes that included *An Absentee Staff*, *Vengeance of an Injustice* and *Peck on the Sword*.

Yu considers the HKAF to be a significant event that many Mainland Peking opera houses endeavour to be part of. "It is no easy feat to organise an international arts festival for 50 years. We first joined this annual event in 2000. It was important for us to showcase this traditional Chinese art form in Hong Kong, a metropolis and window on the world. Peking opera is a multi-faceted art form that brings together aesthetics and skills in singing and martial arts, with classic repertoire which exemplify the Chinese virtues of loyalty, filial devotion and benevolence." Yu says all the company's programmes in Hong Kong were carefully selected to showcase Peking opera from different perspectives. "We discussed with the Festival team curating programmes tailored for Hong Kong audiences, and we were grateful for their generous reception. Besides the older generation, there seemed to be people of all ages, with the younger generation also in the audience."

Peking opera is all-embracing by nature and adapting to new circumstances is in its blood. When the China National Peking Opera Company performed for four nights at the HKAF in 2018, the programme line-up included *The Return of the Phoenix to the Nest*, a classic opera of the Mei School, and *Breaking the Siege*, essential repertoire for painted-face roles. Probably the most notable programme was the adaptation of *Princess Changping*, the Cantonese opera classic. Well known to Hong Kong audiences, this

觀摩。當時龍劍笙演出精采萬分，非常震撼，觀眾看得很投入，頓時讓我得到啟發，是否能夠以京劇元素，同時保留粵劇的精粹去演出這齣經典。」于魁智回想當天帶著好奇，想了解作品的優點，看後覺得果然是名不虛傳，之後得到國家藝術基金支持下改編成京劇。

京劇《帝女花》孫桂元導演，顏全毅、宋洋編劇，李勝素飾演長平公主。珠玉在前，于魁智說到這一百五十分鐘版本的挑戰，「就是如何保留粵劇精華，當中的家國情懷，還有觀眾熟悉的音樂。我跟導演、音樂創作反覆思考，創作團隊看過很多錄像，還有相關文章。我們明白無論在哪裡演出，必須先要經過粵語觀眾去檢閱，因此首演必定要在香港。我作為演員跟負責人，壓力很大，一但粵語觀眾不滿意那就不成了。」

「到香港演出前，心情還是很忐忑，我們站在台上對於觀眾的反應會很敏感。我特別跟作曲家商量，就是從入場直至大銀幕升起的開場時段，要以《落花滿天蔽月光》這曲作為背景音樂，讓觀眾投入氣氛。香港首演時，白雪仙、梅雪詩、汪明荃也有來欣賞。後來在廣州演出，白雪仙也專程再來看，這是她畢生的創作，對此劇有豐厚的情感，非常感激她的支持。更感激藝術節讓我們有機會完成這個新創作，多謝譚榮邦和多位專家的意見。」把現場演出拍成電影，或是轉到網上播放，于魁智說國家京劇院

京劇《帝女花》 *Princess Changping* in Peking Opera (2018)

masterpiece was written by Tong Tik-sang in 1957 specifically for Yam Kim-fai and Pak Suet-sin. As artistic director of the performance, Yu also took the leading role of Zhou Shixian. He still recalls with excitement the adaptation of the work: "*Princess Changping* is such a beloved classic. When I got wind of Lung Kim-sung returning from Canada to Hong Kong to star in the performance, I was determined to get to Hong Kong for the show, as I had never seen her perform live. Lung Kim-sung was mesmerising on stage. And I was captivated, just like everyone else in the audience. This led me to consider adapting it as a Peking opera while retaining the essence of the Cantonese original." Yu was initially driven by curiosity to get to know the enduring classic better, which he says is deservedly acclaimed. The adaptation became a reality when he got the support of the China National Arts Fund.

For its Peking opera rendition, *Princess Changping* was directed by Sun Guiyuan; Yan Quanyi and Song Yang wrote the playscript and Li Shengsu starred as Princess Changping. In paying respect to the original classic, Yu's challenge with his 150-minute version was to "retain the essence of Cantonese opera's deep sentiments for family and nation, and of course the popular tunes which were familiar to the audience. The director, musicians and I thought carefully about the work. The creative team went through video archives and related articles, and concluded that the performance, wherever it might be presented, should be first appraised by a Cantonese-speaking audience. So the premiere would be held in Hong Kong. As an actor and person in charge, it was quite daunting, as the show would have crumbled if it did not pass muster with a Cantonese-speaking audience."

"I was still feeling unsettled prior to the Hong Kong performance. As onstage performers, we are particularly sensitive to the audience's reactions. From the very beginning up to when the show started, I was in discussion with the composer, and made special arrangements to play *Fallen petals fill the air and obscure the moonlight* as background music to get the audience in the mood. Pak Suet-sin, Mui Suet-si and Liza Wang all attended the Hong Kong premiere.

《紅鬃烈馬》 *Rekindling a Life-Long Romance* (2018)

《打漁殺家》 *The Fisherman's Revenge* (2018)

近年已積極開拓新科技,「事實上我們劇院已經拍了很多京劇電影。因為疫情關係,2021年春節,《龍鳳呈祥》在電視播映了十五天,吸引了過百萬觀眾收看。從前對於網上放映一直有所保留,擔心會影響演出票房。但三月開始在劇院演出,票房卻沒有受到影響,證明喜歡走進劇場的觀眾,一定會繼續支持現場演出。所以我們也會繼續在這方面推動京劇,擴闊觀眾層,這也是後疫情時代的一個轉向。」

線上線下,國內海外,京劇早在大師梅蘭芳的帶領下走上國際,中國國家京劇院亦先後出訪五十多個國家和地區。「到訪歐美多個地方巡演,我最大的體會是,過去日子我們都以為外國人看不懂,所以很多時只演一些多用肢體語言、不太著重唱唸部分的劇目選段。但現在我們都是原汁原味,演出整套大戲,國內怎樣演國外也怎樣演,最重要的是邀請當地著名的藝術家作翻譯和導賞,把作品介紹給海外觀眾。」

When it was performed in Guangzhou, Pak Suet-sin made the trip to watch the performance again. The opera is her tour de force, one she is emotionally attached to, and I was immensely grateful for her support. I am even more appreciative of the opportunity given to us by the Festival to make this new production happen. We are thankful for the advice from Tam Wing-pong and many experts."

The China National Peking Opera Company also pioneered new technology in recent years and has broken out into online broadcasts. "We have already filmed many Peking operas," Yu says. "Because of the pandemic, *A Perfect Matrimony* aired on television for 15 days during Chinese New Year 2021 and attracted over a million viewers. We had reservations beforehand about online screenings eating into the box office for live performances. But in early March when performances resumed, box office takings were not affected. This proves that audiences who prefer visiting the theatre will continue to support live performances. So we will continue to promote Peking opera in this way to expand our audience base. This is a change of direction in the post-pandemic era."

Long before the discussion of online and in-person, domestic and overseas performances, Peking opera was already a presence on the international stage, with performances by the great master Mei Lanfang. The China National Peking Opera Company had visited more than 50 countries and territories. "Having visited many places in Europe and North America, my greatest insight was that we used to presume foreigners couldn't understand the performances. So we would present programme excerpts with more emphasis on body language and less on singing and reciting. We now present whole programmes in all their original glory. A performance overseas is identical to one in China. What matters most is to invite renowned local artists to perform translations, and appreciation guides to introduce the programme to the overseas audience."

吳興國
用創新延續傳統生命

如果于魁智是在傳統中找突破，吳興國就是突破傳統。身兼演員、導演、劇作家，作品橫跨電影、電視、傳統戲曲、現代劇場的吳興國，在1986年創立台灣當代傳奇劇場，致力以創新方法推動京劇，讓傳統戲曲與當代劇場接軌。2003年首次以《李爾在此》與香港藝術節的觀眾見面，把莎士比亞的《李爾王》變成一人飾演九個角色的獨腳戲，令觀眾留下深刻印象。

從西方的文學經典開始，再融合音樂劇、歌劇、舞蹈、流行音樂，京劇走上創新之路，對吳興國來說，大概是回應時代的一個方案。「京劇觀眾越來越少，時代走得太快，我們自小練功學京劇，是否因為市場越來越少而要改行嗎？回看我們的前輩們，他們在黃金歲月，為了觀眾也不斷創作。所以我們也不應滿足於前輩留下的經典，也要為時代貢獻。」吳興國回想當日創團，就是下定決心，要為京劇尋找未來。多年來與他並肩作戰，當代傳奇劇場的行政總監林秀偉笑言，吳興國最初是為了生存，於是拿出勇氣和創造力，可說是從生存主義到存在主義的一個過程。

「當然最初也遇到困難，不少人會說，你又不是梅蘭芳，你又不是誰，憑甚麼去改編。但我想這是過程吧，像當年普契尼創作《蝴蝶夫人》也受到批評，今天不是已成為經典嗎。所以從事專業的劇場工作者，必須往前走，要面對未來，實驗的過程是非常珍貴。」

創新與傳統，看似兩個相反的概念，吳興國卻用行動告訴大家，兩者是可並存的。《水滸傳108》是三部曲系列，用七年時間向中港台三地的觀眾展示，創新不是摒棄傳統，而是延續傳統，把京劇傳承到新一代。「藝術節的蘇國雲在台北看過第一部後，說我真的很大膽，很想把隨後的兩部曲帶到香港。《搖滾水滸傳》是特別為年青一代而創作，他們這一代跟我們一樣，自小受嚴格訓練，也面對京劇觀眾越來越小。我想是否可以找到一個傳統的故事題材，以另類形式比較接合這個時代，讓年輕人展演自己的能力。」把搖滾加入京劇裡，吳興國說看起來像破壞傳統，但實際上卻是走進時代。「沒有明天，別談後天，我想兩岸三地都看到這個事實吧。」

Wu Hsing-kuo
Maintaining Tradition through Innovation

While Yu Kuizhi pursues breakthroughs in tradition, Wu Hsing-kuo simply breaks with tradition. Wu is a performer, director and playwright whose works span cinema, television, traditional Chinese opera and modern theatre. In 1986, he established Taiwan's Contemporary Legend Theatre (CLT) to promote Peking opera by integrating traditional Peking opera performances with modern theatre. Wu made his HKAF's debut in 2003 with *King Lear*, adapting Shakespeare's work as a one-man Chinese opera, in which he played nine roles, leaving an indelible impression on audiences.

Wu began with classics of Western literature and continued his innovative journey blending musical, Western opera, dance, pop music and Peking opera in his work. To Wu, it was probably a natural response to generational changes. "The audience for Peking opera was dwindling as time moved on. For those of us who learned Peking opera from a young age, do we simply change profession as the market gets smaller? Looking back at our predecessors, we see that they continued to come up with new ideas at their artistic peaks. So we could not become complacent simply doing the classics our predecessors did but make contributions to our own times as well." Wu recalls he founded CLT for this very reason, to explore the future of Peking opera. Lin Hsiu-Wei, Wu's ally and Administrative Director of CLT, remarks with humour that Wu founded CLT simply to survive, based on courage and creativity. The growth of CLT can be described as a shift from survivalism to existentialism.

"Of course there were challenges in the beginning. Some people doubted that we were qualified to do theatrical adaptations. But I think this is just a process. Puccini also faced criticism at first when he created *Madama Butterfly* and it is now a bona fide classic. So professional theatre practitioners should always move forward and embrace the future. The experimental process is invaluable."

Although innovation and tradition might appear to be diametrically opposite concepts, Wu's works show they can co-exist in harmony. With the trilogy *108 Heroes*, Wu spent seven years demonstrating to audiences in Mainland China, Hong Kong and Taiwan that innovation was not about abandoning but extending tradition. The legacy of Peking opera continues to inspire the new generation. "After watching the first part of *108 Heroes* in Taipei, So Kwok-wan of the HKAF commented on its boldness and said he wanted

《水滸108—忠義堂》 *108 Heroes, Tale from the Water Margin* (2011)
(© Patrick Leung)

2011年藝術節委約製作的《水滸108—忠義堂》，由吳興國導演，張大春編劇，周華健作曲，王立軍任京劇指導，林秀偉編舞，是傳統京劇的唱做念打藝術與流行元素進行「交匯」。

到了2014年藝術節與上海國際藝術節聯合委約的《水滸108之終極英雄—蕩寇誌》，由當代傳奇劇場和上海戲劇學院戲曲學院合作創排演出，這回更大膽，以搖滾演繹，故事結構、戲劇節奏、音樂、舞蹈、服裝和舞台視覺全都顛覆了。「很難得碰到一個藝術節會全心全意支持你的想法，還給與充裕資源，更把三方的橋樑搭建起來。」

二胡與結他，琵琶跟鍵盤，唱做唸打與電音的碰撞，是噪音還是和弦，可能只是一線之差。林秀偉說這也是過程中的一個挑戰。「這是一個幾百年前的故事，怎樣找到一個現代表達方式、一個節奏，京劇的傳統表現接上周華健的搖滾音樂，兩者的時代差距太多，是有點奇怪。作品就是需要時間去打磨，可能中間只需要一秒的空白，但這一秒的空間，就讓節奏流通了。」

水滸傳系列後，當代傳奇劇場跟藝術節最新的合作，是聯同上海崑曲名家張軍演出的《凱撒》。「原定於2020年藝術節作首演，然後再在台灣巡演，卻因疫情無奈取消。現期望2022年6月在台灣演出，翌年在香港藝術節上演。希望這演出能再度重生，凱撒是永遠不會死的！」

吳興國認為藝術節把香港觀眾拉到世界水平，觀眾都站在世界尖端。林秀偉也直言很喜歡到香港演出。「我們到過很多地方演出，

to bring the next two instalments to Hong Kong. *108 Heroes – Tales from the Water Margin* was created especially for the new generation. They, just like my generation, received vigorous training since a young age but faced a shrinking audience for Peking opera. I wondered if there was a traditional story that could be adapted to suit the sensibilities of the current generation for young people to display their talents."

Infusing rock into Peking opera might seem to violate tradition but in fact it propelled the art form forward. "If there is no tomorrow, there's no point talking about the future to come. I believe this is the simple truth which Mainland China, Hong Kong and Taiwan can all readily observe."

In 2011, the Festival commissioned the production of *108 Heroes – Tales from the Water Margin* with Wu as director, Chang Ta-chuen as playwright, Chau Wa-kin as composer, Wang Lijun as Peking opera adviser and Lin Hsiu-wei as choreographer. In the programme, traditional Peking opera techniques come face-to-face with popular theatrical elements.

When the Festival co-commissioned 108 *Heroes III* with China Shanghai International Arts Festival in 2014, the programme was created by CLT and the College of Chinese Opera of Shanghai Theatre Academy. It went further with rock 'n' roll interpretations and overturned notions of story structure, dramatic rhythm, music, dance, costume and stage visuals. "It is rare to find an arts festival that supports your ideas without reserve and even provides resources to bridge the three parties."

There may only be a hair's breadth of difference between pure noise and harmony when combining the sounds of erhu and guitar, pipa and keyboard, or integrating traditional Peking opera techniques with the electronic sounds. Lin considers this a challenge during the creative process. "This is a story from centuries ago. The pursuit of modern expression, and of a rhythm for the story while connecting traditional Peking opera elements with Chau Wa-kin's rock music may seem like filling an unbridgeable time gap. It might feel odd, but the work can find its cadence and flow."

After the "Water Margin" series, the latest collaboration between CLT and the Festival is *Julius Caesar*, which features renowned kunqu singer Zhang Jun from Shanghai. "Originally scheduled for the Festival in 2020 followed by a performance in Taiwan, the programme had to be cancelled because of the pandemic. We now look forward to the performance being held in Taiwan in June 2022

當中不少是歐洲的劇場，要讓對方認識我們的作品，首先要打破文化隔閡。但跟香港的溝通交流是非常直接的，很喜歡看到香港觀眾的反應和評論，有喜歡傳統的亦有追求前衛的，更喜歡尖銳的聲音來鞭策我們。」

面對不確定的未來，吳興國依然抱持信念，「劇場是城市的象徵，裡面都是有理想的人，而藝術節在當中扮演一個重要角色。」2016年成立的興傳奇青年劇場，可說是延續京劇傳統的一個使命，「所有的可能性也在裡面，就看年青人有多大能量。」

《凱撒》原來的場刊 Original house programme of *Julius Caesar* (2020)

粵劇展現與推動

流行於中國廣東省的粵劇，過去一個世紀，隨著歷史文化發展，逐漸在香港演變成有別於內地的一種風格，成為本地重要的傳統藝術。過去數十年，粵劇在香港雖然經歷興衰，但演出卻從無間斷。

節目委員會委員譚榮邦提到，雖然藝術節創辦初期已有粵劇節目，直至九十年代，才開始參與委約及製作粵劇節目。「以主題式的節目推動粵劇發展，當時有兩個目標，第一是恢復一些行當，所以連續三、四年製作了小武戲，像《西河會妻》和《斬二王》。第二是恢復傳統，製作傳統例戲，2000年的《百年回顧八和鳴》，從《玉皇登殿》、《胡不歸》，到最有影響力的《帝女花》，一次過演繹粵劇的轉變。」

and at the HKAF the following year. The programme, in the spirit of Julius Caesar, will never cease to exist!"

Wu believes the Festival brings Hong Kong audiences into contact with international performances at the forefront of the world stage. Lin also likes visiting Hong Kong for performances. "We performed in many places including theatres in Europe. To truly let an audience understand our works requires breaking through cultural barriers. Yet our communication and exchange with Hong Kong is quite direct. We love the reactions and reviews from Hong Kong audiences. Some crave tradition while others look for cutting-edge elements. We also value the stronger comments that drive us to improvc."

In the face of an uncertain future, Wu remains steadfast in his belief that "theatre is symbolic of a city and full of people with ideals. And an arts festival plays an important role". The establishment of Hsing Legend Theatre in 2016 is another mission fulfilled in continuing the tradition of Peking opera: "There are all sorts of possibilities within, given the immense potential of young people."

Staging and Promotion of Cantonese Operas

Popular in Guangdong province, Cantonese opera evolved slowly with cultural and historical development in Hong Kong in the last century and formed a style of its own different from its origins on the Mainland. In recent decades, Cantonese opera might have fluctuated in popularity, but performances of this cherished art form have never stopped.

According to Programme Committee Member Tam Wing-pong, the Festival has presented Cantonese opera programmes since its early years. However, it was not until the 1990s that HKAF commissioned and produced Cantonese opera productions. "Themed programmes were initiated to promote the development of Cantonese opera. There were two objectives at the time, the first being revivals of certain role-oriented productions. As a result, there were warrior-role programmes for three or four consecutive years, including *Reunion with My Wife by West River* and *Execution of the Duke's Second Brother*. The second objective was a return to tradition by producing opera classics. The 2000 programme *Cantonese Opera Treasures* featured a string of classics from *The Imperial Emperor of Heaven Holding Court* and *Why Don't You Return?* to the seminal *Princess Changping*, offering a sweeping overview of development in Chinese opera."

從早期的委約，如《十五貫》（1993）、「紅伶排場戲薈萃」（1999），到以主題上演，如「文武雙全陳好逑」（2002）、「詩情緣繫唐滌生」（2005）、「百年回顧八和鳴」（2010）、「粵劇流芳—芳艷芬名劇選」（2011）、「粵劇越洋半世紀」（2019）。另外也有系列形式，如《粵歷油麻地—三代同台做大戲》（2013），除了演出更注重推廣粵劇文化。有些起用年青演員主演，如「文武新一代」（2014）、經典復興：粵劇戲寶傳承篇」（2015）。更有些是藝術節自己擔任製作的角色，例如「梨園朝暉顯光芒」（2006）、賽馬會本地菁英創作系列：粵劇《百花亭贈劍》（毛俊輝導，2019）、粵劇《挪亞方舟》（文千歲編，2021）。

發掘傳統，重現經典，名伶展演到近年積極推動創新粵劇，當中可見藝術節在策劃粵劇節目上的心思。

粵劇演出
Cantonese opera performance (1976)

阮兆輝
承先啓後粵劇文化

「我知道藝術節在很早期已經有粵劇節目，當時不是我這一輩有資格演出，表演的都是大老倌。」早期藝術節的粵劇節目由張玉麟贊助演出，邀請名伶新馬師曾、鄧碧雲、鳳凰女、梁醒波、吳君麗等在利舞台演出。童年已加入電影和粵劇界的阮兆輝，見證了粵劇在香港不同階段的發展。他提到有段日子藝術節沒有了粵劇節目，感到藝術節跟粵劇界好像有點疏離。直至1993年，第一次跟藝術節合作，由阮兆輝任團長的香港實驗粵劇團在大會堂上演《十五貫》，劇團的前身為活躍於七十年代的實驗粵劇團，演員有李奇峰、尤聲普、羅家英、李鳳、尹飛燕等，於1992年重組，後來易名為粵劇之家。

Commissioned works in the early years included *Fifteen Strings of Cash* (1993), Cantonese Opera: An All-Star Night (1999), and thematic programmes such as Cantonese Opera – The Virtuosity of Chan Ho-kau (2002), Masterpieces by Tong Tik-sang (2005), Cantonese Opera Treasures (2010), Cantonese Opera – The Artistry of Fong Yim-fun (2011) and Cantonese Opera – Global Traces, Local Stages (2019). There were programme series such as In Yau Ma Tei - A Legacy of Cantonese Opera (2013) that had a strong focus on the promotion of Cantonese opera.

Young performers took centre stage in programmes such as Cantonese Opera - Romance and Martial Arts (2014) and Classics Revisited: Cantonese Opera Treasures (2015). The Festival also took on the role of producer with works including Cantonese Opera – New Stars (2006), Jockey Club Local Creative Talents Series: Cantonese Opera – *Pavilion of a Hundred Flowers* (2019, directed by Fredric Mao Chun-fai) and the Cantonese opera Noah's Ark (2010, written by Man Chin-sui).

From unearthing traditions, the revival of classics and showcases by Cantonese opera masters to the drive for innovation in the genre, the HKAF is proactive in its efforts to promote Cantonese opera.

Franco Yuen Siu-fai
Maintaining the Legacy of Cantonese Operas

"I know that Cantonese opera was performed in the early days of the Festival. At the time, they were headlined by opera masters."

粵劇演出記者招待會 (1979)（左起）：鳳凰女、馮秉芬、張玉麟、邵逸夫主席、湛兆霖副主席、新馬師曾
Press Conference on Cantonese Opera (1979) (from left): Fung Wong-nui, Kenneth Fung Ping-fan, Cheung Yok-luen, Run Run Shaw (Chairman), Cham Siu-leun (Vice-Chairman) and Sun Ma Sze Tsang

《文武雙全陳好逑》 *The Virtuosity of Chan Ho-kau* (2002) (© 謝明莊)

Cantonese opera programmes in the early editions of the HKAF were sponsored by Cheung Yuk-lun and featured renowned performers like Sun Ma Sze Tsang, Tang Bik-wan, Fung Wong-nui, Leung Sing-por, Ng Kwan-lai, with the shows staged at the Lee Theatre. Franco Yuen, who performed in films and Chinese operas at a young age, witnessed the different stages of Cantonese opera's development in Hong Kong. He recalls that Cantonese opera programmes were not in the Festival's line-up for a period of time, but the situation was remedied in 1993 with *Fifteen Strings of Cash* performed by The Group of Experimental Cantonese Opera Hong Kong led by Yuen. Active since the 1970s, The Group consisted of Cantonese opera artists including Li Ki-fung, Yau Sing-po, Law Ka-ying, Lee Fung, Wan Fei-yin. It was re-formed in 1992 and renamed House of Cantonese Opera.

Yuen later took part in the HKAF's Cantonese opera programmes as a performing artist and also as an organiser: "One memorable programme is *Three Generals Trapped at Mount Xiao* (2000) by the House of Cantonese Opera. I remember the Festival asking me at the time if I felt comfortable with Freeman Lau designing the set. I welcomed the arrangement because The Group of Experimental Cantonese Opera (The Group) had also worked with avant-garde artist Kwok Mang-ho and we are always very happy to collaborate with different artists. I was responsible for planning *Lu Meng-zheng — A Poor Scholar* in 1998, which featured Chan Ho-kau and Yau Sing-po. I also proposed the programme *Cantonese Opera – The Virtuosity of Chan Ho-kau* in 2002 because of Chan's rich repertoire of excellent works. It was a rare gem as Chan starred in five different roles in five nights of performances, sharing the stage with different male leads. I was also rather satisfied with *Three Generals Trapped at Mount Xiao* as the programme showcased the calibre and stylised performances of the artists in their full glory."

Yuen recalls the initial partnerships with the HKAF being more interactive in nature, with the two parties having discussions on what programmes to present. The Festival started to have clear goals for its Cantonese opera programmes with a specific theme each year. "The programme should meet the requirements of the HKAF. It should also be something that our group is interested in. An example would be *The Golden Age of Cantonese Opera* in 2012. The term 'Hundred Flowers' in the programme's Chinese title was inspired by the 'Hundred Flowers Campaign' promoted on the Mainland in the 1950s when many new works were created. Renowned performers including Lo Ban-chiu and Lui Yuk-long were still active at the time, and we thought it was the right opportunity to have re-runs of these outstanding works."

隨後阮兆輝多次參與藝術節的粵劇節目，不只是演出，也參與策劃。「其中比較印象深刻是粵劇之家的《三帥困崤山》(2000)，還記得當時藝術節問我是否敢起用劉小康做佈景設計，我當然非常接受，因為實驗粵劇團也曾跟前衛藝術家郭孟浩合作，非常樂意跟不同藝術家合作。由我負責籌辦的還有1998年的《呂蒙正·評雪辨蹤》，有陳好逑和尤聲普演出。另外2002年的《文武雙全陳好逑》亦是我的提議，因為逑姐（陳好逑）有很多出色作品，當時一連五晚演出不同節目，每晚逑姐配搭不同的生角，是非常難得的演出。還有《三帥困崤山》，都是我個人比較滿意的節目，因為能夠展示到演員的實力、功架。」

阮兆輝提到跟藝術節的合作，初期是比較互動，一起商討做甚麼節目，後來藝術節在粵劇節目方面的目標清晰，每年有特定的主題。「所以一方面是要符合藝術節要求，另外是我們的劇團也有興趣。例如2012年，由我取名的《且在香江賞百花》。「百花」是指內地在五十年代推動的「百花齊放」，當時有很多新作品出現，而羅品超、呂玉郎這些著名演員還是很活躍。當時我們想到應該找個機會重演這些好劇本。」

不論是與粵劇團的建議，還是藝術節提出的主題，發掘傳統和傳承可說是當中兩大核心精神。2006年的「梨園朝暉顯光芒」正是以傳承的概念貫穿的節目，由阮兆輝擔任藝術指導，由新人擔演。參與這次演出的十五位新演員，當中大部份出身自林家聲的頌新聲劇團，已經具有十餘年的演出經驗。另外幾位較年輕的演員，也在不同的劇團擔任二線演員，累積了不少舞台經驗。他們在《趙氏孤兒》及五齣不同類型的折子戲中，不僅生角、旦角有大量發揮的機會，其他的行當，如：鬚生、花臉、武旦、老旦，甚至丑角，都能各展所長。值得一提的是，差不多在三十年前，阮兆輝、羅家英、梁漢威、尤聲普、尹飛燕、李鳳、賽麒麟，也曾在香港大會堂合演《趙氏孤兒》。這次在藝術節由新生代接棒再演此劇，別具意義。

當然，薪火相傳，那炬熾熱的火把必須持續燃點。2013年的《粵歷油麻地—三代同台做大戲》，就是另一個關於傳承的演出。由三代香港粵劇人同台，意念是「舊人帶新人」，上一輩帶領新一輩演出，由四位前輩龍貫天、阮兆輝、新劍郎和李奇峰擔任藝術總監。另外，演出劇目都是悉心安排，全是幾位著名老倌的代表作，包括何非凡、吳君麗戲寶《雙仙拜月亭》、任白戲寶《再世紅梅記》，還有羅家寶戲寶《夢斷香銷四十年》。

阮兆輝出演《文武雙全陳好逑—文姬歸漢》
Yuen Siu-fai in *The Virtuousity of Chan Ho-Kau - The Reptriation of Cai Wenji* (2002)

Whether proposed by Cantonese opera groups or created to match a certain theme designated by the Festival, programmes were always conceived with the two core objectives of exemplifying traditions and continuing the legacy, the latter of which underlay the programme Cantonese Opera – New Stars in 2006. Yuen was artistic advisor to 15 new talents who took leading roles. Most of the up-and-coming stars emerged from Lam Kar-sing's Chung Sun Sing Opera Troupe and had accumulated at least ten years of artistic experience. The other younger performers were also quite experienced and qualified, most having had years of performing supporting roles in various opera companies. In *The Orphan of the Chiu Family* and excerpts from five operas, they had ample opportunity to show their worth in leading roles, as well as bearded, painted face, female martial arts, elderly women and even clown roles. It is notable that more than 30 years ago, performers including Franco Yuen, Law Ka-ying, Leung Hon-wai, Yau Sing-po, Wan Fei-yin, Lee Fung, and Choi Kee-lun also formed the cast of *The Orphan of the Chiu Family*, performed at the Hong Kong City Hall. With the help of the HKAF, the same work has appeared on stage a second time with emerging talents giving extra poignancy to the production.

For the torch to be passed on, the flame has to be kept alive. This was the concept behind 2013's In Yau Ma Tei – A Legacy of Cantonese Opera, another programme conceived to continue the legacy featuring three generations of Hong Kong Cantonese opera performers sharing the stage. The idea was to partner veteran performers with young stars as a way of nurturing the new generation. The four veteran performers included Lung Koon-tin, Franco Yuen, Sun Kim-long and Li Ki-fung who took on the role of Artistic Directors. The programmes were carefully selected to represent the most famous works of different Cantonese opera master performers, including *Praying to the Moon*, a classic created by Ho Fei-fan and Ng Kwan-lai; *The Reincarnation of Lady Plum Blossom*, famously realised by Yam Kim-fai and Pak Suet-sin; and *The Long-Cherished Love*, which Law Ka-bo made his own.

After years of collaborating with the HKAF, Yuen recognises the impact of reaching different audiences through the Festival. "Because of the HKAF's prestige and branding, there are certain expectations from the audience, and the bar is set high." In addition to guiding new performers, Yuen is tireless in promoting Cantonese opera. For almost 40 years, Yuen has continued to promote

多年來跟藝術節合作，阮兆輝認為這個平台讓他們可以接觸不同的觀眾，「因為藝術節這個品牌，觀眾有期望，所以水準一定要高。」除了在台上帶領新演員，阮兆輝一直不遺餘力推廣粵劇發展，在學校推廣粵劇已差不多四十年，籌辦講座、興趣班、工作坊等不同類型的活動。「我認為向年青一代介紹粵劇，不能強迫也不能硬銷。試想想一個經常流連球場的十多歲年青人，怎能突然要求他安坐在劇院。所以我經常會對他們說，你們不用現在就喜歡粵劇，但要知道這是你的東西你的文化。」七歲已在台上演戲，阮兆輝說當時看到台下都是公公婆婆，已經想到將來長大了，誰來看自己演戲。今天他明白到，原來一定要有觀眾，「但必須承認觀眾是有年齡斷層，只待他們有時間有經濟基礎，便會走進劇院來看粵劇。我常形容粵劇就像海邊的石頭，潮漲時被衝擊，會被掩蓋，一浪接一浪，但潮退時便會再次出現。我們經歷了很多次潮漲潮退，畢竟粵劇是傳統的藝術，不是潮流。」

Cantonese opera in schools by organising a host of activities including talks, classes and workshops. "It is not a good idea to introduce Cantonese operas to the new generation by force or a hard sell. There is no point in asking a teenager who hangs around a sports ground to suddenly stay seated in the theatre. So I often tell them that there is no need to like Cantonese opera at this moment. However, this is your culture and it belongs to you." Having already performed on stage at the age of seven, Yuen remembered the audiences at the time being seniors and he already wondered who would come to his performances when he grew up. He now realises that audience is essential. "Admittedly, there is an age gap among the audiences. When they have the time and financial resources, they will attend Cantonese opera performances in the theatres. I often describe Cantonese opera as rocks along the shore. Surging waves might hit and cover them. However, they will always appear again at low tide. We have experienced many high and low tides. Cantonese opera is, after all, a traditional art and not a brief fad."

汪明荃
致力推動粵劇發展

身體力行推動粵劇的，還有汪明荃。她在 1983 年開始投身粵劇，1988 年成立福陞粵劇團，多年來除了在幕前帶來多齣經典和創新劇目，更是八和會館首位女性主席。有一百三十餘年歷史的八和會館，以弘揚傳統粵劇藝術為宗旨，不單向公眾推廣粵劇，也關注粵劇工作者的專業發展與承傳。「藝術節差不多每年也會有粵劇演出，其實是別具意義，因為最能代表香港的本地藝術是粵劇。香港很多的藝術文化都是吸收外來，粵劇卻是土生土長，從來沒有間斷的傳統藝術，在香港一代一代傳承下去。」

粵劇在 2009 年獲聯合國教科文組織列為《人類非物質文化遺產代表作名錄》（非遺），2010 年藝術節的開幕節目「百年回顧八和鳴」，正是展示粵劇在香港的發展。一連三晚的節目，除了有系統地介紹四個傳統例戲，也恢復傳統，以《玉皇登殿》作為藝術節的開台演出，並且每晚均先演例戲，再上正本；而在正本戲中，更帶領大家走進時光隧道，回顧香港粵劇過去百多年的演變。

Liza Wang Ming-chun
Dedicated to the Development of Cantonese Opera

Another performer devoted to the cause of promoting Cantonese opera is Liza Wang. In 1983, Wang made her first foray into Cantonese opera, later forming the Boomabliss Cantonese Opera Troupe in 1988. For many years, she featured in a large number of traditional and innovative programmes. Wang became the first woman to be elected chairperson of the Chinese Artists Association of Hong Kong (Barwo). Established more than 130 years ago, Barwo upholds the mission of promoting the classical traditional art of Cantonese opera to the general public. It is also concerned with the professional development of Cantonese opera practitioners, and the propagation and preservation of Cantonese opera. "The HKAF presents Cantonese opera programmes almost every year. This is significant as Cantonese opera is the local art form that best represents Hong Kong. A lot of art and culture in Hong Kong was introduced from elsewhere but Cantonese opera is truly local. This traditional art continues to develop uninterrupted and maintains its heritage from one generation to the next."

汪明荃出席「百年回顧八和鳴」開幕演出
Liza Wang attended the opening of Cantonese Opera Treasures (2010)

Cantonese opera was inscribed on the "Representative List of the Intangible Cultural Heritage of Humanity" by UNESCO in 2009. As the opening programme of the HKAF in 2010, the programme Cantonese Opera Treasures was a tribute to Cantonese opera's development in Hong Kong. The three evenings of performances featured a systematic introduction of four Traditional Set Pieces and re-adopted the tradition of performing *The Imperial Emperor of Heaven Holding Court* as the opening performance. Each evening, a regular repertoire work was performed after one of the Traditional Set Pieces. The regular repertoire also chronicled the evolution of Cantonese opera in Hong Kong over the past hundred years.

Traditional Set Pieces are performed to celebrate special occasions. They include: *The Imperial Emperor of Heaven Holding Court, Offer Sacrifice to White Tiger, The Eight Immortals Bestowing Longevity, A Fairy Delivers Her Son to the Mortal Father, Prime Minister of Six States* and *Birthday Feast on the Mountain of Fragrant Flowers*. They are played to enhance the festive atmosphere before the regular repertoire is presented. Other than *Offer Sacrifice to White Tiger*, which is performed exclusively for burnt offering ceremonies, they were rarely performed on their own. However, these Set Pieces are the treasured essence of traditional Cantonese opera. The music in the Set Pieces is a cultural relic preserved in its century-old original form. Thanks to the perseverance of senior artists keen to preserve the heritage, multiple aspects of these traditional Cantonese operas including the *paichang* (performance practice), *gongjia* (feats), *luogu* (gongs and drums), music and singing are kept largely intact.

The programme is significant considering the four Set Pieces were thought to have been lost. Moreover, they are finally revived on stage and performed by more than 30 of the most sought-after veteran masters of Cantonese opera, making the programme the stuff of legends. With Barwo as programme coordinator, Chairperson Liza Wang also finds this performance an extremely rare occasion. "First, these large-scale performances involve a large ensemble of performers including the veteran opera masters. For this reason, it takes Barwo to handle the coordination. Second, these programmes are sung in authentic *gunhua* (Classic Dialect) which the new generation of Cantonese opera performers never learned. In addition, the dialect is difficult to learn. Other opera troupes will not perform these traditional works because they involve a lot of stage movements but little singing while the pieces are short in length. So Barwo needs to take the lead on the project. The programme was a tribute to Cantonese opera being listed as a World Intangible Cultural Heritage in 2009. It highlighted the importance of Cantonese opera as well as its legacy because these

所謂傳統例戲，是指幾個在特殊場合必須上演的劇目，包括《玉皇登殿》、《祭白虎》、《八仙賀壽》、《天姬送子》、《六國大封相》和《香花山大賀壽》等，目的是祭祀、酬神、兼為正本戲演出前營造熱鬧氣氛。除《祭白虎》為純祭祀用的儀式外，其他例戲絕少單獨上演；然而「例戲」卻是傳統粵劇的精華所在。因為現存的例戲都有超過百數十年的歷史，在香港粵劇藝人不斷努力發掘和保存之下，在排場、功架、鑼鼓、音樂、唱腔各方面，都很大程度上保留了傳統粵劇的原來風貌。

另外值得留意的是四齣幾乎失傳的例戲，能夠復現舞台，更有超過三十位最炙手可熱的老倌演出，成為粵劇界一時佳話。節目由八和會館統籌，作為八和會館主席，汪明荃也認為這是極度難能可貴的機會。「首先要演出這些排場戲，需要有很多演員參與，包括資深的大老倌，所以必須要由八和統籌。另外，這些劇目都是唱官話，年青一代的粵劇演員不懂唱，而且也很難學。其他劇團亦不會演出這些傳統戲，因為做功多，唱的部份少，而且都是短篇，所以才需要由八和牽頭籌辦。那次演出剛好是回應2009年粵劇成為非遺，展示了粵劇的重要性，更是一種傳承的意義，因為這些劇目都接近失傳。」粵劇最初演出用的是中原音韻，稱「中州」或「正字」，亦稱為「官話」。自1930年代粵語引入戲棚，粵劇漸漸以粵語演出為主，以「官話」的演出就逐漸減少。

除了難得一看的演出，藝術節還在節期與香港文化博物館聯合舉辦了「盛世梨園：百年粵劇文物選」展覽。

2010年香港演出後，藝術節把香港粵劇經典帶到2010年上海世博會，演出兩場，劇目包括《玉皇登殿》、《六郎罪子》及《曹操關羽貂蟬》。「大會指定由我演貂蟬，羅家英做關公，是他的首本戲，還記得紅綫女也專誠到上海觀看。」這次上海演出促成了汪明荃與香港藝術節的首次合作。「直至2020年，終於有機會真正在香港藝術節演出，在2020年藝術節四大南戲之《荊釵記》與羅家英拍檔演出，因疫情關係，節目延至2020年11月上演。」南戲是傳統戲曲中最古老的劇種之一，約有八百年歷史。編劇葉紹德曾言《荊釵記》是四大南戲之首。

「藝術節做四大南戲，因為我曾經演過《荊釵記》，於是找我來參與，藝術節一般就是定了題然後才找適合人選。《荊釵記》是葉紹德特別為我編寫，當年跟文千歲演對手戲，還有尤聲普，可惜他已過身。尤聲普是很出色的藝人，早已超越自己的行當。」《荊釵記》的主線相對簡單，演繹是戲之所在，而在藝術節的演出，羅家英進一步整理〈雙祭〉、〈會母〉一場。羅家英如何得心應手地配合鑼鼓演出，以及汪明荃如何演繹「青衣」的大段唱詞，是為亮點。

《荊釵記》節目場刊
House programme of *A Thorn Hairpin* (2020)

programmes were close to being lost." Cantonese operas were initially performed with Zhongzhou phonetics, a pronunciation referred to as *Zhongzhou* or *zhengzi*, which is known as *gunhua*. Since the 1930s, when Cantonese was introduced into opera troupes, Cantonese opera has been performed primarily in Cantonese, with performances in *gunhua* gradually declining.

To complement these rare and treasured performances, the Festival also co-organised the exhibition "Silk, Sequins and Scripts: The Splendour of Cantonese Opera" in association with the Hong Kong Heritage Museum during the Festival period.

After the 2010 performances in Hong Kong, the HKAF brought Cantonese Opera Treasures to Shanghai World Expo 2010 for two performances with programmes including *The Imperial Emperor of Heaven Holding Court*, *Luk-long Reprimands His Son* and *Towering Legends of the Three Kingdoms*. "The organiser specifically asked me to play the role of Diao Chan, with Law Ka-ying starring as Guan Gong as this is his signature work. Hung Sin Nui also travelled to Shanghai to attend the performance." The Shanghai performance also marked the first-ever collaboration between Wang and the HKAF. "It wasn't until 2020 that I finally had the opportunity to perform at a proper HKAF performance. It was *A Thorn Hairpin* as part of the Four Southern Opera Classics programme and I performed opposite Law Ka-ying. Because of the pandemic, the programme was delayed to November 2020." Southern opera *(Nanxi)* is generally regarded as one of the oldest operatic genres in China, with a history of 800 years. According to playwright Yip Siu-tak, *A Thorn Hairpin* is the most prominent of the Four Southern Opera Classics.

"When the HKAF presented the Four Southern Opera Classics, I was invited because of my previous performance of *A Thorn Hairpin*. The HKAF usually starts looking for a suitable performer after deciding on the programme. *A Thorn Hairpin* was written specifically for me by Yip Siu-tak. I have previously performed this piece opposite Man Chin-sui, as well as Yau Sing-po, who sadly passed away. Yau Sing-po was an outstanding artist who excelled at the typical repertoire and role types." With a relatively simple story line, *A Thorn Hairpin* is commanding for the interpretations by the actors. For the HKAF's performance, Law Ka-ying further arranged the "Mutual Commemoration" and "Reunion with Mother" segments. Law's virtuoso performance in tandem with the *luogu* ensemble as well as Wang's performance as *qingyi* (young or middle-aged female role) were the highlights of the performance.

何超儀與張繼聰於《情話紫釵》綵排
Josie Ho Chiu-yi and Louis Cheung Kai-chung at the dress
rehearsal of *The Liaisons* (2010) (© Keith Hui)

林錦堂與胡美儀演出《情話紫釵》
Lam Kam-tong and Amy Wu performed
The Liaisons (2010) (© Eddy Zee)

毛俊輝
結合粵劇與現代劇場

2010年跨界音樂劇場《情話紫釵》是毛俊輝 (毛 Sir) 對粵劇和戲劇的一個實驗作品，也是他對戲曲的情意結。「一直對戲曲有興趣，偶然跟朋友談到戲曲中的愛情故事，朋友說這個時代沒有人喜歡看這些故事。我有點不服氣，因為這些戲曲能夠流傳至今一定有其價值。後來看到《愛的藝術》一書，頓時得到啟發，戲曲中的愛情，其實是最高層次，只是默默付出，而不問收穫。於是想到用《紫釵記》去寫現代愛情故事，還邀請莊文強、麥兆輝編劇，嘗試做一個音樂劇場。」《情話紫釵》將粵劇《紫釵記》的那份遙遠又浪漫的情懷，轉移到今日連愛情都是講效率、交易、求變的現代社會裡。當中的粵劇片段不是傳統粵劇的表演，亦不是概念化的實驗創作，而是專注在戲曲的「唱情」，從中尋找劇場演繹的可能性。

《情話紫釵》在藝術節首演後，被邀請到上海世博演出，並榮獲2011年上海壹戲劇大賞的「年度時尚戲曲大獎」，隨後再被邀請到北京演出。「我想大家是看到作品的可能性，寫現代愛情故事中的關係，兩代的矛盾，更具備了香港中西文化結合的特色。」

毛 Sir 在2014年，應香港演藝學院邀請出任新成立的戲曲學院創院院長一職，讓他重新思考香港粵劇未來的發展路向。「2016年離任戲曲學院後，剛好藝術節的賽馬會本地菁英創作系列給我這個機會，在戲曲學院的工作只是起步，現在有機會做戲曲創作，當然要作出新嘗試，所以演出陣容全是年青的演員。」

Fredric Mao Chun-fai
Integrating Cantonese Opera and Contemporary Theatre

The 2010 cross-disciplinary music theatre *The Liaisons* is an experimental work in Cantonese opera and theatre by Fredric Mao Chun-fai. It is also borne out of his affection for Chinese opera. "I have always been interested in Chinese opera. When talking to my friends about love stories in Chinese operas, these stories were dismissed as being of no interest to people nowadays. I was not entirely convinced. There must be reasons these Chinese operas were passed down through generations. Later, after reading the book *Art of Loving*, I was immediately inspired. The notions of love depicted in Chinese operas are of the highest level, being altruistic in nature. This moved me to write a modern love story based on *The Legend of the Purple Hairpin*. I invited Felix Chong and Alan Mak to be co-playwrights for this attempt at music theatre." *The Liaisons* transplants the remote and romantic sentiments of the Cantonese opera *The Legend of the Purple Hairpin* into the modern world, where everything including love has become a kind of transaction that requires efficiency and novelty. The Cantonese opera excerpts in *The Liaisons* are not in the traditional style, nor are they conceptual or experimental. They are explorations in the Cantonese opera technique of "singing emotions" through the possibilities of interpreting traditional operas.

於是便有2018年由藝術節委約及製作的《百花亭贈劍》。「如果沒有創作《情話紫釵》，我會把戲曲與現代戲劇分開，所以這個作品對我影響很深。」

《百花亭贈劍》是1958年唐滌生為吳君麗及何非凡等名伶領導的「麗聲劇團」編寫，當年在九龍「新舞台戲院」首演。「我嘗試改編，首先是把三、四小時的演出時間改成兩小時，當時粵劇界也有點聲音，認為戲寶不能改編。幸好藝術節很開放，也邀請了年輕編劇江駿傑參與改編。」毛Sir更希望透過此次排演去研究整個粵劇的創作過程，從劇本改編、表演手法，音樂處理、製作設計，以至排練方式都嘗試作一番探討，看看現代劇場的創作模式是否對傳統粵劇有值得借鏡的地方，尋找戲曲與現代劇場的結合。

毛Sir說首演時吸引了不少從來不看粵劇的觀眾入場。「他們可能是出於好奇，也可能是因為藝術節的品牌。雖然也有傳統的粵劇觀眾不太接受，他們認為這不是粵劇，但也有人說這樣的粵劇很好看，還記得陳好逑也來欣賞，給予正面的評價。所以我跟藝術節也認為要繼續推動。」2019年藝術節上演《百花亭贈劍》(更新版)，更先後赴深圳、上海、廣州巡演。

創新傳統的過程總會遇到不少困難和挑戰，不過毛Sir的決心一點也沒有動搖。「這次給我最寶貴的經驗，就是嘗試透過改變劇種和行業，從而尋求粵劇發展之路。創新傳統藝術是必然的過程，決不是為新而新，而是令傳統發揚光大。」

《百花亭贈劍》 *Pavilion of a Hundred Flowers* (2018) (© Hiro Graphics)

After its premiere at the HKAF, *The Liaisons* was invited to be performed at the Shanghai Expo. It won the Best Modern Chinese Opera Award at the Shanghai First Drama Awards in 2011 and was later performed in Beijing. "I think people see the value in the work as it portrays modern relationships, conflicts between generations and how Chinese and western culture are blended in Hong Kong."

In 2014, Mao was invited by the HKAPA to be the Chair of its newly established School of Chinese Opera. The new position led him to reassess the future development of Cantonese opera in Hong Kong. "After I left the School of Chinese Opera in 2016, I was given an opportunity in the HKAF's Jockey Club Local Creative Talents Series. The work at the School was just the beginning, and this was an opportunity to create a Chinese opera. This prompted me to be bold and have young performers headline the performance." His aspirations led to the 2018 programme *Pavilion of a Hundred Flowers* commissioned and produced by the Festival. "*The Liaisons* had a great influence on me. Had I not created the show, I would have placed a divide between Chinese operas and contemporary theatre."

Pavilion of a Hundred Flowers was written in 1958 by librettist Tong Tik-sang for the Lai Sing Opera Troupe led by opera stars Ng Kwan-lai and Ho Fei-fan. The opera premiered at the Apollo Theatre in Kowloon. "For my adaptation, the top priority is to create a two-hour version of the original performance which is three to four hours in length. There were voices from the Cantonese opera circle at the time about opera classics being sacrosanct and should not be modified. Fortunately, the HKAF welcomed innovation, and young playwright Jason Kong was also invited to take part in the adaptation."

Mao placed his focus on a more comprehensive overview. Rehearsing the show, Mao closely studied the entire creative process of Cantonese opera, including production, script editing, performance methods, handling of the music, and mechanisms of rehearsals. The aim was to see if modern theatrical production methods could contribute anything to spark new developments in traditional opera and to explore opportunities of uniting traditional opera and contemporary theatre.

Mao said that at the premiere there were a fair number of audience members who have never seen a Cantonese opera before. "They came perhaps out of curiosity or because it is a HKAF's production, the quality of which they trust. There were traditional Cantonese opera fans not too receptive of the work, thinking it wasn't a proper Cantonese opera. But there were also people who enjoyed

本地製作的孵化器

藝術節早期在鄭新文和梁掌瑋推動下，大力發展本地節目，鼓勵本地藝團參與製作，為藝術節帶來新創作。1992年更舉辦「香港演藝日」展現本土的藝術家。雖然藝術節創辦之初也有本地藝團參與，不過到了九十年代，乘著本地藝術發展漸次成熟，除了大型藝團的節目外，年青一代的藝術家在藝術節也有發表新創作的機會。毛俊輝和鄧樹榮便是最早一批在藝術節發表新作的本土藝術家。

毛俊輝
見證本地原創劇的崛起

「那個時候藝術節的本地節目主要是依靠幾個大劇團的演出，中英劇團是其中之一。」毛俊輝第一次參與藝術節，便是替中英劇團執導《閒角春秋》(1989)。因為反應不錯，第二次合作也是中英劇團的節目。「當時學生張達明剛加入了中英劇團，他改編了台灣作家羅智成同名詩作《說書人柳敬亭》(1993)，我覺得劇本很不錯，成為了我在香港執導的第一個原創劇，之前在演藝學院跟學生導的都是翻譯劇。那個時候演藝學院的畢業生剛開始活躍，除了張達明，還有詹瑞文、甄詠蓓等等。」1985年香港演藝學院成立之初，毛俊輝被邀從美返港執教，出任戲劇學院表演

《跟住個嘅妹氹氹轉》綵排
Rehearsal of *The Girl Who Turned the World Upside Down* (1997) (© 謝明莊)

this new type of opera. I remember Chan Ho-kau also attended the performance and was positive about it. So the Festival and I were resolved to go further in this direction." *Pavilion of a Hundred Flowers* (Reboot) was performed at the Festival in 2019 and later toured to Shenzhen, Shanghai and Guangzhou.

Although there were plenty of difficulties and challenges during the process of innovating tradition, Mao's determination never wavered. "This production was a treasured experience of exploring a path in the development of Cantonese opera through transforming its format and practice. Innovation in traditional arts is part of an inevitable process and change is not there for the sake of it but rather to further promote the traditions."

Incubator of Hong Kong Productions

Led by Tseng Sun-man and Grace Lang, the HKAF strengthened its efforts to develop local programmes and encouraged Hong Kong arts groups to produce new works for the Festival. "Hong Kong Performing Arts Day" was presented in 1992 as a showcase for Hong Kong artists. While Hong Kong arts groups did take part in the Festival's early years, arts development in Hong Kong had only started to come of age in the 1990s. In addition to programmes by major performing arts groups, a new generation of artists were given the opportunity to present their latest works at the HKAF. Fredric Mao Chun-fai and Tang Shu-wing were among the earliest local artists to debut their new works at the Festival.

Fredric Mao Chun-fai
Witnessing the Rise of Original Hong Kong Productions

"Local programmes featured in the HKAF at the time primarily came from the several major performing arts groups which included Chung Ying Theatre Company." Fredric Mao Chun-fai's very first work in the HKAF was to direct *Rosencrantz and Guildenstern Are Dead* (1989), produced by Chung Ying Theatre Company. With the positive reaction, the second collaboration was also a programme with Chung Ying Theatre Company. "At the time, my student Cheung Tat-ming had just joined Chung Ying Theatre Company and adapted *The Legend of a Storyteller* (1993), which is based on the poem of the same name by Taiwanese writer Luo Chi-cheng. I thought it was rather good and it became the first original work I directed in Hong Kong.

毛俊輝與《百花亭贈劍》男女主角王志良及林穎施合照
Fredric Mao Chun-fai, Wang Zhiliang and Lin Yingshi
(leads from *Pavilion of a Hundred Flowers*) (2018)

系主任。八十、九十年代是個轉折期，本地劇團發展漸趨成熟，演藝學院訓練了一批台前幕後的新力軍，慢慢從只演翻譯劇發展到原創作品，藝術節也在這個大趨勢下成了重要的推手。

「要做原創劇不是那麼容易，必須要有合適的創作團隊。」毛俊輝特別提到1997年藝術節委約作品《跟住個嘅妹氹氹轉》。「在演藝學院導了很多經典劇目，當中包括《聖女貞德》。那時想到這個貞德不是屬於我們的故事，而是別人的東西，其實我們也可以有自己想說的版本，於是改編了《聖女貞德》成為一個比較實驗性的作品，設計了兩個貞德，分別由陳麗珠、甄詠蓓飾演，其他演員還有黃秋生、陳炳釗、陳曙曦、詹瑞文、紀文舜等。」毛俊輝指出當時藝術節的本地節目仍不多，直至這個作品，令他感到藝術節對本地藝術家的支持，很信任整個創作團隊。「一般劇團有自己路線和風格，很難作出不同的嘗試，加上當時具規模的劇團也不算多，而藝術節已是一個具規模的平台，相對地較靈活，迴響會大一點。最重要是藝術節的創新節目也會刺激其他劇團，更有信心更有勇氣去進行新創作。」

事實上在九十年代，藝術節已積極推動本地原創，1994年的音樂劇《風中細路》是香港原創音樂劇的大膽嘗試，由毛俊輝執導，潘光沛負責劇本、音樂、歌詞，黎海寧編舞，發生於選民投票日的一個故事，緊扣了當時的社會環境。「那是一個突破，潘光沛是非常出色的音樂人。當時的演出很成功，贏得口碑和票房。」

The student productions I directed earlier in the HKAPA were all translated works. HKAPA graduates began to be more active, and other than Cheung Tat -ming, there were also others, including Jim Chim and Olivia Yan." When the HKAPA was first established in 1985, Mao was invited to return from the United States to join as the Head of Acting. The 1980s and 1990s were a turning point as local theatre groups started to mature, and the HKAPA had trained up a new group of onstage and offstage talents. There was also a gradual shift in exclusively translated works to more original works being performed. So the HKAF became an important driving force in this new direction.

"Creating an original production is far from easy as it requires a suitable creative team." Mao cites *The Girl Who Turned the World Upside Down*, commissioned by the Festival in 1997, as an example. "One of the many classics I directed at the HKAPA was *Saint Joan*. I used to think this story of Joan of Arc as not rightfully ours, belonging to others. We can tell the story in our own version. So we adapted *Saint Joan* as a more experimental work and designed two Joan of Arc characters played by Bonni Chan and Olivia Yan. The cast also included Anthony Wong Chau-sang, Chan Ping Chiu, Chan Chu-hei, Jim Chim and Sean Curran." Mao noticed there was a scant number of local programmes in the HKAF at the time. It was not until this programme that he truly felt the Festival's support of local artists with complete confidence on the creative team. "Theatre groups tend to have their own artistic inclinations and style, and it could be difficult to try something new. In addition, there were only a few major theatre companies. The HKAF by then had already become a large-scale platform, which was more flexible and would have a greater impact. Most important was the Festival's ability to present innovative programmes that stimulated and challenged other theatre groups, giving them the confidence and courage to create new works."

By the 1990s, the HKAF was already proactive in presenting original productions by Hong Kong artists. The Hong Kong original musical *The Kids, The Wind & The City* in 1994 was one such bold attempt. It was directed by Mao with script, music and lyrics by Eric Pun and choreography by Helen Lai. The story was closely related to the societal environment at the time and revolved around what happened on an election day. "It was a breakthrough. Eric Pun was an exceptional music artist and the work became a critical success with great reviews and box office."

鄧樹榮
不同階段的探索平台

差不多在同一時間，鄧樹榮也開始了與藝術節的合作，不同的作品除了見證了鄧樹榮過去二十多年的創作歷程，同時也反映了藝術節在香港劇場發展上的角色轉變。鄧樹榮第一次參與藝術節，是1995年翻譯和執導法國作家派屈克·徐四金的作品《小男人拉大琴》，那時他剛從法國進修回港。「這是一齣獨腳戲，一個大提琴手在樂團的位置是甚麼？在樂團裡有些人是不可缺少，但卻不甚起眼，由此引發存在的哲學問題。那時毛俊輝剛從美國回港重返演藝學院，我找他演出此劇他也很興奮。」

1999年藝術節委約的《解剖二千年》，結合了錄像、木偶、真人演出的作品，「那時很想探討多媒體劇場，對我來說，這個作品的重要性，是令我確立了多媒體只是工具而不是目標。」到了2002年的另一委約作品，是改編自高行健的《生死界》。鄧樹榮在法國進修戲劇期間認識了高行健，成為朋友。「《生死界》是我跟高行健在巴黎結緣的回憶，透過他的作品，某程度上是呈現個人在到法國前及在法國的一些掙扎。」

從分享感受、探索藝術形式到個人經歷的總結，藝術節也從跟劇團的合作，慢慢開始委約作品，2008年的《泰特斯》是鄧樹榮探索形體劇場的一個起點。

「2004年入演藝學院後，集中在教學和學生創作，也銳意探索形體概念與表演的關係。於是提議藝術節，如何透過當代形體劇場去演繹西方的經典，最大的挑戰是如何用最簡約的形式去呈現這個複雜故事。當時決定無實體的佈景，唯一的舞台設計是一排面向觀眾的十二張櫈，而演出時甚至連音樂也沒有，是非常大膽的

（右起）鄧樹榮與毛俊輝
(from right) Tang Shu-wing and Fredric Mao Chun-fai (2002)

Tang Shu-wing
An Enduring Platform for Continuing Exploration

Tang Shu-wing started working with the HKAF around the same time. His work is not only an account of his creative journey spanning more than 20 years but also reflects the evolution of the Festival's role in Hong Kong theatre's development. Tang first took part in the HKAF in the 1995 programme *The Double Bass*, by German writer Patrick Süskind, which Tang translated and directed. At the time, Tang had just returned to Hong Kong after studying in France. "This is a one-man show in which a double bass player reflected on his position in the orchestra. Some performers are essential for an orchestra but hardly noticeable, and these thoughts give rise to philosophical questions on the topic of existence. Fredric Mao Chun-fai had at the time just returned from the United States to the HKAPA. I asked him to perform in the play, which he was also excited about."

In 1999, the Festival commissioned *Millennium Autopsy*, a show that combined video images, puppets and actors. "I wanted to explore multi-media theatre at that point. Personally speaking, the significance of the work was to affirm my belief that multi-media is merely the means but not the end." In 2002, another commissioned work for Tang was *Between Life and Death*, an adaptation of Gao Xingjian's play. Tang became friends with Gao during his theatre studies in France. "*Between Life and Death* is borne out of my encounter with Gao Xingjian in Paris and, to some extent, reveals some of my personal struggles before going to France and during the time there."

From sharing of thoughts, to explorations of theatre and recollections of personal experiences, Tang's works evolved as the Festival gradually enhanced its collaboration with theatre groups through commissioned works. A case in point is *Titus Andronicus* in 2008 with Tang's exploration of physical theatre.

"After joining the HKAPA in 2004, I focused on teaching and works by students. I was also determined to explore the relationship between physicality and performances. For this reason, I proposed to the HKAF the performance of a Western classic through contemporary physical theatre. The biggest challenge was to present a complicated story through minimalist aesthetics. It was decided then that there would be virtually no mise-en-scène, with the stage design consisting of just a row of 12 chairs facing the audience. There was not even music during the programme. It was a very bold attempt that I wasn't entirely satisfied with. It was still bound by

《泰特斯》 *Titus* (2008) (© Cheung Chi-wai)

嘗試，成果不是太滿意，自覺還是受制於戲劇，必須要呈現故事人物的條件。」新創作要不斷的改良，於是後來又有了《泰特斯2.0》，而粵語版的莎劇吸引了英國環球劇場的注視，邀請鄧樹榮參與2012年倫敦文化奧運之環球莎士比亞戲劇節。在英國演出前，率先在香港藝術節作首演。「《泰特斯2012》是2008年的版本基礎上，結合《泰特斯2.0》的某些元素。由於作品將會在英國環球劇場上演，那劇場一部份是露天，採用自然燈光，所以在香港的演出也運用了演藝劇院的空間，在一個室內的演出場地打造三面觀眾與台前站席。」

從《泰特斯》到《馬克白》，鄧樹榮再次創作粵語莎士比亞劇，2016年在藝術節首演的《馬克白》，是藝術節與莎士比亞環球劇場聯合委約作品。「這是一個現代夫妻午夜夢迴，回到古代東方，遇上了莎士比亞原劇的不同人物，一個權力鬥爭的故事。」《馬克白》從2015年首演至2019年改名為《馬克白的悲劇》，作品不斷修改。鄧樹榮說藝術節提供了一個平台，讓他作試驗。「我在藝術節的節目，反映了不同年代不同的藝術的追求，還有對社會環境的回應。」

鄧樹榮回想藝術節也經歷很多階段，見證不同年代。「從最初帶來外國、主要是英國的節目，後來多了本地粵劇和粵語節目，用藝術節的形式，推動香港文化藝術發展。讀書時每年也會到大會堂排隊買學生票。中學時期開始對戲劇有興趣，看了很多藝術節的節目，雖然很多時候看不懂，藝術節無疑是看國際演出最重要的窗口。我在藝術節看到的外國節目，見識到原來可以用這樣的方法演繹傳統劇本。後來到法國進修，直至1992年回港，察覺到藝術節已有很大的變化，藝術節照顧了本土文化，主動去發掘、探討如何展示香港的文化特色，大概是對香港回歸在即的回應。藝術節伴隨成長，品牌越來越強大，毫無疑問已是國際知名的藝術節，五十年殊不簡單。」

the drama and the story as well as the characters." The new work continued to undergo improvements and resulted in *Titus 2.0*. This Cantonese version of the Bard's work attracted the attention of Shakespeare's Globe in London, which invited Tang to take part in Globe to Globe, a World Shakespeare Festival as a highlight of the 2012 London Cultural Olympiad. Before the performances in the UK, the work premiered at the HKAF. "*Titus Andronicus 2012* integrates the 2008 version and certain themes from *Titus Andronicus 2.0*. As the work was to be performed at Shakespeare's Globe with part of the theatre uncovered, natural light was used. The Hong Kong performance also made use of the theatrical space of a simulated three-sided free-standing auditorium within an indoor venue."

After *Titus*, Tang continued with another Cantonese Shakespearean play *Macbeth*, co-commissioned by the HKAF and Shakespeare's Globe. "This is a story of a modern couple. As they dream and enter the universe of Macbeth in the buried past of ancient China, they encounter different characters from the play in a struggle for power." *Macbeth*, since its premiere in 2015, has been revised and was retitled *The Tragedy of Macbeth* in 2019. Tang spoke of the platform provided by the HKAF which gives him the opportunity to experiment. "My programmes in the HKAF reflected my artistic pursuit during different eras as well as responses to the societal environment."

Tang also recalls the Festival having undergone changes of its own during different eras. "The programme shifted from having an initial focus on overseas programmes primarily from the UK to having more local Cantonese operas and programmes in Cantonese. This shows how the Festival, with its own approach, promotes Hong Kong's arts development. When I was a student, I used to queue up at City Hall for student tickets. I became interested in the theatre during secondary school and attended many HKAF programmes. Although I didn't understand many of them as a student, the Festival was clearly the most important window for seeing international performances. It was not until I watched the overseas HKAF programmes that I realised traditional scripts could be interpreted in different ways. When I returned to Hong Kong in 1992 from my studies in France, I noticed there had been a big transformation in the HKAF. The event addresses the needs of local culture and takes the initiative to discover and explore how to showcase Hong Kong's cultural assets. It seemed an appropriate response to Hong Kong, on the cusp of the reunification. I grew alongside HKAF, which is becoming stronger still as a brand. It is undoubtedly an arts festival of international renown. Staying vibrant for 50 years is no small feat."

有機的監製角色

隨著本地藝壇發展成熟，藝術節不只停留於委約新作品，還嘗試肩負起以監製的角色，為演藝者搭建創作平台。藝術節副節目總監蘇國雲談到當中的一些轉變。「最初委約製作，一般是交由藝團創作。現在我們的做法有點像荷李活製片，即是從一個概念開始，然後找不同的創作人參與，可能是平日沒機會做這種題材，或是從沒合作過的人。香港某程度上是需要這一種獨立製片人，而不是受制於某個劇團。」

蘇國雲指出這樣有機的監製角色，讓藝術節近年作出了有很多新嘗試，「像賽馬會本地菁英創作系列《世紀·香港》音樂會，用歌聲和音樂去述說香港由開埠至回歸後的百年故事，集合了本地不同界別的藝術家。戲劇方面，又有不同的系列式作品，例如回應時代的《香港家族》，探討內地和香港矛盾的《論語三部曲》，還有講述孫中山少年時代的《日新》，都是一些大眾有興趣看，或我們希望大眾會關心的議題。」

「另外，十多年前，發覺當時香港沒有資源去推動年青一代的舞者，所以我們策劃了『香港賽馬會當代舞蹈平台』，每年不只是介紹一個舞者，而是集合不同風格的編舞而製作的系列節目。到今天這個平台已完成其任務，我們也要轉變，藝術節的思維就是要有新嘗試。現在香港表演藝術最缺乏的是甚麼，就是要發展的方向。所以下一個系列就是要嘗試科技，AR、VR、3D mapping 也好，外國做得很多，也越來越尖端，香港還是起步，相對較簡單。我們會透過一個新的『賽馬會創藝科媒系列』去探討，從小的規模開始嘗試。」

至於以演員身份開始參與藝術節的潘燦良和蘇玉華，經歷了由翻譯劇到原創以至藝術節製作的不同階段。獲獎無數的編劇莊梅岩多次在藝術節發表新作，年青的鄧智堅以編劇及導演身份參與系列式製作。不論是台前還是幕後，與藝術節一起為本地藝壇開創新方向。

The HKAF as Producer

As the local performing arts sector grew, the HKAF became an integral part of this development. Instead of commissioning new works, the Festival began to take on the role of producer, providing a creative platform for artists. So Kwok-wan, the HKAF's Associate Programme Director, spoke of the transformation: "Initially, the commissioned productions were totally in the hands of the arts groups. Our updated approach was close to making a Hollywood production. We started with a concept and looked for different creatives to take part in the production. It could be a rarely explored subject or someone whom we had never worked with before. To some extent, Hong Kong needs this kind of independent 'producer' instead of working under constraints of specific theatre groups."

According to So Kwok-wan, being a producer allowed the Festival to make many new attempts in recent years. "With the Jockey Club Local Creative Talents Series concert *Hong Kong Odyssey*, local artist from different art forms came together to recount through songs and music the story of Hong Kong from the city's colonial era to the post-reunification years. As for theatre works, we had different series of works such as *A Floating Family – A Trilogy*, which cast light on Hong Kong society, the *Chinese Lesson Trilogy* which explored the relationship between Hong Kong and the Mainland. *Yat-sen* is a reimagining of the fiery youth of Sun Yat-sen. These are topics either of interest to the public or what we hope the public will find interesting."

"More than a decade ago, we observed a lack of resources in Hong Kong to promote the new generation of dancers. So we planned the Hong Kong Jockey Club Contemporary Dance Series, which, rather than just introducing a single dancer each year, was a fully-fledged series of programmes featuring performances with different styles in choreography. The platform has now accomplished its mission and we are ready for more challenges. The Festival is poised to do something new. Whatever the Hong Kong performing arts sector needs the most will be our direction for development. For this reason, our next series will deal with technology which might include AR, VR, 3D mapping, among others. It has been done abroad and has become increasingly sophisticated. It is only starting in Hong Kong and is simpler by comparison. Use of technology will be explored in our new series called Jockey Club InnoArts Series, which will start with something smaller in scale."

馬師雅
本地舞蹈平台的實踐

創辦於 2012 年的「香港賽馬會當代舞蹈平台」，目的以推動本地現代舞發展，每年讓本地獨立年青編舞及舞者發表新作及演出，今天不少已在舞蹈界闖出名堂。畢業於香港演藝學院、2020 年獲頒香港舞蹈年獎「白朗唐新晉編舞獎」的馬師雅 (Alice)，曾多次參與舞蹈平台。

「2013 年第一次參與，當時是舞者身份。2018 年開始專注編舞，發表的《烏》是從自己出發的作品，並嘗試建立自己的一套美學。2019 年再有機會參與，對自己的創作信心大了，作品《點指》的反應不錯，也有重演的機會。到了 2021 年的《叮叮叮叮叮》，更嘗試從宏觀一點出發，談多點人性。」回看 Alice 在舞蹈平台的演出和創作，見證了舞者不同的發展階段。對 Alice 來說舞蹈平台對獨立編舞的支援是非常重要。「平日籌辦一個演出，作為獨立編舞要兼顧很多事情，而舞蹈平台的資源較充裕，台燈聲以至一切行政工作，也有專業的幕後團隊協助，讓我可以專心創作。對於初出茅廬的編舞，平日可能只有機會在黑盒劇場演出，舞蹈平台則讓我們走進正式的劇場，是很好的演出經驗。而且，藝術節的觀眾層很不同，能夠吸引一些平日很少看現代舞的觀眾，讓我們的作品可以接觸得更廣。」

馬師雅參與藝術節外展計劃的示範講座演出
Lecture demonstration by Alice Ma for student audiences, as part of a Festival outreach programme (2018)

Poon Chan-leung and Louisa So Yuk-Wah both began their participation in the HKAF as actors, and experienced the different stages of the Festival with a shift from translated to original works and HKAF's productions. The multi-award-winning playwright Candace Chong Mui Ngam often debuted her new works at the Festival while Eric Tang Chi Kin took part in a series of works as both playwright and director. Whether working on stage or behind the scenes, they all work hand in hand with the Festival to pioneer new directions for Hong Kong theatre.

Alice Ma
A Local Dance Platform Showcase

Established in 2012, the Hong Kong Jockey Club Contemporary Dance Series aims to contribute to development of contemporary dance in Hong Kong by allowing young independent dance makers to create and present new works every year. As a result, a number of emerging dance artists have now gained recognition in the sector. One such artist is Alice Ma who participated in the Contemporary Dance Series several times. A graduate of the Hong Kong Academy for Performing Arts, Ma received the Tom Brown Emerging Choreographer Award in the 2020 Hong Kong Dance Awards.

"My first participation in the Contemporary Dance Series was as a dancer in 2013. By 2018, I started to focus on choreography in a production entitled *Wu*, a self-reflective piece in which I tried to establish my own dance aesthetics. Becoming more confident as an artist, I participated again in 2019 with *Over-master* which was well-received and enjoyed a rerun. I went further with *Dingdingdingding* in 2021 with an overarching theme of human nature." Ma's performance and choreographic works in the the Contemporary Dance Series, in retrospect, perfectly illustrated the different stages of development for a dancer. The availability of a dance platform, according to Ma, is quite important for an independent choreographer: "Planning a performance typically requires an independent choreographer to be occupied with lots of administrative matters. The resources are more adequate with the Contemporary Dance Series. A professional backstage team is available to handle sound, lighting and stage as well as general administration. The arrangement allowed me to focus on artistic creation. While works by emerging choreographers are usually staged at black box theatres, the Contemporary Dance Series gave us the valuable opportunity to perform at a formal theatre. Moreover, the platform allowed our works to reach a wider audience as the Festival is able to attract diverse audiences including those who rarely attend contemporary dance performances."

《重回凡間的凡人》 *An Ordinary Man* (2011)

潘燦良
從演戲嘗試編劇創作

潘燦良最初是以話劇團演員身份參與藝術節，分別是《梧桐別墅》(1997)及《明月何曾是兩鄉》(2001)。到了2011年藝術節委約及製作的《重回凡間的凡人》則是他的編劇導演之作，及後亦以演員身份參與藝術節委約及製作《香港家族》(2017)三部曲。潘燦良說藝術節與本地戲劇的發展息息相關。「藝術節在香港戲劇環境成熟下，做了不少本地製作，提供多一個平台發展香港本地作品，而且比起中小型劇團的資源多一點。一般劇團最多只演一個週末，藝術節的場次較多，對於新創作是很好的支持，因為有發展的空間，接近一個成熟的製作模式。另外某些演出更可以到外地巡演。」

潘燦良一直是藝術節的支持者，由觀眾變成參與者。「讀書時看藝術節演出不是這樣簡單，沒有太多錢買票入場，讀演藝學院時就利用學生票看了很多精采的節目。因為藝術節的品牌有代表性，每年也會期待，看看今年又會有甚麼好節目。後來自己的作品竟然出現在藝術節，感到能夠參與是一種榮幸，從一個忠實觀眾到可以參與其中，是一件不可思議的事。」潘燦良回想在演藝學院求學的日子特別期待藝術節，「藉著藝術節接觸外面世界，世界頂級、在香港少見的藝術作品，令我大開眼界，對我日後演員之路很重要，實在是影響一生。」

Poon Chan-leung
From Actor to Playwright

Poon Chan-leung first took part in the HKAF as an actor of Hong Kong Repertory Theatre in the productions of *Villa Parasol* (1997) and *We are One Family* (2001). In 2011, the Festival commissioned and produced *An Ordinary Man*, Poon's first work as playwright, which he also directed. He later starred in the trilogy *A Floating Family* (2017), which was commissioned and produced by the HKAF. Poon spoke of the close relationship between the HKAF and the development of Hong Kong theatre: "When Hong Kong theatre started to mature, the Festival presented a fair number of theatre productions and became an additional platform for local works to be developed. It provides more resources than small and medium-sized theatre groups. While most theatre groups present their performances over one weekend at most, there are more performances with the HKAF. It provides great support for new work because of the space given to develop the work and a more sophisticated production model. Some programmes might be performed abroad too."

Poon had always been a loyal supporter of the HKAF, first as an audience and later as a participant. "When I was a student, watching a Festival performance was not that easy. Though money was tight, I bought student tickets for many excellent programmes during my study at the Hong Kong Academy for Performing Arts. The Festival is a landmark event which I always looked forward to, wondering about the great programmes coming up the following year. Instead of being an anticipating audiences, I became a participating artist when my work was part of the Festival's line-up. This felt incredible as being featured in the Festival is no small feat."

Poon recalls his anticipation of the event when he was a student. "It was only through the HKAF that I would get a glimpse of the

潘燦良（前右）參演《香港家族》
Poon Chan-leung (front right) at *A Floating Family* (2017) (© Lawrence Ng, Work House)

演出之外，潘燦良亦嘗試創作，2010年創作劇本《重回凡間的凡人》，發表於新域劇團舉辦之「劇場裏的臥虎與藏龍」，獲得藝術節的垂青。「剛從外地旅行回港，在機場等行李時收到藝術節的短信，邀請我合作，今天還記得那一刻的雀躍。藝術節的自由度大，很信任不同崗位的藝術家，提供了一個發表平台，藝術上沒有任何要求，只是持著開放的態度，最大的優勢就是提供一個最信任的自由空間。而且藝術節不像劇團，有其風格和藝術路線的限制，因此藝術節的節目更多元化，容許創作人自由發揮，因為無特定風格，所以更易吸納更多不同類型觀眾。」

蘇玉華
琢磨演技的煉金石

蘇玉華每年也是期待藝術節數之不盡的精采節目，羅伯特·利伯殊、羅伯特·威爾遜、翩娜·包殊、雲門……。「我去看藝術節是抱著可以一睹高質素節目的期待，因為藝術節是全年的盛事，一定是最高質最多元的節目，讓你在很短時間可以看很多精采節目，戲劇以外，舞蹈音樂不同類型的藝術，非常豐盛，對我來說非常重要。」

當然，觀眾以外，蘇玉華的名字多次出現在藝術節。早年是以香港話劇團演員的身份參與藝術節。「藝術節代表高水平，一個平台集合了世界頂尖藝術節目，又有本地的藝術家參與，所以能夠參與藝術節令我很自豪。」蘇玉華其中一個最深刻的演出，是2002年鄧樹榮導演的無人地帶—《生死界》。「還記得當日鄧樹榮致電給我，說高行健剛拿了諾貝爾文學獎，很想在這個時候演這個作品，邀請我去做女角。聽到這個消息後心跳得很厲害，很渴望參與，但其實還不知道是怎樣一回事，隨即趕往他家中拿劇本，然後把車泊在街角一旁，看完劇本便立即回覆鄧樹榮答應演出。掛斷電話後，回過神來才問自己是否有點衝動，因為這個獨腳戲不易處理，對當時的我來說是很深的戲劇理論。當然很開心答應了演出，藝術節也很開放包容，信任藝術家。」蘇玉華更憑此劇奪得2003年香港舞台劇獎最佳女主角。

及後蘇玉華多次參與藝術節製作的作品，翻譯劇《改造情人》，原創劇《重回凡間的凡人》和《金蘭姊妹》，不同演出正好也看到了藝術節在節目策略上的轉變。「藝術節就是不斷去檢視，怎樣對待本地劇場發展，不是每年湊合一些節目，而是做了推手。

world outside and the chance to attend world-class performances rarely presented in Hong Kong. The experiences broadened my horizon, which was also important for my subsequent journey as an actor. The impact stayed with me my whole life."

In addition to being an actor, Poon also started writing plays. His script in 2010, *An Ordinary Man*, was featured at the Prospects Theatre's Playwright Scheme and caught the attention of the HKAF. "I had just returned to Hong Kong and was waiting at the airport for my bags to arrive. I still remember the moment of joy when I received the HKAF's invitation by SMS. The HKAF gave us a lot of freedom and had great trust in the creative team. It provided a platform for performance, did not make any specific requests on the artistic front and remained open-minded. Its biggest strength is this space for creative freedom with a high degree of trust. The Festival is also not a theatre group, which might be constrained by the group's style and artistic direction. This meant the HKAF's programmes could be more diverse, without being attached to a certain style, and more effective in attracting different kinds of audiences."

Louisa So Yuk-wah
The Place to Hone an Actor's Craft

Louisa So Yuk-wah looks forward to the numerous exciting programmes of the HKAF every year, and is excited to see the likes of Robert Lepage, Robert Wilson, Pina Bausch and Cloud Gate. "I attend the Festival with great anticipation, knowing there will be excellent productions because it is the biggest event of the year. You get to enjoy many extraordinary programmes within a short span of time. Other than drama, there's also dance, music and other art forms. This abundance is quite important to me."

Louisa So is not just an audience member, having herself featured numerous times in the Festival. During the early years, she joined the Festival as an actor in the Hong Kong Repertory Theatre. "The HKAF is synonymous with high quality, a platform of the top arts programmes from around the world that also features local artists. So it is an honour for me to take part in the Festival." One of Louisa So's most memorable work was No Man's Land – *Between Life and Death* directed by Tang Shu-wing in 2002. "I remember the day Tang phoned me. He told me that Gao Xingjian had just been awarded the Nobel Prize in Literature and now was the right time to present the work. My heart was jumping out of my chest with excitement and I wanted to be part of it even without knowing the details. I rushed to his place for the

無人地帶 —《生死界》
No Man's Land — *Between Life and Death* (2002) (© Jolans Fung)

《金蘭姊妹》節目場刊
House programme of *The Amahs* (2015)

由九十年代開始，以翻譯劇為主，後來慢慢給予機會香港劇作家，鼓勵他們寫屬於香港土地，或用香港視野去關心世界的作品。這個出發點非常好，難得一個藝術節積極去實踐，本地劇場多了香港劇作家的作品，是件非常可喜的事。」蘇玉華期望日後可透過藝術節，與外國藝術家交流合作，「我不知道可以是甚麼形式，或者是跟外國藝術家共同創作，一起建構演出，在我演藝歷程沒有此經驗，藝術節跟海外藝術家有緊密聯繫，很有潛質去促成這種合作關係。」

莊梅岩
沒有重演的機會也願意

香港著名劇作家莊梅岩，除撰寫舞台劇，亦常參與劇本翻譯、改編。從《法吻》、《野豬》到《聖荷西謀殺案》，莊梅岩的不少經典作品，都是誕生於藝術節這個平台。「喜歡跟藝術節合作，除了不用擔心行政上的問題，最重要是自由的組合，可以有不分門派的創作空間。平日跟劇團合作，必須選用他們的演員，難免欠缺新鮮感。所以每當想到是否可跟某演員合作，便會想到藝術節。」《法吻》(2005) 的李鎮洲，《聖荷西謀殺案》(2009) 的劉雅麗、鄧偉傑、彭秀慧，《野豬》(2012) 的廖啟智、黃子華、林嘉欣。不同的班底創造了各具特色的新創作。

script, parked my car on the kerb and immediately said yes to Tang on the phone after reading the script. It wasn't until after the phone call that I came back to my senses and worried if I had been too impulsive. It is not easy to handle a solo performance and the underlying drama theory is quite profound. Of course I was quite happy to have said yes. The HKAF was also very open with complete trust in the artists." For her performance in No Man's Land – *Between Life and Death*, Louisa So received the Best Actress Award at the 2003 Hong Kong Drama Awards.

Louisa So later took part in many HKAF's productions, including the translated work *The Shape of Things* and original productions *An Ordinary Man* and *The Amahs*. The range of performances is also indicative of the HKAF's change in its approach to programmes: "The HKAF continues to review how it relates to Hong Kong's theatre development. It doesn't just gather together programmes every year but plays the role of instigator. The focus was on translated works at the beginning of the 1990s. This slowly shifted to giving opportunities to Hong Kong playwrights, encouraging them to write something that belongs to Hong Kong or works with a global vision from a Hong Kong perspective. This was an excellent start, and rare for an arts festival to put into action. Having more work by Hong Kong playwrights is great for the local theatre world."

Louisa So looks forward to collaborations with overseas artists in the future through the HKAF. "I don't know what format it will take. It could be working with overseas artists to build up a performance together. This is something I have never tried in my career in theatre. The HKAF has close ties with overseas artists and has the potential to create this kind of partnership."

Candace Chong Mui-ngam
No Reruns Not a Problem

In addition to crafting plays, renowned Hong Kong playwright Candace Chong Mui Ngam is also engaged in translations and adaptations of stage works. Many of Chong's formidable works, including *The French Kiss*, *The Wild Boar* and *Murder in San Jose*, were conceived on the HKAF's platform. "I love working with the Festival. There are fewer worries about administrative matters, and the key advantage is having free rein in the team set-up and an all-embracing creative space. When working with certain theatre groups, their actors come as part of the package. For this reason, I think of the Festival whenever I hope to work with a certain actor." With Lee Chun-chow in *The French Kiss* (2005), Alice Lau, Tang Wai-kit and Kearen Pang in *Murder in San Jose* (2009) and Liu Kai-chi,

莊梅岩提到跟藝術節的合作，要有一心理準備：「就是藝術節委約的作品，要預期沒有機會重演。」聽起來有點負面，但也有箇中道理。「一般來說，劇團的節目如果票房好口碑佳，重演是理所當然的事。藝術節跟劇團的情況不一樣，加上能夠湊合不同劇團的班底是相當困難的事，所以不能經常作出重演。即使如此，能夠在藝術節以最理想的團隊去呈現作品，只發生一次也很滿足，很想經歷一個最好的製作過程。當原創劇沒機會重演是很大犧牲，但我也願意，因為在藝術節，作品往往能以最美姿態呈現。其實，《聖荷西謀殺案》對我來說是很大的驚喜，好像是藝術節第一個重演的劇目。」

《聖荷西謀殺案》2009年在藝術節首演，六場演出很快爆滿，隨即在九月重演，2011年在香港作第三度重演，隨後更到新加坡巡演。作品榮獲第十九屆香港舞台劇獎四獎，包括「最佳導演（悲劇／正劇）」、「最佳劇本」、「最佳女主角（悲劇／正劇）」及「十大最受歡迎製作」，迴響很大。「原本也擔心新加坡的觀眾是否理解這個故事，怎料觀眾反應很好，幽默的地方比香港人笑得更大聲，到危機來了，全場屏息靜待，比香港觀眾更緊張投入。新加坡的演出是一個很難忘愉快的經驗。」

藝術節多齣委約作品，除了《改造情人》是翻譯劇，其他都是原創。「文本題材都是我的提議，藝術節給予很大的空間。其實我曾把《法吻》建議給幾個劇團，但他們也不太接受這個劇本，可能是題材比較冷門，感覺也像很沉悶。藝術節相對沒有太多包袱，不需要迎合市場，能夠接納實驗性較強的作品。之後不論是談新聞自由的《野豬》、關於同性戀的《我們最快樂》，從來也沒有干擾創作，希望藝術節能繼續這種精神。」《我們最快樂》原定於2020年藝術節上演，已延至2022年。「我覺得《我們最快樂》很適合藝術節，有點實驗性，有點非主流的風格。而且我很欣賞黃龍斌這位導演，雖然我們的風格很不同，他從形體出發，視覺很強，我多寫三一律劇和音樂劇。但我很想和他合作，藝術節成了一個最佳的平台。」莊梅岩直言也很想自己成為某種平台，給其他人機會，與不同藝術家的合作。「其實藝術節經常起用年輕藝術家，是年青具潛力劇作家的原創作品的平台，其中一個印象深刻的一個新創作是《爆·蛹》(2013)。」

Wong Chi-wah and Karena Lam in *The Wild Boar* (2012), the different ensembles come together in stellar works, each with their own character.

On working with the HKAF, Chong talks about being mentally prepared for one very real possibility: "With works commissioned by the Festival, there might be no opportunity for reruns." That might seem slightly negative but it's a reasonable observation. "When a programme does well at the box office with good reviews, having reruns is almost a foregone conclusion in a theatre group. However, the Festival operates differently. It is also difficult to assemble the same team from multiple theatre groups, and reruns are therefore rare. Even so, the IIKAF makcs it possible to find the best possible team to present my work even if it is just a one-off opportunity. A superb production process is satisfying enough, even if it happens only once. *Murder in San Jose* was a very pleasant surprise for me. I think it was the first HKAF programme to have a rerun."

When *Murder in San Jose* premiered in 2009 at the Festival, tickets for all six performances sold out immediately. It enjoyed a rerun in September and a second rerun in Hong Kong in 2011 before touring to Singapore. The critically acclaimed work swept four major awards at the 19th Hong Kong Drama Awards, including Best Director (Tragedy/Drama), Best Script, Best Actress (Tragedy/Drama) and Top Ten Most Popular Productions. The response was overwhelming. "I was initially worried about audiences in Singapore not understanding the story. Their reactions, however, were great. They laughed even louder at the funny moments, became even more engaged than Hong Kong audiences and the venue went quiet at moments of suspense. It was a memorable and very pleasant experience."

Other than *The Shape of Things*, which is a translated work, all of Chong's commissioned works for the Festival have been original plays. "The scripts were proposed from my side and the HKAF gave me a lot of space. I actually proposed *The French Kiss* to several theatre groups but they were not receptive, perhaps because the subject matter is relatively obscure and sounded dull. The HKAF is less burdened by market concerns and receptive of works that are more experimental in nature. Later on, whether it was with *The Wild Boar*, which talks about freedom of the press, or *We Are Gay*, on the topic of homosexuality, the Festival never interfered with my work. I hope the Festival will continue in this way." *We Are Gay* was originally scheduled for performance at the Festival in 2020 and has now been postponed till 2022. "I think *We Are Gay* suits the Festival, as it is somewhat experimental with an unconventional

莊梅岩特別提到藝術節另一個獨特之處是能吸引外國觀眾，「藝術節展示了英文字幕的重要性。音樂舞蹈不需要翻譯，主流舞台劇都是以本地觀眾為主，戲劇要推廣到海外就有點困難。《法吻》是第一個有英文字幕的作品，因此後來我可以把作品帶到美國演出及圍讀。《聖荷西謀殺案》因為有中英文字幕對照，將我的文字帶到更遠的地方，對編劇來說是很重要的事。甚至乎在網上更可購買《聖荷西謀殺案》的電子版劇本，這些都是藝術節的功勞。其實很多機構也不是沒有資源，但願意放在長遠的發展，沒有即時回報，作為存檔紀錄和推動文本，藝術節確是行了重要的一步。不論是字幕翻譯還是劇本出版，也多得藝術節，把這些原創作品，推到更遠，令更多人知道香港有這樣的故事。」

莊梅岩（左）協助《法吻》的演員綵排
Candace Chong (left) facilitated the acting team to rehearse *The French Kiss* (2005)
(© Chi Wai)

《聖荷西謀殺案》
Murder in San Jose (2009)

鄧智堅
展現新銳舞台

身兼演員、編劇、導演的鄧智堅，除以演員身份參與鄧樹榮在藝術節的兩部作品《泰特斯》和《馬克白》，近年更為藝術節編導了三部原創作品──學問三部曲：《論語》(2016)、《大學之烈火青春》、《中庸之幸福學堂》(2018)，探討年青人和現今社會的關係，追求的教育又是甚麼？「一直很想以教育為題材，所以跟藝術節很快就決定要以三部曲的形式，原本計劃以六年時間演出三部，後來一次過在同一年推出兩部曲。一般劇團很難成事，而且由我包辦編劇及導演，在藝術節是比較罕見，因為藝術節希望邀請未曾合作過的編劇，大家傾談時，我提出希望主題是關於年青人，想知道年青人在做甚麼。創作過程中，藝術節提供很多的支援，例如幫助聯絡年青人做資料搜集，完全是一條龍服務。」

style. I quite admire the director Tony Wong too. Although we differ in style as he begins with movements and a strong visual emphasis, while I tend to write either plays that adhere to classical unities or musicals. But I wanted to work with him and the HKAF is an ideal platform." Chong is candid in hoping to be a platform herself as well facilitating collaborations between different artists. "The HKAF often features young artists, being an accessible platform for original works by young playwrights with potential. One original work that I found memorable was *Blast* (2013)."

Chong highlighted the HKAF's unique advantage of drawing foreign audiences. "The Festival demonstrated the importance of having English subtitles to accompany a programme. Translations are not needed for music and dance programmes. Mainstream dramas are geared towards Hong Kong audiences and overseas promotion might be difficult. *The French Kiss* was my first work with English subtitles, which allowed me to bring it to the United States for performances and for the script to be read. Because of the Chinese and English subtitles for *Murder in San Jose*, I was able to take the play further and this is very important for playwrights. Thanks to the HKAF, it is even possible to purchase the script of *Murder in San Jose* in electronic format online. Other organisations might not necessarily lack the resources. However, the HKAF takes bigger and more significant steps in long-term development that might not yield immediate returns, as well as archive work and promotion of scripts. Whether it was subtitle translation or publication of scripts, I am grateful for HKAF's efforts in taking these original works great distances, allowing more people to know about these works from Hong Kong."

Eric Tang Chi-kin
Young Blood for the New Stage

Eric Tang Chi-kin is a theatre man of many talents, being an actor, playwright and director. He joined the HKAF as an actor for two works, *Titus Andronicus* and *Macbeth*, both directed by Tang Shu-wing. In recent years, Eric Tang wrote and directed three original works for the HKAF in a trilogy on learning: *Chinese Lesson* (2016), *The Great Learning* and *Doctrine of Happiness* (2018), posing questions about how younger people relate to the times they live in and the goal of education. "I've always wanted to work on the topic of education, and decided with the Festival to create a trilogy, with the programmes spanning six years. In the end, the second and third programmes were presented the same year. This arrangement would probably not be possible for most theatre groups, especially with me as both playwright and director. I don't think it happens all that often with the HKAF either. The Festival wanted to invite playwrights

《中庸之幸福學堂》
Doctrine of Happiness (2018) (© Hiro Graphics)

《大學之烈火青春》
The Great Learning (2018) (© Hiro Graphics)

鄧智堅說藝術節可能是看中了他幽默的一面,事實上,以教育為題材直覺上是令人沉悶的,用怎樣的方式處理才能引起觀眾的共鳴,便是核心所在。鄧智堅提到個人的經歷,就成了最紮實的元素。「還記得會考那一年,班主任對我說,我會考應該不會合格。你說對一個中學生來說會有何感想?其實我很喜歡文學和中國歷史,很喜歡上課,卻因為我寫字太慢而導致會考中文科不合格。因為報讀演藝學院一定要中文科合格,於是我寫了一封信解釋,最後獲取錄了。《論語》中涉及考試制度的問題,考試就是將學生評定為某個類別,但其實很多學生還有未被發掘的一面,這多少也是我自己的經歷。」藝術節副節目總監蘇國雲提到《論語》,是圍繞青少年面對社會矛盾,面對人生、學業,面對未知的將來。這齣由幾個年青演員挑大樑的戲,被英文《南華早報》挑選為 2016 年最佳戲劇之一。

2018 年藝術節一口氣推出可說是《論語》續篇的《大學之烈火青春》與《中庸之幸福學堂》,延續《論語》中各位主角的青春求學歲月,到踏入社會生兒育女為未來下一代打拼的故事。類似連續劇的設計,又能獨立成篇的劇本及舞台創作,可算是本地戲劇的新嘗試。

whom they'd never worked with before. During our discussion, I mentioned my preference for the plays to be about young people and about what young people are doing. During the creative process, the HKAF provided a lot of support such as help in contacting young people for research. The support given was comprehensive."

Tang believes he may have been picked by the HKAF because of his humorous side. Topics on education might seem intrinsically boring to many people. In this case, the key challenge was to make the works resonate with the audience. Tang says his personal experience became a key element of the work. "I remember that when I sat for the HKCEE, my teacher told me that I would probably fail. How do you think a secondary school student would take that? I liked literature and Chinese history a lot and loved going to classes. But I still failed the HKCEE Chinese Language examination because I wrote too slowly. As a pass on the subject was required to apply to the Hong Kong Academy for Performing Arts, I wrote a letter to explain the situation and was eventually admitted.

Chinese Lesson talks about how students are assessed and pigeonholed into certain categories. But there are aspects to many students yet to be discovered. This has been more or less my personal experience." The HKAF's Associate Programme Director So Kwok-wan describes *Chinese Lesson* as a drama that revolves around how young people deal with social conflict, their lives and studies, and an uncertain future. Featuring a young cast in the lead roles, the play was named one of 2016's best productions by the *South China Morning Post*.

In 2018, the Festival presented *The Great Learning* and *Doctrine of Happiness*, which are sequels to *Chinese Lesson*. The two plays expand on the stories of the protagonists in *Chinese Lesson*, tracing their lives through college, early careers, parenthood and their striving for the future of the next generation. These plays are akin to a drama series, but are at the same time stand-alone new works that collectively constituted a new departure in Hong Kong theatre.

《論語》 *Chinese Lesson* (2016)

本地歌劇創歷史

本地歌劇一直是尚待發展的一個藝術領域，早於三十年前，藝術節已開始製作本地歌劇，除了 1997 年譚盾的《馬可·波羅》大型歌劇，亦曾邀請了盧景文與不同作曲家合作，製作室內歌劇，包括 1999 年與郭文景合作的《夜宴》和顧七寶的《三皇墓》、2000 年與蘇鼎昌合作的《阿綉》。近年藝術節發展華語歌劇，與陳慶恩與盧定彰兩位不同年代的作曲家繼續開創歷史。

陳慶恩
華語歌劇音樂新方向

從《蕭紅》、賽馬會本地菁英創作系列《大同》到《世紀·香港》，陳慶恩與香港藝術節一起開創了華語歌劇創作的新方向。

2013 年的《蕭紅》是陳慶恩首次創作歌劇，「學生時代一直不喜歡歌劇，因為歌劇都是外語，有語言的障礙。」想不到陳慶恩第一個歌劇作品，更是華語歌劇。「這是創作生涯中很重要的突破，不只是技巧上，而是讓我看到一個新世界。」陳慶恩指出華語歌劇跟中國傳統戲曲很不同。「歌劇誕生於 17 世紀的意大利，後來發展到歐洲不同的語言系統，這些作曲家無可避免要解決語言跟音樂結合的問題，而華語還有聲調上的限制、語言節奏等問題。而因為歌劇要跟語言緊扣，不可能全然跟從西方的一套技巧。華語歌劇大概只有一百年的歷史，必須要有很多代作曲家努力，才能留給後世借鑑。我們這一代可以借鑑的不多，大家都是摸著石頭過河。我自己是每寫一個作品，便覺得是行了一步，但在整個華語歌劇發展也只是一小步。」

《蕭紅》 *Xiao Hong* (2013)

The Genesis of Hong Kong Opera

Hong Kong opera was still a nascent artistic field when the HKAF took the initiative to produce local operas 30 years ago. In addition to the major opera production *Marco Polo* by Tan Dun in 1997, a number of composers, including Lo King-man, were invited to produce chamber operas such as *Night Banquet* by Guo Wenjing and *The Tomb of Three Kings* by Brian Chatpo Koo in 1999 as well as *The Shopkeeper's Daughter* by So Ting-cheong in 2000. In recent years, the Festival has continued to develop operas in Chinese with works by Chan Hing-yan and Daniel Lo, two composers from different eras who continue to travel on this relatively untrodden path.

Chan Hing-yan
New Direction for Opera in Chinese

From *Heart of Coral* and Jockey Club Local Creative Talents Series *Datong: The Chinese Utopia* to *Hong Kong Odyssey*, Chan Hing-yan and the HKAF have worked hand in hand to pioneer a new direction for opera in Chinese.

Heart of Coral in 2013 is Chan's first operatic work. "During my student days, I did not like opera because of the language barrier of operas being sung in foreign languages." Chan was even taken aback when he heard his first operatic work sung in Chinese. "This was a significant breakthrough on my creative journey, not just on a technical level. A new world emerged before me because of it." Chan points out the big difference between opera in Chinese and traditional Chinese opera: "Opera traces its origins back to Italy in the 17th century and it was later developed in other European languages. The composers had to inevitably resolve the challenges of combining language and music. There were also issues such as the tonal restrictions and rhythms of the Chinese language. Since an opera has to be closely linked to its sung language, some Western techniques are not applicable. With opera in Chinese having a short history of about a hundred years, it has taken a lot of hard work by generations of composers to leave something for the next one. There is little that our generation can refer to and we are still experimenting. It still feels like taking a new step whenever I complete a piece. In the grand scheme of development of opera in Chinese, however, it is only a small step."

《大同》於倫敦演出　*Datong: The Chinese Utopia* touring in London (2017)
(© Kii Studios Photography & Film)

2013年，陳慶恩與文本創作意珩及導演黎海寧踏出了一小步，創作了三幕室內歌劇《蕭紅》。結果口碑不錯，「雖然我自己的部份是不太滿意，不過意珩的劇本是很出色，當時在戲劇界也引起迴響，之後多了戲劇導演希望執導歌劇。」不只在本地受到關注，2014年更到台北參加「香港周」演出。「《蕭紅》在台灣也很受歡迎，當地很少華語歌劇創作。」兩年後，陳慶恩與藝術節走多一小步，再次創作三幕室內歌劇《大同》。文本是從陳耀成紀錄片《大同：康有為在瑞典》出發，鄧樹榮執導。《蕭紅》是一個中國傳奇女作家的故事，而《大同》牽涉的人物關係以至跨越的時代背景更為複雜。「寫《蕭紅》時，只是想寫一個別人容易接受的作品，到了《大同》，很想花心思去把語言和音樂結合。」過程中遇到不少挑戰，陳慶恩說最後自己花了很多時間剪裁劇本。《大同》的反應很理想，2017年適逢香港回歸20周年，《大同》更到倫敦巡演，別具意義。「當時有觀眾專程從法國飛來觀看，我想在海外推華語歌劇除了音樂上的創新，主題也很重要。」《蕭紅》到台灣，《大同》到英國，可見其他的機構也認同其成就，「最少要有作品，才有機會有好作品留下。雖然委約時不能保證作品質素，但不委約就一定沒有好作品。」

In 2013, Chan took a step forward with librettist Yi Heng and director Helen Lai in creating *Heart of Coral*, a chamber opera in three acts about the life of the celebrated writer Xiao Hong. The production was warmly received. "Although I was not overly satisfied with my work, the script by Yi Heng was outstanding and generated a lot of excitement in the theatre world with more directors looking to direct operas." As well as generating attention in Hong Kong, the work was presented in "Hong Kong Week 2014" in Taipei. It was also well-received in Taiwan, where operatic works in Chinese are rare.

Two years later, Chan and the HKAF made further strides with the three-act chamber opera *Datong: The Chinese Utopia*. The libretto was based on the documentary *Datong: The Great Society* by Evans Chan, and Tang Shu-wing directed. While *Heart of Coral* was about the life of a legendary female writer in China, *Datong: The Chinese Utopia* was considerably more complicated with the characters and their relationships spanning different eras. "When composing *Heart of Coral*, I simply wanted to write something easily accepted. With *Datong*, I put tremendous effort into integrating the language and music."

There were many challenges and Chan would spend a lot of time tailoring the script. *Datong* was well-reviewed and toured to London in 2017 on the 20th anniversary of Hong Kong's reunification with China. "In the audience was someone who came from France to see it. For overseas audiences, it takes more than musical innovation to promote opera in Chinese. The topic is quite important, too." That *Heart of Coral* and *Datong* were performed in Taiwan and the UK respectively is testament to Chan's accomplishments being recognised beyond Hong Kong. "You have to produce some work before you do something that has a chance of passing the test of time. Commissions might not necessarily guarantee the quality of a work but they are essential for good works to exist."

As the two collaborations had generated critical acclaim and excitement, the Festival started discussions with Chan after *Datong* about producing a large-scale performance scheduled for 2017, the 20th anniversary of the reunification. The result was *Hong Kong Odyssey*. The concert had a conceptual framework using literary works about Hong Kong as a creative axis and was presented in the format of a staged cantata, in which over 100 performers recounted the story of Hong Kong from the city's early colonial era to the post-reunification years.

兩度合作，泛起陣陣漣漪。《大同》演出過後，藝術節已跟陳慶恩討論籌劃一個大型演出，2017年適逢香港回歸二十周年，其中一個重頭音樂節目便是《世紀·香港》。概念是以書寫香港的文學作品為骨幹，以戲劇化的清唱形式，由逾百位演出者唱頌香港由開埠以來至回歸後的百年滄桑。陳慶恩擔任音樂總監，聯同三位年青作曲家李家泰、盧定彰及鄺展維合力編寫香港百年之歌。「以文學作品去帶出香港歷史，我花了整個暑假，差不多將所有香港新詩看了一次。過程中藝術節給予我很大的創作自由，選用甚麼文本、說哪段歷史完全沒有意見。當中絕大部份歌曲是用廣東話演唱，在文化界也引起哄動。」

回想這些創作，陳慶恩感謝藝術節給予寶貴的機會。「創作人有平台寫這麼多不同的作品，中國歷史、香港本土文化，實在是難能可貴的經驗。更要多謝藝術節讓我有機會為自己上訴，因為2022年將會再度上演《蕭紅》。我對之前的版本不甚滿意，沒處理好語言的問題，所以我將會重寫。」2022年藝術節聯合香港舞蹈團，上演的版本是舞蹈歌劇。同時以兩個女性為主題，除了陳慶恩的《蕭紅》，還有盧定彰的賽馬會本地菁英創作系列《兩個女子》。

Chan took on the role of music director and partnered with three young composers Phoebus Lee, Daniel Lo and Charles Kwong in this music tribute to a century of Hong Kong. "To highlight Hong Kong history through literature, I spent the entire summer reading almost all the new Hong Kong poems there were. The Festival gave me a lot of creative freedom and did not give its opinion on what texts to choose or what historical events to include. The work was largely sung in Cantonese, which caused a sensation in cultural circles."

Looking back at his work, Chan is grateful for the precious opportunities afforded by the HKAF. "It is a rare and treasured experience to be given a platform to create so many works on Chinese history and the local culture of Hong Kong. I am even more grateful to the HKAF for giving me an opportunity to improve my work, and *Heart of Coral* will be staged again in 2022. I was not entirely satisfied with the earlier version and it will be rewritten as I hadn't fully dealt with the language issues first time around." The 2022 version will be a dance opera co-produced by the HKAF and Hong Kong Dance Company. In addition to *Heart of Coral* by Chan, another new opera produced by the Festival was a Jockey Club Local Creative Talents Series work *Women Like Us* by Daniel Lo.

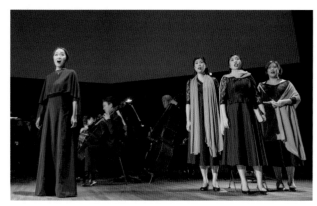

《世紀·香港》
Hong Kong Odyssey (2017) (© Hiro Graphics)

賽馬會本地菁英創作系列舞蹈歌劇《兩生花》（同場上演）《兩個女子》及《蕭紅》
Jockey Club Local Creative Talents Series Dance Opera: *Love Streams* (A double–bill : *Women Like Us* and *Heart of Coral*) (2022)

盧定彰
粵語歌劇的先河

正如陳慶恩說在開創華語歌劇路上，需要當代作曲家不斷的嘗試，盧定彰(Daniel)是當中的一份子。Daniel在香港大學師隨陳慶恩，後到約克大學完成作曲博士課程。近年與本地及外國樂團合作多個委約作品。陳慶恩邀請Daniel參與藝術節的《世紀·香港》，可說是替後來藝術節另一委約作品《兩個女子》埋下種子。

「創作《世紀·香港》時有系統地閱讀了香港作家的作品，從早期南來作家，到西西、也斯、董啟章，讓我大開眼界。那是第一次參與大型的演出，當時做了兩個作品，其一是用廣東話演唱，選用了陳冠中的小說《金都茶餐廳》，配合許冠傑的歌，像一個迷你版音樂劇場。」Daniel說那次是非常寶貴的經驗，同時開始思考可否以香港文學作品為題材創作歌劇。「用現代文學作為音樂文本不是很常見，一般多選詩詞歌賦，或者是也斯、余光中的近代詩。我在思考短篇小說是否也有轉化成音樂的可能，戲劇經常有小說改編，但音樂卻不常見。」於是在完成《世紀·香港》後，Daniel繼續他的研究，「看了很多西西的作品，一開始吸引我的是《感冒》，剛好收到捷克奧斯特拉瓦現代新歌劇節的委約，因為只得一年時間籌備，所以決定改編西西另一著名並已有英文翻譯的作品《像我這樣的一個女子》，寫成英文歌劇。」Daniel隨即又收到藝術節的邀請，促成了他的第一部歌劇作品《兩個女子》。「我在構思時已決定用廣東話，因為用廣東話唱藝術歌確實是很少。」

Daniel Lo
A Pioneer of Chinese-Language Opera

Daniel Lo studied with Chan Hing-yan at the University of Hong Kong before completing his PhD in composition at the University of York in Britain. In recent years, Lo has worked with local and overseas orchestras on a range of commissioned works. Chan Hing-yan also invited him to participate in *Hong Kong Odyssey* at the HKAF, which no doubt prompted the HKAF's later commission of *Women Like Us*.

"When creating music for *Hong Kong Odyssey*, I pored over works by Hong Kong writers ranging from the earlier Southbound writers, who came from the Mainland, to Xi Xi, Yasi and Dung Kai-cheung, which broadened my outlook. It was my first time to take part in a large-scale performance, and I contributed two pieces. The first was sung in Cantonese with lyrics selected from the novel *Café CAN DO* by John Chan. It was coupled with the songs of Sam Hui and resembled a mini-musical." The experience was invaluable for Lo who started to consider the possibility of writing operas based on Hong Kong literature.

"Adapting contemporary literature in song is not too common. The source material generally tends to be classic poems and songs or modern poetry by Yasi and Yu Kwang-chung. I also examined the feasibility of adapting short stories. Hong Kong novels are often adapted as plays but rarely put to music."

盧定彰與黃怡參與「香港藝術節@牛棚 — 藝術共生創造社」計劃的室內歌劇實驗創作
Daniel Lo and Wong Yi take part in the "HKAF@Cattle Depot Creative Hub" project, beginning experimental development of a chamber opera (2019)

Daniel是第一個藝術節委約創作粵語歌劇的作曲家，對他來說是個很大的挑戰。「這次特別慶幸藝術節促成的一個新合作模式，就是有時間做展演（work-in-progress），表示我們可以將創作期伸延，可以先做試驗，然後慢慢改進。」《兩個女子》原本的計劃是2020年在藝術節上演，之前一年先在牛棚藝術村展演。「既然可以在牛棚作實驗，於是把《感冒》和《像我這樣的一個女子》結合，因為兩者像雙生兒，有很多互涉。」Daniel很感恩可以在牛棚作實驗。「一般新創作的時間很趕急，排練時發現不滿意的地方，也沒時間修正，我們經常笑說，完成就是勝利。這次在牛棚大概有三星期時間，差不多每日綵排，因為唱粵語也要適應，很多不能在樂譜詳細列明，還有對角色的討論，都需要排練去解決這些問題。」期後他們做了一小時的節目，當中包括二十分鐘的展演，其餘時間是介紹作品和觀眾分享。「當時西西也有來看，她對我們說不用緊張，鼓勵大家放膽去做，不妨放開懷抱去創作。」

Daniel認為用廣東話創作不是想像中般困難，語言最重要是其節奏。「好的歌劇，起承轉合要有很多情緒，西西小說最厲害的地方，是展示了人的複雜情緒，有嫉怒、糾結、甜蜜、求人原諒等不同情緒，所以最困難是如何用現代作曲表達不同的情緒。」Daniel笑言有朋友跟他說聽粵語歌劇感覺像有點奇怪。「我不知道多聽十齣八齣是否會習慣。畢竟這些事情沒人做過，大家都是歷史見證人。歌劇是『比生命還大』的藝術，本身也是超現實，或許一些不太寫實的劇本比較適合？」

《兩個女子》的綵排
Rehearsal of *Women Like Us* (2021)

Lo continued his research after finishing *Hong Kong Odyssey*. "I read many works by Xi Xi and was initially interested in the story *The Cold*. At the same time, I was given a commission by New Opera Days Ostrava in the Czech Republic. Because there was only one year of planning, I decided to adapt *A Girl like Me*, another story by Xi Xi, which was already available in English translation. It was adapted as an opera sung in English." This was immediately followed by the HKAF's commission, which led to *Women like Us*, his first libretto. "I had already decided on using Cantonese when it was first conceived because there are so few art songs sung in the language."

Lo is the first composer to be commissioned by the HKAF to create a Cantonese chamber opera, and the work was a big challenge. "I am grateful for the new approach of collaboration provided by the HKAF which was as work-in-progress. With this approach, it was possible to get more time to complete it, and to experiment before making improvements." *Women like Us* was already scheduled for performances at the Festival in 2020 and had been showcased at the Cattle Depot Artist Village one year earlier. "As we were able to experiment with the production at Cattle Depot, we brought *The Cold* and *A Girl like Me* together because they are like a pair of twins with a lot of interactions." Lo recalls, Xi Xi was also at the showcase at the Cattle Depot. She encouraged us to be more relaxed, to be bold in our creations and to have an open mind."

Lo says he found creating vocal works in Cantonese to be not as difficult as he imagined, and that rhythm mattered the most for the language. "A good opera involves a variety of emotions along with all the plot's twists and turns. The extraordinary quality of Xi Xi's work lies in its portrayal of people's complicated emotions. So the challenge lies in expressing a collage of emotions." Lo laughs that some of his friends felt a bit odd when listening to opera in Cantonese. "I don't know if they will get used to it over time. After all, it is not something that has been done before. Opera is an art that is larger than life and is surreal in nature. Perhaps a less realistic script might be more appropriate?"

提升本地演藝製作水平

對於舞台製作的工作者來說，能與海外的優秀藝團合力製作，實在是難得的觀摩交流機會。香港演藝學院的技術部門因爲有足夠經驗處理大型演出，是香港藝術節長期的合作夥伴，這樣，本地技術人員與外來藝團的合作過程中，便能見識到一些複雜精妙的舞台製作，從中獲得豐富的專業知識，藝術節無形中對培訓本地的演藝製作人才起了一定作用。

楊福全
舞台製作講求精準

楊福全(Frank)畢業於香港演藝學院，主修舞台管理。從自由職業的技術統籌舞台工作者，到今天西九文化區管理局表演藝術（技術發展）高級經理，Frank認為藝術節對培養本地藝術人才起了很大作用。「我1992年還是演藝學院學生，第一次參與藝術節，充當技術總監蘇迪基的助手，負責大型歌劇的舞台製作。自此在藝術節多次接觸海外藝團的製作，與頂級的藝團合作擴闊了我的眼界，某程度造就了今日的我。」

Frank提到其中一個最深刻的製作，是1997年翩娜·包殊烏珀塔爾舞蹈劇場的《抹窗人》。「我是節目的技術總監，有幸跟Grace（藝術節節目總監）一起去德國看首演，跟他們的舞台經理、技術總監見面，研究佈景、道具、舞台設計的元素，對我來說是很重要的經驗。我的職責是確保舞團到香港演出時，能夠呈現這些舞台設計，因為當地的劇院跟文化中心的設計很不同，需要很多的改良和配合。當時的舞台設計有幾個重要的元素，其中一個是要噴火。在舞台上噴真火，在香港要通過很多程序才可以成事。另外還有一個玫瑰花山，我們也需要如實呈現。我的職責是如何百份百，或差不多百份百去實現編舞家Pina的創作。簡單來說，我們的角色就是如何在香港的劇院環境裡呈現外國的演出，特別是一些度身訂造的技術設計，如何翻譯到香港的環境。」

Raising Production Standards of Local Performances

For stage production crews, working with outstanding overseas arts groups have been invaluable learning opportunities. The HKAF is in long-term partnership with the technical department of the Hong Kong Academy for Performing Arts (HKAPA) and collaborating with visiting groups often allowed the Hong Kong crew to observe practices of their counterparts from different places. In this way the Festival makes an additional contribution to the development of production arts professionals in Hong Kong.

Frank Yeung
Pursuit of Precision in Stage Production

Frank Yeung graduated from the HKAPA with a major in Stage Management. His career evolved from being a freelance technical coordinator for stage productions to his current post of Productions Senior Manager, Technical (Performing Arts) at West Kowloon Cultural District Authority. Yeung readily recognises the HKAF's contributions to fostering local talents in the arts. "I was still a HKAPA student in 1992 and my first participation in the HKAF was as assistant to technical director Philip Soden, who was responsible for the stage productions of large-scale operas. I have since been part of many HKAF's productions by visiting arts groups. Working with the very best arts groups in the world broadened my vision and, to some extent, made me who I am today."

One of Yeung's most memorable productions was *The Window Washer* by Tanztheater Wuppertal Pina Bausch in 1997. "I was the programme's technical director and had the opportunity to attend its premiere in Germany with Grace (HKAF's Programme Director). I met their stage manager and technical director, and went through the details including the set, props and stage design. It was an important experience for me as my responsibility was to present these stage designs when the company performed in Hong Kong. Because the design of their theatre was quite different from our Cultural Centre, we had to make a lot of changes and compromises. One requirement was having fire on stage. Having real flames on stage in Hong Kong will only be approved after passing a series of stringent procedures. Another was a mountain of flowers, which we needed to replicate to the best of our ability. My responsibility was to realise Pina's work to perfection, or close to perfection."

提到《抹窗人》，還有另外一件趣事。「舞團的同事跟我說 Pina 很怕冷，大概是她習慣了歐洲有暖氣的環境，所以要求在劇院裡不可有任何冷風。我負責把這個要求轉告場地的同事，說一有冷風 Pina 便會離場。後來有觀眾投訴太熱，最後我們也私下放了些冷風。」

Frank 亦提到1996年加拿大歌劇團的《藍鬚子城堡／期待》。「節目有兩個演出，當中的技術要求有點複雜，有牆又有水，不能有差錯。那次演出很順利，劇團很滿意，稱讚香港的技術人員很專業。藝術節面對的是海外藝術家，藝團透過跟我的合作而認識香港劇場技術。跟外國劇團的合作經驗，令我知道要預計問題，因為有解決方案就不是問題，要提供方法，才達到他們在藝術上和技術上的要求。這些經驗讓我日後做製作時明白到，一切都是關於細節，就是可以著重細節去到1毫米、0.5毫米這種程度。雖然觀眾未必察覺到當中的分別，但作為劇場工作者，這些都是很重要。」

陳焯華
劇場燈光

陳焯華 (Billy) 在香港演藝學院科藝學院主修劇場燈光設計。多年來參與過藝術節無數節目，海外的本地的，也參與過多種類型的演出，「在劇場演出中，台燈聲不可或缺，與演出服裝道具的位置相等，而燈光也不可能獨立存在。沒有光，甚麼也看不到；當然這是最基本的功能，燈光設計的作用，是令觀眾在導演和製作團隊想呈現的獨特環境內，去感受作品的氛圍。」

香港演藝學院
The Hong Kong Academy for Performing Arts

There were other challenges in this production, some unexpected. "Someone from the dance company told me that Pina couldn't stand cold conditions. She was probably accustomed to having heating in European buildings. So we were asked to not have air conditioning. I forwarded the request to colleagues at the venue, and told them that she would leave if there was air conditioning. But the audience later complained about the heat and we eventually slipped in a bit of air conditioning."

Yeung also recalled *Bluebeard's Castle/Erwartung* by Canadian Opera Company in 1996. "The programme consisted of two performances with complicated technical requirements. With walls and water on stage, there was no room for error. The performances went smoothly and the visiting company was very satisfied, paying compliments to the professionalism of Hong Kong's technical crew. While the Festival liaised with the overseas artists, the arts groups got to know about Hong Kong's theatre technology through working with me. Having worked with overseas theatre companies trained me to anticipate possible problems. There are no problems as long as there are solutions. And we need to provide solutions to fulfil their artistic and technical requirements. These experiences provided insight for subsequent productions I worked on. Everything is about the details, with attention to details and precision levels within 1mm or 0.5mm. The audience may not be aware of the differences, but these are highly important for theatre practitioners."

Billy Chan Cheuk-wah
Theatre Lighting

Billy Chan Cheuk-wah graduated from the School of Technical Arts at the Hong Kong Academy for Performing Arts with a major in Theatre Lighting Design. Over the years, he has taken part in many HKAF programmes, including both overseas and local productions. "Stage lighting and sound are crucial to stage performances, just as essential as costumes and sets. Lighting does not exist on its own, and it is a fundamental feature, without which there is no performance to watch. Lighting design helps the audience enter the atmosphere of the work in the environment created by the director and production team."

Chan was already involved in Festival programmes during his student days at the HKAPA and regularly interacted with renowned overseas theatre groups, opera houses and ballet companies. "It was

《行雷閃電》 *Rave* (1999) (© 非常林奕華)

Billy 讀演藝時已經參與藝術節，經常接觸外國著名的劇團、歌劇院、芭蕾舞團。「當時真的很興奮，平日沒有機會看到他們怎樣工作，對於剛畢業的技術人員是很好的經驗。記得有次是一個倫敦西區劇院演出，應該是《一僕二主》，溝通的過程中讓我學懂很多專業的技術詞彙，即使在學校有英語老師，但這些東西也只能在藝術節學到，透過跟不同國家的劇團合作，便會學習了他們的詞彙，不只是英式，還有美式、意大利式。」Billy 說藝術節經常會為海外的演出聘請本地技術人員「我們的職責就是負責兩方溝通，把對方的要求告訴場地，如何作協調，過程中可以看到不同國家對舞台技術的要求會有所不同，這是一個文化交流的歷程。」

Billy 也曾為香港藝術節與三藩市歌劇院聯合製作的《紅樓夢》(2017) 擔任技術經理。「那次專程到三藩市歌劇院看首演和參加製作會議。這個演出規模很大，而且香港文化中心跟三藩市歌劇院的技術設備也有一定差距，要想辦法如何調較技術以作出相應的效果，事實上，我們還有很多地方可以取經學習。我最大的關注是如何把歌劇院的燈光效果，盡量原汁原味地搬到香港文化中心。」

Billy 長期和「非常林奕華」劇團合作，其中有兩部在藝術節上演，包括林奕華與音樂人雷頌德合創的《行雷閃電》(1999)，以及由藝術節委約、林奕華與胡恩威改編王爾德的《快樂王子》(2003)。

really exciting for me. To see how they actually operate is not an opportunity you have every day, and it was a wonderful experience for a technical crew like me who just graduated. One time, there was a programme from West End of London, probably *One Man, Two Guvnors*. I learned many professional and technical terms. You'll never learn the vocabulary in school or from English teachers. It is only through the Festival that I got to learn this, by working with groups from different countries." Chan says the HKAF would employ local technical crew for performances by overseas groups. "We are responsible for facilitating communication, including relaying the group's requirements to the venue, and to take care of coordination. We often notice that different countries having specific technical requirements for the stage, and this also became an instance of cultural exchange."

Chan was also Technical Manager for *Dream of the Red Chamber* (2017), a co-production by the Festival and the San Francisco Opera. "I travelled to San Francisco to watch the premiere there and joined the production meeting. In addition to the show being a mega production, there are considerable differences between the technical equipment at the Hong Kong Cultural Centre and those at the San Francisco Opera. So we needed to figure out how to adjust the technology to create the same effects. My biggest concern was to have the lighting at the opera house replicated as authentically as possible in Hong Kong."

Chan maintains a long-term partnership with Edward Lam Dance Theater with two productions featured in HKAF; the first one was *Rave* (1999) co-produced by Edward Lam and Mark Lui, followed by *The Happy Prince* (2003) commissioned by HKAF with adaptation by Edward Lam and Mathias Woo based on the classic tale of the same name by Oscar Wilde.

吸引優秀藝術家參與

藝術節的製作演出，機緣巧合，天時地利，往往讓本地優秀的藝術家樂於參與其中，讓每次創作探新都能擦出火花，綻放異彩。

葉錦添

葉錦添對服裝設計、視覺及當代藝術皆精，曾經憑《臥虎藏龍》贏得奧斯卡電影金像獎之最佳美術設計。他的早期作品已揭示了其新東方美學概念，讓海外人士更了解中國文化及藝術之美。

葉錦添的作品跨越不同媒介，首次參與藝術節的是《情話紫釵》(2010)，隨後的《紅樓夢》(2017) 更是首度為美國歌劇院擔任舞台美術設計。他指出：「兩個作品代表了我不同階段的創作，都是對一個傳統的中國有所回盼。兩個作品都巧妙的利用了當代的意識，在傳統的氛圍裡，每個作品都有它很獨特與不同之處，每個地域的創作都有所不一樣，每一天我都希望找到一個獨特的介入點。」

「《紅樓夢》的創作過程使我進一步瞭解，在西方世界中，他們怎麼瞭解中國的傳統世界，原來一個文化的樣貌，很受到他所處於的空間所影響。中國文化博大精深，高雅飄逸，但存在於國際的環境裡面還是有非常多的不理解，可能在我的大半個創作生涯裡，都繞不開這個問題，就是讓全世界更明白中國的美在哪裡，提昇人們對中國文化的理解，通過古典與前衛的創作手法，去讓世界感受中國的無限可能。香港藝術節給了我這兩次愉快合作的機會。」

《紅樓夢》 Dream of the Red Chamber (2017)

Attracting Top Artists to Collaborate

The HKAF's productions are possible only through the collaboration of artists both on stage and behind the scenes. Creative sparks often fly and take a production to new levels with outstanding local artists.

Tim Yip

Tim Yip is highly revered for his artistry in costume and art direction, as well as visual and contemporary art, and won an Academy Award for Best Art Direction for his work on the film *Crouching Tiger, Hidden Dragon*. He broadened the appeal and deepened the world's understanding of the beauty of Chinese culture and arts by introducing his "New Orientalism" aesthetic in his earlier works.

Working across different disciplines, Tim Yip's first work at the HKAF was *The Liaisons* (2010). It was followed by *Dream of the Red Chamber* (2017), which was the first time he worked as production designer for an American opera house. "The two productions represent different eras of my creative work with both being retrospections of a traditional China," he says. "There was use of contemporary consciousness within the traditional setting. Each piece is unique, just as productions from different regions have their own features, I always look for a special point of intervention while working."

"The creative process of *Dream of the Red Chamber* led me to further understand how the Western world perceives traditional China. It turns out the impression of a culture is greatly influenced by where the person is. Chinese culture, being rich, profound and exquisite at the same time, is yet to be genuinely understood in the international environment. This is perhaps the conundrum I deal with in the bulk of my creative work, which is to make the world understand Chinese culture better and where the beauty of China lies. Both classic and leading-edge approaches are employed for the world to experience the infinite potential of China. And I am grateful to the HKAF for these two enjoyable collaborations."

金培達

本地炙手可熱的音樂創作人金培達，除了活躍於流行歌曲及電影配樂，曾參與過藝術節的《海闊天空》(2002)，《獨行俠與亂世佳人》(2004)、《留著愛》(2007) 以及於 2022 年上演的賽馬會本地菁英創作系列《日新》音樂劇。

金培達說道：「記得小時候在電視裡看到香港藝術節的廣告，感覺它像一扇窗，透過它可以看到香港以外的藝術世界。又怎想到若干年之後我竟然能參與在其中。第一次為舞台劇創作音樂是許樹寧的《海闊天空》，那是香港藝術節 2002 年的委約作品。那次的參與，開展了我之後音樂劇創作的歷程。躋身在被邀請的世界級藝術家當中，讓我增添了一種不一樣的創作動力，希望自己的作品無論在藝術性或創意上，更努力邁向國際水準和發揮能代表香港的特色。二十年來四次的參與，也帶來了一份自豪感。」

金培達為《日新》這部音樂劇擔任音樂總監及作曲，作品將重塑孫中山火紅少年時代，並由陳詠燊編劇、鄧偉傑執導、岑偉宗作詞。「今年為香港藝術節五十周年創作《日新》音樂劇，別具意義。能夠和幾位優秀藝術家合作，尤感榮幸。過程中有默契，有笑聲，也有爭辯，但最後總是獲益良多，一切只為了呈現一部更好的作品。過去兩年的創作中，無論是要面對疫情帶來很多意想不到的困難，或是在製作上的追求和支持，都能看到香港藝術節對本地創作的無限支持和不遺餘力。在祝賀香港藝術節五十年的耕耘和成果之餘，期待它開展下一個更美好的五十年。」

Peter Kam Pui-tat

Peter Kam Pui-tat is a highly sought-after composer in Hong Kong, active in pop music as well as film composition. Kam's participations in the HKAF include *To Touch the Untouchable Sky* (2002), *The Good, the Bad and Scarlett O'hara* (2004), *And Then There's You* (2007), and Jockey Club Local Creative Talents Series *Yat-sen Musical*, an upcoming production in 2022.

"I remember the commercial for the HKAF appearing on television when I was young," Kam recalls, "and the event felt like a window through which I could see the art world outside Hong Kong. Never would I have imagined being part of the Festival years later. My first involvement in the HKAF was in 2002 when I was music director and composer for the commissioned work *To Touch the Untouchable Sky* by Hui Shu-ning. This production marked the beginning of my journey in musicals. Being in the ranks of world-class artists invited by the HKAF gave me a particular motivation. It prompted me to work even harder so my work could be representative of Hong Kong while also being of international calibre, both in terms of artistry and creativity. It also gives me a sense of pride to have taken part in the Festival four times in 20 years."

Kam also serves as music director and composer for the musical *Yat-sen* which is a reimagining of the fiery youth of the father of modern China Sun Yat-sen. The musical's creative team includes Sunny Chan as playwright, Tang Wai-Kit as director and Chris Shum as librettist. "It is quite meaningful to be part of the musical *Yat-sen* this year, being the HKAF's 50th anniversary. It is also a great honour to work with a team of exceptional artists. During the two years we spent creating the work, whether it was facing unexpected challenges due to the pandemic or trying to get the production perfect, I could see the HKAF's limitless support and dedication to local works. I congratulate the Festival on its tremendous efforts and accomplishments over the past 50 years, and look forward to its next half-century."

《日新》 *Yat-sen* (2022) (© hiro gazo)

「無限亮」衝破有限

由藝術節與香港賽馬會慈善信託基金聯合呈獻的「無限亮」計劃於 2019年正式開展，致力創造無障礙環境，並透過藝術來探索及推動社會共融。「無限亮」呈獻一眾來自世界各地與本地不同能力藝術家的表演，包括音樂、舞蹈、戲劇及電影等。從藝術家身上，可以體會怎樣克服衝破身體限制，創造出無限精采的藝術世界。

丁怡杰
努力不懈照亮世界

年紀輕輕的丁怡杰，憑著對古典小提琴的熱愛及絕妙的技巧，感動無數觀眾。她六歲開始學習小提琴，視力隨著成長惡化，到了十五歲就完全失明。但視障的困擾和缺乏凸字樂譜的難關，無阻對音樂的追求和堅持。她靠記憶力將無數樂譜印於腦海，並且為求在香港進修音樂，曾經不辭勞苦每天往返佛山。

2019年，丁怡杰在首屆「無限亮」舉行了首場獨奏音樂會。「得知被邀請的消息時十分驚訝，同時也非常感動自身的努力得到了大家的肯定。由於挑選的曲目難度頗高，音樂會前我每天平均要花上八至十小時的練琴時間準備，加上演藝學院的學業繁重，真有精疲力竭的感覺，但每次一點點的進步成為了我最大的動力前進，希望將最好的演繹展現給香港的觀眾。」

丁怡杰在「無限亮」演出小提琴獨奏
Ding Yijie perfoming solo violin at "No Limits" (2019)

Defying Boundaries with "No Limits"

The HKAF launched "No Limits" in 2019 to create a barrier-free environment to explore and promote inclusiveness and understanding through the arts, with the support of The Hong Kong Jockey Club Charities Trust as funder and co-presenter. "No Limits" features a series of programmes which cover music, dance, theatre and film by international and Hong Kong artists of different abilities that defy constraints and boundaries.

Ding Yijie
No Limits in Illuminating the World

The young Ding Yijie captivates the hearts of audiences with her passion and phenomenal skill on the violin. Since picking up the instrument at the age of six, Ding's eyesight deteriorated and she became completely blind by the time she was 15. Her visual impairment and a dearth of scores in braille have not hindered Ding in her career. She memorises scores by heart.

In 2019, Ding presented her first solo violin recital in the first edition of "No Limits". "I was surprised by the invitation," she says, "and I was very moved by the fact that my efforts were recognised by others. Because of the difficulty of the selected programme, I spent eight to ten hours every day practising for the recital in addition to my studies at the HKAPA. It was exhausting. Every little bit of progress, however, became my biggest motivation to move forward as I wished to give my very best for the Hong Kong audience."

"Beyond all my expectations, the recital sold out two months in advance. I was moved by the Hong Kong audience's passion for music and was thrilled and nervous at the same time, hoping to present all that I'd learned to the audience through music."

Many of the artists featured in "No Limits" believe in not being bound by their abilities. "Personally speaking," Ding adds, "No Limits" is an inclusive platform and it allows people with different abilities to express themselves. Although I am visually impaired, I have never felt different from others. I even believe I am able to achieve more than people of the same age through hard work. So the performance in "No Limits" allowed the audience to better appreciate the abilities and talents of different people. It also had an impact on people with different abilities and encouraged them to face challenges, excel and create a wonderful life."

「出乎意料的是，門票在音樂會前兩個月就已全部售罄。香港觀眾對欣賞音樂的那股熱情令人佩服。那時我的心情既興奮又緊張，希望將我所學的知識透過音樂來傳遞給每一位觀眾。」

能衝破身體的限制，是許多「無限亮」藝術者的信念。「對我來說，『無限亮』是一個共融的平台，也是一個讓更多不同能力人士展現自我的平台。我雖先天失明，但從不認為自己與他人有什麼不同，甚至相信靠著努力可以做到比同齡人更優秀。所以在我看來，在『無限亮』的演出更能讓觀眾體會到不同人的能力和才華，也能感染更多不同能力人士，使他們勇於挑戰，突破自我，創造出精采的人生。」

露卡・帕杜里
舞出超能量

超能量街舞團是一隊國際霹靂舞團，由七名活躍於加拿大、美國、荷蘭、智利、巴西、南韓的不同能力舞者組成。舞團旨在透過參加國際性賽事和演出，向世界展示「一切皆有可能」的理念。團名突顯嘻哈文化的特色，用了否定的字眼表達正面的意念——「ILL-Abilities」中的「ILL」不是指患病，而是指令人驚嘆和多元化的才能，代表著這個團隊看不到殘障帶來的局限。超能量街舞團獲邀參與了 2020 年第二屆由香港藝術節和香港賽馬會慈善信託基金聯合主辦的「無限亮」。

超能量街舞團的創辦人露卡・帕杜里（Luca）患有先天多發性關節攣縮症，十五歲開始跳舞，早已發展出獨特的舞蹈風格，融合拐杖和雙臂的力量。「舞蹈是少數可以把所有年紀、種族、性別、不同能力人士聚集在一起享受當刻的活動。對我來說，舞蹈是自我表達的終極方式。」

除了演出之外，超能量街舞團也被邀負責第二屆「無限亮」的導師培訓工作坊及藝術家進駐計劃，對Luca及舞團來說，這是一個極難忘的經驗。「我感受到整個『無限亮』計劃的工作團隊，對共融藝術都很盡心熱誠。2020 年 1 月，我們很高興能夠和香港約十個不同舞蹈團體交流，本來同年 3 月再訪作正式演出，可惜因新冠疫情打亂了計劃。但是大家都鍥而不捨，終於以線上形式跟觀眾見面，就正好體驗了舞團的信念：『無藉口，無限制！』」

Luca Patuelli
Dance with High-Octane Energy

ILL-Abilities is an international breakdance crew composed of seven members who come from Canada, the United States, the Netherlands, Chile, Brazil and South Korea. It aims to compete and perform internationally to show the world that anything is possible. The "ILL" in ILL-Abilities does not refer to "sick" but rather to the incredible, amazing and complex talent of the group, dismissing the supposed limitations of "disability". ILL-Abilities was invited to take part in the 2020 "No Limits", the second edition of the project co-presented by the HKAF and The Hong Kong Jockey Club Charities Trust.

Luca Patuelli, founder of ILL-Abilities, was born with arthrogryposis, a muscle disorder that affects the legs. He started dancing at the age of 15, and has developed a unique dance style incorporating his crutches and the strength of his arms. "Dance is one of the few activities that brings people of all ages, all races, all genders, and all abilities together," Patuelli says. "To me, dance is the ultimate form of self-expression."

In addition to performances, ILL-Abilities was also invited to take part in the Train-the-Trainer Workshop and Artists-in-Residence Programme during the second edition of "No Limits". The experience was a memorable one for Patuelli and the dance crew: "I could feel the passion and enthusiasm towards inclusive arts from the entire 'No Limits' project team. We were very happy to interact with ten Hong Kong dance groups in January 2020. We were supposed to have our performances in March 2020, but that was unfortunately interrupted by the pandemic. But we were able

超能量街舞團七位舞者
Seven members of ILL-Abilities (© Kien Quan Photography)

Luca 介紹兩場演出：「《無限亮街舞對決》是一場鬥舞比賽。我們挑戰健全的舞者，激勵他們跳出思維定式的創作，在每場街舞對決中，舞者需抽選例如輪椅、拐杖、眼罩等道具，應戰者需將道具融入舞蹈，發揮所長，決一高下。而《失·聯》則由七段獨舞組成，分別呈現每位團員跨越困難時的心路歷程。演出更通過舞蹈設計，將這些獨舞聯繫起來，代表我們上下一心，合而為一。」

對這次排除萬難，線上演出，舞團引以為榮。「不過，始終現場的表演是無可媲美，觀眾可以聽到舞者的呼吸及感受到動作的意思，那是特別的連繫。」

縱使未能現場接觸觀眾，Luca 也認為藝術家進駐計劃是一個絕妙的平台，「因為能讓我們分享共融的教學法及霹靂舞經驗，以及聯同本地藝術家，引導參加者一同創作。由於疫情前我們之間已有很多碰面機會，所以建立了一定的連繫，最大的挑戰是時差，不過都能克服，最後攝製成舞蹈錄像展演，透過網上平台分享創作成果。看到參與計劃的同學如巨星般燦爛奪目，實在令人雀躍！」🌼

to present it to audiences online. The experience is yet another testament to our dance company's motto: 'No Excuses, No Limits!'"

Patuelli describes the two performances: "*No Limits Concept Battle* is a dance battle where we challenge dancers without disabilities to compete with a form of limitation using a wheelchair, crutches, eye mask or other props. The work challenges local dancers to think outside the box. In *Dis-Connect*, there are seven unique solos sharing each dancer's respective journey through adversity, combined with intricate choreography that connects the crew as a whole."

The company is proud to have overcome obstacles in making the online performance happen. "Live performances are still superior, as the audiences can even feel the dancer's breathing and the meaning behind the moves at close range. It is a special connection."

While Patuelli may not have got to meet the audience in person, he considers the Artists-in-Residence Programme an excellent platform. "It allows us to share our inclusive teaching methods and experiences in breakdance. Together with local artists, we guide the participants in creating new dance works. We had already built a certain connection before the pandemic as we had opportunities to meet each other. The biggest challenge was the time difference, which we managed to overcome. Eventually we finished filming the dance piece and shared the creative process with the audience in the final online showcase. It was thrilling to watch everyone shine like superstars!" 🌼

舞團創辦人露卡·帕杜里
Luca Patuelli, founder of ILL-Abilities (© Jacob Jonas Photography)

第四章 Chapter 4

群策群力 得道多助
Community Support, Sponsors and Donors

社會各界慷慨支持
成就今天的藝術節

五十年來，香港藝術節得以成長至今天的規模，實在有賴社會各界的支持。多年來，藝術節從政府恆常資助所得的收入一般佔總收入的兩成左右，而較大的一部份收入需來自民間，包括票房收入、贊助和捐款。

社會各界的支持從首屆藝術節開始便已經非常重要。最初，私營機構的資金支持了藝術節提供學生票優惠，不少本地及來自英國的商界精英更成為「擔保人」，以確保早期的藝術節能夠有足夠經費持續營運。他們對藝術節往後的發展確是功不可沒。

直至鄭新文於 1988 年上任藝術節協會總經理，並在行政架構增設發展統籌一職，藝術節開始有系統地進行籌款工作。時至今日，籌款收益已在總收入當中佔舉足輕重的地位。回眸半世紀，可以肯定的說，如果沒有眾多贊助機構與捐助者慷慨的支持，藝術節也許不可能達到今天的成就。

篇幅所限，本書只能邀請極少數的贊助機構和捐款者做訪問，或請他們發表與藝術節合作的感想。然而，眾多贊助機構與捐助者與藝術節攜手，五十年來為香港觀眾帶來台上無數精采演出和深入學校與社區的藝術教育活動，是不爭的事實。在這裡，藝術節團隊向在過去半世紀曾經支持藝術節的每一家贊助機構、每一家贊助舍會員和每一位捐款者致以衷心的感謝。

Generous Support from Society
Instrumental to Festival's Development

The Hong Kong Arts Festival would not have grown to its current stature over the past 50 years without the strong support of the community. For many years, government subventions constitute around 20 per cent of the Festival's total income; the bulk of the revenue comes from the public through ticket sales, sponsorships and donations.

Support from the public has been of paramount importance to the HKAF since its inception. Initially, funding for discounted student tickets came from the business community. A number of prominent business figures from Hong Kong and the UK also became "guarantors" to ensure the Festival has sufficient funding for operations during its early years. Their contributions were crucial to the subsequent development of the HKAF.

After Tseng Sun-man was appointed General Manager of the Hong Kong Arts Festival Society in 1988, the post of Development Coordinator became part of the administrative structure.

This marked the start of systematic fundraising for the Festival. To this day, income from fundraising efforts form a significant portion of total income. In retrospect, it can be safely concluded that the HKAF would not have attained its current level of accomplishments without the generous support of many sponsoring organisations and donors.

Limited space prevented us from including interviews with a large number of sponsoring organisations and donors on about their collaboration with the HKAF. The interviews we present here are, however, characteristic of how the numerous sponsors and donors worked closely with the Festival. These partnerships have made possible countless excellent performances for Hong Kong audiences over the past 50 years in addition to arts education activities that reach deep into schools and the community. These interviews and articles serve as heartfelt gratitude and appreciation from the HKAF team for all sponsoring organisations, member of the Patron's Club and donors over the past half-century.

香港賽馬會
攜手同行五十載 藝術節的重要夥伴

香港賽馬會半世紀以來一直支持香港藝術節，提供達四億港元的捐助。以下是香港賽馬會2020-2022年度主席陳南祿的訪問。

可否分享一下香港賽馬會多年來選擇支持和贊助香港藝術節的原因？香港藝術節的工作與香港賽馬會的理念和取向如何保持一致？

馬會的宗旨是致力建設更美好社會。我們透過多管齊下的方式，以達致這個目標。我們一直相信藝術是至關重要的元素之一，因為藝術能夠創造社會資本，同時可以為香港注入文化活力，亦是社會共融的強大支柱。

這正是馬會一直大力支持香港藝術節這個藝壇盛事的原因。馬會深信，每個人都有創作及欣賞藝術的平等機會。事實上，如果將香港藝術節與馬會聯合呈獻的「無限亮」計劃計算在內，馬會自香港藝術節成立以來，至今實際上已捐款超過五億三千萬港元。

我想補充的是，馬會透過許多不同方式支持本港藝術發展。我們早於八十年代捐款興建香港演藝學院。及至近期，我們將中區警署建築群保育及活化成為「大館— 古蹟及藝術館」。截至目前為止，大館的訪客人數已超過八百萬，並舉辦了一千二百多個節目及活動，包括一系列「香港藝術節@大館」節目。

一如對其他所有慈善及社區項目的支持，馬會對香港藝術節的持續捐助，實在有賴其獨特綜合營運模式，透過稅收及慈善捐款，將博彩及獎券收入回饋香港。單單在上一個年度，我們回饋社會二百九十四億港元，創新紀錄。

如只選擇一個字或詞語來形容這段跨越五十年的合作關係，那會是甚麼？原因何在？

我會用「togetherness」形容馬會與香港藝術節的多年合作。這不單是馬會和藝術節together，更是透過藝術節的節目，與來自不同背景的人士一起分享感受藝術帶來的樂趣。

一方面，香港藝術節薈萃本地以至全球最優秀的藝術項目，給予藝術家表演、共同創作及互相學習的機會。就是這樣，透過香港藝術節，香港續漸成為國際藝術界其中一個重要樞紐。

藝術另一個更重要的功能，是可以凝聚社區。不論是參與現場表演帶來的互動及喜悅，或是欣賞世界級演出的畢生難忘，這些體驗都是無可比擬的。所以馬會一直支持藝術節的外展及教育工作，期望透過藝術豐富社會大眾的生活，包括那些一般無法接觸藝術的人士。

* 訪問於 2021 年 11 月進行。

香港賽馬會2020–2022年度主席陳南祿
Philip Chen, 2020–2022 Chairman of The Hong Kong Jockey Club

The Hong Kong Jockey Club
Supportive Partner for Half-a-Century

The Hong Kong Jockey Club has supported the Hong Kong Arts Festival for half a century, providing a total of HK$400 million in funding. The following is an interview with the 2020-2022 Chairman of the Hong Kong Jockey Club, Philip Chen.

Could you share why you have chosen to support the Festival for so many years? How does the Festival's work align with your organisation's vision and values?

The Club's purpose is for the betterment of society. We pursue this objective in many different ways, but we have always believed that the arts are absolutely essential. The arts create social capital, they contribute to the cultural vibrancy of our city, and they are a powerful tool for social inclusion.

This is why we have been pleased to support and fund the Hong Kong Arts Festival since its inception. The Club believes that everyone should have an equal opportunity to create and appreciate the arts. Indeed, taking into account the No Limits initiative, co-presented by HKAF and the Club, the Club has actually contributed over HK$530 million.

I should add that the Club contributes to the arts in many different ways. We funded the construction of the Hong Kong Academy for Performing Arts in the 1980s. More recently, we conserved and revitalised the Central Police Station compound as Tai Kwun – Centre for Heritage and Arts. To date, Tai Kwun's visitation has exceeded eight million and it has hosted more than 1,200 programmes and events. These include several HKAF events as part of HKartsFestival@TaiKwun.

It is important to remember that the Club's support for the Hong Kong Arts Festival, as for all its charity and community projects, is made possible by its Integrated Business Model. Through this, racing and wagering generate tax and charity support for Hong Kong. Last year alone we contributed a record HK$29.4 billion.

If you were to use one word or one phrase to describe this 50-year-old partnership, what would it be and why?

I would choose "togetherness". Our work with the HKAF has focused to a large degree on bringing diverse people together to practise and appreciate the arts without boundaries.

On one level it's bringing together the best international and Hong Kong arts and providing opportunities for artists to perform, co-create and learn from each other. In this way, thanks to the Festival, Hong Kong is becoming integrated into the global arts scene.

In another, and perhaps even more important way, I think of how the arts bring our community together. Nothing can compare with the shared enjoyment of a live event or the lasting impression of a world-class performance. This is why the Club has always put a great deal of effort into outreach and education. We want to share the pleasures and life-changing experiences of the arts with as many people as possible, including those who would not normally have the means to engage with them.

So that's why, for me, "togetherness" perfectly sums up our partnership and what the Festival has managed to achieve.

* The interview was conducted in November 2021.

香港賽馬會當代舞蹈平台（第五屆）徐奕婕《牽牛花》
The Hong Kong Jockey Club Contemporary Dance Series V
Morning Glory by Ivy Tsui (2016) (© Keith Hiro)

在過去半世紀，賽馬會在支持藝術節的焦點有何演變？

馬會對香港藝術節的支持隨着時間不斷蛻變。早於七十年代初期，馬會的捐助主要是讓學生觀賞香港藝術節的節目，藉此啟發他們對藝術的興趣。自 1980 年起，馬會開始撥款支持香港藝術節的營運，令其規模與日俱增。

在 2000 年代中期，馬會與香港藝術節的合作更趨緊密，捐助各類型活動，藉以培育不同藝術範疇的本地人才。例如，「香港賽馬會當代舞蹈平台」鼓勵本地舞蹈家及編舞者實驗舞蹈創作；而「賽馬會本地菁英創作系列」則支持本地傑出藝術家發揮創意及藝術性，涵蓋粵劇、戲劇、音樂及舞蹈等不同藝術領域。馬會支持的部份節目，現已成為深受觀眾歡迎的藝術節年度主題項目。其中廣受注目的，當然要數「香港賽馬會藝粹系列」，為觀眾帶來世界頂尖的精采表演，系列當中的一個節目更是每年香港藝術節的指定開幕表演節目。

此外，馬會一直支持香港藝術節的藝術外展教育工作。透過相關活動，我們旨在讓普羅大眾有更多機會接觸藝術，特別是弱勢社群，並且提升市民對藝術的了解。這一切皆為達致建設更美好及共融社會的目標。

Has the focus of the Club's support for the Festival evolved over the last half-century? In what ways?

The Club's support for the HKAF has become more far-reaching as the years passed.

In the early 1970s, the Club subsidised seats for students to enjoy and be inspired by the Festival's performances. From 1980, the Club started subsidising the Festival's operations, enabling it to grow in size and standing.

In the mid-2000s, the Club began to work even more closely with the HKAF, funding various unique platforms that have nurtured local talent across genres. The Hong Kong Jockey Club Contemporary Dance Series, for example, provides local dancers and choreographers with a platform to create experimentally. The Jockey Club Local Creative Talent Series, moreover, supports the creativity and artistry of outstanding local artists from an array or disciplines including Cantonese opera, theatre, music and dance. Some of the programmes the Club has supported have gone on to become popular annual features of the Festival. Notably The Hong Kong Jockey Club Series brings top-notch programmes, one of which is invariably the Festival's opening performance.

An important part of our support has always been to provide outreach and education opportunities. Through these we seek to make the arts more accessible to the wider community, especially the disadvantaged, and to enrich people's understanding of them. This all serves the wider purpose of fostering a more inclusive society.

「香港賽馬會藝粹系列」莫斯科大劇院芭蕾舞團《巴黎火焰》
The Hong Kong Jockey Club Series – The Bolshoi Ballet — *The Flames of Paris* (2015)
(© Leisure and Cultural Services Department)

「賽馬會本地菁英創作系列」《炫舞場 2.0》
Jockey Club Local Creative Talents Series — *Danz Up 2.0* (2017)

「賽馬會本地菁英創作系列」《陪着你走》
Jockey Club Local Creative Talents Series — *Always by Your Side* (2019)
(© Keith Hiro)

「賽馬會本地菁英創作系列」《百花亭贈劍》
Jockey Club Local Creative Talents Series — *Pavilion of a Hundred Flowers* (2018)
(© Hiro Graphics)

香港藝術節＠大館 群眾舞蹈《同根共生》
Hong Kong Arts Festival Community Dance: *Rizoma* (2019)

香港藝術節＠大館宣傳
Promotion of HKartsFestival@TaiKwun (2021)

在過往賽馬會贊助的藝術節項目中，哪一個最具意義及影響？

我希望馬會支持的每個藝術節項目都能夠為觀眾帶來意義，不論是情感層面，還是讓他們以不同的角度去檢視自己，或思考社會，甚或兩者。這就是藝術的力量！

這些節目亦為台前幕後的藝術參與者帶來裨益。如要揀選一些特定項目，我會首選「香港賽馬會當代舞蹈平台」。這個系列去年踏入十週年，一直發揮跳板作用，讓超過二百名本地藝術人才能夠在本港表演原創新作，部份其後更獲邀在世界其它地區發表作品。

另一個很好的例子是「賽馬會本地菁英創作系列」。馬會一直銳意支持及孕育本地人才。透過這個系列，我們致力讓潛質優厚的本地菁英，在薈萃國際級演藝名家的藝術節舞台上盡展所長。

還有「香港賽馬會學生專享節目」。這計劃為基層學生提供免費門票，讓過往缺少機會現場觀賞藝術演出的學生接觸及欣賞優質表演。透過這種方式，我們致力打破隔膜，展示每個人都可享受藝術。

除了香港藝術節的年度節目外，馬會與香港藝術節亦聯合呈獻「無限亮」計劃。這是亞洲首個同類的項目，匯聚本港及海外不同能力的藝術家，盡展才華。對觀眾及表演者而言，他們的演出都是極其感人，強勁有力，充份體現藝術無疆界的精神。

Which Club-supported Festival projects do you consider most impactful?

I would hope that every programme we support has an impact on its audience, whether it be on an emotional level or in making them think differently about themselves, or their community, or both. That's the power of the arts!

These programmes have, of course, also benefited the participants. To single out some specific initiatives, I would first mention the Jockey Club Contemporary Dance Series. Celebrating its 10th anniversary last year, the Series has been a springboard for more than 200 local talents, many of whom have subsequently travelled the world with new and original productions.

Another good example is the Jockey Club Local Creative Talents Series. At the Club, we are very keen to support and promote local talents. Through this Series, we seek to give it a voice and forum at the very highest level, on a par with the very best international performers.

There is also the Jockey Club Student Matinee Programme. This provides complimentary tickets to students with less resources. Most importantly, since many have seldom, or never, been to a live arts event before, it shows them how to participate in and appreciate a quality performance. In this way, we try to break down barriers and show that the arts can be enjoyed by everyone.

Outside of the Festival's annual programming, the "No Limits" initiative, which is a co-presentation of the Club and the HKAF, is the first of its kind in Asia. This brings together performers of different abilities, from both Hong Kong and overseas, to share and showcase their talent. It's incredibly moving and very powerful for both audience and performers, and really underscores that the arts have no limits.

自 2007 年，藝術節推出「香港賽馬會學生專享節目」，至今已為超過四萬五千名平日較少機會接觸表演藝術的學生帶來免費欣賞世界級演出的機會，並輔以到校演前導賞講座以及演後分享會，豐富他們的觀賞經驗。

Since 2007, "The Hong Kong Jockey Club Student Matinee Programme" has enabled more than 45,000 students, who had infrequent access to the performing arts, to enjoy world-class performances for free, supplemented by pre-performance talks in schools and post-performance sharing sessions. The Programme has helped students to enrich their experience in performing arts appreciation.

「香港賽馬會學生專享節目」米克洛夫斯基芭蕾舞團－《睡美人》
The Hong Kong Jockey Club Student Matinee Programme of The Mikhailovsky Ballet －
The Sleeping Beauty (2016)

「香港賽馬會學生專享節目」美國芭蕾舞劇院－《芭蕾小忌廉》
The Hong Kong Jockey Club Student Matinee Programme of the American Ballet Theatre －
Whipped Cream (2018)

「香港賽馬會學生專享節目」漢堡芭蕾舞團－約翰·紐邁亞《胡桃夾子》
The Hong Kong Jockey Club Student Matinee Programme of The Hamburg Ballet － John Neumeier's *The Nutcracker* (2019)

尤德爵士紀念基金
悉力支持「青少年之友」計劃

尤德爵士紀念基金自「青少年之友」計劃成立以來一直為其贊助機構之一，多年來致力支持這項計劃的原因是什麼？

尤德夫人：「香港藝術節『青少年之友』於1992年成立以來，尤德爵士紀念基金一直有贊助這個計劃，讓數以萬計的青少年體驗不同類型的文化藝術。我很高興看到這計劃深受學生歡迎，在過往近三十年，惠及約八十萬名中學及專上學生，招募超過十七萬七千名會員。透過贊助『青少年之友』，基金能夠給予青少年更多機會接觸表演藝術，拓闊視野，成果豐碩，我們感到十分欣喜。」

你認為推廣青少年藝術教育背後的理念是什麼？

尤德夫人：「沒有什麼比發展青少年的潛質更為重要。藝術教育是全人發展中不可或缺的一環。這個計劃讓青少年有機會接觸到最優秀的國際及本地藝術家，從中獲得啟發，我感受到同學對文化藝術的熱誠因此點燃起來。」

Sir Edward Youde Memorial Fund
Most supportive of the "Young Friends" scheme

As the Founding Sponsor of the "Young Friends" Scheme, what has made the Sir Edward Youde Memorial Fund so committed to supporting this initiative?

Lady Youde: It is indeed the Fund's pleasure to have offered sponsorship to "Young Friends" since its inception in 1992. Through "Young Friends", we have sponsored thousands of our youngsters wishing to experience different aspects of arts and culture. I am very pleased to note that the scheme has been very popular among students. Over the past few decades, "Young Friends" has reached out to almost 800,000 secondary and post-secondary students and recruited over 177,000 members. We are so glad that the Fund's sponsorship has been fruitful in helping youngsters widen their exposure to the field of performing arts.

What do you think is the philosophy behind promoting arts education for young people?

Lady Youde: There is nothing more important than developing the potential of young people. Arts education is an integral part of one's whole-person development. By creating opportunities for young people to interact with and be inspired by selected international and local artists, I see students' enthusiasm for arts and culture ignited.

(左起) 夏佳理、邵逸夫、尤德夫人與鮑磊出席1996年
「香港藝術節傑出青少年之友頒獎典禮」
(From Left) Ronald Arculli with Run Run Shaw, Lady Youde and Martin Barrow at
"Outstanding Young Friends Prize Presentation Ceremony" in 1996

你認為香港近數十年來在文化方面有取得正面進展嗎？

尤德夫人：「誠然，我樂見政府和香港藝術節等不同的藝術文化團體，不遺餘力地推動香港的文化藝術發展。過往數十年間，世界級的文化設施和表演場地陸續落成，包括西九文化區，得以吸引到著名的藝術家來港獻藝。我覺得曾努力推動香港文化藝術發展的人士，實在功不可沒。」

可否和我們分享你和「青少年之友」計劃參加者見面時的難忘點滴？

尤德夫人：「每當我在『傑出青少年之友頒獎禮』和得獎者見面、交談時，領略到他們在不同藝文範疇的熱誠、抱負和才華，都令我留下深刻印象。他們年輕、充滿活力！」

Do you see a positive development in the cultural scene of Hong Kong over the past few decades?

Lady Youde: Yes, indeed. I am so pleased to see the tremendous efforts from the Government and various arts/culture societies and organisations, of course, including the Hong Kong Arts Festival, in promoting arts and culture in Hong Kong. With the opening of world-class cultural facilities and performing venues in the past few decades, including the West Kowloon Cultural District, Hong Kong has attracted renowned artists to perform here. I believe credit should also go to those who have made concerted efforts in promoting arts and culture in Hong Kong.

What are some of your memorable moments when seeing our "Young Friends"?

Lady Youde: Every time I have met and talked to awardees at the Outstanding Young Friends Prize Presentation Ceremony, I have been most impressed by their enthusiasm, high aspirations and talent in different aspects of arts and culture. They are young and energetic!

尤德夫人(中)與香港藝術節傑出「青少年之友」得獎學生
Lady Youde (middle) and awardees at Outstanding "Young Friends"
of HKAF Prize Presentation Ceremony (2002)

信興集團
支持多元化創新

自 1991 年起，信興集團對香港藝術節的支持從未間斷，不經不覺已經三十一年。集團主席兼行政總裁蒙德揚憶述：「早期信興集團多是贊助來自日本的藝術節目，大概是因為我先父的好朋友鮑磊主席及他的日籍太太關係，當年他們推介很多精采的日本節目，而且我們覺得很配合集團當時的品牌形象。這些別開生面的節目包括日本邦樂樂團（1991）、梅若研能會（1992）、地人會（1993）及《姬神》（1996）等，都是一些平日在香港很少機會可以欣賞到的日本表演藝術。印象深刻的是 1992 年的梅若研能會，對香港觀眾來說，日本的國寶藝術『能劇』是很獨特的體驗，即使是日本人對於這種傳統古典歌舞劇，也會覺得不易理解，還記得當時我們邀請的嘉賓都樂意用心去欣賞，令我們很感動。」

蒙德揚（右二）與《金蘭姊妹》演員
David Mong (second right) with actresses of *The Amahs* (2015)

Shun Hing Group
Champion for Diversity and Innovation

Since 1991, Shun Hing Group has been a loyal supporter of the Hong Kong Arts Festival for 31 consecutive years. David Mong, Chairman and Chief Executive Officer of Shun Hing Group, recalls: "In the early years, most of the Festival programmes sponsored by our Group came from Japan. This is perhaps attributed to my father's friendship with Martin Barrow, the Festival's former chairman, and his Japanese wife. They recommended many excellent Japanese programmes which happened to be aligned to Shun Hing's brand image. The list of top-quality programmes includes Musica Nipponia (1991), Umewaka Noh Theatre Company (1992), Chijinkai Theatre Company (1993) and *Himekami* (1996), all of which are treasures in Japanese performing arts rarely presented in Hong Kong. The performance by Umewaka Noh Theatre Company in 1992 was deeply memorable as Noh Theatre, a national treasure of the performing arts in Japan, was a unique theatre experience of Hong Kong audiences. Although even native Japanese people might not have a full grasp of the traditional art form, our invited guests were very willing to experience and appreciate the unique genre, making the performance a cherished arts encounter."

David Mong recognises the immense efforts made by the Hong Kong Arts Festival every year to source top-quality programmes for the city. As Shun Hing Group's business becomes more diversified, its HKAF sponsorship expanded from a focus on Japanese programmes: "We are glad to support Festival programmes which have become increasingly diverse and innovative. My family is also passionate about the arts. Since I was very young, my mother would take us to concerts, which helped us develop an interest in classical music." From 2000 on, Shun Hing Group sponsored a large number of HKAF programmes featuring internationally renowned musicians and orchestras including

蒙德揚與聖多馬少年合唱團
David Mong with St Thomas Boys Choir (2011)

蒙德揚認為每年藝術節很努力發掘新穎節目，而隨著集團業務逐漸趨向多元化，也不局限於贊助日本節目。「我們非常樂意支持不同類型及創新的節目。我們家族也喜歡藝術，自小母親便帶我們參加音樂會，所以對古典音樂特別有興趣。」2000 年以後，信興集團贊助了不少國際知名的音樂家和交響樂團的藝術節演出，例如法蘭斯·布魯根與十八世紀管弦樂團演奏貝多芬第六及第七交響曲 (2005)、伯明翰市交響樂團合唱團 (2006)、紐約愛樂樂團 (2008) 等等。「柏林德意志交響樂團 (2009) 的演出令我很難忘，整個樂團一反傳統，穿上 T 恤牛仔褲演出。還有聖多馬少年合唱團演唱巴赫的作品 (2011)，那天剛巧是巴赫的生忌，我們更送上蛋糕一同慶祝，非常熱鬧。」

此外，近年信興也有支持藝術節的本地戲劇，像《金蘭姊妹》(2015) 和《九江》(2019) 這些題材獨特的作品。「我們相信甚麼也可以嘗試，更希望支持一些特別的作品，這種支持才更有意義。」

蒙德揚說母親對他們的影響很大，不只培養了他們對藝術的興趣，也讓他們明白藝術對個人成長的正面意義。「不論是個人還是社會成長，需要各方面平衡發展，文化、教育、體育多元推動，而藝術無疑是重要的一環。我相信藝術文化在一個健全的社會有著不可或缺的位置。而最重要的是不能等待藝術家或藝術作品成功後才去支持，而是要主動去發掘有潛質的作品，然後積極去推動，讓社會更多人認識和接受。我看到近年藝術節的節目越來越多元化，除了有精緻的藝術，亦有富娛樂性、雅俗共賞的節目，把藝術推向更廣闊的層面。這是可喜的現象。」

Frans Brüggen and the Orchestra of the 18th Century (2005), the City of Birmingham Symphony Chorus (2006) and the New York Philharmonic (2008). "The Deutsches Symphonie-Orchester Berlin (2009) was quite memorable for me. In a break with tradition, the entire orchestra performed in T-shirts and jeans. There was also St Thomas Boys Choir, which performed the works of Bach (2011). It happened to be the birthday of the composer JS Bach and we had a wonderful time celebrating the occasion with a cake."

In recent years, Shun Hing has expended its support of Festival programmes to Hong Kong theatre productions, including *The Amahs* (2015) and *Gangsters of Hong Kong* (2019), both of which were poignant works with distinctive themes. "We believe in exploring untrodden paths in the arts and wish to support unique works which render the support even more meaningful."

Mong cites his mother's tremendous influence in cultivating the family's interests in the arts and how the arts provide a positive impact on personal growth: "Whether it is growth for an individual or society, one should aim for a well-rounded and balanced development, which includes culture, education and sports. Art is an integral component of this process. I have a deep conviction that art and culture are essential for a healthy society. It is crucial that the sector should be supported, not just when artists or their work become successful. On the contrary, there should be initiatives to explore works with potential which can gain recognition and acceptance by the public through active promotion. I notice how the Hong Kong Arts Festival continues to be more diverse in recent years. In addition to programmes featuring sophisticated art forms, there were also highly accessible entertaining programmes, enjoyable by all, which helped take the arts to wider audiences. This is certainly an encouraging trend."

工銀亞洲
攜手十年 成果豐碩

工銀亞洲主席兼執行董事高明表示：「作為享譽國際的重要藝壇盛事，香港藝術節今年迎來成立五十周年紀念，工銀亞洲有幸自2013年起與藝術節合作獨家贊助閉幕演出，攜手走過輝煌十年。藉藝術節五十周年誌慶之際，本人謹代表工銀亞洲送上誠摯祝福，衷心感謝香港藝術節為推動香港文化藝術所做出的傑出貢獻，並祝願藝術節的未來之路長青！」

高明出席第 46 屆香港藝術節閉幕演出
Gao Ming at the 46th Hong Kong Arts Festival Finale (2018)

「**相與十年親且舊，香江攜手展宏圖**。工銀亞洲作為具本地系統重要性銀行，在業界銳意進取，為客戶提供專業金融服務的同時，也不忘履行企業社會責任，每年與香港藝術節攜手為香港市民帶來視聽盛宴，將世界各地的藝術潮流匯聚香港，推動藝術發展。十年間，藝術節閉幕演出匯聚了全球一流的藝術團體和演出，如拿波里聖卡洛歌劇院、三藩市歌劇院、莫斯科大劇院芭蕾舞團、米克洛夫斯基芭蕾舞團、漢堡芭蕾舞團、俄羅斯莫伊謝耶夫舞團、愛沙尼亞國家交響樂團及男聲合唱團、薩翁林納歌劇節等；涵蓋各類藝術形式，有傳統古典的芭蕾舞和歌劇，如《睡美人》、《茶花女》，有中西合璧的香港藝術節特別製作《紅樓夢》，還有餘音繞樑的合唱《浮士德》等；在疫情下，更將科技與藝術美妙結合推出網上演出，將精采節目免費帶給了香港市民、送給了全球觀眾，工銀亞洲還將節目特別呈現給工商銀行集團內地對口幫扶地區的莘莘學子，為他們打開一扇世界藝術之窗。」

「**五十載崢嶸歲月同藝術夢，五十載春華秋實共歲月歌**。一路走來，工銀亞洲與香港藝術節結下了深厚友誼，也見證了香港文藝事業的發展。繼往開來，工銀亞洲願持續回饋社會，繼續攜手香港藝術節，支持香港發展成為中外文化藝術交流中心，為香港經濟、文化、藝術事業的長足發展做出更多貢獻！」

ICBC (Asia)

Celebrating a Decade of Fruitful Collaboration

Gao Ming, Chairman and Executive Director of ICBC (Asia), says, "A premier arts event of international renown, the Hong Kong Arts Festival celebrates its 50th anniversary this year. Since 2013, ICBC (Asia) has been proud to become the exclusive sponsor of the HKAF's Finale programmes, playing a part in its exceptional accomplishments for the past decade. On behalf of ICBC (Asia), I wish to convey our best wishes to the Hong Kong Arts Festival on its golden anniversary, and heartfelt gratitude for its outstanding contributions to the promotion of arts and culture in Hong Kong. We look forward to many more memorable events in the future."

"Over the past ten years, ICBC (Asia) has forged a steadfast and meaningful relationship with the HKAF in supporting the performing arts in the city. As one of the Domestic Systemically Important Banks (D-SIBs) in Hong Kong, while dedicated to providing professional financial services to its customers with an enterprising spirit, ICBC (Asia) is committed to fulfilling its corporate social responsibility. Every year, we partner with the Hong Kong Arts Festival to bring to Hong Kong outstanding performances from around the world, endeavouring to promote the development of the local arts scene."

"The HKAF's Finale performances over the past ten years have brought to Hong Kong a myriad of excellent international arts groups and programmes including the San Carlo Theatre of Naples, San Francisco Opera, Bolshoi Ballet, Mikhailovsky Ballet, Hamburg Ballet, Igor Moiseyev Ballet, Estonian National Symphony Orchestra and Estonian National Male Choir, and the Savonlinna Opera Festival, to name but a few. The programmes span a variety of art forms including classical ballet and opera such as *The Sleeping Beauty* and *La Traviata*; contemporary East-West cultural fusion such as *The Dream of the Red Chamber*, a special commission by the Hong Kong Arts Festival; and the captivating choral work, *Faust*. During the pandemic, the HKAF has utilised technology to present online performances, some free of charge, to people in Hong Kong and around the world. ICBC (Asia) also took special care to ensure the online programme was available to students from regions in Mainland China receiving aid from the ICBC Group, providing them exposure to arts of the world."

"In the last five decades, many have worked tirelessly in the arts, while others have made remarkable contributions to the prosperity of the city. Over the years, ICBC (Asia) and the Hong Kong Arts Festival have forged a close relationship while witnessing the growth of arts and culture in Hong Kong. We look forward to continue to give back to society by maintaining our partnership with the Hong Kong Arts Festival. We have great confidence in Hong Kong as the leading hub for arts and cultural exchanges between China and the rest of the world, and are committed to supporting the long-term development of the economy as well as arts and culture in Hong Kong."

怡和集團
見證藝術節茁壯成長

自香港藝術節開幕以來，怡和集團一直給予支持，五十年來從未間斷。

在藝術節成立初期，怡和集團接受藝術節發起人的邀請，成爲藝術節的「擔保人」之一。「擔保人」肩負著非常重要的角色，確保藝術節有足夠資金得以啓動及營運。集團行政總裁韋梓強説：「香港藝術節就像是一直推廣藝術的火炬手，怡和集團很榮幸當年能成爲藝術節的擔保人，並在過去五十年，熱心支持香港藝術及文化發展。」

其後，怡和集團開始贊助藝術節的學生票計劃。這是一項很有意義的構思，讓香港學生有機會以低廉票價欣賞演出。透過捐助者的支持，香港的全日制學生可以接觸到享譽國際藝術家的精湛造詣，對青少年的全人發展有所裨益；長遠來説，對香港的文化發展也有深遠的影響。

近年，怡和集團成爲藝術節贊助舍計劃會員，繼續為香港藝術節的發展出力。執行主席班哲明・凱瑟克道：「從香港藝術節的成立初期，集團一直給予支持，見證藝術節成為舉足輕重的藝壇盛事。除了每年呈獻眾多國際及本地藝術家的精采演出，更全力推動藝術教育，為年輕一代拓闊藝術視野。我們很高興能夠在藝術節充滿挑戰的成長路上出一分力，未來也會繼續支持藝術節的工作，為香港藝術發展作出貢獻。」

The Jardine Matheson Group
Witness to the Continued Growth of HKAF

The Jardine Matheson Group is an unwavering supporter of the Hong Kong Arts Festival with a long history of patronage from when the Festival first opened in 1973 to the very present day.

During the Festival's early days when it was about to be launched, the Jardine Matheson Group accepted an invitation from the event's founders to be one of the "guarantors". Guarantors played an important role, ensuring sufficient funding for the launch and ongoing operations of the Festival. John Witt, Group Managing Director commented: "The HKAF has long been a torchbearer for promoting the arts, and the Jardine Matheson Group is proud to have been a founding Guarantor of the Festival and an enthusiastic supporter of Hong Kong's arts and cultural development for the past five decades."

The Jardine Matheson Group subsequently supported the HKAF's "Student Ticket Scheme", a very meaningful initiative providing affordably priced tickets for performances to Hong Kong students. With this support from donors, Hong Kong students can enjoy world-class performances, broadening their artistic horizons while supporting Hong Kong's long-term cultural development.

In recent years, the Jardine Matheson Group has continued to support the HKAF's development by becoming a member of the Festival's Patron's Club. Executive Chairman, Ben Keswick said: "Through our support for the Hong Kong Arts Festival since the very beginning, we have witnessed it transform to become a significant arts event. With thoughtfully curated performances including both international and local artists, the Festival is a dedicated promoter of the arts and youth development in Hong Kong. We are glad to have played a part in the Festival's challenging journey of growth and look forward to continuing to make a positive contribution to Hong Kong through our ongoing support of the Festival in the future."

方博德
出版贊助夥伴

方博德在2007年創辦香港雙語文化雜誌《瞄》前，曾擔任《新聞周刊》亞洲區總經理及國際發行部總監。「我最初接觸香港藝術節是2002年觀看高行健編劇、鄧樹榮執導的《生死界》，劇作令我不斷深思回味，嘆為觀止。這齣戲劇雖然非常簡約，但舞台設計和執導都很出色，主角蘇玉華更是令人著迷。」

2008年起，《瞄》協助出版藝術節委約創作的雙語版劇本。這些書籍同時以紙本及電子版推出，涵蓋香港劇作家意珩、鍾燕詩、潘燦良、黃詠詩、潘惠森、李穎蕾及莊梅岩的作品。

方博德提到：「我們一直以來都是香港藝術節的出版合作夥伴，翻譯、出版及發行了不少藝術節舞台劇的劇本。我們製作這些書籍後也在海外發行，希望讓國際觀眾認識這些作品。」

方博德認為藝術節的強項之一，就是為本地藝術家搭建平台。「對我這個外國人來說，就能讓我看懂極具吸引的華語戲劇作品。在香港的外籍人士，平常未必會觀看本地演出，但如果該劇目在藝術節上演，就像得到認證，吸引到海外觀眾的興趣。藝術節在宣傳推廣及字幕翻譯方面，下了不少工夫，而雙語劇本更讓這些劇目衝破語言及文化障礙。」

「我認為香港藝術節是香港的瑰寶。我們身在香港，也許不會察覺到藝術節的可貴，但當你在國外和一些人士交談，他們或許是認識香港藝術節，或許曾在此演出過，又或留意到在藝術節演出過的香港藝術家，這時，你便會非常欣賞藝術節為香港所作的貢獻。」

「要讓來自不同文化背景的觀眾欣賞同一個演出，其實充滿挑戰。在節目編排上如果規行矩步，可能來得簡單，因為觀眾往往對來自某個國家的表演者、演出類型，甚或熟悉的題材，存有既定想像，然而，香港藝術節總能打破這些框框，勇於探索嘗試，力求創新。」

Frank Proctor
A Partner Sponsor in Publishing

Frank Proctor had been the General Manager for Asia and International Circulation Director for *Newsweek* before he founded the bilingual Hong Kong cultural magazine, *Muse*, in 2007. "My earliest recollection of the Arts Festival that really sunk in deep was in 2002 when I saw a play by Gao Xingjian called *Between Life and Death*, and it was directed by Tang Shu-wing. I was just blown away. It was very minimalist, but the staging and the direction were fabulous and Louisa So Yuk-wah, who played the main character, was absolutely spellbinding."

Starting in 2008, *Muse* developed books presenting bilingual versions of plays commissioned by the Festival. The books, both printed and in e-format, included theatrical works by Hong Kong playwrights - Yi Heng, Harriet Chung, Poon Chan-leung, Wong Wing-sze, Poon Wai-sum, Santayana Li Wing-lui and Candace Chong.

"We've been Arts Festival's publishing partner as we've helped with translation, publication and distribution of many of their script books. We create and distribute internationally and try to put it in front of the international audience."

One great strength of the Arts Festival for Proctor is that the Festival has become a platform for local artists, directors and writers to put their works on stage, "and also for me, a foreigner, making a Chinese language play accessible and interesting. Foreigners in Hong Kong might not normally seek out a local work, but if it's presented as part of the Arts Festival, it has that stamp of approval that will really make international audiences interested in it. The Festival does so much in terms of their promotion, subtitling, and the books to make works accessible across language and cultural barriers."

"I think the Festival is a real Hong Kong gem, and sometimes we in Hong Kong don't realise what a treasure it is. But then when you go internationally and talk to people who are familiar with the Festival, who have performed here, or who are aware of Hong Kong artists because they've been presented through the Festival, that makes you really appreciate what the Festival does for Hong Kong."

"It's always challenging to bring different cultural audiences together, and it can be very tempting because in some ways it's easier to just slot yourself into people's pigeonhole about a performer from a certain country, or genre, or easy, feel-good themes, but the Arts Festival has always been able to avoid that and to take creative risks."

梁靳羽珊
為藝術出一分力

梁靳羽珊多年來除了積極參與香港藝術節發展委員會(2017-2021擔任主席)，最近九年更是執行委員的成員。她與藝術節的緣份，始於 1999 年獲邀加入婦女歡迎委員會，與其他成員肩負接待訪港國際藝術家的職責。後來藝術節在組織架構方面亦因應業務的發展，與時並進，婦委會演變成發展委員會，梁女士順理成章變成發展委員會的一份子。

此外，梁太更是藝術節的長期捐款者。「香港藝術節作為一所非牟利機構，除了政府資助及票房收入，其中最重要的經費來源便是社會各界的贊助及捐款。作為藝術節發展委員會的一員，我尤其意識到贊助及捐款對推動藝術節，甚至鞏固本地整個藝文界的重要性。因此，除了透過在發展委員會中的角色，為藝術節提供支持與協助外，我認為我也必須身體力行，捐款支持藝術節。最初我們支持的是『學生票捐助計劃』，這個計劃籌得的捐款都是全數用作資助本地全日制學生，以半價優惠購買藝術節門票的，讓青少年加深對表演藝術的興趣和認識。後來我們希望讓藝術節在使用捐款時有更大自由度，改為捐款予『藝術節捐助計劃』，支持他們把捐款投放於當年最需要支持和發展的項目上。這一段日子新冠疫情嚴峻，很多藝術活動需要移師到網上進行，藝術節也因而推出了『網上藝術教育捐助計劃』，捐款用以支持建立

Yu-San Leong
Walking the Extra Mile for the Arts

A stalwart supporter of the Hong Kong Arts Festival, Mrs Yu-San Leong served tirelessly as part of the Development Committee (Chairman from 2017 to 2021) for years and as a member of the Executive Committee for the last nine years. Her affiliation with the Festival started when she was invited to join the Ladies Hospitality Committee in 1999; committee members were tasked with offering hospitality to the overseas artists. When the HKAF later overhauled its organisational structure to drive its development, the Ladies Hospitality Committee evolved into the Development Committee, which Mrs Leong naturally became a member of.

Mrs Leong is also a long-standing donor of the HKAF: "The Hong Kong Arts Festival is a non-profit organisation. Other than government subventions and ticket sales, the Festival relies heavily on sponsorships and donations from the community for funding. As a member of the Festival's Development Committee, I am acutely aware of the importance of sponsorships and donations. They are crucial not only for the growth of the Festival but also for strengthening Hong Kong's arts and cultural sector. With this in mind, I offer my support both through my role in the Development Committee as well as making donations to support the Festival.

梁靳羽珊（左）與查懋成出席第 45 屆藝術節主席鳴謝晚宴
Yu-san Leong (Left) and Victor Cha at 45th HKAF Chairman's Thank-You Dinner (2017)

網上藝術教育平台，讓學生和公眾可透過特設的網上藝術課程和資料，加深對藝術的興趣和認識。這些計劃能從不同範疇配合藝術節的發展，我覺得非常有意義，也很慶幸能在自己能力範圍內出一分力。」

2021 年是梁太擔任藝術節執行委員會的第九年，亦即三屆任期的最後一年。她回想當初獲邀請加入的時刻：「時間過得真快！也真沒想到一做便做了九年。在這些年裏，我見證了藝術節在行政團隊、藝術家、捐助者、贊助者、觀眾等眾人的共同努力下一步步成長，發展得越來越成熟。」展望未來，她對藝術節有一定的期望。「藝術無邊界，作為一個歷史悠久的國際藝術團體，我期望香港藝術節不但能繼續提供更多元化的優質藝術節目給本地觀眾，更希望能在多個藝術領域提供跨國性的學術和體驗分享。以香港藝術節過往的豐富經驗，相信對未來大灣區的藝術發展會起很大的作用。」

We initially supported the Student Ticket Scheme which enables full-time local students to attend Festival performances at 50 per cent discount, allowing young Hong Kong people to cultivate their interests and understanding in the performing arts. We later made donations to the Festival Donation Scheme instead as it provides more flexibility for the Festival when using the funding for imminent initiatives requiring more support and development in a given year. During these challenging times of the pandemic, many arts programmes have been moved online. Accordingly, the HKAF launched the Digital Arts Education Scheme which raises donations to support the building and maintenance of the new Digital Arts Education Platform, designed to enable students and the general public to access and enjoy a variety of exclusive arts education programmes, training activities and materials. These initiatives are pertinent and meaningful in complementing the HKAF's development through multiple approaches. And I feel very fortunate to be able to make contributions to the best of my abilities."

2021 marked the ninth year of Mrs Leong's service as member of the Festival's Executive. She recalls being first invited to join the Committee: "Time certainly flies and this unexpectedly became a nine-year stint. Throughout the years, I have witnessed how the Festival grows step by step and also from strength to strength. This is only possible through the combined efforts of the administrative team, artists, donors, sponsors and the audiences." Looking ahead, Mrs Leong has certain expectations for the Festival. "The arts know no boundaries. With this adage in mind and the HKAF being an international arts organisation with a rich history, I expect it to keep offering a wide range of outstanding programmes for local audiences. Hopefully there will be more academic exchanges and sharing of experiences across countries in multiple arts disciplines. With the wealth of experiences accumulated from past editions, the Hong Kong Arts Festival is well-positioned to have a great impact on arts development in the Greater Bay Area in the future."

馬漢寧
投資下一代的藝術教育

馬振玉慈善基金會於過去十五年積極捐款支持香港藝術節，而主席馬漢寧博士更特別認同藝術節的「學生票捐助計劃」。「藝術節從早年開始已推出優惠學生票，以降低年青人欣賞表演藝術的門檻，拓闊他們的眼界，並提升他們對藝術的認識和興趣。透過社會各界善心人士及團體的熱心捐款，藝術節每年得以繼續為近一萬名學生提供半價學生票，培養一代又一代的年輕觀眾。我一直覺得這個計劃非常有意義，希望可以為此出一分力。我們想為本地藝術教育作出貢獻，目標不單只是援助學生，更要支持及鼓勵藝術節這個平台，協助他們為學生帶來更多觀賞演出的機會。」

馬振玉慈善基金會多年來致力在不同範疇，例如辦學校、成立助學金等，鼓勵香港學生透過本地及海外的活動，以及課堂內外的研習項目，達至全面發展。馬漢寧說道：「香港藝術節作為國際藝壇中重要的文化盛事，除了把世界各地藝術家及團體的作品帶到香港，亦大力投資下一代的藝術教育，這一方面與我們的理念是一致的。讓我們繼續努力，為下一代提供更多學習及全能發展機會！」

Albert Ma Hon-Ning
Investing in the Next Generation with Arts Education

The CYMA Charity Fund has made generous donations to support the Hong Kong Arts Festival for the past 15 years. Albert Ma Hon-Ning finds the Festival's Student Ticket Scheme especially relevant: "Since its early years, HKAF launched discounted student tickets to lower the threshold for young people to attend arts performances. The scheme allows students to broaden their vision and helps develop their understanding of and interest in the arts. With the gracious donations from individuals and groups in society, the HKAF has been able to provide nearly 10,000 half-price tickets to students, which is instrumental in nurturing new generations of young audiences. I find the scheme very meaningful and hope to continue contributing to the cause. We want to make an impact in arts education with the objective of not just subsidising students but to support the Hong Kong Arts Festival in providing more opportunities for students to attend performances."

The CYMA Charity Fund is a passionate supporter for all-rounded development of students through a variety of initiatives including founding schools and establishing scholarships, encouraging students to take part in local and overseas activities as well as research projects both inside and outside the classroom. Ma adds: "The Hong Kong Arts Festival is a significant event on the international arts calendar. Not only is it a local showcase of exceptional works by artists and arts groups from around the world, the Festival invests heavily in arts education for the future generations. This vision is consistent with our philosophy and we are happy to continue our efforts to provide more opportunities in learning and comprehensive development for the next generation!"

贊助者與捐助者的支持
對藝術節的成長至關重要

「有一點很明確：如果沒有贊助機構和捐助者的支持，香港藝術節根本不可能生存，更不可能持續增長。」2011年底加入藝術節的發展總監余潔儀 (Flora) 談道，從半世紀前第一屆藝術節開始，民間力量在藝術節的發展史，便一直扮演舉足輕重的角色。

「很多人會問藝術節為何能夠得到眾多贊助機構和捐款者的支持，我認為原因很多。首先是節目質素一直能維持著高水平，觀眾喜歡，差不多場場爆滿，贊助機構自然也樂於跟我們合作。我們的執行委員會和發展委員會的人脈和支持，對藝術節的發展也至關重要。另一方面，藝術節的管治具透明度，形象正面，也令企業們願意對藝術節投以信心的一票。」

「我們一直都是本著互相合作的精神與贊助機構建立關係的。藝術節需要贊助機構財政上的支持，才能夠把最優秀的節目帶給香港觀眾。而贊助機構們也希望透過支持藝術節的節目和活動，幫助他們達到某些目標。所以負責籌款的團隊第一步必須先了解不同機構對贊助的理念、需要和期望。例如有些企業是希望透過贊助藝術節某些演出，加強企業形象或增加品牌知名度；有些則希望藉此招待企業貴賓；也有些是透過支持藝術節的外展教育項目，以履行企業社會責任。而發展部的同事則按照企業的目標和需要而建議度身訂造的贊助方案。」

Flora 提到，隨著藝術節成長與壯大，籌款目標也差不多年年遞增。近年的現金籌款目標，每年約港幣六千萬元，佔藝術節全年收入的四成以上。（2020 和 2021 年疫情影響了藝術節的活動，現金籌款目標也相應稍微減少。）而籌款達標，也意味著該年可以獲得政府上限港幣三千萬元的配對資助。

Support by Sponsors and Donors
Vital to Growth of
Hong Kong Arts Festival

"One thing is certain: without the support of sponsoring organisations and donors, the Hong Kong Arts Festival would not even survive let alone maintain its growth." For Flora Yu, who joined the Festival in late 2011 as Development Director, community efforts have played a substantial role in the Festival's development since its first edition half a century ago.

"Many people wonder how the HKAF has been able to garner support from a large number of sponsors and donors. I think there are many reasons. First, the programmes are of consistently high quality. And with high attendances and sold-out performances, sponsoring organisations are naturally happy to work with us. The network connections and support from our Executive Committee and Development Committee also play a major role in the development of the Festival. At the same time, the HKAF enjoys a transparent organisational structure and positive image that gives corporations confidence."

"We have always built our relationships with our sponsors in the spirit of mutual trust and collaboration. The HKAF solicits financial support from sponsors to bring the most outstanding programmes to the Hong Kong audiences while sponsors wish to achieve certain goals and objectives through their support of HKAF programmes and activities. Therefore, the fundraising team needs to have a strong understanding of sponsors' vision, objectives and expectations. For example, some corporations wish to enhance their corporate image or brand identity by sponsoring certain HKAF performances. Others may wish to entertain corporate guests. Some want to fulfil their corporations' corporate social responsibility objectives by supporting the HKAF's education and outreach projects. After understanding the sponsorship objectives of the corporations, our Development Team will then devise and recommend sponsorship plans which meet such objectives and interests."

According to Yu, the Festival's fundraising target increases every year as the event continues to grow and expand. The fundraising target in recent years was around HK$60 million per year and constituted more than 40 per cent of the HKAF's total annual income. There was a slight decrease in the fundraising target in 2020 and 2021, when the Festival was affected by the pandemic.

即使籌款對藝術節的營運是如此重要，Flora 強調藝術節一直以來，堅持以「藝術節目的質素」為主導，竭力引入香港觀眾較少機會看到、甚至不熟悉的高質節目和頂尖藝術家，不會只考慮市場喜好而放棄某些冷門節目，亦不會安排某些很受歡迎但藝術評價不高的演出。聽起來似乎是與自己的錢包作對，但因爲藝術節長久堅持這個信念，加上藝術節的忠實觀眾也是獨具慧眼，久而久之，即使他們不熟悉某位藝術家，仍然會對藝術節投下信任的一票，積極支持。觀眾如是，贊助機構和捐助者也如是。

面對社會和經濟環境轉變，如何開拓資源是重要的課題。「經濟衰退是其中一個挑戰，不過也是周期性的問題，而且有時也只是局部的影響。好像某個時期歐美市場不太景氣，我們便嘗試跟內地的企業洽談，積極尋找新的合作夥伴。」疫症自然是當下最大的挑戰，不少贊助機構也因爲疫情原因暫停贊助活動。「疫症令世界改變，也改變了表演藝術生態。演出形式和大眾欣賞藝術的方法也在改變，我們不能只沿用舊有的籌款方式，要更靈活地引進不同方式、更具創意的贊助和捐助計劃，開拓更多的收入來源。」

Flora 最後補充：「不能不說這一句，而且是發自內心的 —— 謝謝贊助機構和捐款者對我們的信任和支持！」🌸

It is expected that if the target each year is reached, the Hong Kong Government will also provide a maximum matching grant of HK$30 million.

Although fundraising is of paramount importance to the operations of the HKAF, Yu stresses that "programme quality" remains the Festival's priority. The HKAF consistently tries to introduce works rarely presented in Hong Kong. Also considered are high-quality programmes and excellent artists that audiences may not be familiar with. Programme quality may take precedence in importance over market preferences, and popular programmes with low artistic merit are not featured. This may appear to have a slight disregard for ticket sales, but the HKAF has long upheld this steadfast vision on quality, which is shared by the Festival's loyal audiences. In the long run, even when audiences are not too familiar with an artist, they will be supportive because of their confidence in the Festival's standards. This level of trust in the HKAF is readily observed with audiences as well as sponsors and donors.

Faced with changes in society and the economy, pioneering new resources has become increasingly important: "Economic downturn is one of our challenges. It is cyclical by nature, however, and the impact may be partial. For example, a number of years ago when the European and American markets were not booming, we looked for new partners by meeting with companies in Mainland China instead." The pandemic is currently the biggest challenge and has led to some sponsors suspending their sponsorship activities for now. "The pandemic has had an impact on the whole world and has changed the ecology of the performing arts. How performances are presented and enjoyed by the public has also changed. We cannot simply rely on fundraising approaches from before and need to be more flexible by coming up with more creative sponsorship and donation plans to expand our sources of income."

Yu concludes: "With heartfelt appreciation, the Hong Kong Arts Festival is very grateful for the trust and support from all of our sponsors and donors!" 🌸

第五章　Chapter 5

撒種躬耕藝術教育
Planting the Seeds through
Arts Education

I. 學生票捐助計劃：鼓勵藝術欣賞

要說藝術節由始至今一直堅持的初心，其中一環便是設立優惠學生票。對於降低年青人欣賞藝術演出的門檻，培養學生觀眾，以至於作為一種藝術教育的途徑，提供優惠學生票都是當年先行者高瞻遠矚的創舉。

能夠持續推行優惠學生票，實在有賴歷年來眾多的贊助人及機構，支持「學生票捐助計劃」，資助本地全日制學生以最多半價優惠購買藝術節門票。其中最早的要算是何東爵士慈善基金及香港賽馬會慈善信託基金。

起初藝術節每屆提供約八千張優惠學生票，門票只是原價的百分之二十。學生票不可預訂，難怪每年在開始公開售票的前一、兩天，便會有不少學生通宵排隊的場面。學生每場演出最多只可買一張，每次最多也只可買五場演出。很多藝術節的擁躉回憶年少時也曾排隊購買學生票的情境，都津津樂道。其後到了1988年，優惠學生票定為原價的百分之四十；而自1997年起，則為半價。

藝術節的優惠學生票有一特色，就是依靠籌款所得的資源來推行，其他的藝術團體則以降低收入的方法，兩種的理念有所不同。

作為藝術節的策展舵手，梁掌瑋對年少時也曾排隊撲飛的點滴，歷歷在目。「小學時老師已帶我到大會堂聽 $1 音樂會，到1973年第一屆藝術節舉行之時，我就讀初中三年級。記得當時很哄動，因為突然有那麼多不同類型的外國節目來港，非常熱切期待。公開售票時跟幾個同學一大清早去買學生票，到達大會堂時已看到長長的人龍。當輪到我買時有些心儀節目的學生票已售罄，唯有解囊買正價票。隨後幾屆我也有排隊買學生票，直至到外國升讀大學。早年在藝術節看過瑪歌・芳婷、艾薩克・斯特恩、傅聰等世界知名藝術家的演出，印象十分難忘。」

I. Student Ticket Scheme: Encouraging Arts Appreciation

A determined goal of the Hong Kong Arts Festival since its inception has always been to provide student tickets at discount. Discounted student tickets lower the threshold for young people to attend arts performances and help nurture student audiences and propagate arts education. Both the initiative and its lofty vision stemmed from the foresight of the Festival's early leadership.

The "Student Ticket Scheme" has been possible thanks to the generous support over the years from individual and institutional donors. It helps full-time local students attend the Festival's performances at discounts of as much as 50 per cent. Two of the scheme's earliest supporters are the Sir Robert Ho Tung Charitable Fund and The Hong Kong Jockey Club Charities Trust.

When the Arts Festival first started, 8,000 discount student tickets were available each year at only 20 per cent of ticket prices. As student tickets couldn't be booked, many students queued up overnight for tickets one or two days ahead of public ticket sales every year. Each student was allowed to buy one ticket for each performance with a maximum of five performances per purchase. Many supporters of the HKAF have fond memories of queuing up for student tickets during their youth. Starting in 1988, the discounted student tickets were sold at 40 per cent of regular prices. By 1977, student tickets are sold at half price.

One unique aspect of the Arts Festival's Student Ticket Scheme is the fact it is solely supported by donations whereas other arts groups can afford to take a hit on their revenues to offer discounts.

As Programme Director of the Arts Festival, Grace Lang vividly recalls her own experience of queuing up for tickets as a teenager. "In primary school, our teacher took us to City Hall for concerts, which cost one dollar in those days. By the time of the first edition of the Arts Festival in 1973, I was already a Form Three student. It was quite a sensation because of the sudden wealth of programmes from overseas, which I very much looked forward to attending. Several classmates and I planned to be at the ticket counter by early morning on the first day of public ticket sales. However, there was already a long queue as we arrived at City Hall. When it was finally my turn, the student tickets for some of my favourite programmes were sold out and I had to purchase standard price tickets instead. I started to queue up for student tickets in the next few editions of the Festival and continued to do so until I went abroad to study. During my early years, I have enjoyed Arts Festival programmes featuring memorable performances by world-renowned artists including Margot Fonteyn, Isaac Stern and Fou Ts'ong."

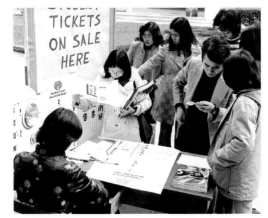

1977年藝術節在浸會書院售賣學生票
Student tickets on sale at Baptist College for the 1977 HKAF

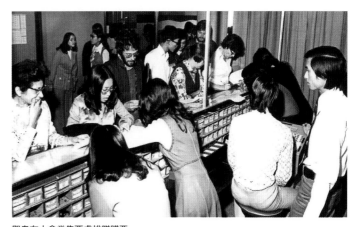

觀眾在大會堂售票處排隊購票
People queueing to buy tickets at the box office of the City Hall (1976)

II.「青少年之友」計劃：打開藝術之門

1992年，時任香港藝術節總經理的鄭新文創立了「青少年之友」計劃（Young Friends），旨在拓展本地觀眾以及培育青少年對藝術的興趣。這個「長青」的外展計劃可謂歷久不衰，過去三十年，一直由尤德爵士紀念基金贊助推行，「青少年之友」的會員總數累計超過十七萬。

從動機來說，計劃的出發點是透過藝術教育拓展新的觀眾層。在九十年代初的香港，這是一個嶄新的概念。

從教育角度，計劃的核心是提升藝術鑒賞。這是藝術節獨有的理念及清晰的定位，因為藝術節不是政府或教育機構，在策劃藝術教育上始終有分別。

為了推行「青少年之友」，鄭新文聘任了梁小衛（Priscilla）成為首個觀眾拓展主任。她提到：「當時觀眾拓展還是一個很模糊的概念，雖說是為未來培養更多的觀眾，我們其實一直把這個計劃當作是藝術教育。增加更多觀眾不只是因為票房，而是希望更多年青人能有機會接觸藝術，透過接觸不同的藝術體驗活動和來自各地的藝術家，從而建立屬於我們自己的文化。」

計劃讓參與的中學生每年有兩個自選的免費節目可供觀賞。「起初有三十多間中學參與，五年後已增加一倍。每逢新學年九月至十一月，便是我們到學校『巡迴演出』的日子。我會帶同一位本地藝術家，如默劇、舞蹈、戲劇等等，把來年藝術節的特色節目，作一個互動的推介展演。從構思到撰寫整個展演，都會和同事商議，我好像是經過重重的考試。」沒想到當年這些學校巡演，為 Priscilla 撒下日後踏台板的種子，離開藝術節的行政工作，後來卻嘗試參與了幕前演出。

「因為藝術節每年有不同類型的節目，所以學生有很多的選擇。要令年青一代有興趣走入劇院，揀選的節目是非常重要，同時也要特別為初接觸藝術的同學作導賞。我們會聯絡藝團，給予同學觀看預演綵排或特別的演出選段，甚或跟他們交流討論。計劃漸漸建立了一群學生擁躉，我們更從中招募了一些較成熟的義工，協助計劃活動，例如執行儲印花獎賞的項目等。」

II. "Young Friends": Opening the Door to the Arts

When Tseng Sun-man was General Manager of the Hong Kong Arts Festival in 1992, he established the "Young Friends" scheme, an initiative that aimed to expand local audiences and cultivate young people's interests in the arts. This "evergreen" outreach project remains as fresh and vibrant as ever. For the last three decades, "Young Friends" has been supported by the Sir Edward Youde Memorial Fund and has accumulated more than 178,000 members.

From an educational perspective, the core objective of the scheme is to enhance appreciation of the arts. This is the Festival's unique vision and clear positioning. As the HKAF is neither part of the government nor an educational institute, there are differences in its planning of arts education.

To implement "Young Friends", Tseng hired Priscilla Leung as the first Audience Development Officer. She says: "Audience development was a very vague concept at the time. Although the goal was to develop more audience in the future, we always perceived the scheme as arts education. Expanding the audience is not just for the sake of ticket sales but for more young people to have opportunities to experience the arts. Through exposure to various arts and artists around the world, we can build our very own culture."

The scheme offers participating secondary school students the opportunity to attend two Festival programmes every year. "More than 30 secondary schools took part in the scheme at the start, and the number of schools doubled after five years," says Leung. "Every year from September to November, we will have our school 'performance tours'. A local artist in mime, dance or theatre accompanies us to give the students an interactive presentation of the special programmes in the upcoming Arts Festival. It feels like one challenge after another as my colleagues and I conceive and write the entire presentation." The experiences accumulated during these school tours turned out to serve Leung well as she too started performing on stage after leaving her administrative role at the HKAF.

"As the Arts Festival offers a wide range of programmes every year, the students have a lot of choices. To generate enough interest for the younger generation to visit the theatre, programme selection is very important. We also make special arrangements to guide students who are new to the arts. We contact the arts groups to

「青少年之友」計劃在成立十五週年之際，得到民政事務局資助，推行一個嶄新的駐校及表演計劃。當時任職外展統籌的陳志勇，對於這個在 2006 年 4 月至 2007 年 2 月期間推行的駐節藝術家計劃，記憶猶新。「計劃藉著參演藝術節的本地藝團，包括樹寧‧現在式單位、前進進戲劇工作坊等，特別設計深化課程活動，與五所參與的學校學生分享經驗，融合藝術與課堂教學，共同製作了兩場戲劇和音樂劇的演出，以及一個視藝展覽。」

至於 2007 年接手做外展統籌的林慧茵（Jess），她印象最深刻的是每年的暑期活動。計劃稱為「夏日 My 藝 My Summer Show」，就不同藝術形式如音樂、舞蹈、戲劇，找來本地藝術家，為參與的學員設計課程，經過訓練、綵排等等，終極來個大匯演。計劃的特色是台前幕後都兼顧，還有藝術行政。「意想不到，藝術行政工作坊竟然最受歡迎，主要由我們藝術節協會不同部門的主管擔任講師，參加過工作坊的青少年，有不少日後也從事了藝術行政的工作。其實，暑期活動也從中幫我們發掘核心會員及義工。」

談到當年的計劃方向，Jess 提到：「我們的舵手何嘉坤（Tisa）除了希望更多的青年人可以受惠這個計劃，同時希望我們發掘多些表演場地，走出傳統舞台，深入社區。 例如，我們的學員匯演曾去過當時剛開幕的香港青年協會 M21，甚至在 apm 商場中庭搭起舞台。」

為了提高同學對演出的觀賞興趣，Jess 記得：「有一次去中學巡演，我們帶了一雙芭蕾舞鞋，讓同學試穿，了解芭蕾舞鞋的構造。 這樣他們稍後觀看芭蕾舞演出的時候，就最少有了一個切入的焦點。」

外展暑期活動：「夏日 My 藝 My Summer Show」
Outreach Summer Programme："My Art My Summer Show" (2009)

arrange for students to attend a rehearsal or to watch an extract from the performance, or engage in discussion with the students. The scheme gradually built up a group of student supporters. We even recruited some of the more mature volunteers to help out in activities such as implementing stamp reward programmes."

On its 15th anniversary, "Young Friends" launched a brand new Multi-Arts Residency and Performance Project supported by the Home Affairs Bureau. Andrew Chan, Outreach Coordinator at the time, remembers the first project, which was held from April 2006 to February 2007. "The project was led by local arts groups that took part in the Arts Festival, including Shu Ning Presentation Unit and On & On Theatre Workshop. They designed an in-depth curriculum of activities and shared their experiences with students from the five participating schools. After combining the arts and classroom learning, they produced two theatre and musical performances, and one visual arts exhibition."

Jess Lam, Chan's successor as Outreach Coordinator in 2007, says what she remembers the most was the annual summer holiday activity. "My Art My Summer Show" was a project that offered a tailor-made course designed by local artists in various art forms, including music, dance and theatre. After training and rehearsals, the students presented a finale performance. The project was unique as the participants needed to take care of everything both on and off stage, including arts administration. "Surprisingly enough, the most popular workshop was on the topic of arts administration. It was presented by the various department heads of the Arts Festival Society. Some of the young people who participated in the workshop chose arts administration as their profession later on. In fact, the summer activities also helped us identify core members and volunteers."

As for the scheme's direction at the time, Lam says: "Tisa hoped for more young people to benefit from this scheme. At the same time, we wished to discover more performing venues as a detour from the traditional stage in order to reach deeper into the community. For example, our members performed at M21, located at the Hong Kong Federation of Youth Groups Building when it first opened. They even performed at a stage at the atrium of a shopping mall."

Lam remembers bringing a pair of ballet shoes to a secondary school tour to raise students' interests in watching performances. "The students gained an understanding of how the shoes work as they tried them on. This experience at least gave them a focal point of appreciation when later attending the performance."

「認識・發掘・創造」

經過多年發展，「青少年之友」計劃現以「認識・發掘・創造」的框架，引領學生認識各種藝術形式及作品，從鑑賞中發掘作品與自身以及世界的連繫，以至從各種周邊活動中創造無限可能。

「很多學生不知道香港文化中心在哪裡，去演藝學院又以為要在灣仔地鐵站搭的士。」我們習以為常的一些事情，對很多人來說卻是很奢侈。前高級外展經理李冠輝 (Kenneth) 在藝術節工作了八年，負責「青少年之友」計劃，耳聞目睹不少故事，「很多學生都珍惜這個接觸藝術的機會。」

中學生 $80、大專生 $120 的年費，兩場免費演出，當然這樣不會令年青人頓時喜歡藝術，但這一扇門卻是重要的第一步。Kenneth 說「青少年之友」的動機是觀眾拓展。「但要建立怎樣的觀眾？就是要對藝術有一定認識才可以豐富其觀賞體驗。」他強調整個計劃不只是為了增加觀眾，而是注重藝術教育。

當不少學生對劇院音樂廳也感到陌生，認識表演藝術就不能只是提供免費看演出的機會。「所以我們發展了『認識・發掘・創造』這三步曲的框架，根據每年藝術節的節目，或是當年的主題去策劃不同體驗活動。」

第一步首先要認識表演藝術。例如要欣賞一場表演，首先要有演前講座，循序漸進式的引導。透過駐校藝術教育、互動劇場及示範講座，把藝術帶進校園，引領學生打開表演藝術的大門。配合內容深入淺出的駐校演前工作坊，讓學生預先從多方面認識演出，為整個觀演體驗作好預備。

"LEARN, EXPLORE, CREATE"

After years of development, "Young Friends" now applies the "LEARN, EXPLORE, CREATE" principle to help students learn about different kinds of art forms and works, explore the connection between the works and themselves or the world at large through arts appreciation, and to access their untapped potential through creations in peripheral activities.

"Many students have no idea where the Hong Kong Cultural Centre is, and assumed that a taxi ride is required to get to the Hong Kong Academy for Performing Arts from Wan Chai MTR station." Things which we are accustomed to or take for granted are actually considered extravagant by many other people. Former Senior Outreach Manager Kenneth Lee, who has worked for the Arts Festival for eight years and is responsible for "Young Friends", can attest to the statement after having heard and witnessed many stories: "Many students cherish this opportunity to know about the arts."

A "Young Friends" member can enjoy two free performances with their annual membership fee of HK$80 for secondary students and $120 for tertiary students. Although this will not turn young people into arts lovers overnight, it is an important first step leading to the world of arts. Lee said the objective of "Young Friends" is audience development. "But what kind of audience do we want to establish? It takes a certain knowledge of the arts to enhance arts appreciation." He emphasises that the scheme does not aim to just increase a certain quantity of audience and that arts education is part of the grand scheme.

As some students are unfamiliar with the concert hall itself, learning about performing arts entails much more than the chance to watch a free performance. "So we developed the three-step framework of 'LEARN, EXPLORE, CREATE' to plan the different arts experiencing activities, according to the programmes or theme of the Arts Festival for a given year."

The first step is to learn about the performing arts. Before watching a performance a preparatory talk is arranged to provide step-by-step guidance. Initiatives including in-school arts education, interactive theatre and demonstrations bring arts into the campus and open up the door to performing arts for the students. Coupled with pre-performance workshops that are simple and easy to understand, students are better equipped to understand and enjoy the performance from different perspectives.

學校巡迴演出與互動劇場
School Tours and Interactive Theatre Performances

第二步便是發掘。透過欣賞藝術，開拓每個人的視野，提升文化觸覺，藉此發掘世界與自身的連繫。藝術節每年帶來不同的世界級藝術演出，「青少年之友」特別為學生策劃專享節目，並為部分精選節目編撰導賞手冊，引領學生反思及發掘不同演出背後的故事，深化其觀賞體驗。

第三步便是創造。觀看演出後，如何建立藝術氛圍，把藝術點滴滲透在學習階段，幫助他們創造自己的不同可能性。「青少年之友」計劃提供的是全方位藝術體驗活動，舉辦不同類型的工作坊，例如實習記者系列，當中包括採訪訓練班、手機短片製作班、藝評寫作班等，邀請專家擔任導師，配合理論與實踐，學習專門技巧，並有機會在藝術節期間，採訪本地和國際藝團，實踐發揮所學。最新推出的青年作曲家工作坊，更提供機會予有志成為作曲家的年輕人，接受專業作曲家指導創作，並發佈作品。這些深化藝術體驗的工作坊，旨在鼓勵學生從藝術創作、表演、行政、報導及評論等多方面接觸藝術，創造屬於自己的藝術生命。

The second step is to explore. Students broaden their horizons and enhance their cultural sense through arts appreciation to explore the connection between oneself and the world at large. Among the variety of world-class arts performances presented by the HKAF every year, "Young Friends" arranged a number of Student Matinee Programmes. To enhance the students' viewing experience, specially designed house programmes are prepared for some of the programmes to guide students to reflect, discover and explore the stories behind the performances.

The third step is to create as students, after watching the performances, incorporate the atmosphere and details from the arts into their learning as well as unleashing their own potential. "Young Friends" provides workshops in interviewing, video production, arts criticism, among others. Experts serve as mentors to help students put theory and practice together while acquiring specific skills, which they can then use when interviewing local and international arts groups during the Arts Festival. The newly launched Young Composers Workshop even provided opportunities for young aspiring composers to receive guidance by professional composers and have their works performed by professional musicians. These workshops encourage students to encounter arts though a multitude of perspectives including creation, performance, administration, reporting and criticism from which they can build their lives in the arts.

駐校演前工作坊
In-school Pre-performance Workshops

藝術行政工作坊
Arts Administration Workshops

「青少年之友」的活動全年無休，是一個不斷前進的旅程。每年九月一日開始登記，設有學校會員和個人會員。Kenneth 也是在中學時代已認識藝術節，雖然沒有參加過『青少年之友』，「當時在學校已有參加藝術活動，而且每年藝術節舉行期間的二、三月也忙於參加學校音樂節。這也是『青少年之友』的其中一個挑戰，因為部分學生實在太忙，有太多活動。當然還有很多學校的學生沒有機會接觸表演藝術，那就是我們想服務的對象。」

「青少年之友」的對象最初是中學生，從 2001 年起推廣到大學，每年超過六千名會員登記，而其他非會員可參加的活動也有過萬人參與。「約十年前教育局推出新高中課程的『其他學習經歷』(Other Learning Experiences)，當中一個範疇是藝術發展，可說是『青少年之友』的高峰，每年超過萬人登記，大概是當時沒有很多這類藝術教育計劃。」Kenneth 說今天不少藝團和機構也推出藝術教育項目，不過藝術節依然是一個品牌。

這個長青計劃以藝術節的節目為主軸，由於節目多元化，讓學生能夠透過計劃接觸海外和本地不同風格的藝團，近年策劃的專場節目都很受學生歡迎。「好像 2016 年《巴洛克音樂之旅》，

"Young Friends", with events running throughout the year, is a journey always moving forward. Registration opens on 1 September every year and students can join either as a School Member or Individual Member. When Kenneth Lee was a secondary student, he knew about the Arts Festival though he did not join "Young Friends" at the time. "I was already taking part in the school's arts activities then, and I was busy with the School Music Festival in February and March every year when the Arts Festival took place. This is one of the challenges for "Young Friends", as some students are busy with many activities. There are also many school students who have not had the opportunity to find out more about performing arts and who we hope will find the scheme beneficial."

The target for "Young Friends" was initially secondary students only but it was broadened to include tertiary students in 2001. There are over 6,000 member registrations every year while over 10,000 people take part in "Young Friends" activities that do not require membership. "Around ten years ago, the Education Bureau launched the new NSS Curriculum with arts development being one of the learning objectives in 'Other Learning Experiences'," Lee says. "It led to the peak of "Young Friends", with over 10,000 member registrations probably because of the lack of other arts education schemes at the time." According to Lee, many arts groups and institutions now offer arts education projects but the HKAF remains a brand of repute.

The long-running "Young Friends" is centred on the Festival's programmes. With its diversified line-up of programmes, students can choose freely among overseas and local arts groups with different styles. In recent years, the "Young Friends Special" programmes were very popular for the students. "*Taking A Musical Journey Back to the Baroque Era* in 2016 as an example, we introduced the students to Baroque music based on its historical background, musical style and classifications of musical instruments with participation by both overseas and local musicians. For *The Curious Incident of the Dog in the Night-Time* in 2018, we made use of drama education to deconstruct the plot, explain about Asperger's syndrome, introduce artists with this syndrome and convey the work's message. We also gave an introduction to Hong Kong's pop music through A cappella music. Starting with Nanyin (southern tunes) was a discourse on the history of Hong Kong's pop music development, which is essentially the history of Hong Kong as well."

我們從歷史背景、音樂風格、樂器分類，介紹巴洛克時期音樂，又有海外和本地的音樂家參與。2018年的《深夜小狗神秘習題》，透過戲劇教育，解構故事大綱，講解亞斯伯格症候群（Asperger syndrome），介紹有這症狀的藝術家，帶出劇作的訊息。另外，我們又以無伴奏合唱方式，介紹香港流行音樂，由南音開始帶出香港流行音樂的發展史，同時也在闡述香港歷史。」

因為新冠疫情嚴峻，2020年藝術節宣告取消，「青少年之友」也自動延長會員會籍，後來節目也轉移到網上。「疫情關係，我們的應變方法之一是推出網上節目，例如《阿根廷探戈網上音樂會》，2021年是阿根廷著名音樂家皮亞蘇拉（Astor Piazzolla）誕生一百周年，這個網上音樂會便介紹他的探戈音樂，由本地年青音樂家何卓彥擔任主持和參與演出。而2022年藝術節的熱門節目主題是藝術科技，我們會將科技融入藝術的沉浸式體驗活動，始終現場體驗表演藝術還是最重要。我們亦希望日後『青少年之友』成員可以有參與創作的機會。」

Kenneth 始終強調：「有一點很清楚，我們並不是藝術學校，以訓練藝術家或藝術行政人員為最終目的，當然參與的年青人最後能成為藝術家是非常好的事。我們相信藝術是生命的一部份，希望更多人能欣賞藝術，成為一個好的觀眾，讓藝術影響其生命。」

Because of the COVID-19 situation, the Arts Festival in 2020 was cancelled. Memberships of "Young Friends" were automatically extended while programmes were moved online. "Because of the pandemic, one of our solutions was to launch online programmes such as *Astor Piazzolla X CY Leo*. As 2021 marked the 100th anniversary of the birth of famous Argentine musician Astor Piazzolla, this online concert gave an introduction to Piazzolla's tango music and was hosted by local young musician CY Leo, who also performed at the concert. As a popular theme for the Arts Festival programmes in 2022 is Art Tech, we will present immersive art experiences in which technology is infused in the arts as experiencing performing arts in person remains important. In the future, perhaps 'Young Friends' members can themselves take part in creating art."

Lee continues to emphasise the importance of "being very clear that the Arts Festival is not an art school with the ultimate objective of training artists or arts administrators. Of course it would be great if the young people taking part ultimately become artists. We believe the arts are part of our lives and hope that more people can appreciate them, becoming audiences with the arts having a positive impact on their lives."

青少年之友會員專享節目：《阿根廷探戈網上音樂會》
Young Friends Special: Online Concert – Tango with Astor Piazzolla ft. CY Leo

青少年之友會員專享節目：《巴洛克音樂之旅》—— 演後舞台參觀
Young Friends Special: *A Musical Journey back to Baroque Era* – Post-show Stage Tour

薛海暉
撒種的前傳

種子撒下，長成果樹，花果掉下，遍地開花。

多年前藝術的種子掉在薛海暉（Harvey）身上，今天的他變成撒種子的人。先後畢業於香港教育學院及香港演藝學院戲劇學院，學教育又學藝術。Harvey自小喜歡繪畫，大概沒想過會走到台前，卻因為「青少年之友」而接觸表演藝術。

「當學校收到『青少年之友』寄來的信件，因為我喜歡畫畫，可能老師認為藝術就是畫畫，於是就把信給我。那時大概是中三、四，其實我不認識舞蹈也不知道戲劇，表演藝術是甚麼也不懂。」第一次入劇場，沒有一見鍾情，卻埋下種子。「早已忘記當天看的是甚麼，不過重點不在此，因為有這次接觸才知道原來這些就是藝術，而藝術的世界不只是畫畫了。直至高中又收到藝術節的邀請，當年一個歌劇節目需要招考大量合唱團員，於是嘗試參加人生第一次試鏡，第一次上台演出。」

故事情節沒有直線發展，Harvey雖然對表演藝術有興趣，最後卻揀選了入讀教育學院。「小時候學畫畫，媒介就是顏料，在教院修讀視覺藝術後，才開始明白藝術不只是靜靜地畫畫。當時也有參加大專的『青少年之友』，看藝術節的演出。上了大專後，眼界見識多了，知道『青少年之友』雖不是唯一接觸藝術的機會，卻令我可以接觸不同地方和不同類型的藝術。」

畢業後，Harvey沒有當起老師，卻走進另一個校園繼續攻讀表演課程。讀演藝學院時做兼職，開始實踐教院學到的藝術理念。

無心插柳，Harvey開始把藝術與教育結合，也因此又遇上藝術節。「可能大家認為我既是演藝畢業，又讀過教院，應該是懂得教學，所以陸續有不少人找我負責藝術教育的課程。『青少年之友』大概也是看中我這個背景，某天問我有沒有興趣一起創作學校的巡演。」於是Harvey又成為「青少年之友」的成員，不過這個時候，他已是執行團隊的一份子。

「最初的學校巡演是介紹來年藝術節某些節目，串連在一起，主要是做宣傳，所以我會說是像廣告雜誌。當時我想到為何學生要花上課的時間看你們的廣告雜誌，有甚麼得著呢？於是我跟負責

Harvey Sit
Before the Seeds were Planted

A mere seed on the ground has the potential to germinate and mature, before producing more seeds towards full bloom.

For Harvey Sit, the seeds of art were sown many years ago. He now stands proud, having himself become a sower. He graduated from the Hong Kong Institute of Education (HKIEd) and the School of Drama at HKAPA. Sit had liked drawing since childhood and probably never imagined he himself would one day be on stage. His encounter with performing arts started with "Young Friends".

"When my school received a letter from "Young Friends", the teacher passed it to me, probably figuring that because I was interested in painting, I'd be into it. I was a Form Three or Form Four student then with little knowledge of dance, theatre or performing arts in general." Although he was not immediately taken with the theatre on his first visit, the seeds of interest were sown. "I have long forgotten the details of the programme. But the encounter itself led me to realise what art can be and it's not all about painting. When I was an upper form secondary student, we received an invitation from the Arts Festival, which was recruiting choir members for an opera programme. I auditioned and then performed on stage for the first time in my life."

Sit's journey thereafter on was not straightforward as he expected. Although interested in the performing arts, he eventually chose to study at HKIEd. "When I learned drawing as a child, the medium was paint. After studying visual arts at the HKIEd, I came to understand that the arts are not only about painting quietly. I also joined "Young Friends", and attended Arts Festival performances. As a tertiary student, I gained more insight and was aware that "Young Friends" is not the only channel to encounter the arts. However, it helped me to encounter many art genres from different places."

Sit did not become a teacher after graduation and went on to study drama in another institute.. During his studies at the HKAPA, he worked part time to practise what he learned about the arts during his study in HKIEd.

Sit naturally started to integrate what he learned into art and education, and encounter the Arts Festival again. "Because I was a graduate of the HKAPA and HKIEd, people were confident about my teaching ability and approached me to teach arts education courses. I suppose "Young Friends" took notice of my background as well and asked if I would be interested in creating school tour performances." So Sit became a member of "Young Friends" again, now as a member of its executive team.

這計劃的 Kenneth 提出意見，開始思考一個藝術導賞應該怎樣做，如何讓學生走進這個世界，要融入欣賞和教育元素，看演出不只是在『看』，而是要在表演的內容上和美學上可以學到甚麼。」

Harvey 跟「青少年之友」的團隊一起改進學校巡演。「一般談藝術教育有四個支柱，就是技巧、創意思維、知識內容及藝術欣賞。藝術節要做的方向是藝術欣賞。雖然一直有零散地做演前講座、演後座談這些活動，但都不應只是單次的活動，而是怎樣貫穿。於是我們發展了藝術欣賞的脈胳，就是『認識·發掘·創造』。第一步，認識作品和藝術範疇，第二步的發掘就是看演出的過程，如何提供資訊，刺激同學思考，要看甚麼；很多人到場地其實不知道要看甚麼，我們就要提供引導。最後一步就是創造，藝術創造不一定是做一件作品，可以寫一首詩，可以是跟人互動，結果可以是任何形式的。簡單來說就是前中後三個過程。有此概念，也就不只是演後談，而是如何幫他們總結整個觀賞經驗。」

當天走進劇場，為 Harvey 打開了藝術之門，因此愛上藝術。不過 Harvey 不認為人人也要喜歡藝術。「我認為任何人也要有機會認識藝術，你可以不喜歡藝術，但是否經過接觸了解後，然後才大聲說不喜歡。所以重點是我們是否有門檻讓青年人進入藝術的世界。曾經有學生提問為何要做音樂劇，為何演戲又要突然唱歌。這學生說他只是喜歡戲劇的部份，而他的美學就是喜歡真實，這點其實沒有問題。我們就是要通過不停接觸，修正美學價值。最終藝術教育是關於批判思考、美感和建立人的價值觀。」

蕭燕凌
名校的隱形學生如何接觸藝術

世界從此不一樣。

她也從藝術中看到美，從喜歡畫戲服到成為舞台及服裝設計師，也許是因「青少年之友」而來的一種緣份。蕭燕凌（Cathy）畢業於演藝學院佈景及服裝設計系，如今開辦設計公司，從事商業和藝術的設計工作，曾為 2021 年兒童歌劇《愛麗絲夢遊仙境》以及粵劇《挪亞方舟》擔任服裝設計。Cathy 跟 Harvey 一樣，自小也喜歡畫畫，卻對表演藝術全無認識。

"Initially, the school tours were focused on introducing certain programmes in the upcoming Arts Festival with snippets of programme materials strung together, which I likened to magazine advertisements. At the time, I thought about what students might effectively gain from skimming these advertisements rather than going to classes? So, I made suggestions to Kenneth Lee who was responsible for the project, and contemplated how students might be guided into the arts by incorporating elements of arts appreciation and education. Watching a performance is not just about watching, it also involves what might be learned from its content and aesthetics."

Sit set to working on improving the school tours with the "Young Friends" team. "Generally speaking, there are four pillars of arts education, namely skills, creative thinking, knowledge and content, and arts appreciation," he says. "The direction for the Arts Festival, in this case, is arts appreciation. Although there were preparatory and post-performance talks here and there, they should be linked instead of being standalone events. So we developed a structure in arts appreciation called 'LEARN, EXPLORE, CREATE'. The first step is to learn about the work and the art form; the second is to explore the process of watching the performance, provide students with information to stimulate their thinking and help them understand what they are watching. In fact, many students do not have any idea of what they are actually watching at a performance, and we should be there to provide guidance. The last step is to create. Arts creation is not about creating a piece of art. It could be writing a poem, interacting with others or an outcome in any format. With this three-step concept, the process does not include a post-performance talk only but assistance for the students to conclude the entire experience of watching a performance."

A visit to the theatre many years ago opened the door to the arts for Sit and kindled his passion for it. Sit, however, believes that not everybody has to like the arts. "I believe that all people should have access to *understand* the arts. You can proclaim a disdain for art but it depends on whether it was based on understanding after you encounter it. The focus, then, is whether there is a threshold barring young people from entering the world of art. A student once asked me why characters burst into song in musicals. The student only liked the drama side of it, and his sense of aesthetics is geared towards reality. This is not a problem, in fact, as we refine our sense of aesthetics through greater experience. Arts education is ultimately about critical thinking, aesthetics and building human values."

「小時候跟嫲嫲在內地生活一段時間，常常跟她一起看潮劇，覺得演員的服裝很美，於是跟著畫，閒來沒事就畫。所以能夠參與《挪亞方舟》覺得很感動，當看到演員化好妝穿上戲服站在我眼前，有夢想成真的感覺。」

Cathy 總覺得一直與藝術節有點緣份，第一次相遇，便是「青少年之友」。「中學時某天周會，『青少年之友』來學校宣傳，記得是有免費票看演出，當時因為要應付音樂功課，也就參加了。」Cathy 說當日的功課正是要去看演出，對她來說完全是不可能的任務。

「我讀香港真光中學，大部份的同學都是來自環境較好的家庭，很多同學都學鋼琴、小提琴等，有去聽音樂會的經驗。可是當中也有像我來自基層，家人沒有帶我看過任何表演，不要說文化中心，去戲院也覺得奢侈。父母也不會帶我們看電影，都只是在家看電視。所以當年還在讀中三的我完全沒有接觸過藝術，跟藝術很有距離。」Cathy 說那時住香港島，未去過香港文化中心，因為要過海，覺得自己像大鄉里，加上成績又一般，功課都做得不好，還要看演出，也有點緊張 。「那是人生第一次進入文化中心，覺得好大、好漂亮，只去過學校禮堂的我，發覺原來世界可以很不一樣。」

《挪亞方舟》服裝造型
Costume designs of *Noah's Ark* (2021)

Cathy Siu
An Invisible Student at a Top School Encounters the Arts

When she was young, Cathy Siu liked to draw costumes and she would eventually become a stage and costume designer. "Young Friends" played a considerable role in shaping her trajectory. Cathy Siu graduated from the Hong Kong Academy for Performing Arts where she majored in Set and Costume Design. She founded a design company and now creates costumes for the commercial and arts sector. She was recently costume designer for the children's opera *Alice in Wonderland* and the Cantonese opera *Noah's Ark* in 2021. Like Sit, Siu loved to draw from a young age but knew nothing about the performing arts growing up.

"I lived with my grandmother in Mainland China as a child for some time, and often went to performances of Chiu Chow operas with her. I thought the costumes were beautiful and would draw them in my spare time. So it was an emotional experience for me to be involved in *Noah's Ark*. When I saw the actors in full makeup and costumes I had designed, it felt like a dream come true."

Siu has always felt a close connection with the Arts Festival since her first encounter as a schoolgirl: ""Young Friends" came to my secondary school for promotion during a weekly meeting. I remembered the mention of free tickets for performances and joined to finish a music assignment." The assignment was to attend a performance, which was something not open to her at the time.

"I studied at True Light Middle School of Hong Kong and most of the students came from financially comfortable families. Most of them learned musical instruments like piano and violin, and had been to concerts before. There were also students like me who came from grassroots families. My family had never taken me to a show. We just stayed at home and watched television as even a trip to the cinema felt like a luxury, never mind the Cultural Centre. So, up until then, I had no exposure to the arts, and it was something quite remote to me."

Siu confesses to feeling somewhat of a country bumpkin at the time as she lived on the Hong Kong Island side and had to cross the harbour to visit Hong Kong Cultural Centre, a place she had never been. She felt a bit nervous as well because her grades were poor and watching a performance on top of doing homework was a bit of

雖然早已忘記那次是甚麼音樂會，跟 Harvey 一樣，Cathy 對藝術也沒有一見鍾情，卻是開了一扇門。「中學時自覺成績不理想，看到演藝學院的招生覺得頗有趣，而且又是學位課程。心想喜歡畫畫，也看過演出，似乎很適合。當年入劇場的經驗令我不抗拒看演出，覺得應該可以應付。」於是順利入讀演藝學院，讀書期間 Cathy 也有看藝術節的節目，「最記得是《沙樂美》歌劇，因為買學生票很貴，還要坐山頂座位，不過同學也說飛去歐洲不只這個價錢。還有《愛德華二世》，服飾很特別，很震撼，之前覺得芭蕾舞很悶，這個演出令我對芭蕾舞改觀。」Cathy 在讀書時跟 Ricky 老師（陳志權）做助手，作品是 2008 年的《泰特斯》。後來到中文大學讀文化研究碩士課程時，又遇上藝術節關於版權的講座，「好像一直跟藝術節有聯繫。」

再次參與藝術節的節目，也是因為 Ricky 老師的推薦。「《挪亞方舟》這個作品，既是《聖經》故事，又是戲曲，要面對這兩批不同觀眾也不容易。這次因為導演很欣賞我設計動物的造型，特別加戲給動物，令我很滿足。」

今天夢想成真，Cathy 很感激當年在學校遇上藝術的機會。「如果讀書不好，學校也沒有其他活動，隨時會變成隱形人。雖然現在社會環境改善，但依然有很多基層學生，如果這些學生有機會接觸藝術活動，可以去看演出，將來也可成就不同的理想。人生的理想不一定只是律師、醫師、工程師，世界還有很多選擇。」

a strain. "That was my first time entering the Cultural Centre. It was very large and beautiful for someone who had only travelled as far as the school hall before. A different world just emerged for me then."

Siu has long forgotten what the concert was. Like Sit, she was not immediately drawn to the arts, even if it did open a door of possibility. "My grades were less than ideal and I was interested in the Hong Kong Academy for Performing Arts. Since it was an undergraduate programme, it seemed suitable, considering my interest in drawing. The study seemed manageable, too, as I felt comfortable enough with arts performances based on my experience watching them." Siu entered the Academy, and attended Arts Festival programmes during her study: "I remember the opera *Salome* very well even though the student tickets were quite expensive and the seats quite far from the stage. However, my schoolmates said that flying to Europe would cost even more. I was also mesmerised by *Edward II* because of its unique costumes. I used to find ballet quite boring, something that was completely upended by that performance." During her studies, Siu became an assistant to her instructor Ricky Chan for *Titus Andronicus* in 2008. When she later studied for her master's in cultural studies at the Chinese University of Hong Kong, she attended another talk at the Arts Festival, on copyright: "I feel like having an ongoing connection with the Arts Festival."

On Ricky Chan's recommendation, Siu again took part in Arts Festival programmes. "*Noah's Ark*, in this case, is both a story from the Bible and a Cantonese opera. It is a challenge to satisfy both audience groups. For *Noah's Ark*, it gave me great satisfaction that the director appreciated my design for the animals in the programme and, as a result, they were featured more prominently than planned."

Siu is grateful for her opportunity to encounter the arts at school many years ago. It helped her realise her dreams: "It is easy to become an invisible student with less-than-ideal grades and few school activities. Although the social environment has improved since then, there are still many grassroots students. If these students are given opportunities to attend performances with exposure in the arts, they will be more equipped to achieve their dreams in the future. An ideal life is not just about being a lawyer, doctor or engineer. There are plenty of options out there."

盧舜劭
從事藝術寫作

盧舜劭（Zabrina）現是雜誌編輯，從事文字工作，也是藝術節替她打開了一道門。

「中學夢想是做英文小說作家，但好像很難實現；大學又想寫影評，又像似乎不能以此為生，卻始終不想放棄寫作。」

Zabrina 在浸會大學修讀英國文學，二年級那年成為「青少年之友」，參加了實習記者計劃。「一直喜歡表演藝術，中學也有參與表演。『青少年之友』令我接觸表演藝術，明白到讀英國文學，不只是看小說，也可以劇場的表達形式。當日揀選了《星耀佛蘭明高》和《歐洲嘉蘭古樂團》(2015) 這兩個節目做採訪，因為對舞蹈有興趣，希望認識不同文化的舞蹈，另外也想認識歐洲古樂團。」

實習記者計劃令 Zabrina 想到當上藝術文化記者之路，隨後到倫敦攻讀英文碩士，也參加了「Plays to See」的計劃，以撰寫藝術評論換取免費看表演的機會，可說是難得的雙重體驗。Zabrina 說：「這也是藝術節播下的種子。」

「青少年之友」實習記者系列（包括寫作、採訪及攝影訓練班）
YFS Reporter Series (including classes and workshops on creative writing, interviewing and photography)

Zabrina Lo
Writing About the Arts

Zabrina Lo is now a magazine editor and it was the Arts Festival that opened the door to her career.

"Although I dreamed of being a novelist writing in English while at secondary school, it seemed a pipe dream. While in university, I considered writing film reviews but it might not have been enough to earn a living. But my dream of writing for a living never waned."

Lo studied English literature at Hong Kong Baptist University. During the second year of her studies, she joined "Young Friends" and became a "Young Friends" Reporter: "I have always liked performing arts and took part in performances while at secondary school. "Young Friends gave me exposure to the performing arts. I came to realise that studying English literature is not just novels, and that theatre can be a form of expression as well. I chose to report on *Gala Flamenca* and *Europa Galante* (2015) as I was interested in dance and wanted to find out more about dance from different cultures. I also wanted to learn more about *Europa Galante*."

"Young Friends" Reporter inspired Lo to become an arts and culture reporter. She later studied for a master's degree in English in London. Lo also joined the "Plays to See" project, for which she wrote reviews in exchange for free tickets for performances, a doubly enjoyable experience for her. Lo attributes her career path to "seeds planted by the Arts Festival."

布鎮權
變成一個熱愛舞台劇的工程師

布鎮權 (Allen) 2008 年參加「青少年之友」計劃，當時在中文大學就讀工程學院，並獲得傑出「青少年之友」的獎項。雖然畢業後在政府從事和藝術拉不上關係的工作，回想起當年，仍然感謝這個計劃對他的正面影響。「轉眼間，想起那三年參與過的活動，特別開心的是能夠欣賞了很多精采的劇場演出，對藝術增加了認識，同時亦結識了很多志同道合的朋友。而我至今依然熱愛欣賞舞台劇，並成了個人的一大興趣。我期望日後更多的青年朋友們參與這個計劃，從中對自己的成長注入更多正能量。」

李芷珊
老師的薪火相傳

「青少年之友」計劃如果沒有學校及老師的配合支持，是不會有成效的。李芷珊是樂善堂梁銶琚書院的中學音樂老師，一直十分支持「青少年之友」計劃。她說：「我們學校在計劃開始時已參加，這麼多年來從無間斷。其實我自己也很喜歡藝術節的節目，我認為藝術學習是對青少年很好的訓練，特別是在紀律和創意這兩方面。要遵守劇院規則、安靜專心看表演，是訓練同學的紀律態度；欣賞藝術、激發思考，是釋放同學的創意潛能。記得其中一個印象很深刻的節目是歌劇《風中細路》(1994)。在我讀書的年代，去看表演是非常昂貴的，如今能夠帶學生去劇場看演出，我自己也有收穫。」

李芷珊老師認為去看一場表演，有點像拆禮物。「第一次去看你未必會很喜歡，但只要抱著拆禮物的心情，可能會有意外驚喜。即使拆開禮物後，發覺不是自己喜歡的東西，但想想這也是朋友為你精心挑選的，可能感受就會不同。記得有次與一位老師去看《天鵝湖》，看後她說因為不懂得欣賞芭蕾舞，所以不小心睡著了。之後每次參與『青少年之友』的活動我也會找她幫忙，不經意地她慢慢培養了看藝術表演的興趣，大家甚至一起訂票，

Allen Po
An Engineer with a Passion for Theatre

Allen Po joined "Young Friends" in 2008 when he was studying Engineering at the Chinese University of Hong Kong. So involved was Po that he won an "Outstanding Young Friends" award. After graduating, Po began working as a civil servant and was not involved in arts-related work. But he remains immensely grateful for the positive impact from "Young Friends". "I vividly recall the activities during those three years. I was very happy to have seen so many wonderful theatre performances which enriched my knowledge of the arts while getting to know many like-minded friends. I am still passionate about the theatre—it became my major interest. Hopefully, more young people will take part in the scheme, which I am sure will inject more positive energy into their growth as much as it did mine."

Janice Ritchie
A Teacher Passing the Torch

"Young Friends" would not be the success it is without the vital co-operation and support of schools and teachers. As a secondary music teacher at the Lok Sin Tong Leung Kau Kui College, Janice Ritchie had always been a staunch supporter of "Young Friends": "Our school has taken part in the scheme ever since it started. I also like the Arts Festival programmes a lot. Learning about the arts is a great form of training for teenagers, especially in areas like discipline and creativity. To watch a performance quietly and attentively while observing the theatre's rules and etiquette trains students to be disciplined. Arts appreciation leads to stimulating thinking skills and unleashes the creativity of students. One programme which left a lasting impression is the musical *The Kids, The Wind & The City* (1994). During my school years, it was expensive to watch performances. And "Young Friends" is beneficial for me now as well because I can bring my students to attend performances at the theatre."

For Ritchie, the unexpected is essential when watching a performance: "You might not like it very much the first time.

後來她又鼓勵身邊的朋友一起去看不同的節目。所以，藝術節其實像一個雪球，越滾可以越大。」李老師也有感而發：「藝術應是生活的一部份，我最開心是在看表演時碰上已經畢業的學生，即表示他們肯掏腰包去看藝術演出，也證明我當初播的種子沒有白費。」

疫情下，藝術節不能到學校巡演，李老師唯有在網上播放巡演的節目。「想不到因為家長也可能陪子女收看，對藝術節計劃的認識多了，支持同學去參與也多了，而且，剛升中的低年級學生都感到很新鮮。藝術節給予同學線上線下的藝術欣賞，提供很多的可能性。假如學生能在年紀更小的時候已經參與藝術節，我相信香港藝術的發展或會更上一層樓。」

尤德夫人頒獎最出色學校獎予李芷珊老師
Lady Youde presented the Top School Award to Janice Ritchie (2002)

However, there might be pleasant surprises if you see it as unwrapping a gift. Even if the gift is not what you fancy, you might feel differently if it is carefully selected for you by a friend. I remember when I watched *Swan Lake* with another teacher. She inadvertently fell asleep during the performance because she did not know how to appreciate ballet. Afterwards, I would seek her help whenever there are "Young Friends" activities. She slowly developed an interest in watching arts performances to the extent that we now book tickets together, and she has even encouraged her friends to attend them. So the Arts Festival created a snowball effect for the arts." Ritchie believes that "the arts should be part of our lives. I am very happy whenever I bump into my past pupils at performances. This shows their eager interest in attending arts performances and proves the seeds I planted have not been in vain."

During the pandemic, the Arts Festival has been unable to conduct its school tours and the tour programmes were streamed online instead. "Unexpectedly, parents got to know more about the Arts Festival and "Young Friends" perhaps because of watching the programmes along with their children, and they became more supportive of students' participation in the scheme. These are new experiences as well for the students in lower forms just out of primary school. The Arts Festival allows the students to take part both online and in person, thus opening up more possibilities for arts appreciation. If it is feasible for students to take part in the Arts Festival at an even younger age, I believe that arts development in Hong Kong will reach even greater heights."

III. 加料節目：將藝術體驗延伸擴大

台上一分鐘的演出，背後有多少個經年故事？

表演藝術，只能在舞台體驗？還是可以深入社區？

「加料節目」是藝術節團隊透過不同活動，在台上台下不同空間，藉以深化大眾對藝術的認識、探知及體驗，領略藝術的種種樂趣。其實每年藝術節有百多場演出節目，而期間舉辦「加料節目」的項目也不遑多樣，無怪乎有「演出之外，更多精采」的推廣句語。

從早年的大師班、演後藝人談，到近廿多年豎立清晰的旗幟，「加料節目」曾舉辦的活動類型包括：示範講座、大師班、工作坊、藝術家沙龍、座談會、彩排參觀、後台解碼、展覽、藝人談、文化導賞團及電影放映等，以多元化、多角度鼓勵觀眾與藝術家互動接觸，並從不同媒介豐富對藝術的參與。

與劇場大師羅伯特·利伯殊對話
In Conversation with Robert Lepage (2019)

III. Festival PLUS: Amplifying Experiences in the Arts

For one minute of glory on stage, what are the years in the making?

Can the performing arts be appreciated on stage only? Or can they reach deep into the community?

Through a diverse range of activities in community locations, Festival PLUS presented by the Arts Festival team aims to share the joys of the arts with the public while enhancing their understanding, exploration and experience of them. While the Hong Kong Arts Festival presents over a hundred programmes every year, the Festival PLUS activities are just as impressive, doing justice to the slogan of "More than Great Performances".

Growing from masterclasses and meet-the-artist sessions held during the Festival's early years to being a branded initiative for more than 20 years, Festival PLUS offers a diverse array of activities including lecture demonstrations, masterclasses, workshops, artist salons, symposia, rehearsal visits, backstage tours, exhibitions, meet-the-artist sessions, guided cultural tours and films to enhance engagement between artists and audiences, strengthening participation in the arts via different media.

認識藝術家的另一面

節目總監梁掌瑋說：透過「加料節目」，我們希望吸引一些對表演藝術未必有興趣的朋友來參與。有些人可能覺得到劇院看表演太過正襟危坐，而加料節目的形式較活潑多樣，是藝術觀賞的適切入門。「另外，我們希望藝術家在香港期間能多做些互動的項目。其實，不少藝術家也喜歡與香港的觀眾交流，而不只是完成一兩場演出便離開。留多一天做不同的活動，這樣更有意義，有時更可以發掘藝術家鮮為人知的一面。好像丹麥國家交響樂團首席指揮法比奧·雷西，2018 年來港演出，他不單是古典樂壇的巨星，原來亦是一位香水調香師。雷西在藝術家沙龍除了指導本地年輕歌唱家，更在華燈美酒下，與觀眾細數他對音樂與香水的熱愛。那次，他特別把珍藏的香水帶來香港，和參與者分享，令大家對這位音樂家有更深刻的認識。」

Knowing the Different Sides of Artists

Programme Director Grace Lang explained that Festival PLUS aims to attract potential audiences who might not be interested in performing arts. Some people find attending performances in theatres too formal. Festival PLUS, being more casual with a greater variety, can serve as an alternative entry point to arts appreciation. "In addition, we hope that artists can be more engaged in interactive projects during their stay in Hong Kong. Many artists actually like to interact with Hong Kong audiences, rather than leaving the city after one or two performances. It is more meaningful to be engaged in different activities by staying on an extra day in the city. At times, we get to discover lesser-known sides of artists. An example would be Fabio Luisi, the celebrated conductor who performed at the Festival in 2018. As well as being Principal Conductor of Danish National Symphony Orchestra, Luisi is also a perfumer. During the artist salon, where he exchanged views on vocal techniques with young local singers, Luisi also shared his passion for music and perfume. He even brought his treasured collection of perfumes to Hong Kong for the participants to enjoy, allowing them to have a deeper understanding of the musician."

「音樂與教堂之旅」華人聖樂音樂會
"Chinese Church Music Encounter" sacred music performance during the "Music & Church Tour" (2016)

黃孔慶怡於《風琴遊蹤》的管風琴獨奏會
Organ recital by Elizabeth Wong as part of the *Pipe Organ Tour* (2019)

多樣化深入社區

「加料節目」的前節目經理游慧姿說，「每年四、五月，當來年藝術節的節目開始定型，她和節目組的同事便集體策劃加料節目，好些項目會結合演出節目來構思，亦會嘗試把一系列活動以主題串連，如 2021 年的『樂遊捷地』系列，除了與觀眾探索捷克四大作曲家的網上互動展覽，更以網上形式帶來捷克布爾諾國家歌劇院及楊納傑克的多場演出，而隨時可觀看的特備加料節目，便為觀眾展現作曲家的立體面貌。」事實上，線上線下同步推出，可以接觸更多新的觀眾群，達到普及推廣的意義，這也是「疫」境誘發探討的新方向。

從藝術節的節目延伸出來的「加料節目」，有時會走入社區，透過一連串特備節目，包括導賞遊、講座、音樂會等，重新發掘相關的藝術寶庫。「我們會四出尋找合適場地、夥伴，以演藝開始連結某種藝術的歷史及地區文化，好像『粵歷油麻地』(2013)、『音樂與教堂之旅』(2016)、『風琴遊蹤』(2019) 等。」

游慧姿提到歌劇是複雜的表演藝術，涉及歷史文學、文本、音樂、服裝、舞台設計等，好像藝術節與三藩市歌劇院聯合製作的《紅樓夢》(2017)，「加料節目」因而可從文學、音樂、歷史背景等多角度去探究。近年「加料節目」一個新嘗試，如 2018 年與威爾斯國家歌劇院、2019 年與萊比錫歌劇院合作，舉辦「歌劇探秘同樂日」一系列活動，反應很理想。

參加者於「威爾斯國家歌劇院《歌劇探秘同樂日》」中透過「魔法蝴蝶虛擬實境」體驗經典歌劇的嶄新演繹
Participant experiences opera scenes reimagined through the "Magic Butterfly VR Experience" during the "Welsh National Opera — *Opera Adventure Day*" (2018)

「萊比錫歌劇院《歌劇探秘同樂日》」
"Oper Leipzig — *Opera Adventure Day*" (2019)

「萊比錫歌劇院《歌劇探秘同樂日》」的《一齊玩》戲劇工作坊
"WE PLAY" Theatre Workshop at the "Oper Leipzig — *Opera Adventure Day*" (2019)

Diversified Approaches in Reaching the Community

As the former Programme Manager for the Festival PLUS, Janet Yau explains that: "during April and May every year when the direction for the next Arts Festival's programmes begins to form, I and my colleagues will plan for Festival PLUS. Some of the Festival PLUS activities are conceived with the Festival programmes in mind and a series of events are linked by a common theme. For example, the "Into the Czech Lands" series in 2021 included an online interactive exhibition that allows visitors to explore four of the greatest Czech composers. In addition, many performances of Janáček's opera by National Theatre Brno were presented as online programmes. The specially crafted Festival PLUS, available for viewing at any time, helps present the composers in a vivid and comprehensive manner." Simultaneously launching in-venue and online programmes also helps to tap into more potential audiences to truly achieve the objectives of popularisation and promotion. This is a fresh direction born out of the challenges presented by the pandemic.

As an extension of the Arts Festival's programmes, Festival PLUS activities are sometimes organised in community locations. Through a series of activities including guided tours, lectures and concerts, the artistic significances of these locations are rediscovered: "We look for appropriate venues and partners to link the history of a certain art form with local culture, resulting in programmes like "Opera Treasures of Yau Ma Tei" (2013), "Music & Church Tour" (2016) and "Pipe Organ Tour" (2019)."

Yau talked about opera being a complicated form of arts performance as it involves many aspects, including historical literature, libretto, music, costume and stage design. An example would be *Dream of the Red Chamber* (2017), co-produced by the Hong Kong Arts Festival and the San Francisco Opera, which Yau and her team explored from multiple perspectives including literature, music and historical background. In recent years, another big hit in Festival PLUS was the *Opera Adventure Day* series of programmes in collaboration with Welsh National Opera in 2018 and with Oper Leipzig in 2019, which was very well-received.

為了覆蓋不同年齡、興趣的觀眾層，游慧姿說他們會不斷構思，發掘不同的場地空間。如「醉人爵士樂」（2016），不是在大會堂，而是在一個酒吧近距離欣賞大師演奏爵士樂就最好不過！另一邊廂，「好！擊！動！」同樂日（2019），讓大小朋友一起參加，是家長和孩子共享天倫之樂與認識藝術的最佳時機，還有漢堡芭樂舞團《胡桃夾子》兒童工作坊（2019），讓小朋友又能玩樂、又能學到新知識。更有一些是歡迎全城參與的，如2017年《幻光動感池》及《聲光頌》的外展活動，走遍這個城市的不同角落，深入社區。

藝術的珍貴價值除了關乎創作空間和發表平台，也在於孕育及實踐過程中，所激發與人文社會相關的獨特理念和自由探索。在達至作品之前，創作團隊經歷漫長的創作過程——尋找表達載體、喚起表演者的共鳴、反覆琢磨、修訂創作藍圖、考量製作未來的實際情況等。因此，藝術節開設另外一個在牛棚藝術村實驗的「藝術共生創造社」計劃（2019），可說是藝術節探索新製作方向的嘗試。讓藝術家在創作過程中，透過公眾及業內人士參與的工作坊展現及互動討論，集思廣益，可以在正式演出前自我檢驗改良作品。藝術家與觀眾的互動參與，達至相輔相成。藝術節作為獨立製作人，希望在香港往往倉促的創作及製作環境裏，與藝術工作者共同經營、規劃及建設更理想的創作生態圈。

藝術節踏入五十周年，「加料節目」繼續透過不同活動，讓觀眾除了演出之外，有機會與藝術家互動接觸，令高質素的藝術表演能更緊扣觀眾的生活。一系列網上文藝活動，當中包括由藝術家和創作人主講的網上研討會、演前講座及網上互動展覽，為觀眾揭露作品的創作概念與演化歷程。而網上放映的紀錄片則讓觀眾猶如置身舞台帷幕之後，窺探一場高水準演出背後的籌備工作。此外，藝術節將呈獻一連串加料電影放映會，多角度追蹤國際知名藝術家的事業軌跡。✿

To attract audiences of different age ranges and interests, Yau and her team continue to think of new ideas and explore different venues. In *Gin & Jazz* (2016), for example, the audience can enjoy performances by jazz masters not in a concert hall but in the intimate setting of a bar, the natural habitat for jazz. At the same time, activities such as *P is for Percussion! Family Day* (2019) and Hamburg Ballet *The Nutcracker Introductory Class for Kids* (2019) allow children to have fun while acquiring new knowledge. Outreach programmes like *SUPER POOL* and *Chorus* in 2017 were staged all over Hong Kong and encouraged participation by everyone.

The value of the performing arts lies in more than just the final performance; the entire creative process stimulates new ideas and free exploration of society and humanity. Therefore, the Festival has started an experimental project "Creative Hub" (2019) which took place at Cattle Depot Artist Village. It can be described as the Arts Festival's attempt to explore directions in new work development. The project aims to optimise the creative process by enabling artists to have interactive discussions with the public and industry professionals through workshops and other activities. The endeavours create synergy and give artists space for self-reflection and improving their works efore the actual performance. For many years, the HKAF has served as a platform for developing, planning and commissioning new works. The Cattle Depot Creative Hub is an endeavor to optimise the creative process by enabling artists access to space and resources to invest their time and energy effectively at the earliest stages of new work development.

In this exceptional year, PLUS embraces the digital and continuously strives to connect, to share and to inspire through the arts. A hybrid line-up of online programmes, including webinars and pre-performance talks where audience can meet artists and creatives to discover the unique stories behind the works, an online exhibition with maps, illustrations and interactive elements, a series of online documentaries that grant audiences a backstage pass to exciting shows, and a selection of cinema screenings that immerse you in the work of world-renowned performers. ✿

作曲家兼鋼琴家柯拉德·尼芬與低音大提琴手雷森福於酒吧 Ping Pong 129
演奏「醉人爵士樂」

Belgian composer–pianist Jean–Philippe Collard–Neven and bassist Jean–Louis Rassinfosse
perform "Gin & Jazz" at Ping Pong 129 (2016)

漢堡芭蕾舞團獨舞員 Konstantin Tselikov 帶領的「漢堡芭蕾舞團《胡桃夾子》
兒童工作坊」

Hamburg Ballet soloist Konstantin Tselikov leads the workshop "Hamburg Ballet —
The Nutcracker Introductory Class for Kids" (2019)

擔任本地潛入式劇場劇團 Banana Effect《空影》製作顧問的英國離奇作業劇團藝術總監傑克·盧爾於「香港藝術＠牛棚 — 藝術共生創造社」計劃主持《蛙人》工作坊

As part of the "HKAF@Cattle Depot Creative Hub", curious directive's Artistic Director Jack Lowe, who serves as advisor for the research project *You are Absent and what does that mean?*
by local immersive theatre company Banana Effect, leads a workshop on *Frogman* (2019)

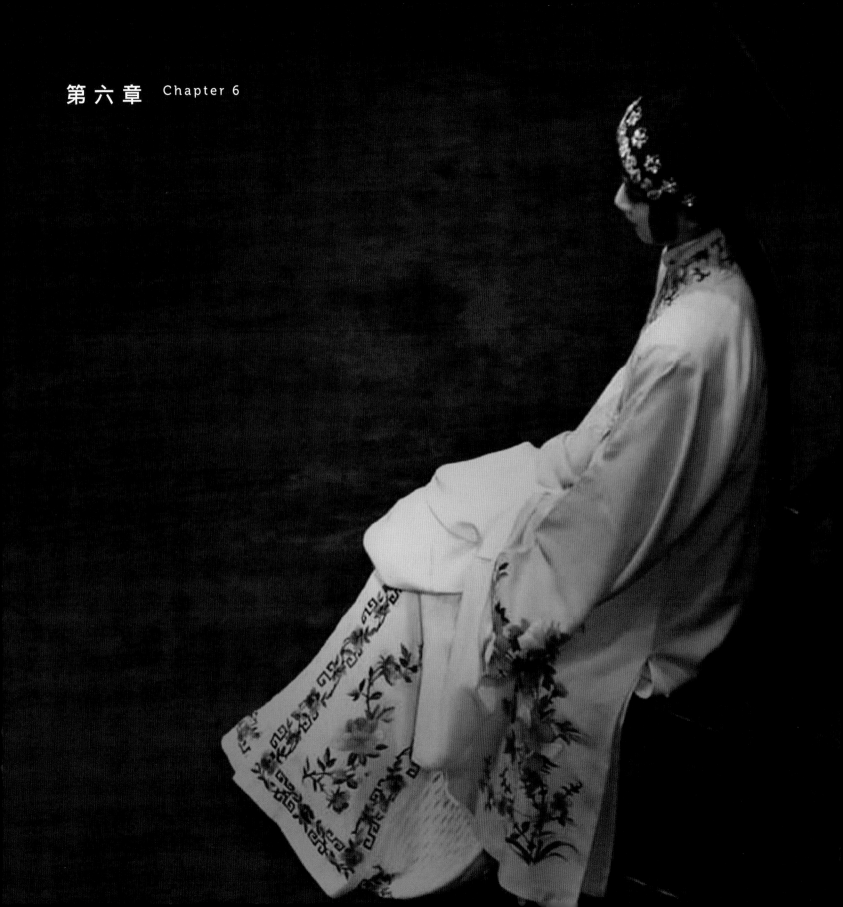

第 六 章　Chapter 6

與社會脈搏並肩
In Sync with the Pulse of Society

走過半世紀的香港藝術節，與香港一起經歷高低起跌，如何回應時代所需一直是重要的命題。

藝術節在上世紀七十年代創辦之初，當時的香港缺乏世界級的藝術文化節目，藝術節的誕生成功為香港打開了一個重要的窗口。到了八十年代，隨著香港經濟起飛，本地文化基礎建設陸續落成，藝術節亦已建立穩定的根基，更能跟隨香港社會發展穩步前進。從九十年代至今，面對香港回歸、科網泡沫、金融危機、世紀疫症等社會環境轉變，經濟結構轉型，以至千禧年代科技發展帶動嶄新消費模式，藝術節在節目編排、營運方針以至市場策略，一直緊貼時代脈搏，與香港並肩同行。

歷年各位主席、行政總監和資深員工，帶領藝術節跨越不同年代的挑戰，讓藝術發揮關注社會、回應社會的功能，繼續讓藝術節成為香港的年度國際盛事。

For the last 50 years, the HKAF has been a part of the life of the city, expressing and reflecting the spirit of the times, and it continues to do so. Indeed, responding to the times has always been a part of the Festival's identity.

During the early 1970s when the HKAF was founded, the city was not a major destination for visiting international artists. With the Festival providing a platform for performances, access to world-class performances by visiting artists was made available to many in the city. By the 1980s, Hong Kong's economy had taken off, leading to the establishment of a range of much-needed cultural venues. The Festival itself established a solid foundation and kept pace with the steady development of Hong Kong. Since the 1990s, Hong Kong's social environment underwent changes brought about by the reunification with China, the dotcom bubble, the Asian financial crisis and the Covid-19 pandemic, among others. The Festival's financial structure was also revamped as technological advances in the new millennium brought new models of consumption. The Festival has continually adapted to these changes.

The Festival's Chairpersons, Executive Directors and senior staff have been instrumental in guiding the HKAF through the challenges of different eras. The Festival continues to be an active participant in society and remains an annual flagship event of international calibre, central to Hong Kong's cultural life.

吳球 行政總監 (1994–2002)

回應市場，穩中求變

由首位華人舵手鄭新文接捧過來的吳球，於1994年出任行政總監。累積了在政府工作的經驗，吳球帶領藝術節經過1997年香港回歸的新里程，以至全球科網泡沫的大環境。

「九七前雖然面對移民潮，經濟不景，不過市場波動偶有發生，對藝術節的衝擊也不算很大，我們的對策主要是在市場推廣上加強應變措施面對。」

「藝術節的成功是群策群力的成果，有賴同事、執行委員會、政府、贊助商，當然還有觀眾的支持，一個都不能少。我在1994年加入香港藝術節，最初是跟主席鮑磊合作，他很平易近人，非常支持藝術節，每年也會在他石澳的大宅舉行午宴招待參與的藝術家。之後的主席梁紹榮夫人(Mona)曾經是婦女歡迎委員會的成員，不只對藝術節非常熟悉，也帶領我們應付不少困難。」

「還記得當年匯豐每年也會贊助開幕節目，可是某年卻考慮不再贊助，Mona 得悉後，帶我一起約見當時匯豐主席艾爾敦，最後成功說服他繼續支持。當時正值經濟不景，藝術節的財務入不敷支，而我們察覺到市場的變化，於是作出一些應變方法，把藝術節舉行的時間由四星期改至三星期，減少節目，這個情況為持了一兩年，穩定後才擴展回四星期。」

梁紹榮夫人(中)與加拿大歌劇團團員出席於鮑磊主席府邸舉行的午宴
Mrs Mona Leong (middle) with artists of Canadian Opera Company at a luncheon hosted at the residence of Chairman Martin Barrow (1996)

Ng Kau Executive Director (1994–2002)

Responding to the Market Seeking Changes While Maintaining Stability

Ng Kau was appointed Executive Director in 1994, succeeding Tseng Sun-man, who was the first Chinese leader of the Festival. Having cut his teeth in the government, Ng led the HKAF through major events including the 1997 reunification and the global dotcom bubble.

Ng recalls: "Although faced with the tide of emigration and economic downturn before 1997, the Festival was not gravely affected by occasional fluctuations in the market. Our approach was to strengthen our contingency measures in marketing."

"The Festival's success is based on the concerted and dedicated efforts by multiple parties including the staff, the Executive Committee, the government and sponsors, all of whom were essential. Another critical factor is, of course, support from the public."

Upon joining the Festival in 1994, Ng initially worked with the then Chairman Martin Barrow, of whom he speaks highly. "He was approachable and highly supportive of the Festival and would hold luncheons for the artists at his house in Shek O every year. Mrs Mona Leong, the subsequent Chairperson, was a member of the Ladies Hospitality Committee. She was familiar with the Festival, and also led us through a fair number of challenges."

Mona Leong was instrumental in convincing one of the Festival's main sponsors to stay on board at a critical juncture.

"HSBC used to sponsor the opening programme every year, but considered not sponsoring in a certain year," says Ng. "After Mona learned about the situation, I went with her to meet the then HSBC Chairman David Eldon, whom she persuaded to continue the bank's support. The economy was gloomy at the time and the Festival's revenue fell short of its expenditure. As we noticed changes in the market, we made some contingency measures, including shortening the Festival from four to three weeks and reducing the number of programmes. The arrangement lasted for a year or two, and the Festival returned to four weeks when things improved."

Marketing is an important part of an arts festival, and the ease of buying tickets has a direct effect on the box office. "To make it easier for the public to purchase tickets, we made an important change to the ticketing system," says Ng. "There were two ticketing systems

市場推廣是籌劃一個藝術節的要務，觀眾的購票經驗，也會影響票房的成果。「為了方便觀眾購票，我們在售票系統上作出重要的改變，當時市面上有兩個售票系統，分別是出售政府康文署場地節目門票的『城市電腦售票網 (Urbtix)』，和香港藝術中心及香港演藝學院的『快達票 (Ticketek，現名為 Hong Kong Ticketing)』。經過多番協商後，我們成功打通兩個系統，讓觀眾從一個票站便可購買所有場地的門票。當藝術節門票開售時，Urbtix 把終端機搬到 Ticketek 的系統，也將經 Ticketek 售票的部份節目門票分配到 Urbtix。其實這是把藝術節的觀眾也帶到藝術中心和演藝學院，造成了雙贏局面。」

「另外當時我們開始了傳真和電郵預售門票。在此特別多謝負責票務的同事，每年也要花很多晚通宵，不眠不休，因為時間緊迫，必須先處理好預售門票，才能作公開售票。」

「當然節目部的同事也努力帶來更多不同類型的節目，好像1995至1997年間，當時節目部同事劉振強帶來非常出色的中國節目，1996年《古琴會友》、一票難求的《大紅燈籠高高掛》，最特別的還有北京民間搖滾。另外，為了拓展觀眾層，又邀請流行歌手與本地劇團參與，1997年《黃耀明人山人海演唱會》、1998年《陳奕迅 — 我的快樂時代音樂會》、1999年《一個戀人的獨白 — 戀講戀唱潘源良》、2000 年蔡琴的《花天走地》等等。這些演出到今天回想起來還是深刻難忘。香港藝術節的特色，正是把外國、中國內地和香港節目共冶一爐，正如香港這個城市一樣，所以藝術節的確是很貼切地代表了香港。」

吳球（右一）出席第28屆香港藝術節閉幕典禮
Kau Ng （1st right) at the 28th HKAF Finale (2000)

at the time. One was Urbtix, which sold tickets for programmes at government-run LCSD venues, and the other was Ticketek (renamed as Hong Kong Ticketing), which handled tickets for programmes at the Hong Kong Arts Centre (HKAC) and the Hong Kong Academy for Performing Arts (HKAPA)."

"After a few rounds of negotiations, the two systems were linked up, allowing tickets for all venues to be bought at the same counter. Ng describes it as a "win-win situation" as it introduced new Festival audiences to the HKAC and the HKAPA."

"We also started to allow advance booking through fax and email," adds Ng. "I am especially grateful for our ticketing staff who worked overnight for many nights each year. The timing was tight because public ticket sales could only begin after all advance bookings were processed."

Ng also recalls how the Festival's Programme Department helped bring more diversity to the programme line-up. "From 1995 to 1997, Lau Chun-keung at the Programme Department introduced many outstanding programmes from Mainland China, including *Guqin Recital* in 1996, the hit programme *Raise the Red Lantern* and the special music genre of Beijing folk rock. To expand our audience reach, we also invited pop singers and local theatre groups to collaborate which resulted in works including *Anthony Wong Sings People Mountain People Sea* in 1997, *Happy Days – Eason Chan in Concert* in 1998, *A Lover's Discourse by Calvin Poon* in 1999 and *Walking with Wings*, featuring Cai Qin in 2000. These performances remain memorable events. One thing unique about the HKAF is how it mirrors the city of Hong Kong by featuring programmes from Mainland China, Hong Kong and the world at large. The Festival is truly emblematic of Hong Kong."

鄭尚榮與《金蘭姊妹》演員劉雅麗 (右二)、蘇玉華 (左一) 和彭杏英 (右一)
Katy Cheng and the cast of *The Amahs*—Alice Lau (2nd right), Louisa So (1st left) and
Pang Hang–ying (1st right) (2015)

鄭尚榮　市場總監 （1995-）

鞏固並拓展觀眾群

鄭尚榮 (Katy) 於1995年加入香港藝術節，在這之前，她一直在商界工作，順理成章把商界的經營模式引入藝術節。市場營銷的本質，是價值的創造並以創意方式傳達，凸顯當中不凡之處。Katy 深明此道，二十多年來一直以提升目標觀眾滿意度出發，懂得快速回應大環境轉變，而且與時並進，緊貼數碼營銷趨勢。

預售門票　發揮優勢

Katy 上任的首要任務是處理預售門票的去留。基於當時的生活模式和節奏，大眾對演出前四個月預先訂票的接受程度減退，一般都傾向臨近演出或者演出當日才購票，這種趨勢令藝術節執行委員會有意取消預售門票，並推出即日減價速購門票的計劃，以達至滿座的目標。其實在那個年代，只有藝術節和香港國際電影節的節目才可以透過時稱「城市電腦售票網」作預售門票，Katy 認為不應放棄這項優勢，反而更要加強「預售門票」計劃的吸引力，於是遊說委員會保留預售策略。多年來經過不斷的創新及優化，至今藝術節每年在「預售門票」期間皆售出 50% 的門票，成效有目共睹。

Katy Cheng　Marketing Director　(1995 -)

Building and Expanding the Audience Base

Katy Cheng joined the HKAF in 1995. Having previously worked in the business sector, she introduced the new and more commercially inclined operating models to the Festival. The aim of marketing, by its nature, is to create value and to reach the market through innovative measures. A seasoned professional, for a quarter of a century, Cheng has been dedicated to continually improving the Festival's experience for target audiences, quickly responding to changes in society, the market and the commercial environment, and keeping pace with trends in digital marketing.

Making the Most of Advance Booking

Cheng's top priority when she first joined the HKAF was to make a decision on advance booking. Changing lifestyles and the increased pace of people's lives meant the public were becoming less receptive to booking tickets four months ahead of a performance. Indeed, it was becoming more likely that they would buy their tickets close to the date, or even on the day itself. This trend led the Executive Committee to consider cancelling advance booking altogether while introducing same-day discount tickets to maximise attendances. Advance booking at the time was only available through Urbtix for programmes presented by the HKAF and the Hong Kong International Film Festival. Yet, Cheng believed it would be

就此 Katy 認為：「我們要改變策略，主動去接觸觀眾。首先，是提早通知觀眾有甚麼精采節目訊息。藝術節以往的宣傳方式，是於每年 10 月的記者會當天才公布來屆節目詳情，在此之前一切消息保密，即使是媒體也無從得悉任何資訊。雖然這個做法能營造神秘感，但正因為沒有提早給予觀眾足夠的節目資訊，而未能吸引他們購買預售門票。為了營造『四個月前要來搶票』的氣氛，我和團隊決定在開始『預售門票』前，預先在 7 至 8 月份發放有關來年藝術節的消息。我們甚至於藝術節節目場刊內，預告部份來屆節目，把握機會率先跟觀眾溝通，鼓勵觀眾在『預售門票』期間搶票。」

除了推出精采的節目預告，Katy 認為也要提供足夠的誘因，才能吸引觀眾預先訂票。「首先是增加預售折扣，最高可達八五折。此舉是為了鼓勵觀眾與親友一同購票，既有助門票銷售，同時擴充藝術節的觀眾群，亦能營造『藝術節』的節慶氣氛。我們更附送飲品券，讓觀眾演出前後或中場休息時，可以拿著飲品傾談。針對 1997 年移民潮，一班核心觀眾的流失，加上隨後的經濟衰退，我們便因應推出信用卡免息分期購票去吸引觀眾，這個計劃一直沿用至今。」

Katy 指出「預售門票」有助掌握各個節目的銷情，因而可以隨即作出相應的資源調配，加強宣傳。「首先我們絕對信任節目部同事所選擇或製作的節目，而我們市場營銷部的任務，是要吸引觀眾入場。」

a mistake to give this up and that it would be better to make advance booking more attractive instead. So she persuaded the Committee to keep the service, and after a few years of innovation and improvement, ticket sales during the advance booking period accounted for up to 50 per cent of the annual total.

"We needed to change our strategy and take the initiative to contact the public," Cheng says. "First of all, we informed them of our exciting programmes in advance, revealing highlights of the programme line up as early as possible. The Festival used to announce upcoming programmes in a press conference in October, with the information kept under wraps beforehand, even from the media. Although this approach might have piqued people's interest by creating a sense of mystery, the public was not given enough information about the programmes to consider booking in advance. To create a greater sense of anticipation, of 'scrambling for tickets four months in advance', my team and I decided to release updates on the coming year's Festival from July to August, before the advance booking period. In the house programmes, we even provided previews of some of the following year's programmes. By seizing the opportunity to communicate with the public, we encouraged them to purchase tickets during the advance booking period."

In addition to launching exciting previews for the programmes, Cheng also felt there should be sufficient incentives for the audience to consider advance booking: "First, we offer additional discounts for advance bookings. These could be as high as 15 per cent, to encourage people to buy tickets along with friends and family. This helped expand the Festival's audience base and cultivated a festive atmosphere. We even included drink coupons so they could enjoy a drink either before the performance or during the intermission to add to the social aspect of the Festival. The tide of emigration in 1997 led to a reduced core audience. With the subsequent economic decline, we launched the interest-free instalment plan to attract audiences and the plan has been with us ever since."

For Cheng, advance booking shows sales trends for each programme, so that marketing resources can be used where most needed. "First of all, we have complete faith in the programmes selected or produced by colleagues in the Programme department. The task in Marketing is to attract the audience."

革新科技 領先手法

掌握不斷革新的科技，與時並進，更是現代市場營銷的要訣。「在互聯網還未普及時，為了讓觀眾足不出戶也可以買票，我們於 1996 年推出了『傳真資訊 (fax-on-demand)』。」當年藝術節亦同步計劃建立官方網站，並於 1997 年推出電郵購票。「猶記得推出第一年，便收到二百個電郵購票！我們是第一個推出手機應用程式的藝術機構，這個手機應用程式更成功贏取 2011 年香港資訊及通訊科技獎金獎。」

另一創舉例子，是運用當時的新興科技——擴增實境 (Augmented Reality，簡稱 AR)，在平面廣告，如地鐵海報、報章廣告等印上 AR 符號，去宣傳 2010 年的薩頂頂演唱會。結果，嶄新科技揉合陌生的場地（現時的九龍灣國際展貿中心）、獨特的藝術家，拓展了新的觀眾層。對藝術節成為香港第一個運用 AR 作宣傳的藝術機構，Katy 引以為榮。

認識觀眾群

藝術節每年都帶來不少精采節目，除了鞏固核心觀眾，Katy 也明白開發新觀眾群的重要，所以定價方面一直保留最低票價的門檻，不會錯過任何觀眾。「我們要找出觀眾不買票的原因。例如從前的英語劇場沒有字幕，有時甚至因為口音問題，即使母語是英語的觀眾也聽不明白。那如何吸引觀眾入場呢？於是自 2003 年開始，我們便為英語劇場加設中英文字幕。」

語言的挑戰也可以是另一層面。Katy 記起 2001 年的藝術節開幕節目——由洛杉磯歌劇院聯合製作的《仙鈿奇緣》，預售情竟然大失所望。「原來大家讀不懂那意大利文劇名《La Cenerentola!》，於是我們立即改用英文名《Cinderella》。此外，因為其中一場在情人節當天演出，我們以『星空下的戀情』這句標語，成功吸引到一群新觀眾入場。當中一些人更因此認識了藝術節，並從此成為歌劇表演的固定觀眾。」

New Technology, New Tools

A firm grasp of ever-evolving technology and keeping pace with the times are also important to Cheng. "Before the internet became popular, we launched 'fax-on-demand' in 1996 so the public could buy tickets from the comfort of their homes." The Festival's official website was also established at that time, and ticket sales by email became available in 1997. "In the first year, we received 200 emails for ticket purchases!" says Cheng. "We were the first arts organisation to launch a mobile application, and the iPhone app won Best Lifestyle (Social Community) Gold Award at the Hong Kong ICT Awards 2011."

Another first was the use of AR (Augmented Reality) integrated into print advertisements and embedded in subway posters to promote Sa Dingding's concerts in 2010 at what is now KITEC in Kowloon Bay. The combination of this unique artist, the unusual venue and innovative communication resulted in sold-out concerts and bringing a new audience to the Festival. Cheng is proud that the Festival was the first arts organisation in Hong Kong to use AR for promotions."

Understanding the Audience

Although the Festival has a core audience which looks forward to the exciting programmes presented every year, Cheng also understands the importance of reaching new audiences, and the Festival has maintained a cap on the lowest ticket prices to provide a low entry point for those who are not yet ready to make a larger commitment. "We always try to find out why tickets didn't sell. For example, subtitles used not to be available for dramas in English. Even native English-speakers might find some accents difficult to understand and following things hard. From 2003, Chinese and English subtitles became available for theatre productions, including works in Chinese and in English." This was to make the performances more easily accessible to a broader spectrum of audiences, she explains.

Language can be a challenge in other ways. Cheng recalls that the opening programme of the Festival in 2001, *La Cenerentola*, co-produced by the Los Angeles Opera was seriously under-performing at the box office during advance bookings, and it turned out that Italian name was an impediment. "So we decided to use the English *Cinderella*; and as one of the performances was on Valentine's Day, we focussed on the romance of the work and drew new audiences, some of whom got to know more about the Festival and became regulars at opera performances."

《蘇絲黃的美麗新世界》香港演藝學院外牆的大型廣告
Large advertisement on Hong Kong Academy for Performing Arts' facade for *A Brave New World of Suzie Wong* (2001)

Another programme the same year was the dance theatre *A Brave New World of Suzie Wong*, produced by Yuri Ng and Michael Lam with Eason Chan as guest performer. Surprisingly, ticket sales during advance booking were sluggish. Cheng had a whimsical idea. "Yuri Ng told me that Eason Chan in the show played a storyteller on a mission to look for the fictitious character Suzie Wong, through an emotional journey marked by both laughter and tears. So we launched the slogan 'Eason Chan weeps!' with large ads placed on Gloucester Road. It had an immediate effect, and the programme was a box-office success. Though the marketing focused on a celebrity, it was respectful of the programme itself."

Then came Jane Birkin's concert *Arabesque* in 2004, for which ticket sales during advance booking were below expectations. "Although the Hermès bag named after her is a highly coveted product, not many Hong Kong people were familiar with Jane Birkin herself," Cheng says. "I decided to place ads in MTR stations in luxury shopping districts, with the slogan 'Birkin, the inspiration behind the bag, live in Hong Kong'. We ended up drawing many handbag lovers to the performance!"

Cheng recalls promoting *Edward II* by the Birmingham Royal Ballet in 2000: "Traditional ballet programmes are usually popular for families. However, given the subject matter, there were some fairly explicit scenes not suitable for children. So 'for adults only' was specified in the ads. The show then attracted new audiences who were only starting to find out about the Festival. And, as the programme involved issues of interest to minorities, the show ushered in new regular audiences drawn by the subject matter."

同年，伍宇烈和邁克合作的舞蹈劇場《蘇絲黃的美麗新世界》，邀請陳奕迅坐陣參與演出，未料最初預售也不理想。Katy 忽發奇想：「伍宇烈告訴我陳奕迅擔任說書人角色，尋尋覓覓傳說中的蘇絲黃，情感表達有笑有淚。於是我們便創作了『陳奕迅哭了！』這句『吸睛』標語，在告士打道外牆掛上大型廣告，效果立竿見影，票房成功達標。市場推廣雖然是以明星作賣點，但沒有和節目相違。」

然後是 2004 年珍·寶金（Jane Birkin）的音樂會《Arabesque》，預售情況亦未如理想。「雖然以她命名的名牌手袋 Birkin Bag 叫人趨之若鶩，但 Jane Birkin 本人卻不是那麼為港人熟悉。於是我在名店集中地區的地鐵站賣廣告，明言：『Birkin 手袋名字主人，真身演繹，潮流魅力，Live in Hong Kong』。結果成功吸引一眾『手袋黨』太太們入場！」

Katy 想起 2000 年推廣伯明翰皇家芭蕾舞團《愛德華二世》的經歷：「雖然傳統芭蕾舞節目向來很受家庭歡迎，不過當中有比較露骨的場面，屬兒童不宜。於是我在廣告中註明是『adults only』，結果吸引了一批新的觀眾，他們更因而認識了藝術節。此外，由於這次的內容牽涉小眾議題，自此亦為藝術節帶來對此題材感興趣的新常客。」

《Arabesque》節目海報 Poster of *Arabesque* (2004)

高德禮(左)出席鳴謝晚宴
Douglas Gautier (left) at Sponsors Thank-you Dinner (2000)

高德禮 行政總監 (2002-2006)

藝術與市場並重

「當我在香港電台第四台工作時，已常常期盼在香港藝術節工作，幾年後我終於夢想成真。人生很好玩吧，對嗎？」

高德禮 (Douglas Gautier) 跟香港藝術節的緣份從他來到香港那一刻已開始。他曾任節目委員會成員，歌劇監製，直至2002年正式加入成為行政總監。從香港電台、STAR TV、旅遊發展局，再到香港藝術節，高德禮把媒體及旅遊業的經驗帶到藝術節，在藝術與市場兩方面取得平衡，令藝術節保持為香港的重要文化資產，香港一年一度的盛會，是香港作為國際城市不可或缺的重要部份。今天高德禮在澳洲阿德萊繼續推動藝術文化，把香港的經驗帶到南半球，與亞洲各個城市以藝術結連。

當初你為何來香港？可否分享一下你由何時開始與香港藝術節結緣？

我之前在BBC倫敦工作，於1979年底被聘任為香港電台第四台台長，在香港電台任職的六年，也積極參與香港的藝術活動，尤其是香港藝術節。當時我是節目委員會成員，與其他成員合作無間，特別是史達敦及潘恩，我們關係最緊密。在藝術節工作時也執導過歌劇《士兵的故事》(1980)、《秘婚》(1983)、《女人心》(1984)，全部均由香港電台及香港藝術節聯手製作。我來自阿德萊德和倫敦，能參與香港藝術節這個備受尊崇的藝術節，實在是很美好的體驗。

Douglas Gautier Executive Director (2002-2006)
Emphasis on Both the Arts and the Market

"When I was at Radio 4, I always wanted to work in the Arts Festival and my wish came true years later. Life is fun, isn't it?"

Douglas Gautier's connection with the HKAF started from the moment he arrived in Hong Kong. He was a member of the Programme Committee and an opera producer before joining the Festival as Executive Director in 2002. Having held posts at RTHK, STAR TV and the Hong Kong Tourism Board, Gautier brought his wealth of experience in media and tourism to the HKAF. He struck a balance between artistic and marketing considerations and focussed on maintaining the Festival's position as a significant annual event in Hong Kong's cultural heritage, and an essential component of what makes Hong Kong an international city. Gautier continues to promote arts and culture in Adelaide, Australia. He has brought his Hong Kong experience to the Southern Hemisphere and continues making cultural connections with other Asian cities.

What brought you to Hong Kong and how did you get involved in the HKAF?

I was working at the BBC in London and was then offered a contract to Radio Television Hong Kong in late 1979 as the Channel Head of RTHK 4. I spent six years at RTHK and at the time I was pretty much involved in the Hong Kong art scene, especially with the HKAF. I was in the Programme Committee and had a close relationship with the Committee members, especially Keith Statham and John Pain. I directed *The Soldier's Tale* in 1980, *The Secret Marriage* in 1983 and *Così fan tutte* in 1984, which were jointly produced by RTHK and the Arts Festival. Coming from Adelaide and London, it was very wonderful to be actively involved in such a prestigious festival in Hong Kong.

Can you share your experience of working with Keith Statham, the Executive Director of HKAF in the early 1980s?

Keith was a wonderful man and had tremendous knowledge of music. We always worked together to look at the repertoire and do planning together. He had a house on Lamma Island. We'd often get together on weekends to listen to music and hang out. I remember those days when I lived in the Old Victoria Barracks. One time there was a typhoon and he couldn't get back to Lamma. So he stayed at my home for a few days, drinking beer and listening to music. They were great times.

可否分享一下八十年代初期你和香港藝術節行政總監史達敦合作的經驗？

史達敦非常出色，而且對音樂的認識相當淵博。我們不時一起檢視曲目及策劃，他家住南丫島，我們會在那裡度周末，聽聽音樂放鬆心情。還記得那時我住在金鐘，有次刮颱風他無法返回南丫島，就在我家住了數天，喝喝啤酒聽聽音樂，留下不少美好回憶。

我們更曾為藝術節並肩合作。記得 1982 年上演格魯克的歌劇《中國人》，這部作品已多年沒公演過，我們終能將其搬上舞台。另外，演出《女人心》時，我們發現壽臣劇院場地面積較小，在場景佈置方面有一定難度。我和史達敦一直保持聯絡，直至他在紐西蘭逝世。當年香港很多機構不時聯手製作演出，包括香港電台、香港藝術中心、香港藝術節，以及新成立的香港演藝學院，香港藝術界可謂十分蓬勃，大家都充滿活力，對我來說是一段十分精采的時期。

當你成為香港藝術節行政總監後，曾與梁紹榮夫人及李業廣兩屆主席共事，可否分享和他們合作的有趣點滴？

梁紹榮夫人就像母親般的體貼，對每個人都關懷備至。她善於和政府相關部門商談，也是一位很慷慨的贊助人。

李業廣是我職業生涯中最喜歡的主席，不論與政府部門或贊助商商談，他都展現了長袖善舞的非凡能力。他擅於處理人際關係，

梁紹榮夫人（中）、吳球（右一）與莫斯科塔干卡劇團《薩德侯爵》導演尤里·柳比莫夫（右二）等出席主席午宴
Mrs Mona Leong (centre), Ng Kau (first right) and Yuri Lyubimov (Director of Moscow Taganka Theatre – *Marat & Marquis de Sade*, second right) at Chairman's Lunch (2002)

And we did work together closely for the Arts Festival. I remember Gluck's opera *Le Cinesi* in 1982. It hasn't been performed in many years and we made it happen. Hong Kong is a place where we can try to do everything. We also did *Così fan tutte*, and it was very difficult to get the set to fit in the Shouson Theatre as the venue was quite small. We stayed in close touch until he passed away in New Zealand. I think at that time there were lots of collaborations: RTHK, the Arts Centre, the Arts Festival and the newly established Academy for Performing Arts. There were lots of things happening and people with energy, a very positive period.

When you became the Executive Director of the HKAF, you served under two chairpersons, i.e., Mrs Mona Leong and Charles Lee. Can you recall any interesting memories with them?

Mona was quite maternal and was concerned about everybody. She was very helpful in terms of dealing with the government and a generous benefactor.

Charles Lee was by far among all jobs I did, my favourite Chair. He is a wonderful and remarkable man on all levels, no matter whether he was dealing with the government or sponsors. I always admired how he dealt with people. There is always something I can learn from him. We remained close after I left. Whenever I came back to Hong Kong, we'd always have lunch together. I am a great fan of Charles.

We talked a lot about what the Festival can be. He strongly believed the Arts Festival was prestigious in Asia and supported us in setting up the Asia Pacific Arts Association. He always thinks big and did everything to make the Festival an asset of Hong Kong as an international city.

You were a member of the Programme Committee long before you became the Executive Director. Can you recall any experience of working with the Committee?

We had a very distinguished programme committee, with Lo King-man and David Gwilt, all with extensive music knowledge. We did have robust discussions on the Committee but ones which were quite useful and I enjoyed them. Though it is an advisory committee, unless something is extremely expensive or logistically difficult, the Committee's proposals would generally be accepted.

令我十分欽佩，在很多事上讓我獲益良多。我仍和他保持緊密聯絡，每次來香港也會一起共進午餐。我非常欣賞李業廣。

我們不時談及對一個藝術節的可能性，他深信香港藝術節在亞洲備受推崇，並支持我們成立亞太藝術協會。他目光遠大，致力讓香港藝術節成為香港這座國際都會的瑰寶。

你擔任行政總監前，早已是節目委員會成員。可否分享一下你在委員會的經驗？

節目委員會精英雲集，成員包括盧景文、紀大衛等，他們的音樂知識均相當淵博。而委員會成員之間都有不少激烈討論，我也很享受這些有建設性的討論。雖然節目委員會只是諮詢性質，但提出的建議通常都會被採納，除非建議的節目成本高昂或在執行上存在困難。

你現在是阿德萊德慶典中心的主席及藝術總監，有從香港藝術節的工作經驗中借鏡嗎？

當然有，香港藝術節『青少年之友』計劃辦得有聲有色，參加人數眾多。我在阿德萊德也開展了類似項目，不過規模較小。過往十年間，澳洲和亞洲文化交流頻繁緊密，當中香港擔任重要角色，我們多年來經常和香港藝術家合作，並從香港招募了不少實習生。香港對我來說仍然十分重要，我在過往四至五年擔任亞太表演藝術中心協會主席，也見證著彼此之間不斷加強合作。

對你來說，香港藝術節獨特之處是什麼？

香港藝術節多年來享負盛名，雖然香港是華人城市，但對國際的影響兼容並蓄。藝術節一直獲得觀眾、政府及商界支持，透過「青少年之友」計劃連繫年輕一代，藝術節已被公認為亞太地區的國際盛事。

香港藝術節是我們口中所指的旗艦盛事，在一年裡的特定期間舉行，而非全年活動。過去三十年來，香港藝術節透過「青少年之友」計劃發掘年輕觀眾，推出愈來愈多具實驗性的作品，不斷致力突破框框，與時並進，而且更開放包容。

梁紹榮先生夫人出席第28屆香港藝術節閉幕典禮
Mr Sydney and Mrs Mona Leong at the 28th HKAF Festival Finale (2000)

You are now the CEO & Artistic Director of Adelaide Festival Centre, is there any good experience that you have brought with you from the HKAF?

Yes, indeed. The "Young Friends" scheme is very impressive and has a remarkable number of participants. I have initiated similar things in Adelaide on a smaller scale. For the last ten years, Australia has had a strong cultural connection with Asia. Among all, Hong Kong is a major player. We always work with Hong Kong artists and over the years we have recruited lots of interns from Hong Kong. Hong Kong remains very important to me. I chaired the Association of Asia Pacific Performing Arts Centres over the last four to five years and I see the growth of co-operation with each other.

What is the uniqueness of the HKAF to you?

It has had a great reputation for many, many years and though Hong Kong is a Chinese city, it embraces international influences in an open way. It has been supported by audiences, by the government, and the business community. It connects to the young people through the "Young Friends" scheme. It has a strong reputation as an international event in Asia Pacific.

The Festival is what we call a marquee event–not all year round but for a particular period of events. For the last 30 years, they have been refreshing the audience through the "Young Friends". They have more experimental work and are always trying to push boundaries. It has certainly changed over time and is much more open.

李業廣　香港藝術節主席 (2003–2012)

開拓資源 培育新進

「我是藝術節的常客，每一年也會『撲飛』，知名樂團的音樂會、歌劇，還有京劇都不會錯過。所以當我有機會出任藝術節的主席，自然是義不容辭，帶著興奮的心情加入這個團隊。當然最重要的原因，是體會和明白到藝術節對香港這個國際大都會城市的重要性。」

曾經擔任香港交易及結算所有限公司主席多年的李業廣，每天也跟來自世界各地的金融專才接觸，經常跟他們閒談在香港的生活狀況，他們特別提到，要提升在香港的生活質素，必須要有世界級的藝術表演，所以藝術節對香港的貢獻實在很大。

2003 年末加入的時候，藝術節已經舉辦了三十一屆，無疑是香港一個重要的品牌，基礎很穩固，而發展下去需要更多的資源去深化整個藝術節。

「還記得 2008 年的金融海嘯，對我們尋找贊助方面也有影響。剎那間所有美資銀行的贊助消失了，頓時需要努力開拓新的市場，尋找不同的合作夥伴。」

其實，在營運模式及資源比例上，一直是藝術節面對的挑戰。「每年我們都要努力維持政府的資助，並且透過自己的票房及籌款達到收支平衡。不過，若然藝術節能夠透過籌款及市場營銷取得盈餘，歸入儲備，那麼，我們便可以開展一些較長遠的計劃，例如和大型海外藝團的合作、委約新作品及自家創作，這些籌備工作往往要橫跨幾屆。」

「於是，我們曾委託顧問進行了一個研究，比較亞洲及歐洲接近十個不同藝術節的運作，得出一些數據例證，如就政府的資助方面，香港跟其他藝術節相比是少的。我們把資料呈交給政府，反應很正面，其後政府增撥了資助，讓我們可以多走一步，落實想推進的計劃。香港賽馬會慈善信託基金也在 2008 年起，採行一個有遠見的資助模式，每年確保支持藝術節的『三大』演出。」

此外，藝術節在短短一個多月內有百多個節目，最高紀錄是一天有十多場演出之多，有觀眾反饋疲於奔命。「於是我們作了一個

Charles Lee　Chairman of HKAF (2003–2012)

Pioneering Resources while Cultivating New Talents

Charles Lee recalls: "I often attended the HKAF's programmes and would scramble for tickets every year. Performances by well-known orchestras, operas and Peking operas were not to be missed. So I gladly took up the opportunity to be the Festival's Chairman and joined the Festival team with excitement. The important underlying reason is, of course, the Festival's importance to Hong Kong as an international metropolis."

As the Chairman of Hong Kong Exchanges and Clearing Limited for many years, Lee maintained contact with finance professionals from all over the world daily. When chatting about their lives in Hong Kong, these professionals especially mentioned world-class arts performances being a critical factor in the high quality of living in Hong Kong. So the Festival's contributions to Hong Kong cannot be overstated.

By the time Lee joined the HKAF in late 2003, the Festival already had 31 editions under its belt. It had become an important Hong Kong brand with a solid foundation. To sustain the Festival's further development through in-depth enhancements, more resources were required.

Lee recalls: "The financial tsunami in 2008 had a big impact on our search for sponsors. All sponsorship from American banks fell through in one go, and we had to work hard without delay to look for new market opportunities and partners."

The Festival's operating model and allocation of resources had in fact been an ongoing challenge. "We strove to maintain the same level of government funding every year," says Lee. "As well as box office revenue and funds raised, the goal was to cover the Festival's expenditure. However, if the Festival could register a surplus and accumulate reserves through fundraising efforts and ticket sales, we could realise various long-term plans such as collaborations with major overseas arts groups, commission new works and have our own productions. Planning for these initiatives often spans several editions of the Festival."

"As a result, we commissioned a consultancy to conduct a study of the operations of around ten arts festivals in Asia and Europe, and collected data for reference. For example, the proportion of arts festival funding by the government was smaller in Hong Kong by comparison. We submitted the findings to the government and

李業廣出席第40屆香港藝術節記者會
Charles Lee at the 40th HKAF press conference (2012)

研究，看看藝術節能否一年舉辦兩次，即春季、秋季各一。結果，礙於資源的考慮唯有擱置。」

談到培育本地藝術人才方面，李業廣說道：「藝術節多年來也以培養年青一代藝術家為宗旨。香港有很多有才華的年青藝術家，但卻因為資源問題，欠缺演出機會，政府在這方面的支援並不足夠，藝術節便填補了這個空缺，擔當了孵化器的角色，多年來支持了不少年青藝術家的新創作。好像2002-2011年推出的『埃克森美孚新視野』(1998-2001年名為『埃克森能源新視野』)，我們也於2012年成立了 香港賽馬會當代舞蹈平台，從策劃、製作、推廣、宣傳到外展教育，全面照顧本地年輕藝術家的創作需要，讓他們在更理想的環境中專注發展新作品。」

「我相信藝術教育的重要性，所以加強了『青少年之友』計劃的發展。這個計劃是藝術節特別為培育年青人對藝術的興趣和認識而設立，除了提供觀賞藝術節演出和參與各種活動的機會，每屆都會招募青少年之友做義工，並挑選部份資深會員，協助藝術節的現場活動安排。我記得青少年之友還會擔任記者，報道藝術節的活動如記者招待會，和訪問藝術家。相信這些實戰經驗，對這班年青人無論日後從事藝術工作或培養藝術興趣，會有深遠的影響。」

當然在節目上，除了要保持水準，同時也需要新嘗試。「其中一個有趣的嘗試，是2009年《王健@IFC55空中演繹巴赫組曲》，中國大提琴家王健在國際金融中心五十五樓演奏，我想很多樂迷也沒想像過，可以在雲端上的金融管理局聽古典音樂。還有2011年的委約及聯合製作作品，跨媒體創新京劇《水滸108 ──忠義堂》，更是港、台、滬三地合作，特別記得吳興國導與演，

the response was highly positive. Subsequently, the government increased our funding and allowed us to get one step closer to implementing our plans. From 2008, The Hong Kong Jockey Club Charities Trust also adopted a more visionary funding approach and pledged to support the Festival's 'three pillars' performances."

With the Festival presenting more than 100 programmes in just over a month, with a record-high of more than ten performances in one day, audience feedback suggested many were overwhelmed by the schedule. "So we conducted a feasibility study on the Festival being held twice in a year, during Spring and Autumn. Due to constraints in resources, however, this idea was shelved."

On cultivating local talent, Lee says: "Over the years, the Festival had been committed to nurture new generations of talent. Moreover, there are many young talents who lack opportunities to perform because of constraints in resources. As government support in this area was inadequate, the Festival filled the gap by playing the role of incubator. Over the years, we supported many new works by young artists. From 1998 to 2001, for example, we presented 'Exxon Vision' (renamed 'ExxonMobil Vision' from 2002 to 2011). In 2012, we also established The Hong Kong Jockey Club Contemporary Dance Series which includes curation, production, promotion, publicity and dance education. By fully addressing the creative needs of local young artists, they can be focused on developing new works in a more ideal environment."

"I believe in the importance of arts education so I strengthened the development of 'Young Friends'. The scheme is established to nurture young students' interest in and understanding of the arts. In addition to offering its members the opportunity to attend the Festival's programmes and various activities, volunteers are recruited with some senior members selected to assist in event arrangements. 'Young Friends' members also worked as reporters to cover the HKAF's events including press conferences and interviews with artists. These practical experiences will likely have a lasting influences for the young people when they work as arts practitioners or continue their passion for the arts in the future."

While maintaining the calibre of the programmes, it was just as important to venture into new artistic territory. Lee recalls: "An interesting attempt was *Wang Jian plays Bach @ IFC55* in 2009, with Chinese cellist Wang Jian performing on the 55th floor of the International Finance Centre. Many music fans probably never imagined they might enjoy classical music up in the clouds at the Hong Kong Monetary Authority. In 2011, there was the innovative cross-disciplinary Peking opera *108 Heroes, Tales from the Water*

《京劇名家匯演 —— 京劇彩唱及折子戲》節目場刊封面
House programme cover of *Beijing Opera Extravaganza* (2009)

令我大開眼界。而2009年的《京劇名家匯演 —— 京劇彩唱及折子戲》更是我個人最難忘，集合了不同派別的名家大老倌演出，可說是史無前例，令我這些京劇迷大飽眼福和耳福。安坐觀眾席欣賞台上藝術家的精湛演出實在是賞心樂事，2010年馬林斯基芭蕾舞的演出，看到台上每個舞者超卓的技術，令我讚嘆不已。」

「除此之外，我們一直致力委約及製作新作品，鼓勵藝術創新和培育人才，當中有不少本地原創作品獲得了相當好的成績！猶記得2009年有一個本地委約及製作的新作品《聖荷西謀殺案》，不但大獲好評，獲得第19屆香港舞台劇獎四獎，其後更多次於香港及外地重演。我們當年還出版了這作品的劇本集，在藝術節期間出售呢！」

「當然我也很懷念每年在藝術節完結後，有機會邀請整個團隊一起吃一頓飯，在感謝各人努力之餘，也能夠加深認識這班對藝術充滿熱情的同事。藝術節的品牌得來不易，有賴多年來政府、贊助商、藝術節委員會委員的支持，當然最大功臣是五十年來曾經在藝術節工作的同事，他們的使命及應變能力，其實不是理所當然的，再次感謝他們。」

「今天的成功不是永恆，面對市場環境變化，藝術節必須回應社會需求，未來將繼續推廣藝術文化，服務社會。」

Margin, which was a commissioned work co-produced by artists from Hong Kong, Taiwan and Shanghai. I remember in particular the director Wu Hsin-kuo and his captivating performance. *Beijing Opera Extravaganza* in 2009 was quite unforgettable, as an unprecedented performance that united famous veteran artists from different genres of Chinese operas. It was a feast for the eyes and ears for Peking opera fans like myself. I also had nothing but admiration for the dancers of the Mariinsky Ballet during their performances in 2010."

Lee continues: "We were also dedicated to commissioning and producing new works to encourage artistic creations and nurture talents. Some of the local and original works were critically acclaimed. In 2009, the locally commissioned and produced original work *Murder in San José* won rave reviews and four awards at the 19th Hong Kong Drama Awards. The production enjoyed multiple reruns in Hong Kong and abroad. We also published the play script, which was sold during the Festival."

"I have fond memories of inviting the entire Festival team for dinner after the Festival ended each year," Lee says. "It was both a gesture of gratitude for the team's hard work and an opportunity for me to get to know our staff, who were all passionate about the arts. The Festival's reputation is hard-earned, with the continuous support of the government, sponsors and members of the Festival Committee over the years. The highest praise should undoubtedly be given to all the staff who worked for the Festival over the past 50 years. Their resilience and dedication towards the Festival, which I am truly thankful for, are not to be taken for granted."

Lee remarks: "Today's success will not last forever. Faced with changes in the market and environment, the Festival should be ready to respond to society. In the future, the HKAF will continue its mission of promoting the arts while serving society at large."

《王健@IFC55 空中演繹巴赫組曲》 *Wang Jian plays Bach @ IFC55* (2009)

夏佳理 香港藝術節主席 (2013–2015)

改革管治 穩步推進

「我從 2002 年起擔任香港藝術節執行委員會成員，2012 年李業廣離任後，便接任主席一職，感到十分榮幸。我一直相信香港藝術節是香港的重要文化資產。」

「我當時也是西九文化區管理局董事局及亞洲藝術文獻庫董事局成員，故希望讓不同的文化和藝術機構展開相互之間的合作。如果西九文化區和香港藝術節能建立夥伴合作關係，會是一件美事。遺憾的是當我擔任香港藝術節主席時，西九文化區仍只是在早期規劃階段，我的想法在當時無法落實執行。我期望西九文化區和香港藝術節將來會有很多協作。」

「在我擔任香港藝術節主席的三年期間，對執行委員會的成員任期方面進行了一些改革。以往委員的任期設有上限，倘若在任的成員被選為主席，其主席任期便會比完整的期限為短。我修訂了相關條文，讓被選為主席的委員會成員能在完整任期內擔當該職位，這相信是我對香港藝術節作出的一項重要貢獻。」

「我在香港藝術節擔任主席期間，留下很多美好回憶，當中最難忘的，就是曾在薩爾斯堡會晤了馬林斯基劇院的藝術暨行政總監瓦萊里‧格杰夫，我答應他如果來港為藝術節演出，會為他舉行派對，結果他帶來精采絕倫的演出，而我當然兌現承諾。派對一直進行至破曉時分，我們離開時已是凌晨四時。他精力充沛，毫無倦意！」

夏佳理出席第 41 屆香港藝術節開幕典禮
Ronald Arculli at the 41st HKAF Opening Ceremony (2013)

Ronald Arculli HKAF Chairman (2013-2015)

Reform in Governance amid Steady Progress

"I have been a member of the Executive Committee of the Arts Festival since 2002 and was very honoured to succeed Charles Lee as the Chairman in 2012. I have always believed the HKAF is an important cultural asset of Hong Kong."

"As I was also a Board member of the West Kowloon Cultural District Authority (WKCD) and the Asia Art Archive, it was my intention to initiate collaboration between different arts and cultural organisations in Hong Kong. It would be wonderful to establish a substantial partnership between West Kowloon and the Festival. Unfortunately, with WKCD venues still in the early phase of planning during my term as the HKAF Chairman, it was not possible to put this in place. I hope to see collaborations between the two in the years to come."

"During my three years of service with the Festival, I initiated a change in the terms of the Board. There is a maximum period for service on the Festival's Executive Committee, which means that any serving member elected to the Chair can only serve in that capacity for a shorter period than the full term. I had the article amended, such that any member of the Executive Committee elected to the Chair might serve for the full period in that capacity. I would say this was an important contribution to the Festival."

"I had many beautiful moments at the Festival and the most memorable was meeting the Artistic and General Director of the Mariinsky Theatre Valery Gergiev in Salzburg. I promised to throw him a party when he came to perform at the Festival. He gave us fabulous performances. I kept my promise. The party went on till the early hours, and it must have been 4am when we went home. He was indefatigable!"

《藝裳奇幻世界》 *World of WearableArt (WOW)* (2012)

何嘉坤 行政總監(2006–2022)

繼往開來 攀越嶺峰

或許加入藝術節的每位行政人員都有一共通之處，在成為團隊一份子之前，都是藝術節的觀眾。2006年加入藝術節擔任行政總監的何嘉坤(Tisa)，也不例外。

Tisa 與藝術節的緣份，早於1973年，「印象最深刻是伊麗莎白‧舒瓦茲柯芙在大會堂的音樂會。當時也不太知道她的故事和經歷，但她在台上真是艷光四射，她的聲音能夠帶你到另一個境界。」那一年大概是香港所有藝術愛好者引頸以待的經歷，可能是女高音舒瓦茲柯芙、倫敦愛樂交響樂團，又或是帕可‧佩納的佛蘭明高結他，半個世紀後，當日的座上客依然印象難忘。Tisa 隨即成了藝術節的捧場客，後來移居新加坡，二十年後又回歸香港。2006年高德禮卸下行政總監一職回到澳洲，由新加坡回流的 Tisa 接棒，與藝術節一起邁進五十週年。

打開藝術之門

Tisa 回港後，對藝術節難忘的節目，自然越來越多，包括許多由藝術節製作及呈獻的本地原創作品，當中有些更是在藝術節首演後，由她協助帶到海外演出。

除了展現大師級及創新的節目外，Tisa 希望藝術節可以服務更多觀眾，接觸社會不同階層，把藝術的大門開得更大。「我們希望提供一些大眾化而又優質、令觀眾驚喜難忘的節目。在揀選

Tisa Ho Executive Director (2006–2022)

Growing from Strength to Strength and Reaching New Heights

Perhaps a common thread among the Festival's executive staff is the fact they had all been long-time festivalgoers before coming on board. This holds true for Tisa Ho, who became the Festival's Executive Director in 2006.

Ho's first encounter with the Festival dates back to 1973: "My most vivid memory was soprano Elisabeth Schwarzkopf's recital at the City Hall. Although at the time I knew little about her, she was incandescent on stage and her voice transported you to another world." That was a year when arts lovers all over Hong Kong awaited the new festival in eager anticipation. They might have been anticipating Elisabeth Schwarzkopf, the London Philharmonic Orchestra, or flamenco guitarist Paco Peña. Half a century on, the memory of the performances remains vivid in the minds of those who witnessed them. Ho became an instant fan of the Festival. Even during nearly 20 years living in Singapore, she remained in touch. When Gautier returned to Australia and stepped down from the post of Executive Director, the baton was passed to Ho, who returned to Hong Kong and now leads the Festival into its 50th anniversary.

Opening Doors and Making Connections

Since returning to Hong Kong, Ho's list of memorable Festival performances has grown, and includes many original new local work for which the Festival is producer as well as presenter, some of which she has helped take on tour after the Festival premier.

《幻光動感池》 *SUPER POOL* (2017)

《聲光園》 *Power Plant* (2011)

節目時，我們更希望藝術節可以配合當年的大事，把藝術節和香港連結，令藝術節更具時代的意義。好像2008年適逢北京奧運會，香港協辦馬術項目，於是便帶來難得一看的「星躍馬術奇藝坊」。2012年是香港設計年，我們又努力把《藝裳奇幻世界》帶到香港，那是藝團衝出新西蘭的遠征，為香港的觀眾帶來最耳目一新的視覺作品。還有2011年在九龍寨城公園更呈獻戶外聲光雕塑展覽《聲光園》。而在2017年，藝術節聯同香港賽馬會慈善信託基金聯合呈獻《幻光動感池》，在香港多個公共空間亮相，可能是我們首個art x tech的節目，結合藝術與科技。」

Tisa認為藝術節非常具備香港特色。「藝術節的優點，是節目多元化，能夠容納很多不同的風格，不同的選擇。正如可以享用高級料理，也可以簡單地吃一碗雲吞麵，最重要是質素都有保證。」

帶著「香港」這個品牌，可以是優勢，卻難免也有誤解。Tisa說外界有些朋友以為香港藝術節是政府提供了不少資助，事實常規的資助只有大概20%。「如果把我們當作是第十大團，跟九大藝團相比，我們的政府資助比例是最低的。有人會認為，

In addition to presenting great masterpieces as well as adventurous new work, Ho has also sought to reach out to the wider community and open the Festival's doors to more people. "It is our goal to provide accessible quality programmes that are memorable for audiences. And presenting programming that is aligned with signature events or major occasions in Hong Kong helps to forge a stronger connection between the HKAF and the city, making the programme more meaningful and relevant. For example, with equestrian competitions at the Beijing 2008 Summer Olympics held in Hong Kong, we presented the equestrian spectacular Zingaro Equestrian Theatre. And in tandem with Hong Kong Design Year 2012, we brought the *World of WearableArt* to Hong Kong. This was their first foray outside New Zealand, and the company curated a special programme for us, bringing us some of their best and most interesting pieces for Hong Kong audiences. There was also *Power Plant*, the outdoor sound and light performance installation at the Kowloon Walled City Park, in 2011. *SUPER POOL*, co-presented with The Hong Kong Jockey Club Charities Trust in 2017 at multiple public spaces in Hong Kong, may well be our first art x tech programme, arts and digital technology in a colourful interactive work."

In Ho's opinion, the HKAF reflects the characteristic of Hong Kong: "One of the strengths of the Festival is its diversity. We can offer a wide range of choices, a rich variety of genres and styles. Just as it is possible to enjoy fine dining or a simple bowl of noodles. What matters is that both should be of excellent quality."

我們無須支付藝術家的薪酬，但事實上，我們須要支付海外及本地藝術家的薪酬，再加上機票、住宿、物流等支出。近年政府鼓勵文化藝術團體籌募贊助捐獻，設立『配對資助計劃』，所以藝術節也爭取多了一些資源。亦正因為有此計劃，不少藝團也積極尋找贊助，所以競爭也大了。無疑我們有品牌優勢，且節目多元化，但是我們的限制卻是在特定的一段時間舉辦演出節目，這樣令我們有機會配合不到某些贊助商。」

Tisa 強調藝術節的營運方式從一開始已是自負盈虧，所以很多計劃也必須要有適當的資源配合才能成事。藝術節在創始之初已提供優惠學生票，不過多年來卻沒有提供優惠長者票。「因為我們須要作收支平衡，除非是提高票價，又或者開拓贊助，否則很難成事。」另外一種聲音就是藝術節的票價昂貴，「也是因為我們資助較低，又要自負盈虧，其實如果跟周邊的城市比較，像日本、新加坡、上海等，常常同一節目他們的票價都比藝術節高。我們從最初完全沒有政府資助，經歷市政局、康文署、政府資助，還有一直支持藝術節的香港賽馬會慈善信託基金，這種營運模式換來的是行政上比較靈活。不過近年市場競爭越來越大，幸好，我們有一些非常忠實的支持者——不僅是贊助商，還有個人及機構的捐助，他們共同構建了藝術節社群。」

「香港藝術節 @ 大館」節目：《藝術外賣》
HKartsFestival@TaiKwun Programme: *Arts Delivery* (2019)

While being emblematic of Hong Kong can be an advantage, there are misconceptions also. Ho notes that some think the Festival is funded by the government because it carries the name of the city. The reality is that recurrent subvention is about 20 per cent: "Among major performing arts companies, our proportion of government funding is undoubtedly the lowest. Others think that because we do not have performers on staff, we do not need to pay artists. But we are actually paying freelance rates for local artists and top international rates for the world-class performers we bring in, plus airfares, accommodations and other logistical costs. In recent years, the government established the 'Matching Grants Scheme' to encourage arts groups to raise donations and sponsorship. While this enabled the Festival to the additional funding, the competition for sponsorship also became more acute. We do have the advantage of an excellent brand, and our programmes are diversified. However, we are constrained by programmes being presented during a specific time period and this sometimes may not align with sponsors' calendars."

In terms of operating model, Ho emphasises that the Festival has been self-financed since its inception, and some projects are only possible when the appropriate resources become available. While the HKAF has provided discounted student tickets ever since its establishment, tickets for seniors have never been offered: "The only way to do it would be to raise general ticket prices to recover the income or find sponsorship to cover the amount." Another frequent refrain is that the HKAF's ticket prices are on the expensive end. Ho rebuts: "We just cannot operate in the same way as fully funded or even highly funded organisations in Hong Kong, and if you compare us to festivals in neighbouring places like Japan, Singapore and Shanghai, their ticket prices are higher. We started with no government funding. The funding became available later, successively from Urban Council, LCSD and the government. The Hong Kong Jockey Club Charities Trust has also been supportive over the years. This operating model has the advantage of being more flexible in its administration. But competition has become a lot stiffer in recent years. We are quite fortunate to have a very loyal group of supporters. Donations come not just from sponsors but also individuals and organisations, all integral and critical parts of the HKAF community."

不斷開拓 ——
「無限亮」計劃

配合城市的步伐，藝術節也不斷成長。Tisa 說藝術節一直願意作出新嘗試，也希望可以有所增長。「增長不一定是量度，也可以是深度。所以在 2019 年，非常高興馬會邀請我們聯合呈獻『無限亮』這個嶄新項目，讓藝術節更深入社群。」

由藝術節與香港賽馬會慈善信託基金聯合呈獻的「無限亮」計劃，致力創造無障礙的藝術欣賞環境，透過藝術推動社會共融。藝術共融在香港雖不是新概念，卻仍是零星地推展，大眾的認識亦不太深。「所以我們希望藉著這個計劃，讓一些從前少有機會接觸藝術節的人，能夠享受藝術的樂趣。我們的目標有兩個層面，首先，希望所有喜歡藝術的人也來看藝術共融節目，體會藝術家擁有不同的身體及智力情況。舉例說，喜歡音樂的人會來聽菲力斯·克立澤的演出（他天生沒有雙臂，依靠兩腳演奏圓號）。第二是透過這些演出，希望擁有不同能力的群體也看到各種可能，以不同形式來參與和欣賞節目。『無限亮』今年已舉辦至第四屆，因為疫情關係，只做了一屆現場演出，還有許多地方需要學習。我們會邊做邊學，希望能夠服務這個社群，透過『無限亮』把更多人帶入藝術節。」❁

Pioneering New Initiatives —
"No Limits"

The HKAF has grown in tandem with the city. According to Ho, the HKAF is always willing to explore new territory and look for growth opportunities: "Growth is not necessarily measured in quantity. It can be measured in depth of engagement. So we were very happy to receive Jockey Club's invitation in 2019 to co-present the new 'No Limits', a project that allows the Festival to go deeper into the community."

Co-presented with The Hong Kong Jockey Club Charities Trust, the "No Limits" project aims to create a barrier-free environment for appreciation of the arts and to promote inclusiveness and understanding. Although inclusive arts is not new in Hong Kong, development was not systematic and public awareness was not too high. "Through this project, we hope more people who had less access previously would enjoy the arts. Our objective is two-fold. First, we hope all arts lovers will also enjoy inclusive arts programmes and appreciate the artistry of performers with various physical or intellectual conditions. For example, music lovers would be sure to enjoy the performance by Felix Klieser who was born with no arms and uses his feet to play the French horn. Second, people with different abilities may be inspired by the performances to explore their own potential to participate in arts activities. 'No Limits' has completed four editions. Because of the pandemic, however, we have only been able to present in-venue performances in the first edition. There is much for us to learn still, and we are learning by doing, working to serve this community and to bring more people to the Festival through 'No Limits'." ❁

菲力斯·克立澤表演圓號二重奏及三重奏
Felix Klieser performing horn duo and trio (2021) (© Stefan Gawlick)

何嘉坤在「青少年之友」的藝術行政工作坊與學生分享經驗
Tisa Ho sharing her experience with students at the "Young Friends" Arts Administration Workshop (2018)

PART II

半世紀的足印 挑戰與展望
The Past and the Future

WOW®

放眼世界！更要立足本土！
Global Outlook with
Firm Foothold in Hong Kong

周凡夫特稿
Feature by Chow Fan Fu

香港藝術節與時俱進
半世紀的香港故事

如果說，香港藝術節是亞洲區內少有的歷史悠久而又具有廣泛國際影響力的大型綜合性藝術活動，那可是經過半個世紀以來無數人共同努力，不斷焠煉打造的成果，是凝聚了來自全球各地、中國內地，特別是本地無數藝術工作者心血結晶的成果。在新冠肺炎疫情成為「新常態」的當下回望，香港藝術節近半個世紀以來的發展，就更是一個既放眼世界，更立足本土，與時俱進的香港故事。

Hong Kong Arts Festival —
a Hong Kong Story Fifty Years in the Making

It can be said with confidence that the Hong Kong Arts Festival (HKAF) is one of the few major arts events in Asia with a long history and global reach. Its renown, however, is the fruit of 50 years of selfless dedication by people who strive for excellence. The concerted effort involves countless artists from around the world, Mainland China and especially Hong Kong. Looking back as the COVID-19 pandemic shapes the "new normal", the Festival itself tells a classic Hong Kong story of resilience and vibrant growth after a half-century of development as it continues to be relevant, upholding a global vision while establishing a local foothold.

(左起) 港督麥理浩、新日本愛樂交響樂團的鈴木清三和光信利彥，於港督府舉行首屆藝術節招待會
(from left) Governor MacLehose, Seizo Sunsuki and Toshihiko Mitsunobu of the New Japan Philharmonic Orchestra at a Government House reception of the first HKAF

寫好香港故事非易

香港藝術節自1973年創辦以來，不僅香港的政治環境經歷了八十年代中英就香港問題談判的信心危機，六四事件的衝擊，從殖民地枷鎖解脫回歸中國，持續不斷的政治爭拗，世界的大環境變化就更大了，三次石油危機，電腦帶來資訊世代全球化的來臨，九一一事件引爆的恐怖震慄，金融海嘯帶來的經濟災難，沙士、豬流感到新冠肺炎……這些內外環境的變化，大量「傳統」都被衝擊得支離破碎。傳統的藝術式微，傳統的概念、觀念紛紛被扭曲。可以說，世界大局、環境及藝壇變化之急劇，更是人類歷史上從未有過。在這種情況下，香港藝術節仍能寫好香港這個故事，那便不是容易的事了。

這個香港故事從港督麥理浩到特首林鄭月娥（贊助人）；從馮秉芬到查懋成（主席）；從伊安·韓德（藝術指導）到何嘉坤（行政總監），五十年的人事滄桑，亦意味著在由人（行政）帶動的香港藝術節的目的、理念、策略、節目取向，和設計各方面都無可避免地出現變化。

1987年初香港藝術節的藝術總監史迪敦和經理馬斌先後離職，該兩職位於懸空一年多後，1988年7月鄭新文獲委任為香港藝術節協會總經理，成為首位土生土長集藝術及行政權力於一身的掌舵人。猶記得他上任後曾回應社會上一些「聲音」，他特別指出，香港藝術節的正確名字應該是香港「國際」藝術節，且有信心和理由相信九七年香港回歸後的香港藝術節，仍能保持此一國際性的節目取向。事實證明，當年鄭新文的信心獲得確認，直到今日亦確證了香港藝術節自創辦以來，以引進國際性藝術節目為主的取向沒有改變。

但要堅持這種放眼世界的願景需要一定的條件，而香港的藝團和藝術家在此前提下所擔當的角色，能從只是「配角」（第一屆由本土藝術家擔任的演藝節目僅有呂培原指揮的中國音樂演奏會一項），逐漸發展成為香港藝術節立足本土的重要基石，那就更是成就香港藝術節成為香港故事的重要元素。

The Journey of Growth, Far from Straightforward

Since the Hong Kong Arts Festival's inception in 1973, the city has experienced frequent political turbulence, ranging from the Sino-British negotiations in the 1980s and the June Fourth incident, to decolonisation and the reunification of Hong Kong with China, not to mention persistent political disputes. Global events such as three oil crises, the advent of the information age and globalisation, the September 11 attacks, economic turmoil due to the global financial crisis, SARS, human swine influenza, and now COVID-19 have had rippling effects that have been just as, if not more, intense. Faced with changes from near and afar, many traditions have been confronted, resulting in the decline of traditional art and challenges to traditional concepts and notions. The drastic changes in the world, environment and art scene have been unprecedented in human history. With this in mind, the fruitful journey taken by the Hong Kong Arts Festival is far from straightforward.

This tale of Hong Kong spans from Hong Kong's former Governor Murray MacLehose to current Chief Executive Carrie Lam (Patron), from Kenneth Fung Ping-fan to Victor Cha (Chairman), and Ian Hunter (Artistic Director) to Tisa Ho (Executive Director). Fifty years of leadership successions meant waves of changes in the Festival's objectives, philosophy, strategy, direction in programmes, and design, which are driven by its leaders.

The HKAF's Artistic Director Keith Statham and Manager Henry Ma resigned in early 1987. After their positions remained vacant for more than a year, Tseng Sun-man was appointed General Manager of the Hong Kong Arts Festival Society in July 1988. Tseng became the first native Hongkonger to oversee both the Festival's artistic and administrative affairs. Addressing concerns from the public when he assumed the position, Tseng specified that the Hong Kong Arts Festival should be renamed the Hong Kong "International" Arts Festival. In addition, he maintained that the Festival would retain its direction towards international programmes after the 1997 handover. His earlier predictions proved to be correct as the HKAF's initial focus on featuring international arts programmes remains unchanged today.

However, this dedicated global vision did not come about overnight. Hong Kong arts groups and artists became increasingly significant in the Festival, going from initially taking on a supporting role (when the Festival was first held, a Chinese music concert conducted by Lui Pui-yuen was the only programme to showcase local artists) to being integral to the HKAF's foundation in Hong Kong. This becomes the overarching plotline in how the Festival becomes a classic Hong Kong story.

不同文化交流平台

香港藝術節不僅一如國際間的大型藝術節，為不同文化提供交流的平台，通過不同的渠道網絡將各地不同文化的節目引進，從早期較集中經典的重要製作，用以建立觀眾的信心，到逐漸引入在香港難得一見的經典（如布列頓、德布西、華格納、楊納傑克的歌劇，菲力普·格拉斯的《沙灘上的愛恩斯坦》，翩娜·包殊的舞蹈劇場作品，俄羅斯的經典芭蕾舞劇，喬治·威爾遜的《1984》），甚至富有藝術前瞻性、創意性的節目（如2012年的《藝裳奇幻世界》、2017年的表演裝置《聲光頌》、2019年的互動劇場《金錢世界》），這些展現世界最新藝術趨勢的節目，除了拓闊香港觀眾的視野，更能為香港的藝團、藝術工作者帶來新的激素。

《藝裳奇幻世界》 *World of WearableArt (WOW)* (2012)

《聲光頌》 *Chorus* (2017)

Exchange Platform of Diverse Cultures

As expected of a major international arts festival, the HKAF facilitates exchanges and organises programmes of diverse cultures through a variety of channels and networks. In its early days, the Festival cultivated an audience with classic and major productions. Renowned works rarely staged in Hong Kong were gradually introduced (including operas by Britten, Debussy, Wagner, Janáček; *Einstein on the Beach* by Philip Glass, dance theatre works by Pina Bausch, Russian ballet classics, *1984* by George Orwell). The coverage even extended to innovative and cutting-edge programmes (such as *World of WearableArt* in 2012, the installation performance *Chorus* in 2017 and the interactive theatre production *LIES* in 2019). Showcasing the world's latest arts trends, these programmes broadened Hong Kong audiences' horizons and also served as inspiration for local arts groups and artists.

In addition to arranging Asian premieres of works by overseas arts groups or world premieres of new works, the HKAF took the initiative of commissioning international productions, as well as programmes co-produced with overseas groups. Such works included the opera *Marco Polo* by Tan Dun in 1997, *Green Snake*, co-commissioned with the Shanghai International Arts Festival in 2013, and the opera *Dream of the Red Chamber* by Bright Sheng in 2017. More than 20 of these works (programmes) were presented as Asian premieres and world premieres in recent years.

With the HKAF being a platform for cultural exchange, programmes from Europe and North America were initially the mainstay of the Festival. However, Asian arts groups from Japan, South Korea, Singapore, Thailand and elsewhere started to appear in the Festival's programme offering, along with works from more distant countries such as Turkey. Practically every arts group of importance in Taiwan has been invited to the Festival. The number of programmes from Mainland China kept increasing, reaching a high of 16 in 2009. The HKAF thus became a significant event that showcased the artistic landscape and talents of Mainland China.

The HKAF also played matchmaker in forging collaborations between arts groups from different places, resulting in projects including *A Touch of Zen*, co-produced by Taiwan's U-Theatre and the Shaolin Temple Wushu Training Centre in 2006, *Lost Village*, co-produced with the National Theatre Company of China and the New National Theatre Tokyo in 2007, the musical *108 Heroes*,

另一方面，藝術節除了從海外藝團引進亞洲首演，甚至世界首演的新製作節目，更主動委約國際性的製作，還有和海外的藝團、藝術節合作的節目，如1997年譚盾的歌劇《馬可波羅》、2013年與上海藝術節聯合委約的《青蛇》、2017年盛宗亮的歌劇《紅樓夢》。這些亞洲首演，世界首演的作品（節目），發展到近年，往往多達二、三十個。

盛宗亮的歌劇《紅樓夢》Bright Sheng's Opera *Dream of the Red Chamber* (2017)

香港藝術節作為不同文化交流的平台，儘管歐美的節目仍是主流，但隨著世界大環境的變化除了亞洲的日本、韓國、新加坡、泰國的藝團，甚至「偏遠」的土耳其的樂團都在藝術節的節目單上出現，而台灣幾乎所有重要的藝團都已曾獲邀請。同時，上世紀八十年代之後，來自中國內地的節目更是不斷增加，2009年更多達十六個，藝術節便成為中國內地藝術面貌展示的重要窗口。

此外，香港藝術節還擔任「紅娘」的角色，組合來自不同地方的藝團合作演出，如2006年台灣優人神鼓與嵩山少林寺武術館合作的《禪武不二》、2007年中國國家話劇團及日本東京新國立劇院聯合製作《下周村》、台北及上海的藝術家聯手製作藝術節委約的音樂劇《水滸108 ── 忠義堂》、2016年柏林電台合唱團聯同台灣優人神鼓合作的《愛人》。

Tales from the Water Margin, commissioned by the HKAF and co-produced by artists from Taipei and Shanghai, and *LOVER*, co-produced by U-Theatre and Rundfunkchor Berlin.

Similarly, a fair number of Hong Kong arts groups and artists enjoyed collaborations with visiting groups thanks to the HKAF's initiatives. During the Festival's first three editions, the specially assembled Hong Kong Festival Chorus performed choral and symphonic works with the Menuhin Festival Orchestra, the London Symphony Orchestra, the Sydney Symphony Orchestra and the Spanish National Orchestra. In 1977, the Hong Kong Oratorio Society collaborated with the BBC Scottish Symphony Orchestra, performing works by English composers including Wood and Elgar. Subsequently, the regrouped Arts Festival Chorus took part in operas including *The Marriage of Figaro* (1991), *Der Rosenkavalier* (1993), *Die Zauberflöte* (1994), *Un ballo in maschera* (1995), Tan Dun's *Marco Polo* (1997) and Rossini's *La Cenerentola* (2001). In 2018, there were many featured collaborations, including pianist Rachel Cheung and Switzerland's Verbier Festival Chamber Orchestra; Die Konzertisten and the Estonian National Male Choir. Hong Kong's Gustav Mahler Orchestra also performed with many international stars. These partnerships and exchanges have been conducive to enhancing Hong Kong's artistic culture.

In addition, the HKAF has also pursued opportunities for overseas and visiting music groups and artists to perform works by Hong Kong composers. The Festival's efforts led to Russia's St Petersburg Philharmonic Orchestra performing *Morning Sun* by Chan Wing-Wah (1994), the Shanghai Quartet appearing with *L'Air du temps* by Lam Bun-Ching (1996), the 20th Century Ensemble of Vienna with *Overture and Fugue* by Chen Chien-Hua (1997), and the Moscow Radio Symphony Orchestra and the China National Symphony Orchestra performing *Prelude: Ode to the Snow* by Chen Peixun (1998, 2000). These occasions helped promote Hong Kong works as well as being great sources of encouragement for Hong Kong composers.

譚盾的歌劇《馬可波羅》Tan Dun's *Marco Polo* (1997) (© 謝明莊)

《青蛇》*Green Snake* (2013) (照片提供：中國國家話劇院) (© 解飛)

同樣地，香港不少藝團和藝人亦在香港藝術節的「紅娘」助力下，得以和到訪的藝團合作，這包括早期特別組合的藝術節合唱團，在前三屆先後和曼奴軒節日管弦樂團、倫敦交響樂團、雪梨交響樂團和西班牙國家管弦樂團合作演出合唱與管弦樂作品。此外，香港聖樂團也在 1977 年和 BBC 蘇格蘭交響樂團合作演出過英國作曲家鄔德和艾爾加作品；及後重組的藝術節合唱團，還有機會參加了歌劇《費加羅婚禮》(1991)、《玫瑰騎士》(1993)、《魔笛》(1994)、《假面舞會》(1995)、譚盾《馬可波羅》(1997) 和羅西尼歌劇《仙鈿奇緣》(2001) 的演出。2018 年更安排了鋼琴家張緯晴和瑞士韋爾比亞音樂節室樂團、Die Konzertisten 和愛沙尼亞國家男聲合唱團、香港馬勒樂團和多位國際演藝明星的同台演出，這些合作交流都對提升本土藝術水平具有正面作用。

此外，香港藝術節亦不時爭取海外到訪的樂團樂人選演香港作曲家的作品，如俄羅斯聖彼德堡管弦樂團演奏陳永華的《晨曦》(1994)、上海弦樂四重奏演奏林品晶的《時間之歌》(1996)、維也納二十世紀合奏團演奏陳健華《序曲與賦格》(1997)、莫斯科電台交響樂團和中國交響樂團演奏陳培勳《前奏曲：詠雪》(1998、2000)，這對推廣香港作品和對鼓勵香港作曲家來說，都有很大幫助。

多元方式推動本土

香港藝術節能成為一個兼收並蓄，具有廣泛國際影響力的文化藝術交流平台，來自香港本土的藝術成果及社區緊密關係，在長期發展下構建出來的強大基石的支持，和引進國際間不同文化的高質素藝術項目，可說是相互相承，缺一不可之事。

五十年來香港的文化演藝發展，亦經歷了從「業餘」進入「職業」的重大變化，從主流、單一，進入多樣多元的階段。這些變化，大都可以在香港藝術節的本土節目中見得出來，也就是說，香港藝術節和本土藝術活動、藝術創作具有緊密的影響。

回望近半個世紀的發展，香港本土節目在藝術節中扮演的角色，從初期可有可無的「配角」，到後來份量和作品都不斷增加，那可有一個變化的過程。要能達到增強本土節目的質與量，能將資源發揮最大效果，在營運上，香港藝術節便建立了一套行之有效的運作模式，由藝術節直接自外地引入的節目，藝術節承擔費用支出及票房收益。但本土節目則分為兩類，一是「入節節目」，主要是本地具有足夠實力（水平及資源）的藝團（香港中樂團、香港管弦樂團、香港小交響樂團、香港話劇團等）提供的節目，製作費用由藝團自己承擔，票房收益亦由藝團收取；另一是藝術節採取較主動的方式，通過主動聯絡、統籌、委約，甚至製作的方式去設計「自己」的本土節目，而且主要是原創性的節目。這兩種方式，往往能達到激發各方面的積極性，也就得以為本土的藝術發展累積更為豐碩的成果。

就音樂創作而言，第49屆開幕表演的「樂旅中國」，便是是由香港藝術節及香港中樂團開發的「品牌」。十五年來藝術節發表了非僅是中國內地、中國香港和中國台灣，還有來自世界四大洲（馬來西亞、菲律賓、盧森堡、德國、波蘭、荷蘭、比利時、美國、南非），合共四十一位作曲家多達四十九首新作品。

香港管弦樂團亦曾於1977年首演了林樂培的《形象》和黃育義的《踏雪尋梅》，還舉辦過香港作曲家工作坊「蓮香雪影」，演出了曾葉發、吳俊凱、陳慶恩等多位香港作曲家的作品。

Multi-Pronged Approach in Promoting Local Programmes

The Hong Kong Arts Festival, with an eclectic offering of programmes, is a significant platform of artistic exchange that wields influence at an international level. Its stature is supported by a solid foundation based on long-term development of local artistic works and strong relations with the community. Another pillar of support is the introduction of high-quality programmes from different countries and cultures around the world, with both approaches essential and complementing each other.

Arts development in Hong Kong has evolved on multiple fronts in the past 50 years. As the arts groups advanced from "amateur" to "professional" standards and expanded from mainstream to diversified repertoires, these transformations could be readily observed in the Festival's local programmes. In this regard, the HKAF plays a key role in local arts activities and creations.

Looking back after a half-century of progress, Hong Kong programmes played a less important supporting role in the HKAF at first and gradually increased in both significance and proportion. This process of change required the Festival to enhance both the quality and quantity of local programmes, and maximise resources. In this regard, the HKAF has devised an effective operating model. For overseas programmes, the Festival bears the expenses and receives the box office revenues. Conversely, there are two approaches to local programmes. The first approach involves programmes by local arts groups (such as the Hong Kong Chinese Orchestra, the Hong Kong Philharmonic Orchestra, the Hong Kong Sinfonietta, Hong Kong Repertory Theatre) with recognised levels of strength in items of artistic calibre and resources. The arts groups will bear the production costs and receive the box office revenues. Otherwise, the Arts Festival might adopt a more proactive approach by initiating, coordinating, commissioning and even producing its own local programmes, most of which are innovative in nature. The two approaches together often become motivating forces contributing to greater results for local arts development.

A shining example for music productions would be "Music About China", a programme brand launched jointly by the HKAF and the Hong Kong Chinese Orchestra which was designated the opening programme of the 49th Hong Kong Arts Festival. Over the last

本土色彩意識日增

1992年第20屆香港藝術節的開幕日，定名為「香港演藝日」，可說是立足本土節目的新起點，本土色彩與意識的香港原創舞台製作在藝術節中的影響日增。這一年中英劇團推出張達明的《客鄉途情遠》，是藝術節二十年來首齣長篇本地劇作！香港話劇團亦開始推出香港劇作家的原創劇：楊世彭的《閻惜姣》(1994)、潘惠森的《尋人的眼睛》(2000)、何冀平的《明月何曾是兩鄉》(2001)、黑盒劇場周昭倫的《戀戀 4×6》(2002)……。中英劇團亦有古天農及許芬的《蔗林殺機》(1994)、杜國威的《人生唯願多知己》(1995)、古天農的《紅頂商人胡雪巖》(1999)……。

香港演藝日宣傳
Promotion of Hong Kong Performing Arts Day (1992)

1995年開始，在香港藝術節出台的香港劇團變得多樣化，而且推出的幾乎全是濃厚香港本土色彩和意識的劇作，包括剛劇場的《小男人拉大琴》(1995)、佚名劇團的木偶兒童劇《小鞋左左》(1995)、沙磚上張達明《行人電梯上的熱帶雨林》(1996)、毛俊輝實驗創作《跟住個嘅妹氹氹轉》(1997)、劇場組合《射日》(1998)、無人地帶《解剖二千年》(1999)、中港日韓四地合作《悟空》(2001)、進劇場《他和她和他的屋》(2002)。這些劇作在風格、手法上各有不同，大都富有獨特的本土色彩。

香港舞蹈節目1982年才首次在藝術節出現，其後城市當代舞蹈團、香港芭蕾舞團和香港舞蹈團亦陸續在藝術節中登場，同樣推出過富有獨特風格，本土意識很強的原創舞作。如1993年四位編舞家的《四種舞蹈風景》、1994年梅卓燕的《水銀瀉》、1999年黎海寧的《客途秋恨》、梁家權的《都市蜉蝣體》、蔣華軒的《奔流》，2001年伍宇烈的《蘇絲黃的美麗新世界》，還有京劇現代舞《軀體亂彈》……

15 years, it premiered 49 new works by 41 composers from Mainland China, Hong Kong and Taiwan, and other countries across the world including Malaysia, Philippines, Luxembourg, Germany, Poland, the Netherlands, Belgium, the United States, and South Africa.

The Hong Kong Philharmonic Orchestra performed the premiere of *Image* by Doming Lam and *Plum Blossoms in the Snow* by Wong Yok-yee. It also held a composers workshop, in which works by many Hong Kong composers including Richard Tsang, Daniel Ng Chun-hoi and Chan Hing-yan were performed.

Increase in Local Productions and Local Consciousness

The opening day of the 20th HKAF in 1992, designated "Hong Kong Performing Arts Day", was a milestone for local programmes becoming firmly established in the Festival. Original Hong Kong stage productions with a distinct local flavour and consciousness grew in significance within the HKAF. That year, Chung Ying Theatre Company presented *Far Away Home* by Cheung Tat-ming, the first full-length local theatrical work in the Arts Festival in more than 20 years. Hong Kong Repertory Theatre also presented original works by Hong Kong playwrights, including *Yan Xijiao* (1994) by Daniel Pang, *The Naked Eyes* (2000) by Poon Wai-sum, *We Are One Family* (2001) by He Jiping, *A Matter of 4 X 6* (2002) by Hong Kong Repertory Theatre Black Box Theatre and Chow Chiu-lun. There were also productions by Chung Ying Theatre Company, including *Killer Instinct* (1994) by Ko Tin-lung and Hui Fun, *Bosom Friend is Hard to Come By* (1995) by Raymond To Kwok-wai, and *The Merchant of China* by Ko Tin-lung (1999).

From 1995, the Hong Kong theatre groups featured in the HKAF became diversified, with the majority of works seeped in local elements and consciousness. Examples included *The Double Bass* (1995) by Theatre Resolu, children's puppet theatre *The Little Left Shoe* by The Anonymous Theatre (1995), *Tropical Rainforest on the Escalator* by Sand & Bricks with Cheung Tat-ming (1996), *The Girl Who Turned the World Upside Down* by Fredric Mao (1997), *Shooting Suns* by Theatre Ensemble (1998), *Millennium Autopsy* by No Man's Land (1999), *GOKU (Monkey King)* co-produced by theatre groups in China, Hong Kong, Japan and Korea in 2001, *La Casa De* (2002) by Theatre du Pif. Distinct in style and presentation, most of these works were unique and rich with local elements.

1995年以來，由藝術節製作的粵劇，大多是被忽視的經典。如《霸王別姬》(1995)、「紅伶排場戲薈萃」(1999)、《三帥困崤山》(2000)、《曹操關羽貂蟬》(2001)，和「京崑粵紅伶薈萃」(2001)，還有阮兆輝統籌的《呂蒙正——評雪辨蹤》(1998)、「文武雙全陳好逑」(2002)……這些戲曲節目大都能做到叫好叫座，對粵劇的保存發展起著了一定的作用。

室內原創歌劇的製作，走的卻是「高風險」的探索路線，包括有盧景文導演顧七寶的《三王墓》及郭文景的《夜宴》(1999)，還有蘇鼎昌的《阿繡》(2000)，林品晶的《文姬》(2002)，陳慶恩作曲的《蕭紅》(2013) 和《大同》(2015)。

至於跨媒體、跨界別的製作，更能緊扣住香港脈搏，更易傳達出本土意識，風格亦更富探索性。如進念‧二十面體「中國旅程之八」《呢度呢度‧過渡過渡》(1994)、非常林奕華《我要活下去——八十日環遊悲慘世界》(1995)、香港獨立舞者參與舞蹈劇場兩岸三地合作《四川的好女人》(1998)、敲擊和舞蹈《打樂十八層》(1999)、黃耀明、蔡琴與龍植池合作的飛行音樂劇場《花天走地》(2000)、楊春江舞蹈劇場《哥仔戲》(2002) 等。

系列性專題式推動

同時，香港藝術節還採用系列性的專題方式來推動本土節目。1981年至1985年間，便安排持續了五年的香港作曲家作品音樂會。1983年由本地樂人團體演出的「黃昏音樂會」，則持續辦

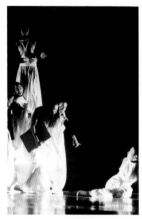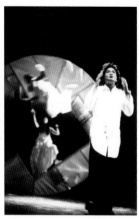

黃耀明、蔡琴、龍植池合作的飛行音樂劇場《花天走地》綵排
Rehearsal of music theatre *Walking with Wings* featuring Anthony Wong,
Cai Qin and Edwin Lung (2000)

Dance programmes from Hong Kong first appeared in the HKAF in 1982. This was followed by City Contemporary Dance Company, Hong Kong Ballet and Hong Kong Dance Company making their debuts in the Festival with unique works that had a strong sense of local consciousness. These original works included *Quadrille* by four choreographers in 1993, *As Quick as Silver* by Mui Cheuk-Yin in 1994, *Autumn Heart* by Helen Lai in 1999, *Mayflies in the City* by Francis Leung Ka-kuen, *The Flowing Sea* by Jiang Huaxuan, *A Brave New World of Suzie Wong* by Yuri Ng in 2001, and the contemporary operatic dance *Kinetic Body Operatics*.

Cantonese operas produced by the HKAF since 1995 have been mostly overlooked classics, including *Farewell My Concubine* (1995), An All-Star Night (1999), *Three Generals Trapped at Mount Xiao* (2000), *Towering Legends of The Three Kingdoms* (2001), "Chinese Opera Extravaganza" (2001), *Lu Meng-zheng — A Poor Scholar* (1998) coordinated by Franco Yuen Siu-fai, and "the Virtuosity of Chan Ho-kau" (2002) series. Most of these Chinese opera programmes were well received by audiences, doing good box office and contributing to the preservation and development of Cantonese opera.

Original chamber opera productions tend to be "riskier" productions that are explorative or experimental in nature, including *The Tomb of Three Kings* and *Night Banquet* (1999) by Brian Chatpo Koo with Lo King-man as director, *The Shopkeeper's Daughter* (2000) by So Ting-cheong, *Wenji* by Lam Bun-ching (2002), *Heart of Coral* (2013) and *Datong: The Chinese Utopia* (2015), the last two composed by Chan Hing-yan.

Cross-media and multi-disciplinary productions have become more relevant in recent times and facilitate a greater expression of local consciousness. Their styles are more exploratory in nature with examples including "Journey to the East Part 8" — *Here Here There There* (1994) by Zuni Icosahedron; *Return of the Cruel Cruel World* (1995) by Edward Lam Dance Theatre; *The Good Woman of Szechwan* (1998) co-produced by Hong Kong and Taiwan dance theatres, featuring independent Hong Kong dancers; percussion and dance - *Boombastic Verses* (1999); the music theatre *Walking with Wings* (2000) featuring Anthony Wong, Cai Qin and Edwin Lung, and dance theatre *Play Boys* (2002) by Daniel Yeung.

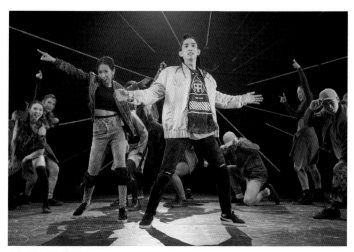

街舞劇場《炫舞場2.0》綵排 Rehearsal of *Danz Up 2.0* (2017)

Launch of Thematic Programme Series

The Hong Kong Arts Festival also promotes local programmes by organising them in thematic series. From 1981 to 1985, the "Music by Hong Kong Composers" programme was presented. The "Serenade at Six" series featuring Hong Kong music artists and groups began in 1983 and continued for six years. It was revamped and repackaged as "Weekend Divertimenti" in 1989. By 1993, it had developed into "Exxon Divertimenti" and further defined its vision in 1998 with the objective of cultivating a younger generation of musicians (1998 to 2001; renamed to "ExxonMobil Vision" from 2002 to 2011). The series comprised three to five programmes each year, diversifying into cross-genre productions and featuring figures from film and television to broaden audience appeal.

The HKAF initiated the "Asia Pacific Dance Platform" in 2009 and the "New Stage Series" in 2011. The Hong Kong Jockey Club Contemporary Dance Series and Jockey Club Local Creative Talents Series were established to nurture Hong Kong's new generation of talent. These programme series became significant driving forces of Hong Kong's performing arts, and helped to polish and shape the Festival's unique identity and branding.

Rich with local elements and consciousness, these unique programmes form the HKAF's important artistic legacy. Some of these productions, with a certain level of artistic calibre and vitality, became the Festival's "international" programmes and have been performed all around the world in recent years. In 2012, *Titus*, directed by Tang Shu-wing, was featured in the Hong Kong Arts Festival before being staged at Shakespeare's Globe Theatre in London; *Green Snake*, co-commissioned with the Shanghai International Arts Festival in 2013, toured Mainland China, Taiwan and Macau before being invited to perform at the John F Kennedy Center for the Performing Arts in Washington in 2014; the commissioned chamber opera *Heart of Coral*, composed by Chan Hing-yan in 2013, was presented in Taipei the following year; the 2015 chamber opera *Datong: The Chinese Utopia*, also composed by Chan Hing-yan, was performed in London in 2018; the 2017 street dance theatre *Danz Up 2.0* was invited to Shenzhen and Singapore; the Cantonese opera *Pavilion of a Hundred Flowers*, which premiered in 2018, subsequently toured to Shenzhen, Shanghai and Guangzhou.

了六年，到1989年更改形式、包裝，改為推出「周末輕組曲」。1993年發展出來的「埃克森能源輕組曲」，持續到1998年才易名為以培養年青一代樂手為宗旨的「埃克森能源新視野」（1998年至2001年；2002年至2011年名為「埃克森美孚新視野」）。每年三至五個項目，形式亦變得多樣化，其中不少都是跨界式製作，還往往引進影視娛樂界藝人，從而亦能打開更闊的觀眾面。

於2009年設立的「亞太舞蹈平台」、2011年設立的「新銳舞台系列」，以及在馬會支持下發掘新一代精英的香港賽馬會當代舞蹈平台 和賽馬會本地菁英創作系列，不僅成為推動本土演藝發展的重要動力，亦成為藝術節打造形象及獨特品牌的重要產品。

這些富有本土色彩和意識，具有獨特風格的節目，都已成為香港藝術節重要的藝術資產，其中好些具有藝術水平和生命力的製作，在各方條件配合下，近年更已成為香港藝術節的「國際性」節目，輸出到世界各地。2012年由鄧樹榮執導的《泰斯特》在香港演出後隨即在倫敦環球劇場公演；2013年與上海藝術節聯合委約的《青蛇》，在中國內地、中國台灣及中國澳門巡演後，2014年還獲邀在華盛頓甘迺迪演藝中心演出；2013年委約陳慶恩作曲的室內歌劇《蕭紅》，翌年出訪台北，2015年同樣由陳慶恩作曲的室內歌劇《大同》，2018年出訪倫敦；2017年街舞劇場《炫舞場2.0》應邀到深圳、新加坡巡演；2018年首演的粵劇《百花亭贈劍》便曾在深圳、上海和廣州巡演。

深耕細作社區扎根

香港藝術節的規模能將國際性的節目和本土節目結合不斷擴大，影響力不斷增強，很多時會被忽略的是奠基在大量於社區深耕細作的扎根工作。從早期開始，香港藝術節便特別重視新一代觀眾的培養，排隊輪購學生特價門票的現象，很多人至今記憶猶新（這是當年報章上「一年一度」的新聞），及後1992年設立「青少年之友」，從早期向中學生擴展至大專院校，發展到今天成為培育青少年欣賞演藝的多元化綜合藝術普及計劃，成立三十年來已觸及七十九萬九千位學生，累計會員人數近十七萬九千。不僅透過講座、大師班、工作坊、後台參觀、觀看綵排、與藝術家對話，還有「學生專場」，甚至「會員專享節目」，提供「認識·發掘·創造」藝術的機會。「青少年之友」規模之大，不僅在國際上實屬少見，亦已成為現今大量演藝觀眾美好的成長回憶。

在「青少年之友」的組織外，藝術節在各方贊助下，通過「學生票捐助計劃」，每年提供約一萬張半價學生票，同時並開展針對大、中、小學生的藝術教育活動。每年還會舉辦逾三百項深入社區的「加料節目」，以多元化，多層面，帶有教育性、普及性的方式來讓不同的社會人士參與。

另一方面，2019年香港藝術節走進擁有一百七十多年歷史的中區警署建築群——「大館」，由香港賽馬會慈善信託基金獨家贊助，將更多元的藝術節目帶入新的空間，拓展新的社群。同年，與香港賽馬會慈善信託基金聯合創辦的「無限亮」計劃，更是香港藝術節透過藝術以及社區合作推動共融的新挑戰，在迎接藝術節五十周年來臨之前的三年間，除引進來自海外優秀的不同能力藝術家和他們出色的節目，更刺激了不少香港傷健同台的表演。即使在非常時期的2021年，亦組織了True Colors Symphony 弦樂組及本地不同能力的音樂家，在網上舉行了一場充滿正能量的音樂會。特別在疫情下，這種聯繫社區，發揮藝術滋潤心靈的作用，便顯得更為可貴。

這些從每年藝術節的節期延伸，於社區深耕細作的扎根工作，正是香港藝術節能持續與時俱進背後至為重要的支持所在。

Careful Cultivation and Taking Root in the Community

The scale of the HKAF allows the event to strengthen the integration of international and local programmes while having a greater impact in the city. An aspect that has often gone unnoticed is the Festival's intensive trojan efforts to take root in the community. Since its early days, the HKAF has paid considerable attention to cultivating new audiences. Many might recall the long queues for student tickets often reported in the news every year. Young Friends, established in 1992, initially catered to secondary school students, later extended its reach to tertiary students. It is now an integrated audience development programme designed to nurture students' interests in the arts. Over the past 30 years, Young Friends has reached over 799,000 students, including around 179,000 members. The spectrum of activities includes talks, masterclasses, workshops, backstage tours, rehearsals, meet-the-artist sessions, and even "student matinees" and Young Friends Specials, all of which provide opportunities to "LEARN, EXPLORE, CREATE" art. It is a major initiative whose size is rare among its international counterparts, and it has also created fond memories for many audiences.

Besides Young Friends, the HKAF also sought donations to make approximately 10,000 half-price student tickets available each year through the Student Ticket Scheme. This is coupled with arts education activities for tertiary, secondary and primary school students. The Festival also presents over 300 "PLUS" programmes that offer diverse, multifaceted, educational and accessible arts experiences to engage people from all walks of life.

In 2019, the HKAF expanded its presence to Tai Kwun, the new arts centre in the historic former Central Police Station compound. An array of diverse arts programmes are presented annually to reach new audiences. The HKartsFestival@TaiKwun is solely sponsored by The Hong Kong Jockey Club Charities Trust. In the same year, the HKAF and The Hong Kong Jockey Club Charities Trust co-presented the "No Limits" initiative, to promote inclusiveness and understanding via the arts. In the three years leading up to the Festival's 50th anniversary, the project featured exciting programmes by outstanding international and local artists of different abilities. Even in the challenging year of 2021, a concert featuring the string section of True Colors Symphony and local musicians of different abilities was held online. Bursting with positive energy, the concert was a rare gem of an event that connected the community and nourished the soul through art during the epidemic.

「無限亮」節目：Shannon Yee《感官重組》
"No Limits" Programme: Shannon Yee — *Reassembled, Slightly Askew* (2019)

「營運之道」爭取平衡

現今要保持一個藝術節的地位和影響力，已非只講求藝術水平的追求，更多的在講求「營運之道」。藝術產品（節目）要平衡，國際性與本土節目的配合，既要滿足藝術消費者的要求，又要發揮帶動藝術發展的影響力；運作收支更要平衡，這便非要有「營運之道」不可了。

香港藝術節自鄭新文掌舵開始 (1988年7月-1994年)，到現任何嘉坤的三十多年，「營運之道」便明顯地在與時俱進去尋求平衡之術。何嘉坤於 2006年上場後，在各方面更為進取，節目上的平衡更是費盡心思，一方面拓展更多不同類型的節目，特別是具有龐大市場，融合了各種元素（特別是娛樂元素）在內的「多媒體」製作；另一方面，為求提升藝術節的地位和影響力，委約創作新作品，引進具有創意的新節目，甚至負起策劃製作，主動催生新意念的新作品，促進不同界別，不同城市的藝術家合作，數量更是逐年增多。

毫無疑問，鼓勵創意性新作，引進新節目，確是具有遠見和地位的藝術節要向歷史交待的責任。經典、大名的節目不能缺，能反映現今藝術世界的原創藝術製作更是必須，既要有市場號召因素的節目，亦要有小眾創意的製作，但高成本的製作卻不能多。在這基礎上「持續」與「多元」便成為近年來藝術節節目發展的兩個重要方向。此外，在經典以外，引進新的作品，和跨媒體，或跨文化，帶有前衛色彩，能拓闊觀眾層面的節目，亦一直是藝術節能緊跟時代脈搏，與時俱進，不能或缺的成份。只有取得平衡，香港藝術節才能加強持續發展，打造獨特的品牌。

These intensive and dedicated efforts by the HKAF to take root in the community, which extend beyond the Festival period, lay the foundation for the HKAF to stay relevant and keep pace with the times.

Seeking a Balance in "Operating Philosophy"

Maintaining the status and prestige of an arts festival nowadays requires not only the pursuit of artistic quality but also a commitment to "operating philosophy". The art products must have a balance of international and local programmes, and meet the needs of art consumers while having an impact on arts development. Needless to say, breaking even is also a key objective. And a certain operating philosophy is needed to make the balance possible.

In the 30-odd years since Tseng Sun-man took the helm of the Hong Kong Arts Festival, the operating philosophy has evolved in sync with the times to seek this balance. After Tisa Ho began to oversee the HKAF in 2006, it became more proactive in general, with the balance in programmes becoming more sophisticated. The Festival expanded its programme diversity, particularly with multi-media productions of mass-market appeal and a variety of elements with entertainment a key consideration. At the same time, new works were commissioned to elevate the stature and prestige of the Festival. Innovative programmes were conceived with the Festival taking charge of planning and production to spawn new works with original ideas. This led to even more collaborations between artists from different disciplines and cities, and the number of such works increases by the year.

Undoubtedly, an arts festival with vision and prestige will make its mark by encouraging new works and introducing innovative programmes. There should be enduring classics and popular programmes, but original artistic productions reflective of the current art world are just as essential. The balance entails both programmes with market appeal and creative productions with a niche audience. However, the number of expensive productions has been curbed. "Sustainability" and "diversity" thus became the two prime directions of development in the Festival's programmes in recent years. Programme line-ups include perennial classics, new works, multi-media or multi-cultural avant-garde programmes that broaden the audience base. The combination is critical to the Festival staying relevant and keeping up with the times. Only with a delicate balance can the HKAF strengthen its sustainability while maintaining its unique identity.

三方平衡豈是易事

香港藝術節現時的經費除了來自香港政府的資助，更多的是來自香港社會各方面的捐款與贊助，以及票房收益。事實上，在這五十年間，藝術節的收入支柱及比例也經歷過不少變化。初期的藝術節未獲得任何政府資助，經費主要依賴商界贊助以及票房收入。然而受1973年的股災影響，當時的票房成績並不理想（1974年僅賣出65%的門票），募集資金也是十分艱難的任務，令藝術節一度陷入財政危機。直至1976年，門票的整體銷售率提升至約90%，而政府也在同年第一次正式撥款資助，並決定在日後繼續給予支持，藝術節的財政狀況亦逐漸穩定了下來。

於1988年，當時新上任藝術節總經理的鄭新文提出必須著手設計一套更完善的籌款制度，讓藝術節有更穩固的財政基礎。因此於1990年，藝術節執行委員會確立了發展統籌一職，專注處理籌款工作；而負責為藝術節尋找贊助的籌款委員會，也在當年的開幕贊助機構 —— IBM的中國/香港常務董事邵偉志的帶領下於1991年成立，藝術節籌款從此正式進入有系統階段。

在藝術節發展中期約十年期間，政府資助及各大企業的贊助各佔總經費約27%，而較大部份的經費則來自票房收益（約38%）。直至近年，來自各大企業、熱心人士和慈善基金會的捐款和贊助，成為了藝術節極為重要的經費來源。以2019年為例，藝術節總收入約港幣一億五千四百萬，當中約38%來自贊助與捐款；約24%來自票房收益。而政府的基本撥款約佔總收入的17%。另外18%左右則來自政府針對捐款和贊助收入而提供的配對資助。

A Tough Triple Balancing Act

The HKAF is currently supported by income from government subventions and, on a greater scale, from Hong Kong sponsors and donors, as well as box office income. The primary sources of the Festival's income and their proportion have also varied throughout the last 50 years. In its early days, the Festival received no government funding and was supported primarily by commercial sponsorship and box office income. Because of the 1973 stock market crash, however, ticket sales were less than satisfactory (only 65% of tickets were sold in 1974). Fundraising also proved to be a very difficult task, and the Festival fell into a financial crisis at one point. It was not until 1976 when the Arts Festival's finances gradually stabilised as overall ticket sales increased to around 90% and the government provided formal funding for the first time and pledged to provide continuing support, which continues to this day.

Tseng Sun-man was appointed General Manager of the Festival in 1988, and he immediately underlined the necessity of devising a comprehensive fundraising system to provide a stronger financial foundation for the Festival. As a result, the Arts Festival's Executive Committee established in 1990 the post of Development Coordinator which is devoted to fundraising endeavours. The Development Committee, responsible for seeking sponsorship for the Festival, was also established in 1991. It was formed under the leadership of Robert M. Savage, then CEO and Chairman of IBM China/Hong Kong, which happened to be the sponsor of the Festival's opening programme. This marked the start of systematic fundraising for the Festival.

For around ten years in the middle phase of the HKAF's development, government subventions and sponsorships from large corporations each accounted for 27% of total income, with the majority generated through ticket sales (around 38%). This trend kept evolving, and in recent years donations and sponsorship from corporations, individuals, and charitable foundations became an extremely important source of funding for the Festival. For example, the Festival's total income in 2019 was around HK$154 million. Around 38% of the Festival's income came from sponsorship and donations, and around 24% from box office. Secured government baseline funding represented roughly 17% of total income, with another 18% coming from the Government's matching scheme, which matches income generated through private sector sponsorship and donations.

為此，爭取社會各界贊助、捐款，以及通過售票方式來支持，便成為藝術節成功運作的重要因素。其實，對香港藝術節來說，票房壓力一直很大。作為藝術節的工作團隊，在節目設計及實際運作(如釐定票價、行銷手法)等各方面，既要贏得藝術上的好評，亦要爭取得高售票率，更要考慮收支補貼的因素。也就是只有在藝評人、觀眾、贊助者這三方面能取得平衡，藝術節才能保持品牌效應，向前發展。毫無疑問，票價制訂高低取用的策略，是藝術節營運中一項重要的元素，但在壓力下要求取得高票房收益，除了選擇節目的「眼光」、市場行銷的成效，更在於選取節目時的種種精準估計，這包括節目的製作成本與票房收益，能否達到預計的目標。為此，選擇合適的場館，確定演出的場數，便往往成為關鍵因素。

如何在票房與藝術之間取得平衡確是很大的挑戰。至於藝術節當局如何去爭取贊助機構的支持來達到平衡之道，那雖然是「業務機密」，但可以肯定的是，作為「香港」的藝術節，能打好立足香港的基石，當是要成功爭取贊助的重要前提，這亦正是香港藝術節要在社區深耕細作的其中一個原因。

香港藝術節一路走來的「營運之道」，經歷過初期探索，進行修訂，再度出發，與時俱進的不同階段；但一直沒有改變的是採用由香港藝術節協會監管，不受官方影響的獨立運作模式，這亦可說是香港藝術節今日賴以成功的基石所在。

第28屆香港藝術節《藝資》中的捐款宣傳廣告
Donation appeal advertisement in the 28th HKAF FESTART

Therefore, seeking support for the HKAF through sponsorship and donations as well as ticket sales is critical to its successful operation. Box office performance has always been a source of great pressure for the HKAF team. In terms of areas like programme design and actual operations such as setting ticket prices and marketing, there are a multitude of factors to consider, including receiving good reviews, achieving a high percentage of ticket sales, and income and expenditure. It is only through a triple balancing act between art critics, audiences, and sponsors that the HKAF can maintain its branding while moving forward. The approach in setting ticket prices is undoubtedly a decisive element in the HKAF's operations. Forced to attain high box office income, having the "foresight" in programme choices and gauging the effectiveness of marketing activities has become vital. Also critical when choosing programmes is having precise estimates as to whether projected production costs and box office figures can be achieved. Consequently, key factors also include choosing the appropriate venue and deciding on the number of performances.

It is indeed a challenge already to strike a balance between box office and artistic success. Adding to the equation is seeking sponsorship, the approach to which may be a "trade secret" kept by the HKAF. What is certain, however, is the HKAF being an arts festival in, of and for Hong Kong with deep roots to the city. This is likely a prerequisite for its success in sponsorship, and one of the motivations for the Festival's dedicated efforts in community outreach.

Over the years, the HKAF's operating philosophy underwent iterations and stages, including initial exploration, revisioning, revamping and a commitment to staying relevant. Nevertheless, what remained constant was the practice of the Festival being overseen by the Hong Kong Arts Festival Society and its operating independent of the government. These are also the cornerstones of the HKAF's success.

幅射影響持續增加

香港藝術節的影響，數十年來對香港藝術發展，對香港社會的文化生活和生態帶來的轉化，一般會從藝術和觀眾的層面去看。藝術上的層面，可從歷年來媒體上專業的和非專業的評論及報導上獲得答案。在過去一路走來，一年一度的香港藝術節早已成為全球媒體聚焦的所在，大量的評論及報導見於歐美及大中華地區，線上及線下的不同媒體空間，這可是一種世界性的影響力！

觀眾的層面自上一世紀七十年代末期，隨著中國內地開放政策的推行，更有了明顯的變化，除了香港本地的觀眾，中國內地觀眾亦加入了台灣、東南亞和澳門周邊一年一度到藝術節「朝聖」的觀眾行列。但更大影響卻是，香港藝術節的輝煌業績在踏入千禧年前開始，對中國內地更發揮了「示範」作用。中國內地隨著經濟逐漸起飛，新修建的音樂廳、大劇院在各省市興建，這些新的演藝場館要組織節目，要辦音樂節、藝術節，亦紛紛到香港來考察「取經」。筆者便曾為好些內地場館穿針引線，近者如深圳音樂廳，遠者如西安音樂廳，都曾連續多年安排有關人員來香港藝術節「觀摩」。這種對中國內地演藝場館的節目策劃管理所帶來的影響有多大，自難以量化來估計。情況就如早著先鞭的台灣，每年藝文界同行與媒體人員都會「組團」到香港藝術節來「觀摩」，對台灣帶來多大影響一樣，那同樣是有待研究的課題呢。

其實更大的影響卻不是一般「觀摩」、「考察」所能看見的，那就是背後的「營運之道」，如何才能取得「三方平衡」，這才是香港藝術節能成功寫下半個世紀的香港故事最具影響力的所在。但無論如何，儘管2020年的新冠肺炎疫情，重創了全球的文化藝術產業，特別是演藝活動，互動交流的機會面對新挑戰，但香港藝術節的影響力仍會持續幅射開去。

Radiating Effect of Festival Continues to Grow

In the last several decades, the Hong Kong Arts Festival has left its imprint on the city's arts development and changed the course of Hong Kong's cultural lives and ecosystems. On the artistic front, its influence can be discerned from reviews, both professional and non-professional, commentaries and news coverage over the years. The annual HKAF has long become a source of attention from international media with a considerable volume of reviews and coverage in both online and print outlets spanning Europe, North America and the Greater China region—a considerable international footprint.

The audience demographic underwent marked changes. Mainland Chinese art lovers joined other nationalities in making annual "pilgrimages" to the HKAF. The greater impact, however, was the significant "demonstrative effect" provided by the Festival towards Mainland China which started before the turn of the millennium. As the economy took off on the Mainland, newly built concert halls and grand theatres sprang up in different provinces and cities. These new performance venues would play host to arts programmes, music festivals and arts festivals, and many arts personnel drew on their experience of visiting Hong Kong for the Festival. On many occasions I acted as liaison for Mainland venues such as Shenzhen Concert Hall and Xi'an Concert Hall. For many years, staff from such venues visited Hong Kong and observed the Festival. These visits had an immeasurable impact on programme planning and the management of performance venues in Mainland China. This is comparable to Taiwan's earlier practice with the arts sector where media personnel formed groups to visit the HKAF to learn and observe. Taiwan's experience from such practices is also worthy of discussion.

What cannot be "observed" or "inspected" on the surface, however, is the underlying operating philosophy which is more crucial for success. Achieving the "triple balancing act" is essential to the HKAF in continuing its journey in Hong Kong in the next 50 years. The COVID-19 pandemic had a severe impact on the global arts sector in 2020, making a significant dent on performing arts activities and opportunities for interactive exchange. Nevertheless, HKAF's radiating effect will continue to grow.

前景新機遇新空間

2020年香港藝術節面對突然來襲的疫情，儘管原定2、3月舉行，合共超過十萬張門票的一百二十三場售票節目要取消，但「香港藝術節@大館」，及第二屆「無限亮」的部份節目仍得以在年底時轉到網絡上舉行。同時儘管失去所有票房收益和要退還贊助機構的大部份贊助，但仍能在各方努力下，在2019-20的財政年度錄得盈餘，保持適當的財政儲備。

2021年更能在疫情「新常態」下，以「遠在⋯咫尺」為「主題」，分別推出「現場節目」（十個）和「網上節目」（二十八個）兩大類，當中仍有二十五個新創作，二十一個為藝術節委約及製作，雖是全新挑戰的一年，但亦為藝術節的發展帶來新機遇，刺激拓展新空間。「現場」與「網上」的特別設計，會否成為日後的新常態，雖然仍難說得準，但對半個世紀以來與時俱進的香港藝術節而言，繼續探索新的藝術形態和拓展新的平台空間，應當是未來的發展路向。能跨越地域文化的網絡世界，如何結合場館實體和網絡特性，尋找新的美學，新的藝術形態，就更是有待探索的新空間。攝影結合劇場戲劇，走上大熒幕發展出第九藝術的電影文化，在網絡5G 4K的世代，與時代緊扣的香港藝術節，又豈會對此忽視呢？

事實上，在2021年特別的第49屆，便靈活地安排了網上及實體演出，以網上實時互動的方式帶來獨特的節目，如海外藝術家史葛・蕭凡的實時互動網上演出《心靈旅程》，以及由六位來自不同國家演員演繹的《鼠疫》（英語版），香港中樂團「樂旅中國」的開幕音樂會同步在香港文化中心上演及於網上播放後，觀眾仍可在網上免費重溫三天。

歷年來在香港藝術節的演出場刊最後部份，都有兩、三頁篇幅清楚列出協會的架構，包括執行委員會、節目委員會、籌款委員會等組織人員；藝術節實際執行團隊，上至行政總監、下至可能只是在主要節期中兼職一兩個月的「合約職員」，都一一清楚列出，展示出藝術節重視每一位參與員工的貢獻的團隊精神。事實上，將要走進第二個五十年的香港藝術節的前景如何打造？能否在放眼世界、立足本土的基石上再上層樓，動力便來自這份名單了。🌸

寫成於 2021年4月2日 耶穌受難日

周凡夫（右二）出席第45屆香港藝術節記者會
Chow Fan Fu (2nd right) at the 45th HKAF Kick-off Press Conference (2017)

Prospects in New Opportunities and New Performing Spaces

In 2020, faced with the sudden outbreak of the epidemic, 123 ticketed programmes originally scheduled for February and March, with more than 100,000 tickets sold, had to be cancelled. Nevertheless, it was possible to present some of the programmes in HKartsFestival@TaiKwun and the second edition of "No Limits" online later in the year. With the dedicated effort of all involved, a surplus was recorded for the 2019-20 financial year, providing appropriate financial reserves. This was no small feat, considering the loss of all ticket incomes and the necessity of returning much of the sponsorship revenue to sponsors.

Adapting to the new normal with the epidemic in 2021, the 49th HKAF's theme was "Separate Together" and featured a combination of ten in-venue programmes and 28 online programmes, 25 of which were new works and 21 commissioned and produced by the Festival. It was a year filled with new challenges, but opportunities also abounded in the development of the Festival as new performing spaces were pioneered. It remains to be seen whether the in-venue and online arrangements will become the norm in the future. However, the HKAF has deftly kept pace with the times over the last half-century, upholding a global vision while being solidly grounded in local development. So it seems reasonable for the Festival to prioritise exploring new art formats and pioneering new performing spaces for the years to come. With the digital world blurring geographical boundaries and culture, there are new opportunities ahead in exploring new forms of aesthetics and art by integrating and exploiting the potential of physical venues and online space. As filmed theatre becomes a staple of cinema distribution and develops into a Ninth Art, the ever-adapting HKAF is certain to take note of it in the current era of internet, 5G connectivity and 4K resolution.

第49屆香港藝術節宣傳廣告
Advertisement of the 49th HKAF

The 49th Hong Kong Arts Festival in 2021 was, indeed, a flexible hybrid of online and in-venue performances, offering unique programmes that were online, live, and interactive. These included *The Journey*, an immersive and interactive live online production by Scottish illusionist Scott Silven, and *The Plague* (English version), directed by Wang Chong and featuring six actors from six different countries. The Festival's opening programme, "Music about China" by the Hong Kong Chinese Orchestra, was presented live at the Hong Kong Cultural Centre and also streamed live, with the programme available for online replay for three days.

Over the years, the last two or three pages of a HKAF house programme have invariably listed the structure of the organisation, including the Executive Committee, Programme Committee, Development Committee, as well as every single member of the Festival's staff team, from Executive Director to the contract staff, some of whom might be employed for just one or two months during the Festival's busiest period. This is testament to the HKAF's team spirit, which values the contribution of each of its team members. With the Hong Kong Arts Festival on the cusp of another 50 years, it has the exciting prospect and potential to reach greater heights by upholding its global vision while maintaining its local foothold. The driving force for this lofty vision will come from everyone in the list. 🏵

Good Friday, 2 April 2021

周凡夫 (1950–2021)

原名周卓豪，為香港資深藝評人。活躍於陸港台澳兩岸四地，評論領域橫跨各表演藝術和藝術行政，一直關注香港藝術節的發展。

Chow Fan Fu (1950-2021)

Chow Cheuk Ho, more often known as Chow Fan Fu, is a highly respected commentator on arts and culture. Based in Hong Kong and active in Mainland China, Taiwan and Macau, Chow has covered a wide range of subjects in the performing arts and in arts administration. Chow was a keen observer of developments in the Hong Kong Arts Festival over the years.

HKAF
香港藝術節
2022

挑戰與展望
Challenges and Looking Ahead

「Not in the same boat but in the same river (面臨同樣的困境)」，正當全球面對突如其來的新冠病毒來襲，2020年香港藝術節也要被迫取消，實屬史無前例，藝術節行政總監何嘉坤 (Tisa) 套用了一句英文諺語來形容疫情。「不獨我們藝術界，整個世界都要應付這突變帶來的艱鉅挑戰，解決眼前當下的問題，揣摩調較未來的導向。」

2020年藝術節原定於2月18日開幕，本來一切就緒，終於在開幕前八天宣佈取消所有的演出及活動。「雖然是極為失望，但很感激執行委員會非常決斷，不是抱著觀望推遲一兩個節目，或是冒險照常舉行，而是很清晰地要取消整屆節目。這樣，我們便可以隨即跟各地藝術家、合作夥伴、贊助商、物流等交待，然後公佈消息，令我們有時間做跟進工作。」Tisa 很感謝不同夥伴的諒解及支持，雖然大家也覺得非常可惜。第四十八屆的節目被迫取消，隨即要密鑼緊鼓，準備部署2021年的節目。

As the entire world battled the onslaught of the coronavirus in 2020, the Festival had to be cancelled for the first time in its history. "Not just the arts sector but the entire world had to deal with sudden and difficult challenges, resolve immediate issues and contemplate future directions. We may not have been in the same boat but we were all in the same river," says Tisa Ho, the Festival's Executive Director.

Originally primed and ready to commence on 18 February 2020, the Festival announced cancellation of all its performances and activities eight days prior: "Although it was disappointing to say the least, we were grateful for the Executive Committee's clear decision. Instead of wavering and considering whether to postpone one or two programmes or taking the risk to proceed, the entire lineup was cancelled with no uncertainty. This helped us to communicate immediately with all the participating artists locally and across the globe, as well as other stakeholders, partners and sponsors while preparing the public announcement. The arrangement gave us time to deal with logistics and follow-up work." Ho was immensely appreciative of the understanding and support from all collaborators. Although cancellation of the 48th HKAF performances and events was a pity to many, intensive planning for subsequent dates immediately went underway.

快刀劇場《無晴情天氣報告》
The Chop – *Pathetic Fallacy* (2021) (© Peter Pokorny)

多瑪倉庫劇院《盲流感》
The Donmar Warehouse – *Blindness* (2021) (© Helen Maybanks)

疫情下的藝術新常態

「我們只能邊做邊學，因為各地的情況不一，檢疫隔離措施對大多海外藝團來說，都會困難重重，所以海外的節目實在難以安排，於是，我們轉以網上版作為後備方案。至於本地節目，我們不希望全部變成線上演出，想盡量安排作現場上演。然而，有段時間香港的場館要暫停開放，或因『限聚令』甚至沒法綵排。若最後準備時間不足夠，唯有改作網上版推出。當然，網上版拍攝需時，拍攝完又要後期製作，因此，2021年藝術節延伸到6月還在進行。」Tisa大讚同事學習、應變能力高強，因為製作網上節目跟劇場演出，完全是兩碼子事。

Tisa分享了疫情下的藝術新常態，「面對疫情肆虐之際，劇場唯有迅速適應新現實，開拓新的形式和製作手法。2021年我們也帶來了兩個海外戲劇作品——《盲流感》和《無晴情天氣報告》，兩齣都是不需要藝術家來港也能做到的節目。另外《鼠疫》(英文版)亦是一個嶄新嘗試，有來自六個國家的演員在網上實時演出。這些節目或許令觀眾重新思考戲劇，因為都不是傳統的觀賞體驗，而是新的演繹模式。」

New Normal for the Arts amid the Pandemic

"For the hybrid form in 2021, we were essentially learning by doing because the situation varied from place to place, and continued to evolve. Quarantine and isolation measures became insurmountable challenges for the majority of overseas arts groups, and online versions of performances became an alternate solution. As for local programmes, we really wanted to deliver some physical and in-venue performances. However, there were times when Hong Kong venues were closed and even rehearsals became impossible because of prohibition against gatherings. Whilst online performances were possible, it takes time to film a performance and to complete post-production work, and so Festival performances continued to be presented till June in 2021." Ho had nothing but praise for the Arts Festival team which was fast in learning and quick in adapting to changes, including producing online programmes which were radically different from in-venue performances.

Ho further commented on the new normal for the arts amid the pandemic: "Theatre was forced to swiftly adapt to a new reality, trying out new formats and production methods. We presented two overseas theatre productions in 2021: *Blindness* and *Pathetic Fallacy*. Both programmes could be presented in venue in Hong Kong without the physical presence of visiting artists."

醞釀演繹新語言

至於2022年第五十屆的節目，同樣要面對不確定的環境，在籌劃的過程中，要作多方面的考量。「我們一方面緊貼政府對不同國家所實行的措施，同時跟海外的藝術家洽談，反覆商討不同的計劃安排，例如藝團能否接受隔離的規定，時間表能否配合，雙方甚麼時候要作最後決定等。」

誠然，有些節目以網上版上演已是必然之選，然而，藝術節不會只是採取直播或網上播放的形式。第五十屆的藝術節重點節目─《拉娜》，便是近年結合藝術與科技的嶄新嘗試。《拉娜》是藝術節與芬蘭國家歌劇院及芭蕾舞團(歌劇院) 聯合製作，並由香港賽馬會慈善信託基金獨家贊助。談到這個大型項目，Tisa 也興奮起來：「2019年特首《施政報告》提到，政府會發展藝術科技，其實我們早已探索各種可能性。」

《拉娜》打破了傳統歌劇的概念與模式，讓參與者猶如親歷其境，既是觀眾又是表演者！我們希望觀眾發覺原來歌劇也可以用這種模式製作，當然大家亦可欣賞到芬蘭音樂大師埃薩-貝卡·沙羅倫的精湛造詣。雖然疫情令到場館再一次關閉，觀眾最後未能親身欣賞《拉娜》，藝術節特意把幕後花絮拍攝成製作特輯，讓觀眾一探藝術科技如何融入於表演藝術當中。」

疫情帶來學習很多新事物的契機，同時要重新思考舊有的模式。Tisa 帶出另一個議題：「我們還要思考的是碳排放問題。這麼多年來，藝團到訪世界各地巡演，整個業界真要考慮有甚麼方法可以減少碳排放的影響？現在的模式似乎是不理想。如果要一百人的藝團遠赴海外演出，是否只演出兩場便離開，可否多留一些時間參與其他活動？我不是期望取消所有的巡迴演出，而是考量怎樣善用每個藝團來訪的機會。」

拓展觀眾群

藝術節一直以服務香港為宗旨，同時也希望吸引訪港旅客。Tisa 認為：「藝術節無論怎樣都是以香港為先，倘若有海外觀眾從周邊地區來港觀看藝術節，其實也是幫助香港的旅遊業。只要我們的節目做得好，便是一個代表到香港的品牌。」Tisa 說其實國際間的表演藝術機構都很欣賞香港藝術節的構思和策劃，對藝術節有很高的評價。

Innovation on the Horizon

In an environment full of uncertainties, numerous considerations were taken into account when planning for the 50th HKAF programmes in 2022: "We kept a close watch on travel restrictions relating to different countries. At the same time, we were in discussion with overseas artists about possible arrangements for their travel, whether they would be willing to quarantine, and having a mutually agreed timetable including the deadline for final decisions to be made."

Some programmes had to be presented online, but it was no longer just a matter of simply presenting live or online. A case in point is *Laila*, one of the major highlights of the 50th HKAF. A bold attempt at integrating performing arts and cutting-edge technology, *Laila* is a co-production of the HKAF and Finnish National Opera and Ballet. It is an immersive, interactive opera experience, solely sponsored by The Hong Kong Jockey Club Charities Trust. Ho spoke with excitement about this large-scale project: "When the government included development of arts technology in the Chief Executive's Policy Address 2019, we were already exploring these possibilities. With *Laila* the audience will see that even opera can be transformed from its tradition form and integrated with technology of today, in the hands of Maestro Esa-Pekka Salonen. Although venues are closed under the severe pandemic situation and audiences cannot experience the work in person, HKAF is specially putting together a making-of that allows audiences to go behind the scenes and explore how arts and technology can be blended into performing arts."

With the new challenges and opportunities thrown up by the pandemic, there was a lot to learn and to reconsider. Ho is also concerned about the environment: "As arts groups tour around the globe, a big question for our entire sector must include the issue of carbon emissions. How can this be reduced? What can we do better? The current practice is not sustainable. We need to think of new ways to manage this. For example, if an arts group with 100 people travels abroad for performances, is it possible to stay longer than the duration for a few performances, and participate in other activities? It is not a question of cancelling touring performances but careful consideration about how to achieve the full potential of each opportunity."

Audience Expansion

Although tourism was high on the agenda when the Festival started, times have changed and the mission of the Festival is to serve Hong Kong. Ho says: "Hong Kong audiences is our first priority,

跨進第五十屆，Tisa 對未來的憧憬是：「希望能把非香港觀眾的比例增至 30%，之前做的統計調查大概是13%。我認為香港觀眾層有飽和的跡象，如果能吸引多點遊客，除了對香港旅遊業好，也幫助藝術節推進多一步，以致香港在國際的形象也會受惠。不過如果多過三成的非香港觀眾，則會改變我們的定位及性質。」

Tisa 認為藝術節的節目絕對可以吸引不同地方的遊客，只需要多點推廣宣傳。「半日之內能抵港已是我們的目標市場。」除了中國內地、中國澳門和中國台灣，韓國、日本、新加坡、泰國，都有遊客專程來香港觀看藝術節目。「記得有一年美國芭蕾舞劇院吸引了菲律賓一班芭蕾舞學生，專程集體來看演出，因為那次除了演出外還有加料節目的大師班，即使飛到美國看演出也沒有機會跟舞者上課呢。此外，常有新加坡遊客來聽歌劇，日本探戈迷來看舞蹈等等。當然，像紐約愛樂樂團這些大團，經常到世界各地巡迴演出，其他城市的觀眾不用刻意飛來香港。不過，藝術節的節目就是可以照顧到不同人喜好，吸引不同群組的人來參與。」

Tisa 強調藝術節一直也是跟隨社會環境轉變，而疫症的出現只是加快了步伐。「我們當下是選取一個較平衡的方法，尋找不同的模式把藝術帶給觀眾。即使是網上節目，我相信藝術節的策展手法就是我們獨特之處。例如 2021年藝術節，我們一口氣帶來多齣馬修·伯恩的舞蹈電影作品，令觀眾對這位藝術家有更深更闊的認識。此外，我們不斷思考，香港藝術節在國際平台怎樣運作下去，與藝術家的合作模式，以及如何把本地的作品推廣至境外等等。」

新冒險舞蹈團及 Illuminations 製作 – 馬修·伯恩
舞蹈電影《紅舞鞋》節目場刊
House Programme of a Matthew Bourne's
New Adventures Production – Ballet Film *The Red Shoes* (2021)

《拉娜》 *Laila* (2022)

but overseas audiences are most welcome and contribute to Hong Kong's tourism industry. As long as we do a good job with the programming, the Festival will continue to be a leading Hong Kong brand." According to Ho, the international arts community holds the HKAF in high regard because they understand and appreciate how the Festival's programmes are composed, curated and planned.

As the Festival enters its 50th edition, Ho has been with the organisation for over 15 years, and would like to see non-Hong Kong audiences go up to about 30 per cent, from the 13 per cent shown in previous surveys. With signs of saturation among the Hong Kong audiences, she feels that this increase could be helpful impetus to the Festival while contributing to the city's tourism industry and international image. "However, if the proportion of non-local audiences exceeds 30 per cent, this will impact our identity and positioning," she says.

Ho believes that with additional efforts in promotion, the HKAF programmes can definitely draw visitors from different places: "Our target market includes anywhere that is within half a day's travel." In addition to visitors from Macau and Mainland China, HKAF audiences also included tourists from South Korea, Taiwan, Japan, Singapore and Thailand who came specifically for HKAF programmes. "I remember students from a ballet school in the Philippines coming to the Festival as a group to attend performances by American Ballet Theatre. They came not only for the performance but also for the PLUS events including classes with the dancers. This would not have been possible even if they attended performances in the United States. The HKAF audience occasionally includes Singapore visitors who came for opera, and tango aficionados from Japan. Of course, major arts groups such as the New York Philharmonic often tour around the region, making it less likely for audiences from other neighbouring cities to visit Hong Kong just for their performances. However, the strength of HKAF programmes lies in its diversity and its appeal to a wide range of potential audiences."

上海歌劇院及蘇州交響樂團
Shanghai Opera House and Suzhou Symphony Orchestra (2022)

在未知中製造可能性

雖然這兩年沒法親自飛到外地尋找節目，節目總監梁掌瑋 (Grace) 跟海外藝團和藝術家依然保持密切聯繫。經歷過劇院關閉的日子，藝術文化節目停擺，Grace 說大家都在積極面對和努力適應。她說：「在這生態下努力讓表演藝術繼續生存，這是無計劃中的計劃。在重重限制和不確定的環境下，策劃藝術節，形式必須要多元化。其實，網上節目只是短期的策略，至於科技的應用，也必須要掌握如何與藝術連繫。」

正正是要考量怎樣善用每個藝團來訪的機會，Grace 指出 2022 年藝術節的一個策劃特色，也許未來會朝這方向：「有別於以往藝團來港演出兩三場，像跑碼頭一樣，這次會有點像駐節藝術家的形式，跟觀眾和本地藝術家多些合作交流。因為防疫政策所限，藝術節的節目多是來自內地，好像從北京來的鋼琴家陳薩，就有三個演出，包括個人獨奏會、與上海『彼岸』團隊合作的《憶韻 —— 黑白琴鍵下的戲韻》，以及與香港管弦樂團合作的貝多芬第五《帝王》協奏曲。也有大型的節目，安排在藝術節後段時間演出，如八十人的中國國家京劇院、二百一十人的上海歌劇院與蘇州交響樂團，希望通關後演出能如期舉行。2022 年的方向著重交流與『駐節』，讓觀眾對藝術家有更深入的認識。我們就是在未知的環境中製造可能性。」

Creating Possibilities while Charting the Unknown

Although unable to look for overseas programmes in person during the past two years, Programme Director Grace Lang continued to maintain close contact with overseas arts group and artists. According to Lang, everyone had been positive and trying their best to adapt to these times of theatre closures and arts programmes being on hiatus: "For the performing arts, struggling to survive is the only available plan in the current unplannable environment. Faced with mounting restrictions and uncertainties, programme formats had to be diversified when planning for the Festival. Online programme is only a short-term strategy, and we need to master the application and integration of technology with arts."

With the increasing focus on mining the full potential in each arts group's visit, Lang pointed out that this is a possible direction when planning for the 2022 HKAF: "Instead of the established practice of an arts group having two or three performances during their Hong Kong visit, a format resembling an artist-in-residence programme can be adopted to facilitate more collaboration and exchange with the audiences and local artists. Because of epidemic prevention measures, programmes from Mainland China become the mainstay of the Festival. For example, Beijing pianist Chen Sa will be featured in three performances including a piano recital, *Reminiscence - Chinese Opera at the Keyboard* in collaboration with Shanghai's 'Nirvana' team and *Beethoven Piano Concerto No 5 'Emperor'* with the Hong Kong Philharmonic Orchestra. There are also large-scale programmes to be performed in the later part of the Festival including the China National Peking Opera Company with 80 performers as well as the Shanghai Opera House and Suzhou Symphony Orchestra with more than 210 performers. Hopefully the performances will be held as scheduled after the border reopens. The direction in 2022 will be focused on exchange and 'artist-in-residence' for the audiences to have a deeper understanding of the artists. These are some of the exciting possibilities that arise under the unpredictable environment."

透過互動參與活動，鼓勵藝術節的持份者分享回憶
A campaign to engage HKAF's stakeholders through memories sharing

數碼營銷助推廣藝術

香港藝術節在互聯網上的足跡，是走在尖端的。在網上購物還未廣泛流行之際，藝術節自1997年便推出了網上預訂門票。當年觀眾集體上網訂票導致網站擠塞的情況，就此成為很多人的集體回憶。經歷了二十多年的發展，網上訂票逐漸成為主流訂票模式，近年更有超過九成的觀眾是透過網站訂票。由網上訂票再發展至手機應用程式，以及有效運用電子郵件和社交媒體來推廣藝術節的節目及活動，數碼科技在香港藝術節營銷上的重要性與日俱增。

市場總監鄭尚榮(Katy)道：「時至今日，掌握互聯網的技術，是市場推廣非常重要的一環。我們在技術上作出的各項投資和發展，都以理解觀眾需要為依歸。疫情期間，現場演出必須移師至網上進行，藝術節即透過網絡發布影片而獲得的各項數據，了解觀眾的觀演習慣和喜好；而在大數據年代，我們亦透過分析平台整合資訊，作為實際的指標和制訂策略發展方向。面對種種日新月異的技術以及推陳出新的科技產品，除了快速適應和投放資源，還要帶著一份敢於實驗及求真的精神，以活用科技為目標願景，將數碼技術應用於藝術推廣之上。」

Arts Promotion through Digital Marketing

Hong Kong Arts Festival was at the forefront of internet adoption. Long before the popularity of online shopping, HKAF launched online booking of tickets in as early as 1997. Website congestion due to online booking of tickets in fact became the collective memory among Festival audiences. After more than 20 years of development, tickets are mostly reserved online with over 90 per cent of the Festival's audiences making their ticket purchases online in recent years. From online booking and mobile apps to the promotion of HKAF events through effective use of electronic mails and social media, digital technology becomes increasing important for HKAF's marketing efforts.

Marketing Director Katy Cheng said: "Leveraging on internet technology is now a crucial component in marketing. To understand the needs of our audiences, we invested on and developed our technological capability. During the pandemic, live performances had to be presented online instead. And the Festival was able to better understand the audiences' viewing habits and preferences when presenting the performances through the internet. In the era of big data, analytic platforms are used to integrate our information to formulate indicators and strategic direction of development. We allocated the necessary resources and quickly adopted to rapidly changing technology along with innovative products. Coupled with an experimental spirit, we aim to make flexible use of technology through digital marketing in the arts."

查懋成 香港藝術節主席（2016–）
藝術節未來發展方針

查懋成是香港興業國際集團有限公司執行主席，一直熱心社會公共事務，關注藝術推廣和教育發展。他在2008年加入香港藝術節執行委員會，並於2016年成為香港藝術節協會主席，帶領藝術節跨越五十周年。

查懋成擔任藝術節主席以來，相信過去兩年應是最具挑戰的時刻。「誠然，全球備受新冠肺炎疫情的衝擊，香港以至世界的形勢湧現前所未有的變化，香港藝術節處身其中，也未能獨善其身。2020年2月，第四十八屆藝術節所有節目在準備就緒之下被逼取消或延遲，雖然事出突然，但藝術節的團隊沉著應對，迅速應變；該改動的，盡快改動，該退票的，有序退票。所謂有危就必有機，過去兩年的經驗，讓我們的團隊深諳靈活變通之道，即使在疫情肆虐下，我們展現無窮韌力，力保呈獻高水準的節目，讓觀眾持續參與到藝術節當中。」

對於藝術節的同事，查懋成深表稱許及感激：「他們都很優秀，讓我非常驕傲。我們的團隊瞬即掌握線上和現場的雙軌模式，在疫情的新常態下，盡力為觀眾帶來觀賞演出的機會，亦以非傳統的方式讓觀眾享受藝術氛圍。我相信今後藝術節的同事除了「專業」以外，更會以「靈活」作為對自己的要求，即使面對未來環境千變萬化的挑戰，都會勇於創新，積極配合科技快速的步伐，開拓更多嶄新的呈現表演藝術方式。」

展望下一個五十年，查懋成認為香港藝術節經過多年的努力，已奠定其作為亞洲區首屈一指的文化盛事的地位，未來在國際藝壇將會繼續擔當舉重要的角色。「藝術節在過去五十年打下穩固的根基，讓我們得以與時代並肩探索，發光發亮。我們會繼續努力做好最擅長的事情，透過呈獻優秀國際及本地藝術家的演出，以及舉辦多元化的「加料節目」和教育活動，將優質表演帶給社會上不同的人群，豐富香港的文化生活。藝術節作為本地及國外文化交流的重要橋樑，未來仍會保持這國際地位，進一步推動香港作為文化交流重要樞紐的獨特角色。

查懋成主席出席第48屆香港藝術節記者會
Chairman Victor Cha at the Kick–off Press Conference of the 48th Hong Kong Arts Festival (2019)

「藝術節扎根香港，一直本著服務這個城市為己任。然而，在港舉辦活動的同時，其實未來可以嘗試擴大版圖，探索在境外發展的潛能。無論是表演場地或是觀眾，大家都不一定只鎖定在香港。」查懋成認為可以先從鄰近的大灣區出發，再發展到其他地方。「例如藝術節可以和內地城市合作，將藝術節每年部份節目，特別是委約的本地新作，帶到內地，讓藝術家或藝團有機會到其他地方表演，藉此進行文化交流，加深內地觀眾對香港表演藝術的關注和認識。其實，過去藝術節已嘗試把一些演出推廣予內地觀眾，早在2010年，『香港粵劇經典』和《情話紫釵》在藝術節首演後，同年被邀請到上海世博演出。除了內地城市，藝術節亦可與海外的藝術節合作，共同策劃聯合製作，促進更多元化的文化交流。」

香港近年積極落實興建大型演藝設施，如「西九文化區」及「東九文化中心」，讓缺乏演出場地的情況，大為改善。但其實查懋成還有一個願望，就是希望藝術節能擁有固定的專用場地，作為藝術研討、培訓、綵排、演出，以及其他藝術體驗和長期教育活動之用。「有了此基地，藝術節便不會像現在一樣，長期受制於場地短缺問題的困擾，更能延續其優良傳統和使命，策劃適合不同社群的藝術體驗，為香港以至國際市場的藝術發展作出更大的貢獻。」🌸

Victor Cha Chairman, Hong Kong Arts Festival (2016-)

Charting the Future Direction of HKAF

As the Executive Chairman of HKR International Limited, Victor Cha is enthusiastic about public and social services with a particular passion for arts promotion and educational development. He joined the Executive Committee of Hong Kong Arts Festival in 2008 and became the Chairman of the Committee in 2016, charged with the task of leading HKAF into its 50th year and beyond.

Cha believes that the past two years have been the most challenging of his tenure as Chairman: "It is true that the COVID-19 outbreak became a global challenge that brought unprecedented changes to Hong Kong and the entire world. HKAF was not immune to the situation. In February 2020, despite it being ready for presentation, we made the difficult decision to cancel our entire programme. While our rhythm was suddenly disrupted, the HKAF team responded to the situation with composure and resilience in addressing and resolving problems. Staying true to the adage of 'with crisis comes opportunities', our team drew on their experience of the past two years. By learning to be even more flexible and adaptable in exploring all channels to present exceptional programmes, they enabled audiences to be part of the Festival even amid the COVID-19 outbreak."

2017 第45屆節目及訂票指南
The 45th Hong Kong Arts Festival programme and booking guide

Cha is complimentary about the Festival team and grateful for their efforts: "Each member of the team was outstanding and quickly grasped the implications of running both online and in-venue programmes. Adapting to the new normal under the pandemic, they made it possible for audiences to enjoy performances and savour the arts in non-traditional settings. It is my belief that, the HKAF team will continue to strive to be both 'professional' and 'adaptable' in their endeavours. They will be ready to meet a constantly evolving environment and tackle whatever new challenges that lie ahead. Decisive in making necessary changes, the team is poised to leverage the latest technologies and find new ways to present the arts."

Looking ahead to the next half-century, Cha believes that after years of hard work, HKAF is now firmly established as Asia's premier cultural event. In the future, it will continue to play a significant role in the international arts sector: "HKAF enjoys a solid foundation which has been built up during the last 50 years. We are in an excellent position to venture into new territories and shine. We will continue to do what we excel at. Through performances featuring leading international and local artists, a diverse range of the 'PLUS' programmes and educational events, we remain committed to enriching the cultural life of Hong Kong by bringing high-quality performing arts to all walks of society. Already a crucial international hub linking local and overseas culture, HKAF will maintain this significant role. More captivating performances await audiences as the event continues to attract acclaimed artists from around the world while driving local arts development."

"Deeply rooted in Hong Kong, the Festival has always aimed to serve the city to the best of its ability. However, performance venues and audiences are not necessarily constrained to Hong Kong. In addition to holding events in the city, there is also exciting potential to expand the Festival's reach by exploring opportunities outside of Hong Kong." Cha believes that this growth could begin in the neighbouring Greater Bay Area, before expanding to other geographies. "For example, HKAF can collaborate with cities in Mainland China by bringing them some of the Festival's programmes, especially new works commissioned from Hong Kong. This would empower artists or arts groups to stage more performances in other places. Cultural exchanges could also deepen awareness and understanding of the Mainland audiences in

Hong Kong's performing arts. HKAF has already made attempts to promote performances to non-local audiences. For example, after their premieres in HKAF's 2010 programmes, the shows *Cantonese Opera Treasures* and *The Liaisons* were invited to be performed at the Shanghai Expo. In addition to cities in Mainland China, HKAF can also work with overseas arts festivals on co-productions to promote cultural exchange."

In recent years, Hong Kong took the initiative to construct large-scale performing arts facilities, including the West Kowloon Cultural District and the East Kowloon Cultural Centre. These venues have greatly alleviated the challenges of a lack of performing venues. At the same time, Cha harbours a wish for a permanent and dedicated venue, which could also be used for arts seminars, training, rehearsals, performances as well as other arts-experience and long-term educational programmes. "With a dedicated base of operations, HKAF would not be affected by venue issues. A dedicated location would also better equip HKAF to continue its fine traditions and tailor new arts experiences for different communities in the city. This would definitely strengthen the Festival's position locally and internationally." 🏵

2019 第 47 屆節目及訂票指南
The 48th Hong Kong Arts Festival programme and booking guide

2018 第 46 屆節目及訂票指南
The 46th Hong Kong Arts Festival programme and booking guide

2020 第 48 屆節目及訂票指南
The 48th Hong Kong Arts Festival programme and booking guide

附錄

香港藝術節委約及新製作

從室內歌劇、當代舞蹈、戲劇、創新戲曲，以至當代音樂，香港藝術節每年都會委約並製作一系列的原創新作品，這些新作聚合了不同藝術界別的藝術家和眾多合作者的共同努力。

新作品的委約及製作採取多種運作模式，大部份由藝術節直接委約及擔任監製，從題材、劇本、創意開始，進而至創作、演出及製作人員的組合，劇本修訂、發展，以及製作安排、宣傳推廣及營銷，甚至新劇本的出版，藝術節都與創作人同行，期望以有限的資源，給予藝術創作最有效的輔助和策劃。

作為獨立製作人，藝術節希望在香港往往倉促的創作及製作環境裏，與藝術工作者共同規劃更理想的創作框架。除了本地原創作品，也積極策劃跨地域的製作，發掘更多題材的可能性以及更新的製作意念，拓展更國際化的展示平台。這是香港藝術節作為一個國際藝術節的願景之一：推動文化交流及服務以此為家的城市。

Appendix

Hong Kong Arts Festival Commissions and New Works

Every year the HKAF commissions and produces a series of original works that range from chamber opera, contemporary dance, theatre, innovative Chinese opera to contemporary music. These works bring together individual artists and collaborators as well as organisations from different artistic fields.

The Festival explores different modes of commissioning and production for each new work. Most of these productions are directly commissioned and produced by the Festival, which supports the creation of these works in every way from the conception of production, script development to selection of performers, creative and production teams, and oversees production arrangements, marketing and publicity, sales, and even the publication of new plays.

As an independent producer working within the limits of this often hectic environment for artistic creation and production in Hong Kong, the aim is to build a stronger framework with arts practitioners for the creation of new works. Apart from original local productions, the Festival established cross-border collaborations to explore new thematic possibilities and creative concepts, and to expand the international reach. This is part of HKAF's vision as an international arts festival: to facilitate cultural exchange and to serve the city which is its home.

香港藝術節委約及新製作
HKAF Commissions
and Production

香港藝術節過往節目
HKAF Past Programmes

風采五十
香港藝術節薈藝國際

編輯委員會	何嘉坤、鄭新文、梁掌瑋、鄭尚榮、余潔儀、黃月妙
主編及統籌	黃月妙
撰稿及訪問	黃月妙、林喜兒
助理統籌	楊璞、張予心、雲希朗、廖子盈、向寶淇、鄒穎妮
翻譯	李旬烈、Oliver Farry
設　計	Acorn Design Ltd
責任編輯	林雪伶

出版	商務印書館（香港）有限公司 香港筲箕灣耀興道 3 號東匯廣場 8 樓 http://www.commercialpress.com.hk
發行	香港聯合書刊物流有限公司 香港新界荃灣德士古道 220-248 號荃灣工業中心 16 樓
印刷	亨泰印刷有限公司 香港柴灣利眾街 27 號德景工業大廈 10 樓

版　次	2022 年 9 月第 1 版第 1 次印刷 ©2022 商務印書館（香港）有限公司 Printed in Hong Kong
國際書號	978 962 07 59031

www.hk.artsfestival.org

Hong Kong Arts Festival at 50: Confluence of Global and Local Artistic Excellence

Editorial Committee	Tisa Ho, Tseng Sun-man, Grace Lang, Katy Cheng, Flora Yu, Kitty Wong
Project Editor & Coordinator	Kitty Wong
Writing & Interview	Kitty Wong, Venus Lam
Assistant Coordinators	Michelle Yeung, Stephanie Cheung, Alana Wan, Sharon Liu, Winky Heung, Wingni Chau
Translator	Cedric Lee, Oliver Farry
Design	Acorn Design Ltd
Executive Editor	Sheelagh Lam

Publisher
The Commercial Press (H.K.) Ltd
8/F, Eastern Central Plaza, 3 Yiu Hing Road
Shau Kei Wan, Hong Kong

Distributor
THE SUP Publishing Logistics (H.K.) Ltd
16/F, Tsuen Wan Industrial Building
220-248 Texaco Road, Tsuen Wan
NT, Hong Kong

Printer
Hang Tai Printing Company Limited
10/F, Tak King Industrial Building
27 Lee Chung Street

© 2022 The Commercial Press (H.K.) Ltd
First edition, First printing, September 2022

ISBN 978 962 07 5903 1
Printed in Hong Kong

www.hk.artsfestival.org